THE CRAFTS OF MEXICO

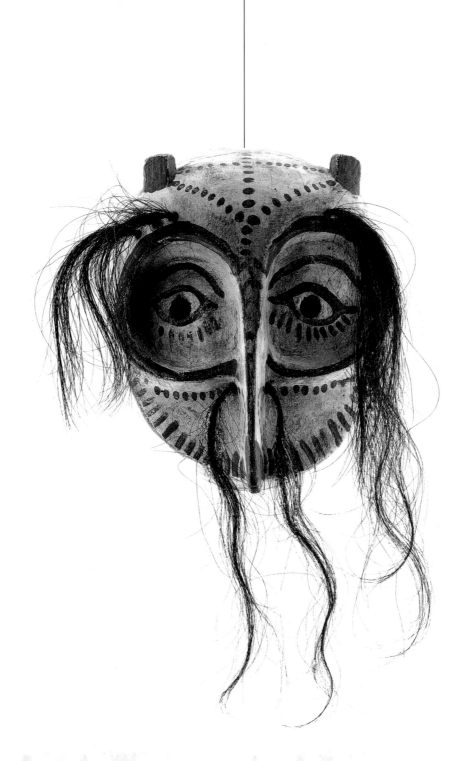

Cover
Francisco "Chico" Coronel.
Gilded lacquerwork gourd.
Olinalá, Guerrero.
Ruth D. Lechuga Folk Art Museum.

Page 1
Owl mask for the Pascola dance.
Painted wood and hair.
San Bernardo Guarijío, Sonora, 1993.
Ruth D. Lechuga Folk Art Museum.

Published in 2004 in the United States of America by Smithsonian Books
In association with Artes de México
Córdoba 69, Colonia Roma, 06700, Mexico City.
Phone: 52 (55) 5525 5905
artesdemexico@artesdemexico.com

ISBN: 1-58834-212-3

Library of Congress Control Number: 2004107715

Printed and bound in China, not at government expense.
09 08 07 06 05 04 1 2 3 4 5

The Crafts of Mexico

EDITED BY

MARGARITA DE ORELLANA

ALBERTO RUY-SÁNCHEZ

GUEST EDITOR

ELIOT WEINBERGER

PUBLISHED IN ASSOCIATION WITH ARTES DE MÉXICO

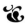

SMITHSONIAN BOOKS

WASHINGTON

The Crafts of Mexico

11 SEEING AND USING: ART AND CRAFTSMANSHIP
Octavio Paz

27 A VISION OF THE HAND
Alberto Ruy Sánchez

37 VISIBLE AND INVISIBLE HANDS
Margarita de Orellana

97 TERRA INCOGNITA
Alfonso Alfaro

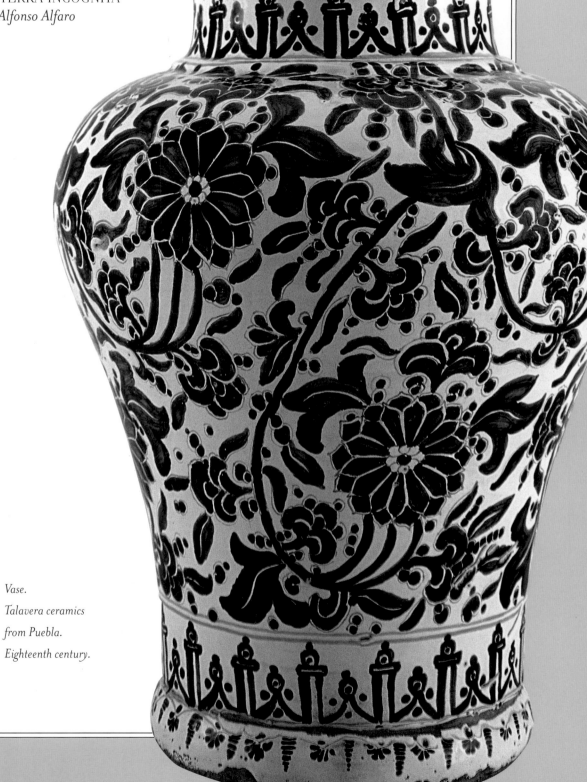

Vase.
Talavera ceramics
from Puebla.
Eighteenth century.

Ceramics

CERAMICS : TONALA

112 CERAMICS OF THE FIVE SENSES
Alberto Ruy Sánchez

120 EARTHENWARE OF WATER AND OF FIRE
Gutierre Aceves Piña

CERAMICS : TALAVERA

132 THE WORLD OF TALAVERA
Alberto Ruy Sánchez

136 TALAVERA: ITS NAME AND MANUFACTURE
Luz de Lourdes Velázquez Thierry

CERAMICS : METEPEC

142 TRADITION AND FANTASY MOLDED IN CLAY
Luis Mario Schneider

150 A LOVER OF CLAY
INTERVIEW WITH TIBURCIO SOTENO
Chloë Sayer

CERAMICS : MATA ORTIZ

168 THE ALCHEMY OF CLAY
Bill Gilbert

182 THE SOUL OF A POTTER
INTERVIEW WITH JUAN QUEZADA
Marta Turok

Lydia Quezada C.

Ceramic pot.

Mata Ortiz,

Chihuahua.

Textiles

TEXTILES : CHIAPAS

POEM
192 | HOW THE MOON TAUGHT US TO WEAVE
Lexa Jiménez López

196 | A WEFT OF VOICES
Margarita de Orellana

212 | THE TEXTUAL TEXTILE
Marta Turok

POEM
220 | FLOWER WOMAN
Sna Jolobil

TEXTILES : OAXACA

224 | THE ANATOMY OF A TEXTILE TRADITION
Irmgard W. Johnson

240 | WEAVINGS THAT PROTECT THE SOUL
Alejandro de Ávila

276 | LIVES SPUN ON TEOTITLÁN LOOMS
INTERVIEWS WITH MANUEL BAZÁN MARTÍNEZ, ISAAC VÁZQUEZ GARCÍA
AND ARNULFO MENDOZA
Chloë Sayer

*Traditional
blouse from
Saltillo, Chiapas.*

Lacquerwork, Basketry, Tinwork

LACQUERWORK

292 ORIGINS AND FORMS OF LACQUERWORK
Ruth D. Lechuga

BASKETRY

304 NATURE AND GEOMETRY
Ana Paulina Gámez

TINWORK

338 A HUMBLE AND EPHEMERAL NATURE
Gloria Fraser Giffords

346 FOUR TINSMITHS SPEAK
INTERVIEWS WITH ARTURO SOSA, MARÍA LUISA VÁZQUEZ DE SOSA, RAMÓN FOSADO
AND VÍCTOR HERNÁNDEZ LEYVA
Magali Tercero

Lacquerwork tray.

Olinalá,

Guerrero.

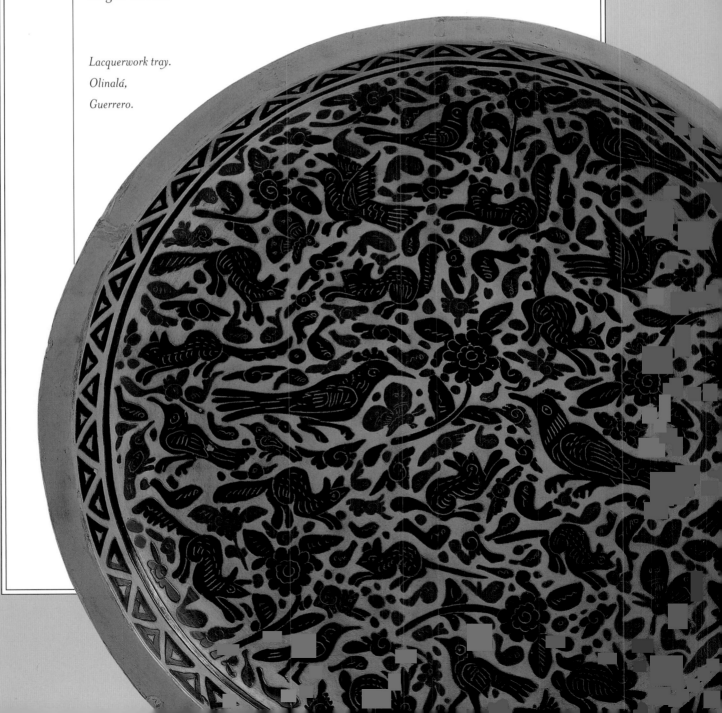

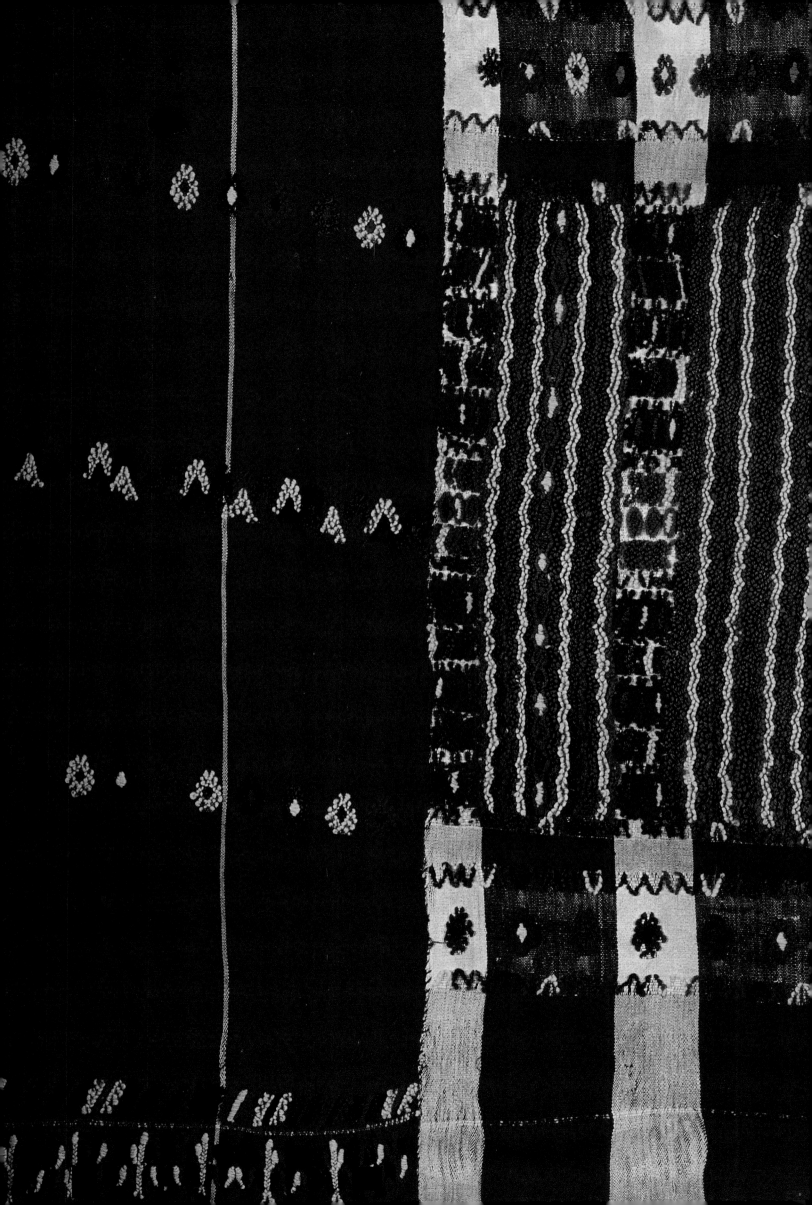

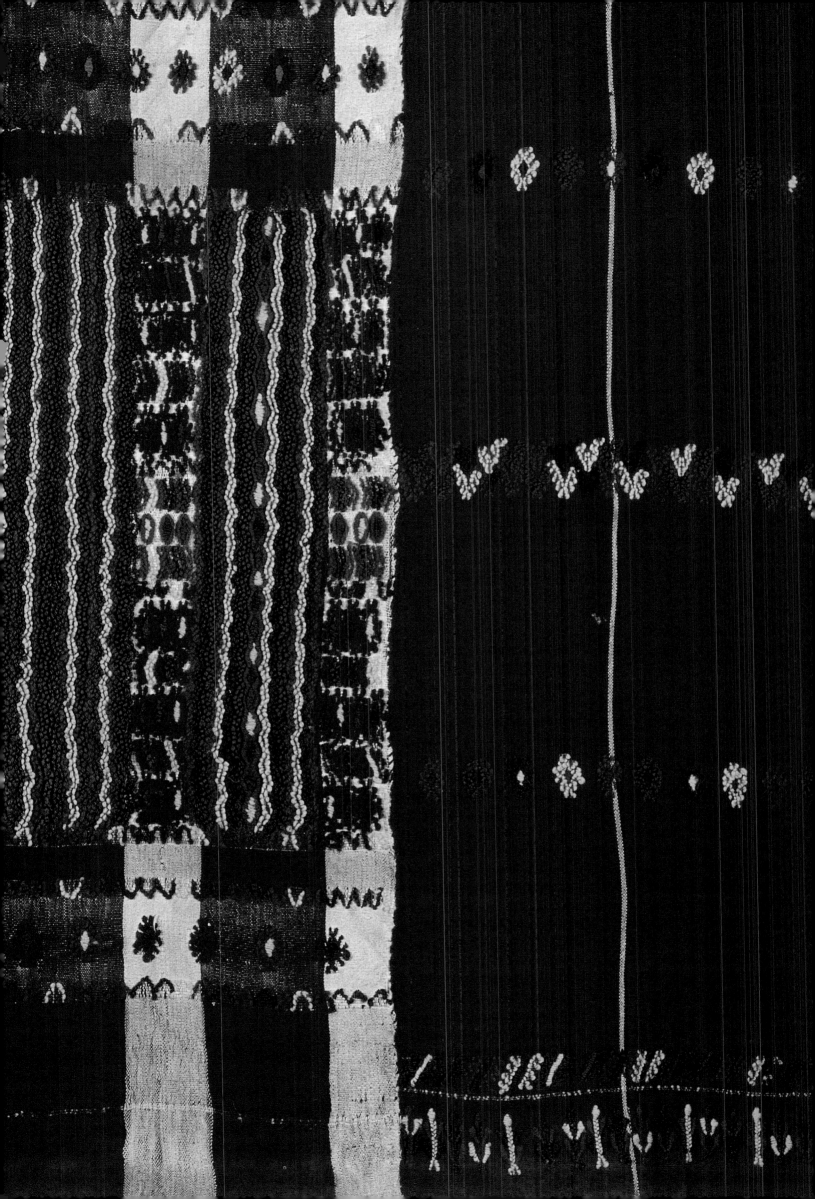

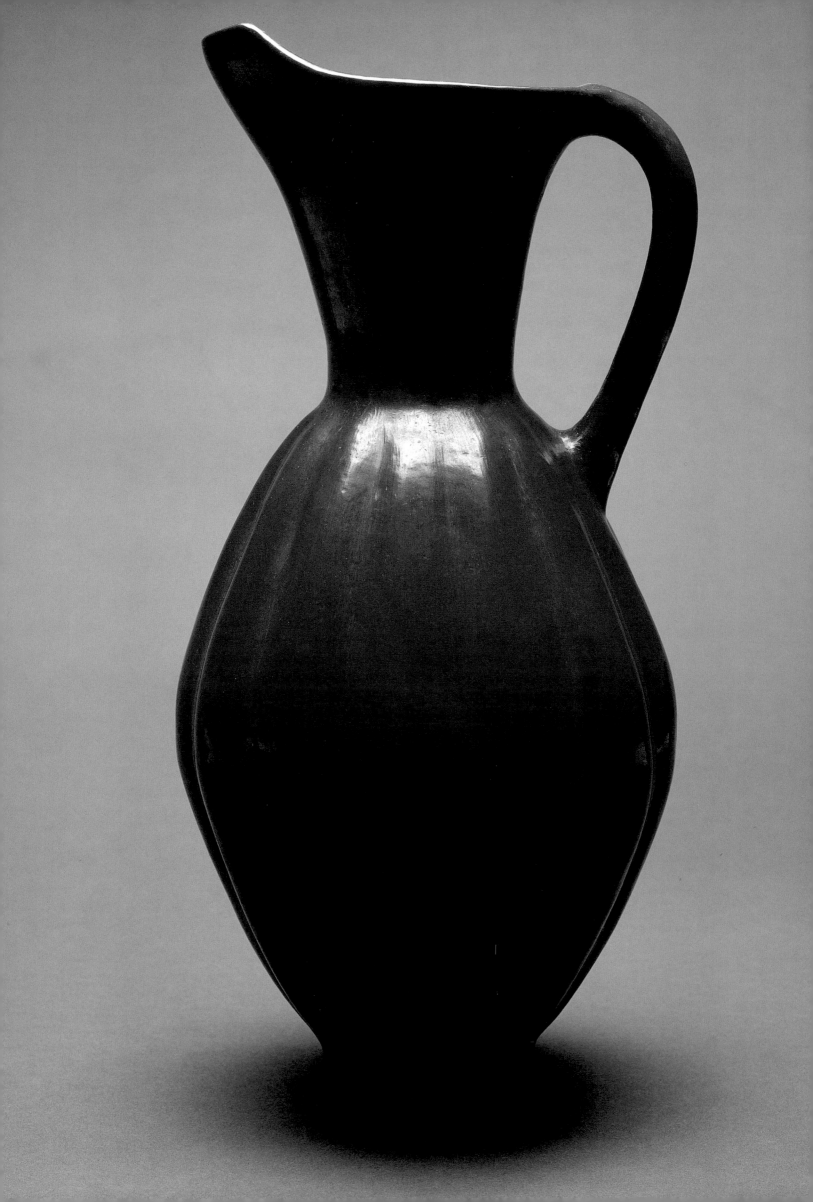

Seeing and Using:
ART AND CRAFTSMANSHIP

Octavio Paz

MADE BY HAND, THE CRAFT OBJECT BEARS THE FINGERPRINTS, REAL or metaphorical, of the person who fashioned it. These fingerprints are not the equivalent of the artist's *signature*, for they are not a name. Nor are they a mark or brand. They are a sign: the almost invisible scar commemorating our original brotherhood and sisterhood. Made *by* hand, the craft object is made *for* hands. Not only can we see it; we can also finger it, feel it. We see the work of art but we do not touch it. The religious taboo that forbids us to touch saints—"you'll burn your hands if you touch the monstrance," we were told as children—also applies to paintings and sculptures. Our relationship with the industrial object is functional; our relationship with the work of art is semi-religious; our relationship with the craft object is corporeal. Indeed, the latter is not a relationship but a contact. The transpersonal nature of crafts finds direct and immediate expression in sensation: the body is participation. To feel is primarily to feel something or someone not ourselves. And above all, to feel with someone. Even to feel itself, the body seeks another body. We feel through others. The physical and bodily ties binding us to others are no less powerful than the legal, economic and religious ties uniting us. The handmade object is a sign that expresses society not as work (technique) or as symbol (art, religion) but as shared physical life. ❖ The pitcher of water or wine in the middle of the table is a point of convergence, a little sun uniting everyone present. But my wife can transform that pitcher pouring forth drink at the table into a flower vase. Personal sensibility and imagination divert the object from its ordinary function and create a break in its meaning: it is no longer a vessel to contain liquid but to display a carnation. This diversion and break link the object to another realm of sensibility: imagination. ❖ This imagination is social: the carnation in the pitcher is also a metaphorical sun shared with everyone. In its perpetual movement back and forth between beauty and utility, pleasure and service, the craft object teaches us lessons in sociability. At celebrations and ceremonies its radiation is even more intense and total. At celebrations the collectivity communes with itself, and this communion takes place through ritual objects that are almost always handmade. While the celebration is participation in original time—the collectivity literally shares the date being commemorated among its members, as if it were sacred bread—crafts are a sort of celebration of the object: they transform a utensil into a sign of participation. ❖

Opposite page
Majolica pottery for
everyday use.
Tonalá, Jalisco.
Nineteenth century.
Private collection.

Pages 8–9
Cloth used in the
fiesta of Saint
Bartholomew.
Venustiano
Carranza, Chiapas.
Pellizzi Collection.

Page 10
Pitcher.
Clay modeled
over a Sayula slip
and burnished.
Jalisco region.
Nineteenth century.
8 x 8 1/4 in.
Montenegro
Collection,
Instituto Nacional
de Bellas Artes.

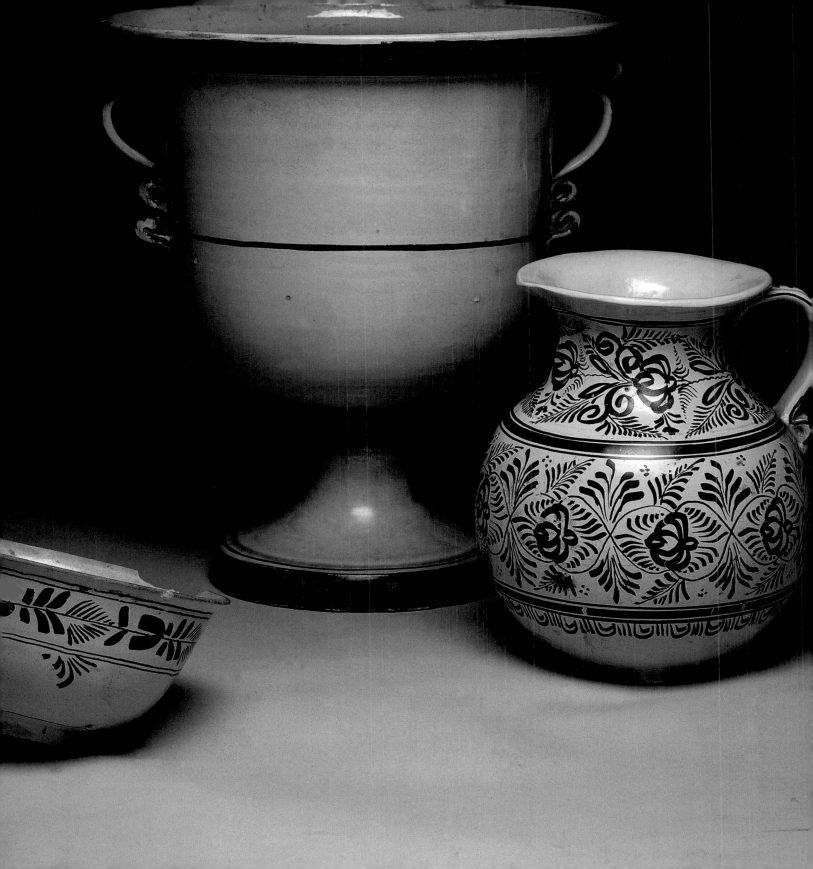

A Lesson in Fantasy and Sensibility

A glass pitcher, a wicker basket, a *huipil* of coarse cotton cloth, a wooden bowl—handsome objects not in spite of but because of their usefulness. Their beauty is an added quality, like the scent and color of flowers. Their beauty is inseparable from their function: they are admirable because they are useful. Handicrafts belong to a world existing before the separation of utility from beauty. ❖

The industrial object tends to disappear as a form and become one with its function. Its being is its meaning, and its meaning is to be useful. It lies at the opposite extreme to the work of art. Craftsmanship is a mediation; its forms are not governed by the economy of function but by pleasure, which is always wasteful expenditure and has no rules. The industrial object forbids the superfluous; the craft object delights in embellishments. Its predilection for decoration violates the principle of usefulness. The decoration of the craft object ordinarily has no function whatsoever, so the industrial designer—obeying his implacable aesthetic—does away with it. The persistence and proliferation of ornamentation in handicrafts reveal an intermediate zone between utility and aesthetic contemplation.

In craftsmanship there is a continuous movement back and forth between utility and beauty; this back-and-forth motion has a name: pleasure. Things are pleasing because they are useful *and* beautiful. This conjunction defines craftsmanship, just as the disjunctive defines art and technology: beauty *or* utility. The handmade object satisfies the need to take delight in the things we see and touch, whatever their everyday uses. This need is not reducible to the mathematical ideal that rules industrial design, nor is it reducible to the rigor of the religion of art. The pleasure that crafts give us has its source in a double transgression: against the cult of utility and against the religion of art. ❖

In general, the evolution of the industrial object for daily use has followed that of artistic styles. Almost invariably, industrial design has been a derivation— sometimes a caricature, sometimes a felicitous copy—of the artistic vogue of the moment. It has lagged behind contemporary art and has imitated styles at a time when they had already lost their initial novelty and were becoming aesthetic clichés. ❖

❖ OCTAVIO PAZ

Contemporary design has endeavored in other ways—its own—to find a compromise between usefulness and aesthetics. At times it has managed to do so, but the result has been paradoxical. The aesthetic ideal of functional art is based on the principle that the usefulness of an object increases in direct proportion to the decrease in its materiality. The simplification of forms may be expressed by the following equation: minimum presence equals maximum productivity. This aesthetic is borrowed from the world of mathematics: the *elegance* of an equation lies in the simplicity and necessity of its solution. The ideal of design is invisibility: the less visible a functional object, the more beautiful it is. ✢

This is a curious transposition of fairy tales and Arab legends to a world ruled by science and the notions of utility and maximum productivity: the designer dreams of objects that—like genies—act as intangible servants. This is the opposite of the craft object, a physical presence that we assimilate through our senses and in which the principle of usefulness is constantly violated in favor of tradition, imagination, and even sheer impulse. The beauty of industrial design is conceptual: if it expresses anything at all, it is the accuracy of a formula. It is the sign of a function. Its rationality makes it fall within an either/or dichotomy: either it is good for something or it isn't. In the second case it goes into the garbage. The handmade object does not charm us simply because of its usefulness. It lives in complicity with our senses, and that is why it is so hard to get rid of it—that would be like throwing a friend out of the house. ✢

A Lesson in Politics

Modern technology has brought about a great many profound transformations, but all in the same direction and with the same import: the extirpation of the *Other*. By leaving the aggressiveness of the human species intact and by making its members uniform, it has strengthened the causes tending toward its extinction. Craftsmanship, on the other hand, is not even national in scope: it is local. Heedless of boundaries and systems of government, it outlives republics and empires: the pottery, basketwork and musical instruments seen in the frescoes of Bonampak have survived Mayan priests, Aztec warriors, colonial friars and Mexican presidents. They will also survive American tourists. Craftsmen have no country; they are from

Huichol votive gourd decorated with beads.

6 1/4 x 1 1/4 in.
Diameter 19 3/4 in.
Ruth D. Lechuga Folk Art Museum.

Opposite page
Carved bull's horn combs decorated with permanganate. San Antonio la Isla, State of Mexico. Ruth D. Lechuga Folk Art Museum.

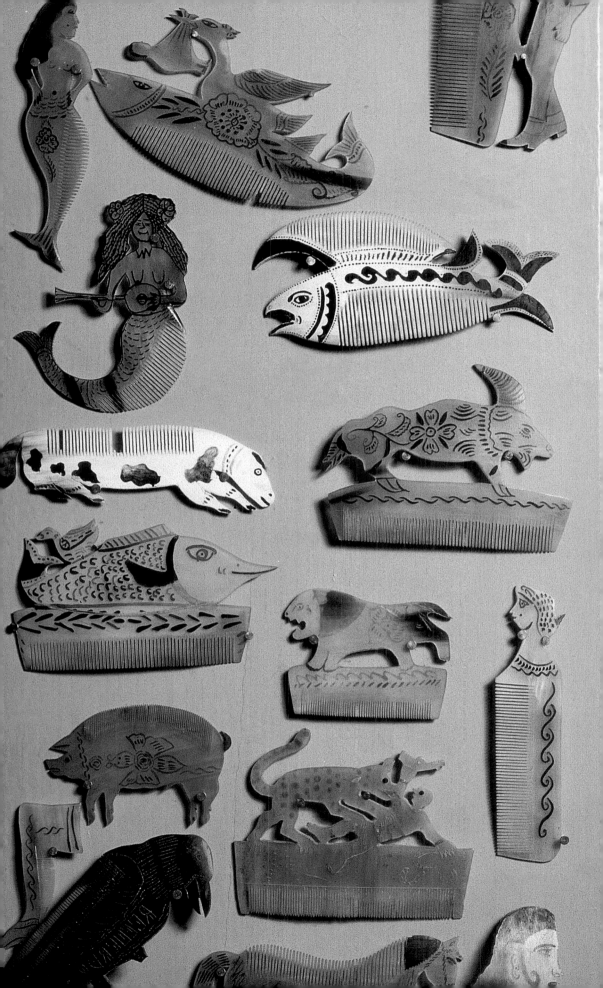

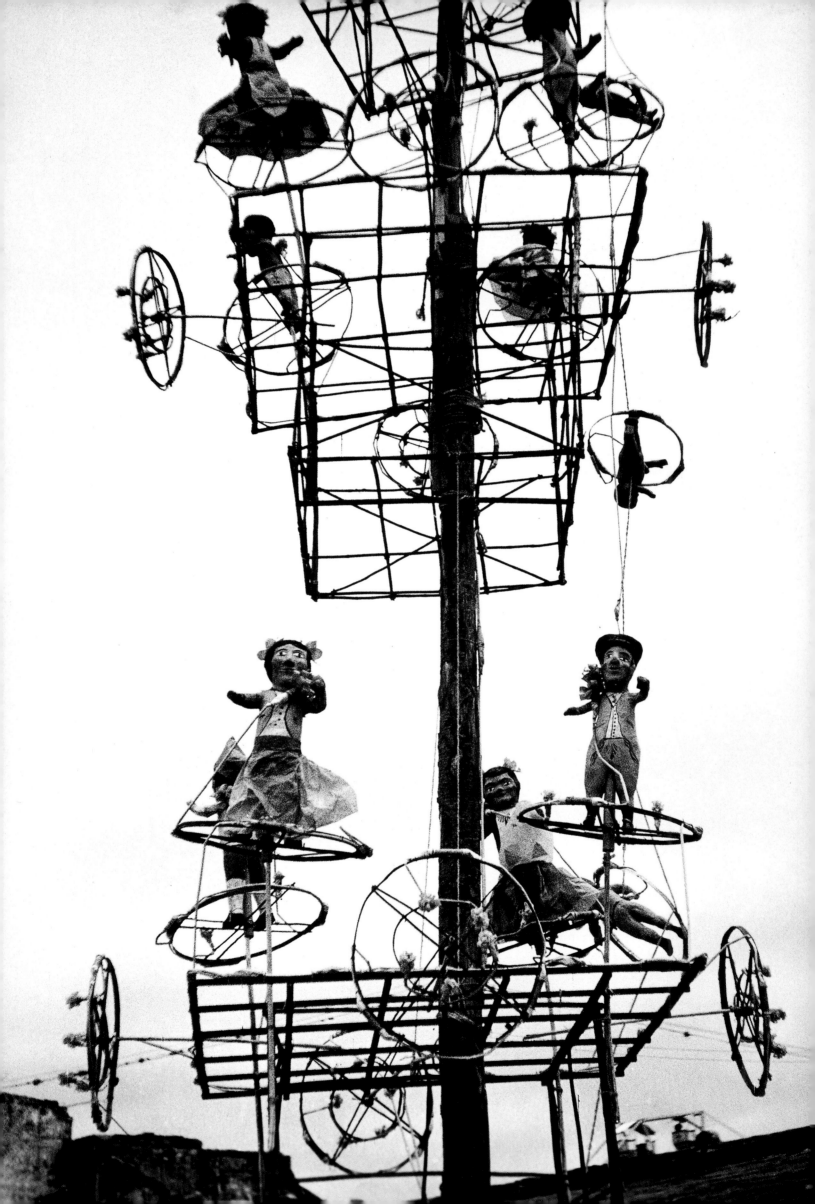

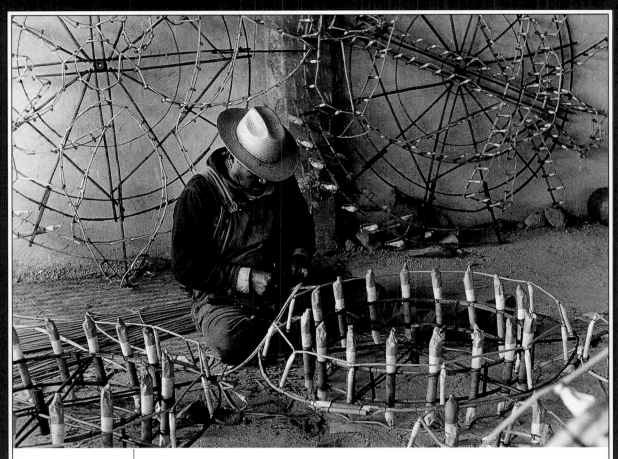

Artisan making castillos (fireworks structures). San Martín de las Pirámides, State of Mexico, 1963. Photo: Ruth D. Lechuga.

Opposite page Castillo (fireworks structure). Los Remedios, State of Mexico, 1950. Photo: Ruth D. Lechuga.

their village. What is more, they are from their neighborhood and their family. Craftsmen defend us from the unification of technology and its geometric deserts. By preserving differences, they safeguard the exuberance of history. The craftsman does not define himself in terms of either nationality or religion. He is not loyal to an idea or image but to a practice: his craft. A workshop is a social microcosm governed by laws of its own. The artisan seldom works by himself, nor is his work overly specialized as in industry. His workday is not ruled by a rigid time schedule but by a rhythm linked more to his body and sensibility than to the abstract necessities of production. As the artisan works he may talk with others and sometimes sing. His boss is not an invisible figurehead but an old man who is his master and almost always a relative, or at least a neighbor. It is revealing that, despite its markedly collectivist character, the craft workshop has not served as a model for any of the great utopias of the West. From Campanella's City of the Sun to Fourier's Phalanstery to Marx's Communist society, the prototypes of the perfect social man have not been artisans but priest-sages, philosopher-gardeners and the worker of the world in whom praxis and science are conjoined. Of course I do not believe that the craft workshop is an image of perfection. Yet I think that its lack of perfection points to how we might humanize our society: its imperfection is that of men and women, not of systems. Because of

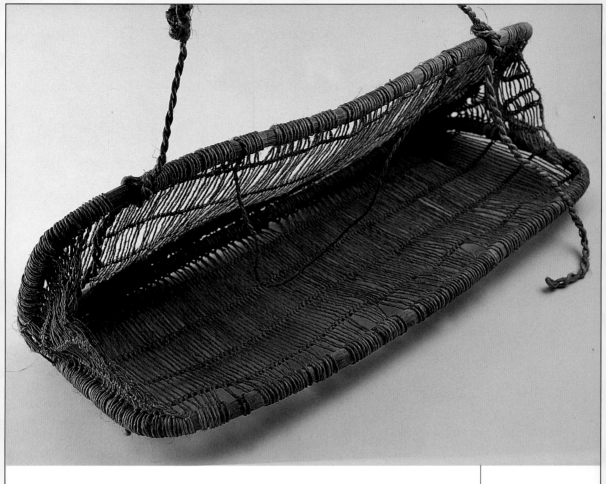

its size and the number of individuals that make it up, a community of artisans favors a democratic way of life; its hierarchical organization is founded not on power but on skill: masters, journeymen, apprentices. In short, craftwork is an occupation that involves both play and creation. After giving us a lesson in sensibility and imagination, craftsmanship gives us one in politics. ❖

A LESSON IN LIFE

The artist of old wanted to be like his predecessors, to make himself worthy of them through imitation. The modern artist wants to be different; his homage to tradition is to deny it. When he seeks a tradition, he looks for it outside the West, in the art of primitives or other civilizations. Because they negate Western tradition, the archaism of the primitive object and the antiquity of the Sumerian or Mayan object are paradoxical forms of novelty. The aesthetic of change requires that each work of art be new and different from those preceding it; novelty in turn implies the negation of immediate tradition. Tradition becomes a succession of abrupt breaks. The delirium of change also governs industrial production, though for different reasons: each new object—the result of a new process—ousts the object preceding it. The

Huacal (basket for carrying a baby). Cuetzalan, Puebla.

*Opposite page
Woman weaving hat.
Tlapa, Guerrero, 1966.
Photo: Ruth D. Lechuga.*

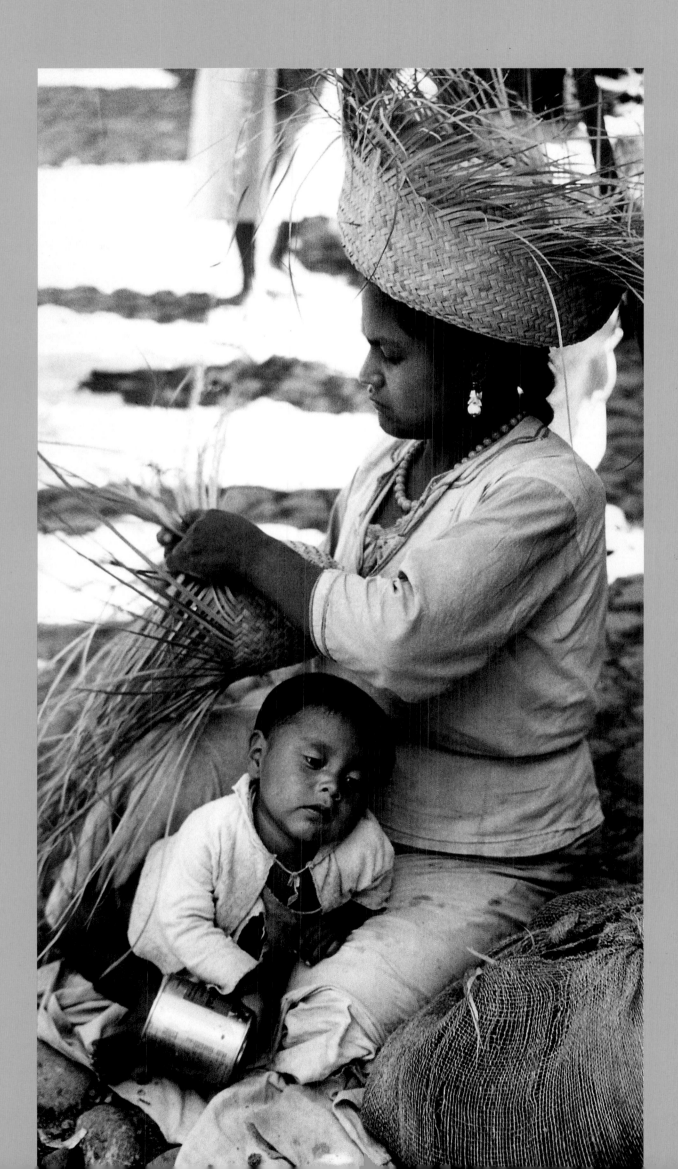

Opposite page
Petate.
Natural and dyed
palm, woven with
variations.
Santa Cruz,
Puebla.

Pages 24–25
Basketry pieces
made with different
techniques and
materials.

history of craftsmanship is not a succession of inventions or of unique (or supposedly unique) works. In reality, crafts do not have a history, if we conceive of history as being an uninterrupted series of changes. There is not a break but a continuity between its past and present. The modern artist has embarked upon the conquest of eternity, and the designer upon that of the future; the artisan allows himself to be vanquished by time. Traditional but not historical, linked to the past but bearing no date, the craft object teaches us to be wary of the mirages of history and illusions of the future. The artisan seeks not to conquer time but to be one with its flow. Through repetitions that are imperceptible but real variations, his works endure… ✣

The fate awaiting the work of art is the air-conditioned eternity of the museum; the one awaiting the industrial object is the garbage dump. Craftwork escapes the museum, and when it does end up in its showcases, it acquits itself with honor: rather than a unique object, it is merely a sample. It is a captive example, not an idol. Craftsmanship does not go hand in hand with time, nor does it seek to conquer it. Experts periodically examine the signs of decay on artworks: cracks in paintings, lines that have blurred, changes of color, the leprosy that eats away at both Ajanta's frescoes and Leonardo's canvases. As a material thing, the work of art is not eternal. And as an idea? Ideas too grow old and die. But artists very often forget that their work holds the secret of true time: not empty eternity, but the life of the instant. The work of art, moreover, has the power to nourish human spirits and to be reborn, even as negation, in the works that are its descendants. ✣

For the industrial object there is no resurrection: it disappears as rapidly as it appears. If it left no trace whatsoever it would be truly perfect; unfortunately it has a body, and once it has ceased to be useful, it becomes mere refuse that is difficult to dispose of. The indecency of waste is no less pathetic than the indecency of the false eternity of the museum. ✣

Craftsmanship does not aspire to last for millennia, but at the same time it seeks no early death. It follows the course of time from day to day, flowing along with us, gradually wearing out, neither pursuing death nor denying it, but rather, accepting it. In between the museum's time out of time and the accelerated time of technology, the work of craftsmanship is the pulse of human time. It is a useful object but also a beautiful one; an object that endures through time yet meets its end and assumes this fact; an object that is not unique like the work of art, but replaceable by another similar yet not identical object. The craft object teaches us to die, and by doing so, teaches us to live. ✣ Translated by Helen Lane. ✣

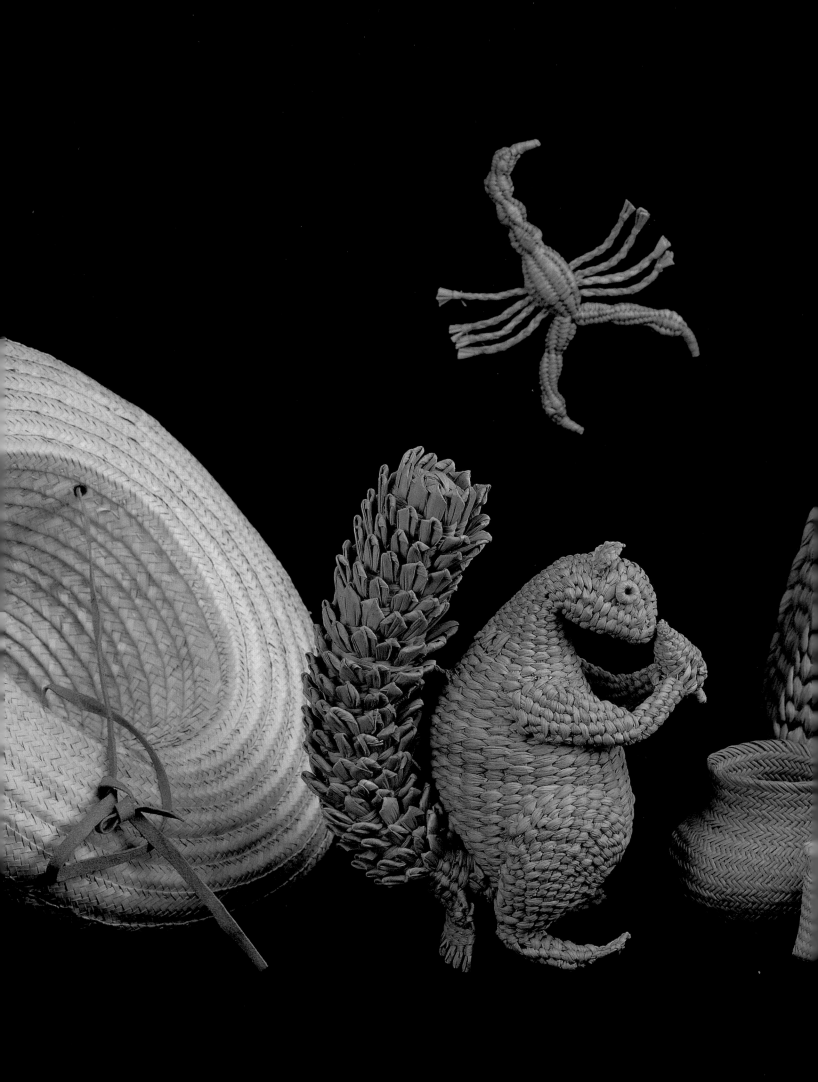

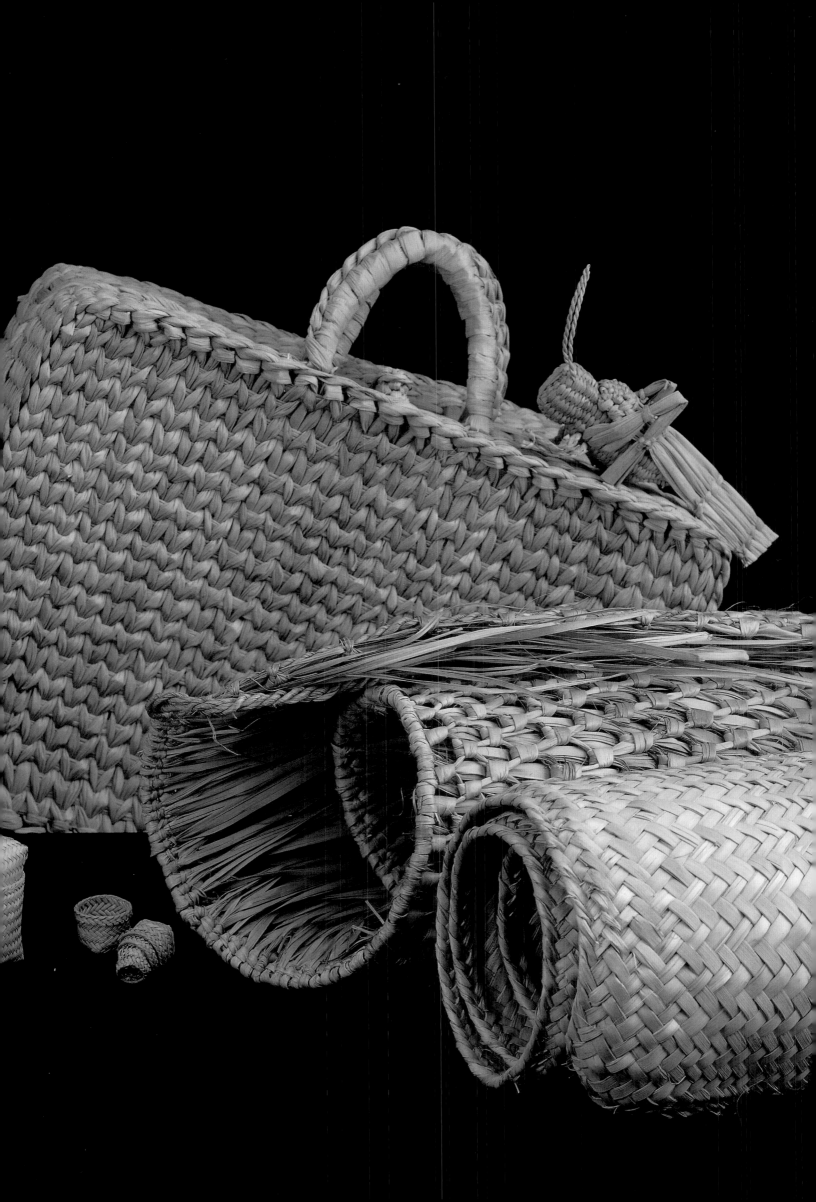

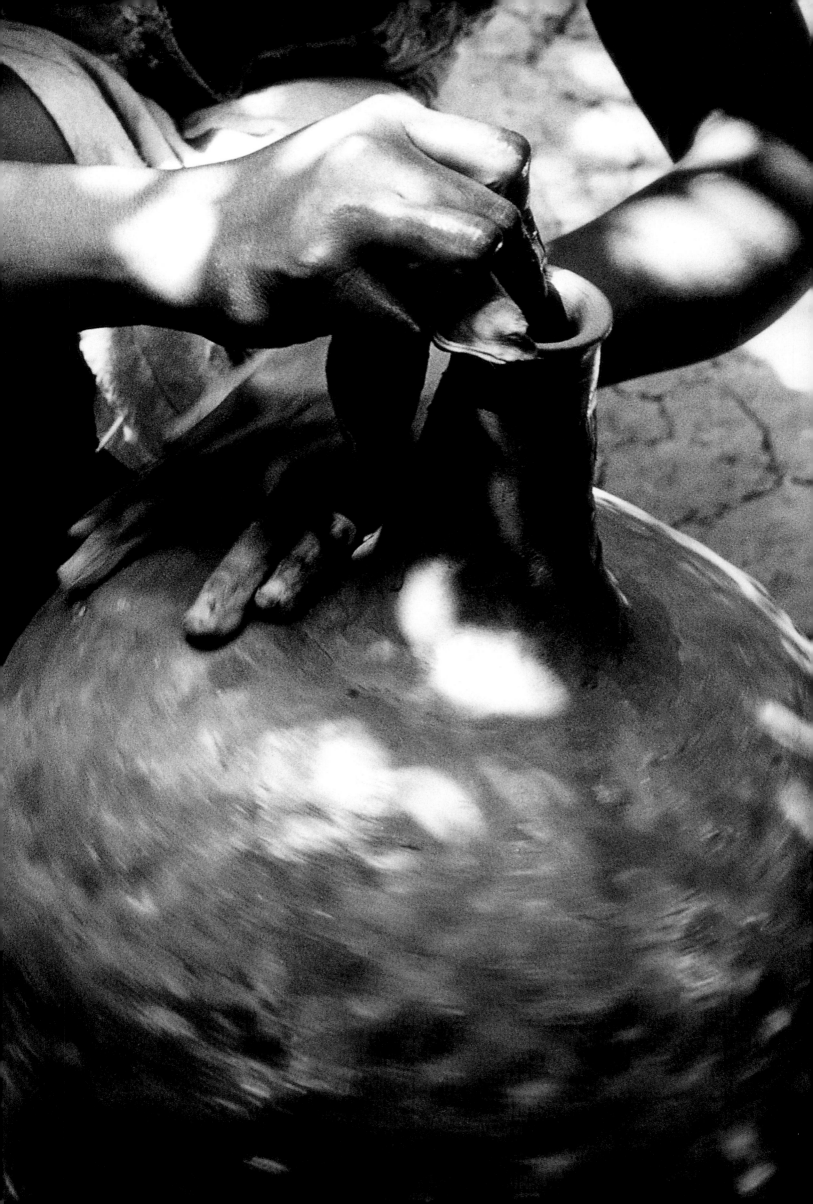

A Vision of the Hand

Alberto Ruy-Sánchez

A POTTER SITS BEFORE HIS WHEEL. IT IS HIS OWN UNIQUE WORKTABLE. He takes a clump of wet clay and places it on the flat, round surface that will start to spin once he begins working the pedal under the table.

❧

Then something close to a miracle happens before our eyes: from the hand deep in the amorphous mass of wet mud appears a beautiful and precise shape. A clay vase emerges with every turn as if an astounding magic trick had allowed it to be born from the artisan's firm fingers. This piece is destined to become a work of art that will intrigue us, brighten our days, and perhaps be of use to us and make our daily life easier.

❧

When we look at a finished handicraft we can easily forget that the piece emerged from a pair of hands that contain within their skin, bones and muscles a certain wisdom, a condition of the soul —something beyond the craft and its materials. The craft models the hand, recreates it and turns it into the "hand of a potter." But the hand itself molds the craftsman's soul, shaping his life and giving meaning to it.

❧

What he does is not only an innate talent, a technique or an acquired skill: it is also a tradition and the will to re-create it. He has learned the craft but more than that, he makes art as if driven to do so, out of a profound need to create. It is more than just a living. It is also—and at times primarily—what gives meaning to his life. And this act is tied to an aesthetic sense of life, to a vital beauty that the potter heightens by creating beautiful objects with his hands.

❧

Hands, for this reason, guide the life of a craftsman as if they were the rudder of a ship. Life's beauty is discovered with one's hands, as when one pulls back a curtain to reveal all the things brought to life by those very hands.

❧

Often the hands of a woman or a man making a beautiful object are like mirrors replicating the gestures that other hands made before them: the hands of their parents, aunts, uncles, grandparents, great-grandparents. There are many hands contained in every craftsman's hand.

Opposite page
Potter.
Reproduced by permission of the Instituto Nacional de Antropología e Historia.

Page 26
Potter from Chililico, Hidalgo.
Photo: Ruth D. Lechuga.

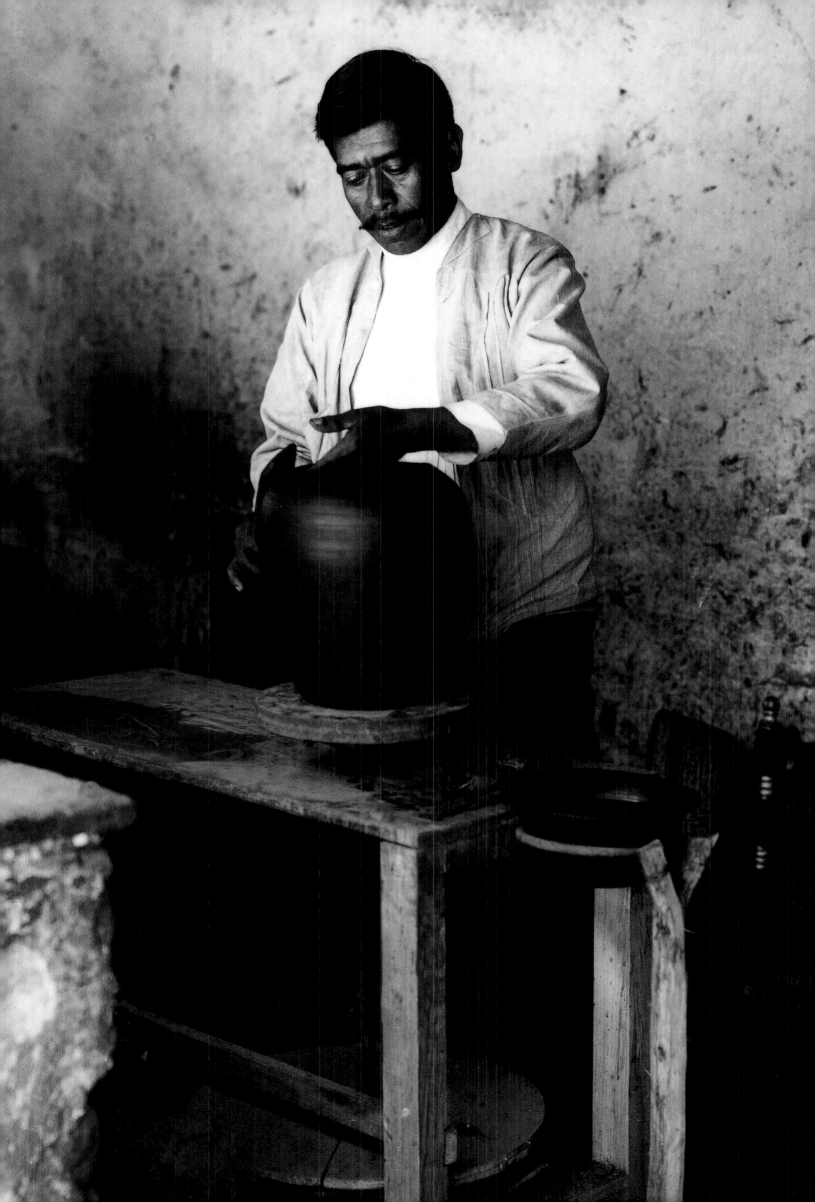

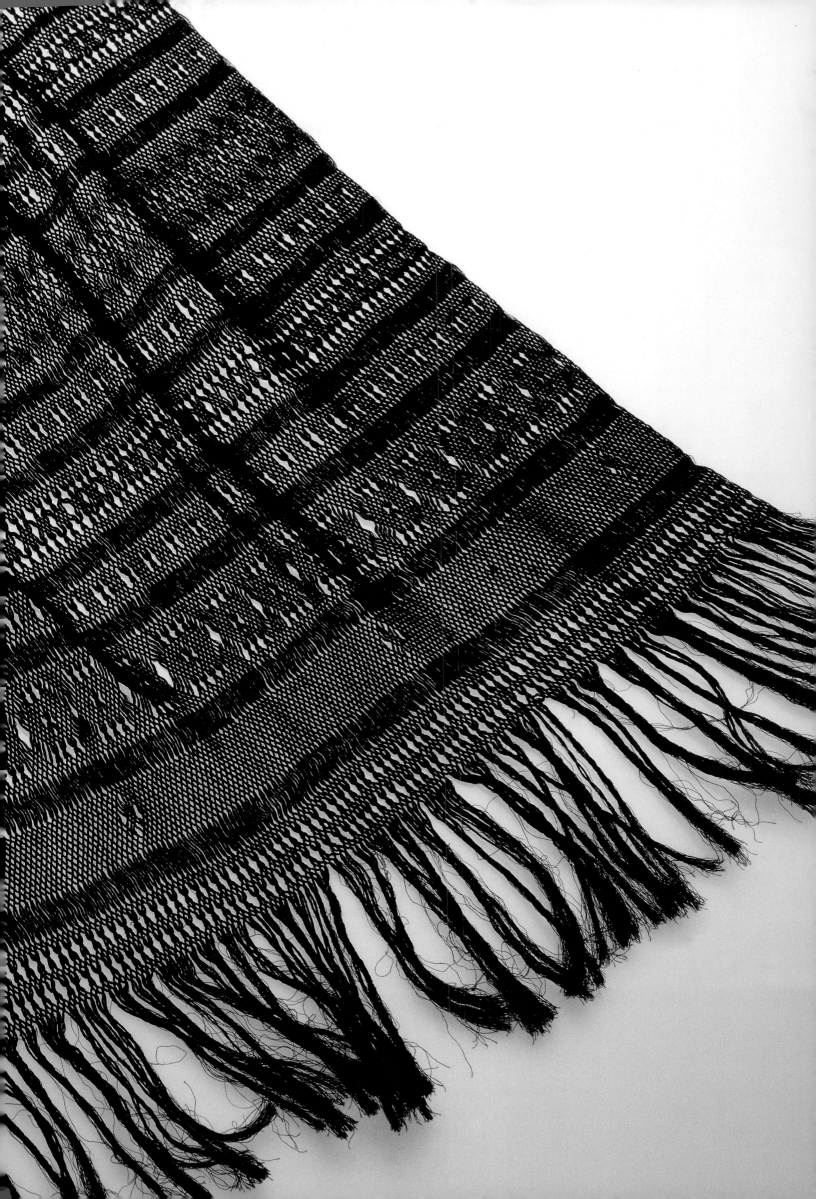

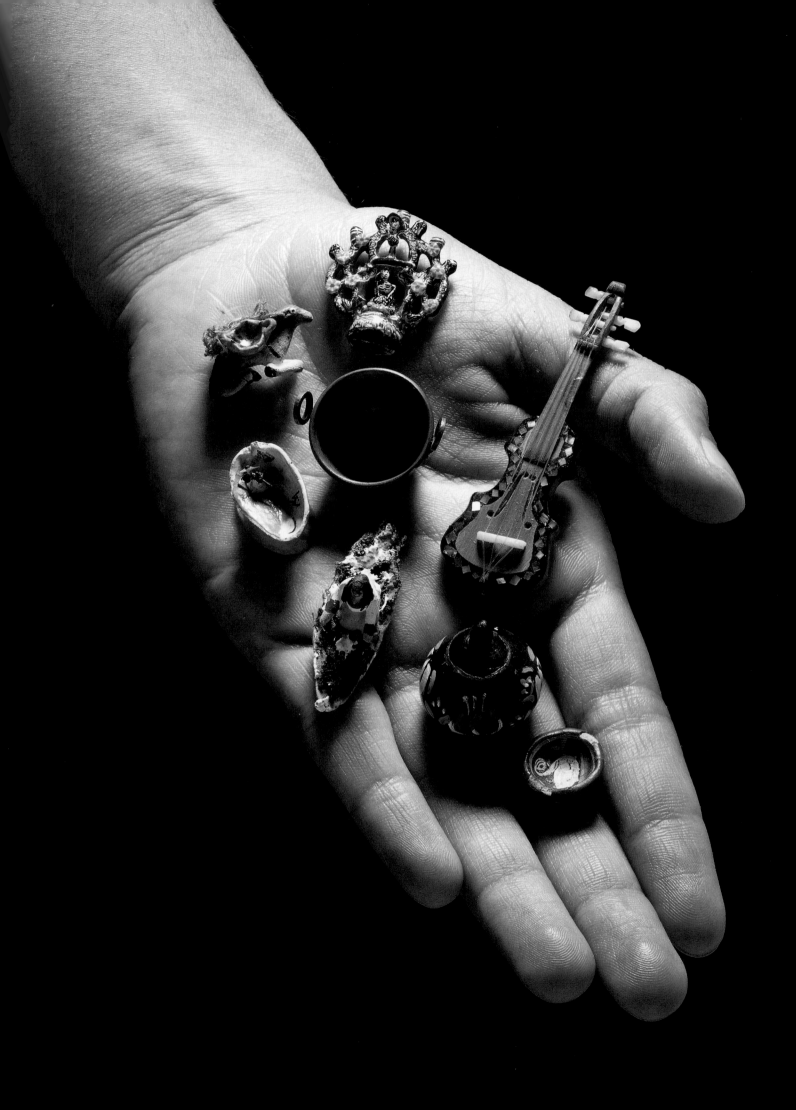

And besides those hands from the past there are the hands of a community engaged in similar activities, thus engendering a kind of collective shape for the work: a shared spirit animates the clay. And it also animates the individual artist, who is bolstered by his sense of community.

❖

Those of us who see these handmade objects as outsiders learn to recognize the presence of their maker and the community in them: two superimposed identities. A thousand hands move in each pair of hands.

❖

Every gesture of a craftsman's hand defies time: the same becomes different, yet it prevails. Only an individual search for perfection paired with the ability to create pieces that are meaningful to one's contemporaries allow a particular craft to survive and endure.

❖

Tradition is in the hands of the artisans because they create instead of mechanically repeating the past. They are the new shoots of a plant that has its roots in the past, leaves and flowers in the present, and seeds for the future. If one forgets that one is creating for the present moment, the plant is nothing but roots that will starve and die. And the seeds are lost, narrowing the plant's chances of surviving in the future.

❖

And when, in the market, at someone's house or in the studio, we find a piece of pottery that surprises us with its beauty and we feel compelled to hold it in our hands and admire it, in some way we are touching the hand of the potter who brought it into the world.

❖

At some moment in the past his eyes were fixed on what we now see. And in his hands we can sense all the hands contained within them, though we also recognize in some small way the hands of a community that is proud of the beautiful objects made by those hands and that give it a sense of identity.

❖

And we also feel the spark of life that only that particular potter could have given the piece, the flash of creativity that is what drew our attention to it in the first place. And in that moment when gazes meet and explode, when hands can hold each other through the material, we sense something beyond it. This is the magic of the craftsman's hand, which is present, both visibly and invisibly, in every craft that fascinates us.

❖

TRANSLATED BY MÓNICA DE LA TORRE. ❖

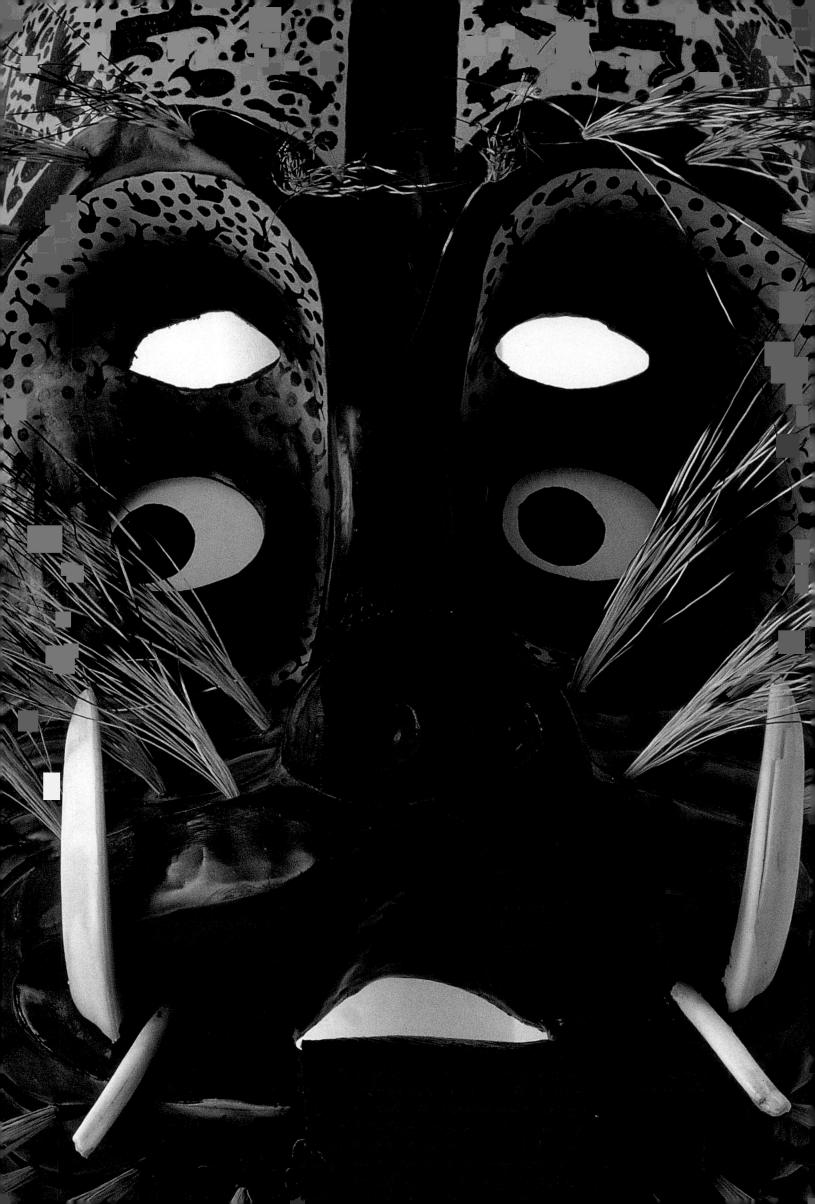

Visible and Invisible Hands

Margarita de Orellana

As I write, an old jaguar with its tongue sticking out watches me from its spot on the wall. It is a wooden mask carved by craftsmen from the town of Olinalá in the state of Guerrero. The animal's face is filled with the silhouettes of other animals, as if its skin bore the colorful dreams of the people who made it. This mask is generally used in the town's traditional dances, and the person wearing it is invested with the mystical powers of the jaguar. ❖

In the bookcase across from me, at eye level, sit twelve clay figures of different shapes; some of them might even seem extravagant. They are painted with white aniline and have purple stripes and glitter. They represent a healer, a sick person, a whistling man, a bull, a scorpion, a centipede, a toad, a coiled snake, a tarantula, a coyote, a lizard and a dove. They are the witnesses and instruments of a healing ritual against *aires* (a blanket term for any number of physical and spiritual ailments) that takes place every year in Tlayacapan, Morelos, and other parts of the country. ❖

Metepec hill is full of similar figures that are buried along with the patients' illnesses. The earth absorbs them, is nourished by them, and turns them into their opposites. Here they are simply a group of whimsical figurines that occupy a privileged space in my study; yet this carnivalesque procession is still a mystery to me. ❖

In the right-hand drawer of my desk I have a small collection of *huipiles* that I bought in Chiapas and Oaxaca. Some of them are copies of garments used only in religious ceremonies. The woman who wears them creates a sacred space around her, a realm where myths and ceremonies converge. ❖

All of a sudden I realize that I am working surrounded by ritual and magical objects. I have been living with them for a long time now, so they have become a part of my daily life. ❖

Other objects, such as an unglazed clay pot from Hidalgo, a vase incrusted with a variety of colorful insects which I bought in Izúcar de Matamoros, and a miniature representation of a wedding party from Tlaquepaque, Jalisco, are here solely for their beauty —another type of magic. Octavio Paz used to say that the craft object lives in complicity with our senses, and that is why it is so hard to get rid of it—that would be like throwing a friend out of the house. ❖
❖

I would like to have a conversation with these presences that are so charged with coded meanings. I would like to decipher them by

Opposite page
Cuadrilla for
healing ritual.
Molded clay
decorated with
glitter.
Tlayacapan,
Morelos.

Pages 34–35
Detail of decorative
lacquerwork mask.
Olinalá, Guerrero.

Page 36
Decorative
lacquerwork mask.
Olinalá, Guerrero.
6 x 3 3/4 in.

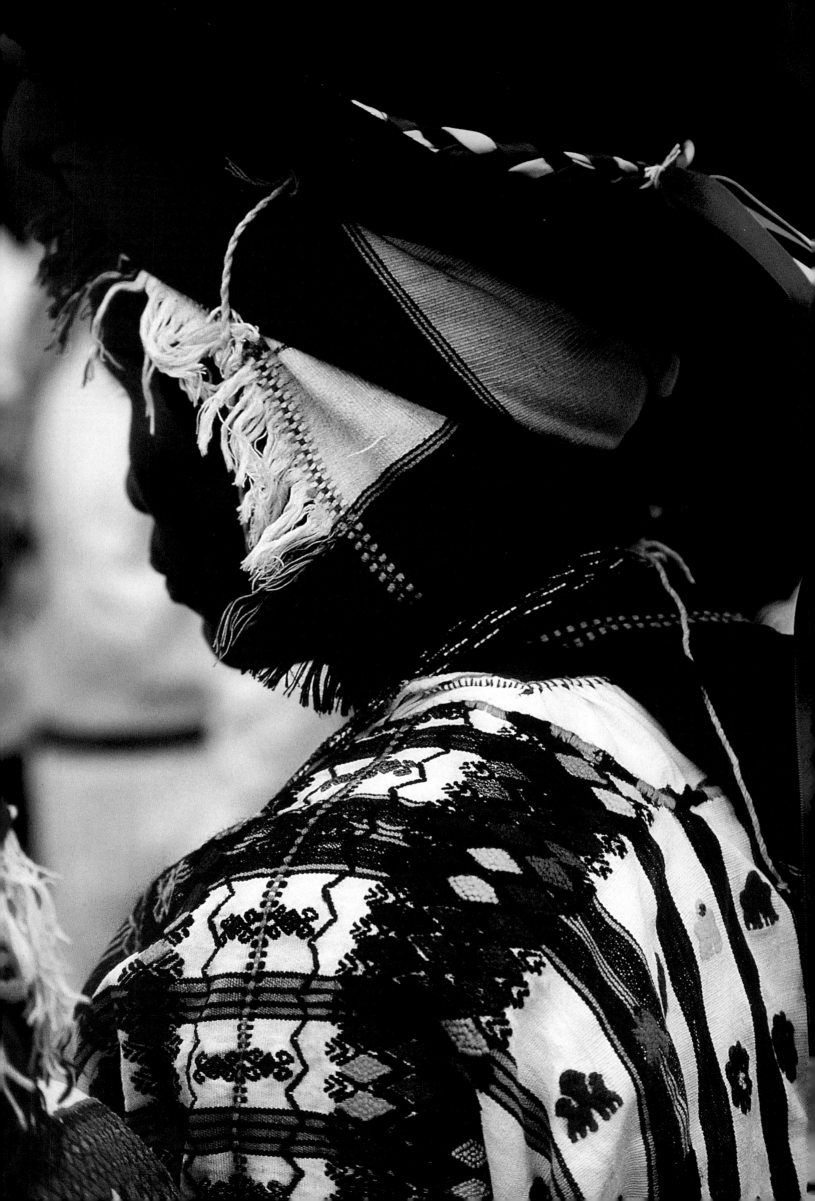

*Attire of lay elder
in church of
San Juan Chamula,
Chiapas. 1993.
Photo: Jorge Vértiz.*

*Opposite page
Man's attire from
Pantelhó.
Chiapas, 1993.
Photo: Jorge Vértiz.*

asking each piece questions, invoking the hands implicit in them, their makers, and making them speak to me, to help me understand their secrets. ✧

Every work of art is the product of its time, tangible proof of one's passage through life. Each one attests to beliefs, myths, social practices, passions and creativity that should be relevant at the time of writing history. For in terms of history, art should not be relevant mainly for its content, as is the case with traditional documents, but for the multiplicity and diversity of meanings that converge in aesthetic forms. ✧

In the same way, all these folk art objects around me are traces, testimonies, clues, original and unorthodox documents for the historian who studies them in detail and with imagination. These pieces indeed pose a number of questions to the historian. How should they be deciphered? How can we explain their powers of communication? How do we extract the many layers of experience and meaning they contain? I am referring in particular to ceramics, textiles, miniatures, baskets and lacquerware—not so much to music or folk literature. ✧

All these works are handmade and seem to be regulated by the unwritten laws of a tradition. However, they also enjoy an

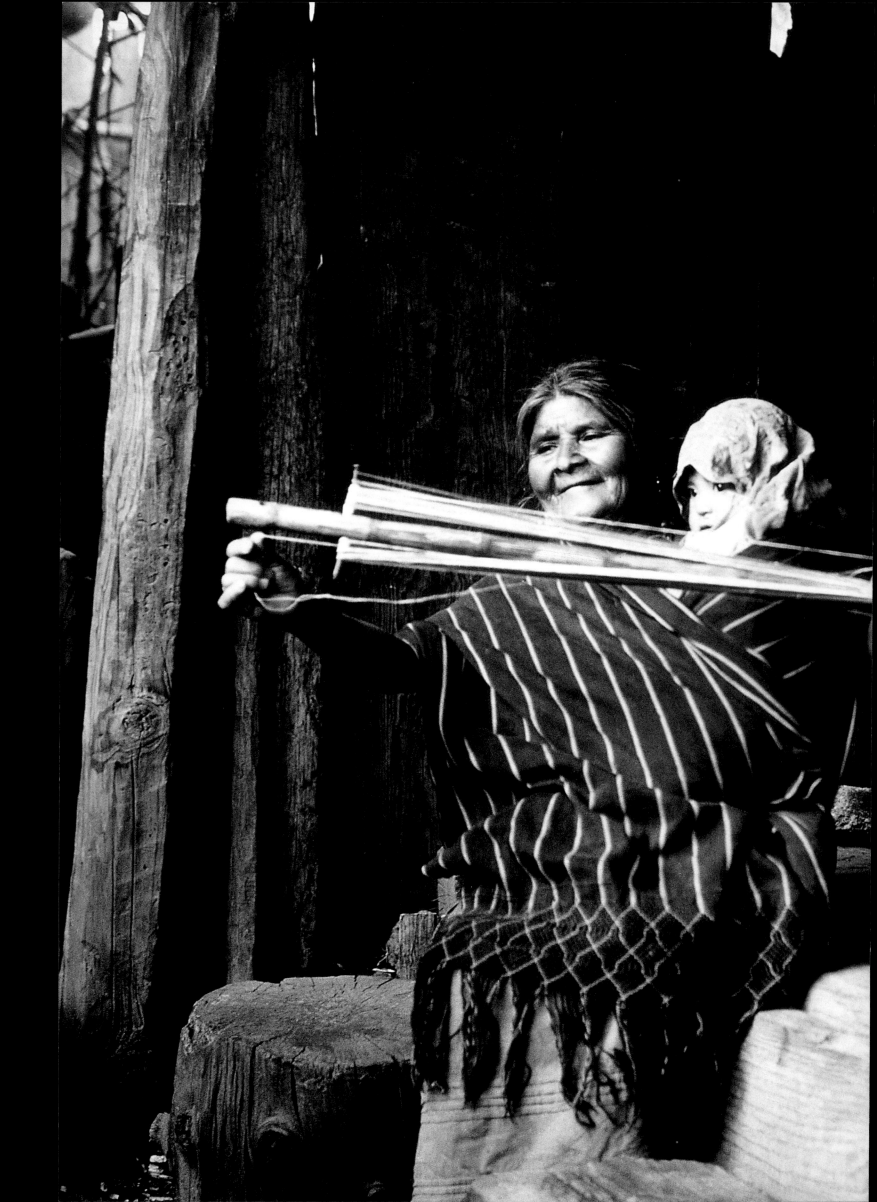

individual freedom and express an artistic sensibility. They are traditional because they are based on ancient techniques and artistic notions that have been transmitted from generation to generation, or else because they seek to revive or reinvent an interrupted tradition. ❖

Their roots lie in a vision of the past that may be shared by one or many artists. They survive thanks to the spirit of preservation in certain communities. They satisfy a common need for shapes, colors and harmonies. They are artistic expressions with a practical, utilitarian or decorative purpose, which may also be magical or religious. ❖

They are a source of valuable information for any historian because they can function as the visual, technical or artistic reminder of the creative life of a community. These works often follow models that have been lost in the distant past, but that still belong to the community. Thus they constitute the perfect emblem of cohesiveness. ❖

Folk art can be seen as the conjunction of individual creativity and a collective order. The craftsman interprets a traditional idea or theme, transforms it, but also becomes at that moment part of a historic continuum. ❖

Again in the words of Octavio Paz, "Crafts do not have a history, if we conceive of history as being an uninterrupted series of changes. There is not a break but a continuity between its past and present. The artisan allows himself to be vanquished by time. Traditional but not historical, linked to the past but bearing no date, the craft object teaches us to be wary of the mirages of history and illusions of the future. The artisan seeks not to conquer time but to be one with its flow."[1] ❖

Folk art has been approached from the perspective of many different disciplines, and with a wide variety of methods. Anthropologists, economists, folk art specialists, art critics and artists have all discussed it, but historians have rarely explored the subject. *Las artes populares en México* (Folk Art in Mexico)[2]—published in 1921—was one of the first reference books on the subject. Over the years, has been a frequent reference source for individuals interested in the topic. Its author Gerardo Murillo, alias Dr. Atl, inspired hundreds of later studies on the topic. His book is not comprehensive, but documents the manufacture of many handicrafts of his time. Dr. Atl set a standard that has held to this day. But how can cultural history contribute to a contemporary study of folk art? ❖

Detail of a sash from the region of Pantelhó, Chiapas. Woven on a backstrap loom. Pellizzi Collection.

Opposite page Huave weaver from San Mateo del Mar, Oaxaca, 1974. Photo: Ruth D. Lechuga.

Pages 42–43 Woman warping. Paracho, Michoacán. Photo: Ruth D. Lechuga.

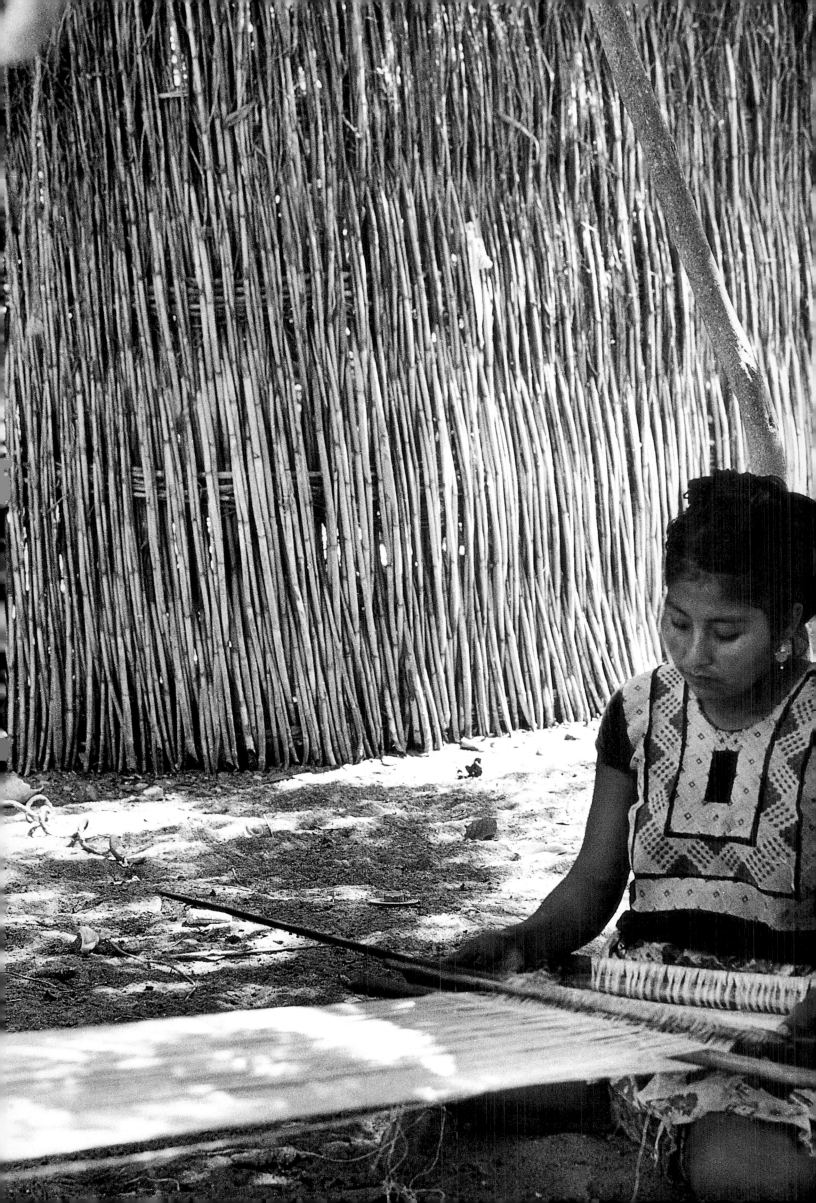

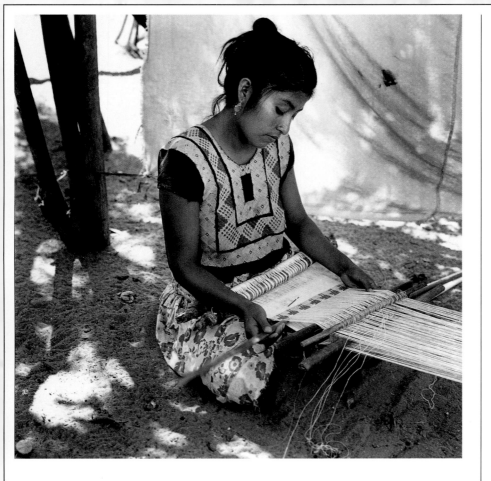

Huave weaver from San Mateo del Mar, Oaxaca. 1974. Photo: Ruth D. Lechuga.

Opposite page Hand of the weaver Me Peshu from San Pedro Chenalhó, Chiapas, 1993. Photo: Jorge Vértiz.

Everything Was Seen through the Hands of Weavers

In 1992 I went on a field trip to research textiles from Chiapas for an issue of *Artes de México* devoted to this subject. I had to visit hundreds of small towns in the Chiapas highlands in order familiarize myself and the public with the weavers' work. I wanted to decipher the secrets held by those beautiful and highly encoded fabrics. I wanted to listen to the old and new stories of those indigenous towns that are so protective of their customs. ❖

I saw the weavers at work: their hands intertwined among the colorful threads of their backstrap looms. I saw how they made their natural dyes and how the colors stained their hands. Then I realized that the movement of their fingers sliding down the threads was a work of art in its own right—the work of art behind the finished piece that we get to see. I saw the soft hands of young weavers beginning to develop their skills, and their scars. I saw the hands of old women, swift and deformed by so many years of labor. Or should I say, *formed* by their craft of creating beauty. In those outstretched hands, I recognized a language of generosity that went beyond words. ❖

Having seen so many different works on that brief scouting trip through the towns of Chiapas, I thought about what steps were

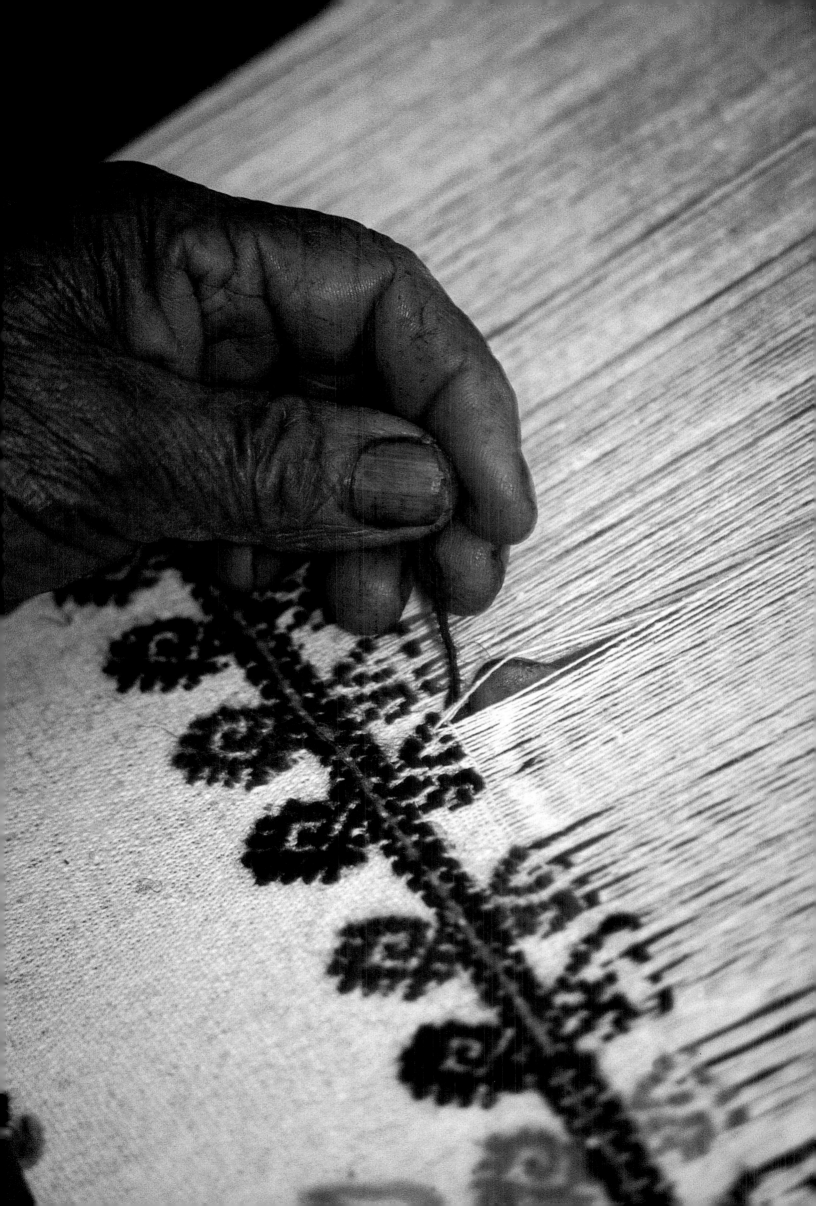

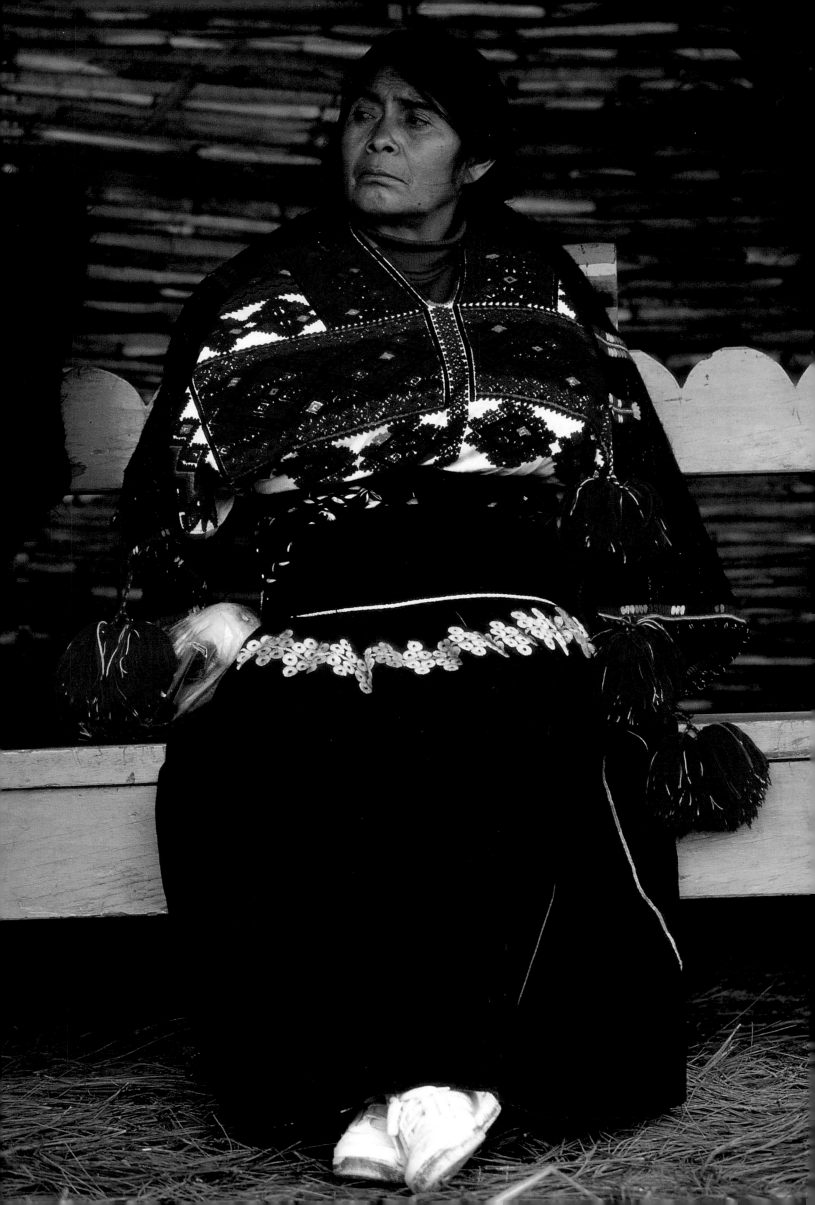

*Detail of a huipil
from San Pedro
Chenalhó, Chiapas.
Photo: Jorge Vértiz.*

*Opposite page
Woman wearing
traditional clothing
from San Andrés
Larráinzar,
Chiapas.
Photo: Jorge Vértiz.*

needed to guide me through a seemingly endless process of reflection. The works themselves led me to conceive of different approaches that could help me impose some order on the questions and answers they had prompted. ❧

Four different approaches that permitted a global comprehension of this art form came to mind. They are progressive and converging approaches that weave a different conceptual web, conceived especially for the understanding of handicrafts. These four ways of deciphering the work allow me to relate textiles to other folk art forms as well. ❧

The first level is aesthetics, relating to the immediate expressiveness of forms, to their beauty. ❧

The second reveals the social nature of garments in their different communities. It indicates, for instance, the hierarchies established by the use of certain apparel. ❧

The third is the symbolic layer that may reveal itself quickly, or remain hidden, or even forgotten. On this level there were very clear signs of a living syncretism. ❧

Finally, there is a level whose study is even more relevant today. It is the level where a craft community's imagination is formed, taking into account the symbolic spaces it shares with other cultures and other times. Such a study would focus on how an outsider's perspective can often disrupt not only the art of a particular community, but its daily life as well. This fourth approach should

implicitly include the other three, since it is only by combining all four that cultural history—with its interdisciplinary nature—can contribute to the study of folk art. ❖

HANDS THAT EXPRESS CREATIVITY

The initial impact when viewing textiles from Chiapas or Oaxaca—or any skillfully made handicraft—is an emotional one. It is impossible not to feel moved by the object's beauty, the blend of colors, its textures and shapes. These works have been made, imagined and contemplated wordlessly, so those of us who appreciate them find it difficult to put our feelings into words. Octavio Paz said that the craft object is a physical presence that enters us through our senses and in which the principle of usefulness is constantly violated in favor of tradition, imagination, and even sheer whim.[3] In a brilliant essay on the textiles of Oaxaca, Alejandro Ávila writes that Chatina weavers from northeastern Oaxaca express this idea better than anyone when they say that their creations "inebriate the eyes."[4] On the other hand, the creation of these textiles clearly involves a collective form of expression, as they follow aesthetic patterns created by the communities themselves. ❖ But there is no uniformity; each piece has its own uniqueness. Each weaver has ample room to explore her creativity. Often we find a small design that represents the weaver's signature, similar to the symbols or letters on some ceramic pieces, which are the potter's trademark. In the textile collection of the Ruth D. Lechuga Folk Art Museum, there are works from Chiapas dating from between the 1940s and 1990s.[5] In recent decades there has been a tendency toward more elaborate ornamentation, with more embroidery and color, and even new designs. ❖

However, this initial sensory contact triggers many questions: How were these collective expressions formed? What traits do they share? How have different crafts evolved over time? Many authors have addressed these questions by studying a range of handicrafts, especially textiles. In her travels around Mexico over the past fifty years, Ruth D. Lechuga has amassed more than 2000 textile pieces and 8000 other folk art objects. Through her writings, these extraordinary pieces have gradually begun to reveal their multiple secrets and different uses. She not only knows every piece, she also knows what day-to-day economic problems weavers and other artisans face in order to do their work. However, there is still much to be learned about the different designs and the evolution of different crafts, especially those

Woman from Oaxaca with tlacoyales in her hair. Photo: Irmgard W. Johnson.

unrelated to textiles, which have garnered more interest than other folk art forms in terms of scholarly research. ❧

Chloë Sayer has documented a large number of crafts over the last two decades. Their designs are the result of many years of evolution, and if an effort is not made to adequately document them soon, it may be too late. Some design motifs have their roots in pre-Hispanic ornamentation, and others did not exist until the arrival of the Spanish. It is imperative for historians to trace this visual memory in time and try to decipher other influences in these works, including African and Asian ones. ❧

After devoting an issue of *Artes de México* to the ceramics of Tonalá, we were surprised to discover that a few months after its publication, craftsmen in that town had begun using the magazine as a reference.[6] They wished to revive forgotten eighteenth-century designs, and the issue had photographs of ceramics from Tonalá forming part of the collection of the Museum of America in Madrid. If there were records of all the designs of that era, ceramics in Tonalá would be that much richer for it today. ❧

To learn more about the expressiveness of folk art, it is essential to consider the work of those authors who began to revive the appreciation of these handmade pieces in the 1920s, specifically Dr. Atl, Jorge Enciso, Roberto Montenegro, Katherine Anne Porter, Juan Ixca Farías, Adolfo Best Maugard, José Rogelio Álvarez, Miguel Covarrubias, Frances Toor and many others who over the years have contributed to the study of folk art. ❧

Dr. Irmgard Weitlaner Johnson's contribution to our understanding of the evolution and techniques of different textiles has been extremely valuable.[7] No one knows more about the origins, techniques and uses of certain garments. Not all folk art forms are fortunate enough to have researchers of such caliber focusing on them. Each craft discipline should have, if not an in-depth study, then at least a record of its designs, techniques and evolution. Filling this gap would require a few hundred researchers and perhaps decades of work. But I think it is important to begin at least the initial stages, given that craft disciplines become obsolete all the time, for many different reasons (for instance, feather art, sugarcane paste sculptures, wax sculptures, certain textiles, ceramics traditions such as

Tlacoyales.
San José Lachiguiri,
Miahuatlán,
Oaxaca.
Ruth D. Lechuga
Folk Art Museum.

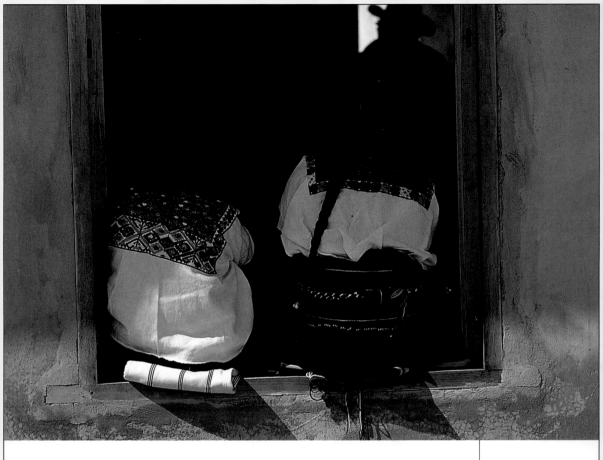

that of Sayula and the majolica of Aguascalientes). A range of interdisciplinary approaches besides the historical one is also essential. ❧

The hands that give shape to expression are inventors and re-creators of forms that are immediately striking and even seductive. They are expressionist signs. They are the result of a formal search for perfection. ❧

And when the initial impact has worn off, we begin to try to understand them. ❧

Hands that Give a Social and Anthropological Meaning to Art
Following this physical and emotional contact with the textiles from Chiapas, my mind was flooded with endless questions about costume and social organization in the different communities I had visited. Who uses these garments? For what purpose? Does what a person wears tell us something about his or her social position? Does it tell us something about the person's importance in daily and ritual life? ❧

Each community has specific ways of differentiating its members: the huipil worn to the town's annual fiesta by the wife of the *alférez* (a lay person with responsibilities in the church and community)

Weavers at a meeting of the Sna Jolobil cooperative. San Andrés Larráinzar, Chiapas, 1993. Photo: Raúl Dolero.

of Zinacantán, Chiapas, is unlike the ones she would wear on any other day. Men holding public positions in San Juan Chamula wear a formal costume that garners them special treatment. Alejandro de Ávila explains that in the past, sashes and red headcloths were what distinguished the men in the highest ranks of the council of the elders, and that now the most eminent members of communities in Oaxaca use these items as markers of respect.[8] ❧

Alfonso Alfaro writes that, "the whole drama of seduction is staged by what we wear and, though employing other means, clothes are no more than the extension of cosmetics."[9] In Zinacantán, one can distinguish a bachelor's poncho from that of a married man by looking at the length of its strings of pompoms and how densely it has been embroidered. ❧

In San Pedro Chenalhó, Chiapas, a woman's most attractive features besides her straight black hair are her beautiful blouse and glittering necklaces. In the 1950s, young men in this town placed a lot of importance on the number of ribbons dangling from their hats. A beautiful huipil on a woman from San Pedro indicates that she is a good weaver, for it would be considered unseemly to wear one she could not make herself.[10] ❧

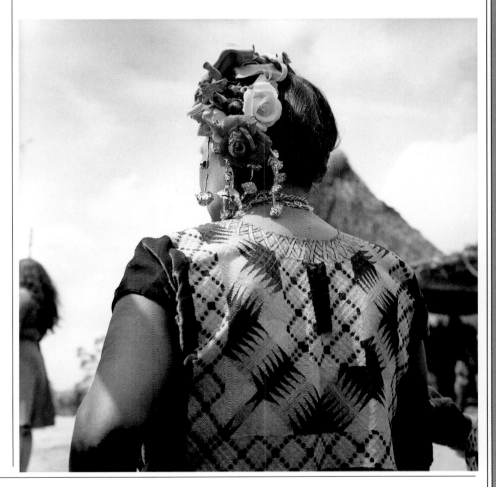

Tehuana woman.
Tehuantepec,
Oaxaca.
Photo: Ruth D.
Lechuga.

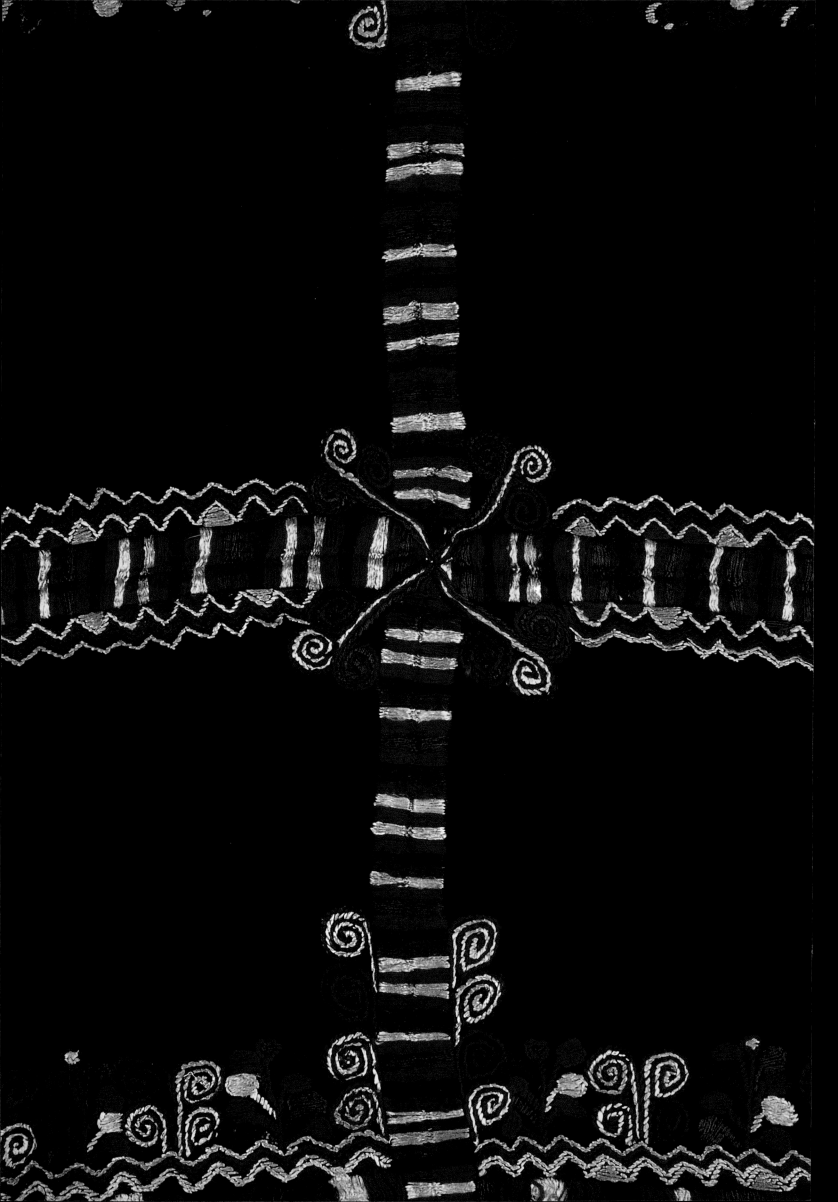

In Ojitlán, Oaxaca, in the Chinantec region, *suchel* flowers embroidered on a young woman's huipil used to indicate that she was unmarried and a virgin. The town's elderly women consider a bouquet of *suchel* flowers to be the clearest proof of a young woman's delicateness and femininity. Once cut, the bouquet will wilt. Nowadays the bouquet has lost its original meaning.[11] ❖

Also in Ojitlán, weavers speak of three types of huipiles. The red one, for brides, is of the best quality. It is not used much anymore because of its high cost. Fortunately, some elderly women have kept their wedding huipiles and wear them at fiestas. The second type does not have as much red on it as the previous one—making it less expensive—and is used mainly at traditional celebrations, and sometimes for outings. The third type of huipil is for everyday use. It is the cheapest, and is even sold in markets. It is white with embroidered designs of birds and animals. ❖

Weavers told the anthropologist Bartola Morales, a native of Ojitlán, that in the past the third kind of huipil was only used by elderly women, but that today even *tlacuache* people wear it, that is, foreigners or anyone who is not from the town.[12] ❖

Women are usually better at retaining their traditional dress. Almost everywhere in the state of Chiapas men have stopped wearing their traditional attire on a daily basis. And probably the rapid disappearance of this custom is a result of the discrimination by *ladinos*, or white men. Moreover, economic hardships make it impossible for weavers to devote entire days to making outfits as elaborate as the ones from Venustiano Carranza, a town known for the quality of its weaving. Some years ago, Ruth D. Lechuga often heard women from Oaxaca say that if they were to travel by bus wearing their traditional dress, other passengers would not let them sit down. And there is also the case of a priest in a very remote area who disapproved of girls going to school in their traditional short-sleeved and low-cut dresses, urging them to wear "decent dresses" instead.[13] ❖

Many anthropological studies have addressed the social significance of different costumes. But it would be helpful to study other Mexican folk art objects that have a specific social function in different Mexican cultures as well. Masks,

for example, may signal not only a social condition but also its transgression. In dances and popular fiestas, such pieces are signs of both the past and the present collective imaginary. ❖

An example of the transgression that takes place during popular fiestas concerns the famous wedding huipil of Zinacantán. This garment embroidered with feathers was allegedly brought to the Chiapas highlands by the Aztecs. In a tradition that has only survived in Zinacantán, the huipil is the sign of a good marriage, and the bride wears it with pride. ❖

But on the day celebrating the town's patron, Saint Sebastian— which also marks the victory of the people of Zinacantán over the Spanish conquerors—the *alférez* of San Lorenzo and Santo Domingo also wear feathered huipiles. Here they represent Spanish ladies, who were considered vain and materialistic and particularly unfit for marriage. The ethical values of the women of Zinacantán are presented humorously. Objects can express both positive and negative signs. The huipil's feathers are associated with the behavior of hens. According to the people of the town, "hens have wings, but are unable to fly. […] They are fenced in, as they depend on humans for their food. And even when allowed to run free, they remain close to home. That is precisely what is expected of a bride."[14] ❖

Recently, Alejandro de Ávila discovered that ancient colonial manuscripts of Oaxaca—such as the one from Teposcolula dating to the seventeenth century—portray feathered huipiles that were available in southern Oaxaca since the sixteenth century. The Zinacantán feathered huipiles were probably modeled on these earlier ones. Before Ávila's discovery, the huipiles were thought to have come directly from Nahua cultures. ❖

Fortunately, ethnologists have extensively documented cases such as these, and have described the different uses of a piece of clothing in a given society. With regard to Chiapas, Ricardo Pozas' books *Chamula, un indio en los Altos de Chiapas* (Chamula: An Indian in the Chiapas Highlands) and *Juan Pérez Jolote*, as well as *Los peligros del alma* (The Perils of the Soul) by Calixta Gutieras Holmes and Ruth D. Lechuga's *El traje indígena de México. Su evolución desde su época prehispánica hasta la actualidad* (Indigenous Dress in Mexico: Its Evolution from the Pre-Hispanic Era to the Present) are important sources on this topic. In Oaxaca, numerous studies by Irmgard Weitlaner Johnson, Alejandro de Ávila, Ruth D. Lechuga and Bartola Morales, among others, are also enlightening in terms of the social significance of textiles. Through the crafts it makes, the artisan's hand establishes a community's

Opposite page
Pedro Meza.
Detail of huipil with
frog motifs inspired
by Mayan designs.
Brocaded cotton
and wool.
Chiapas. 1992.

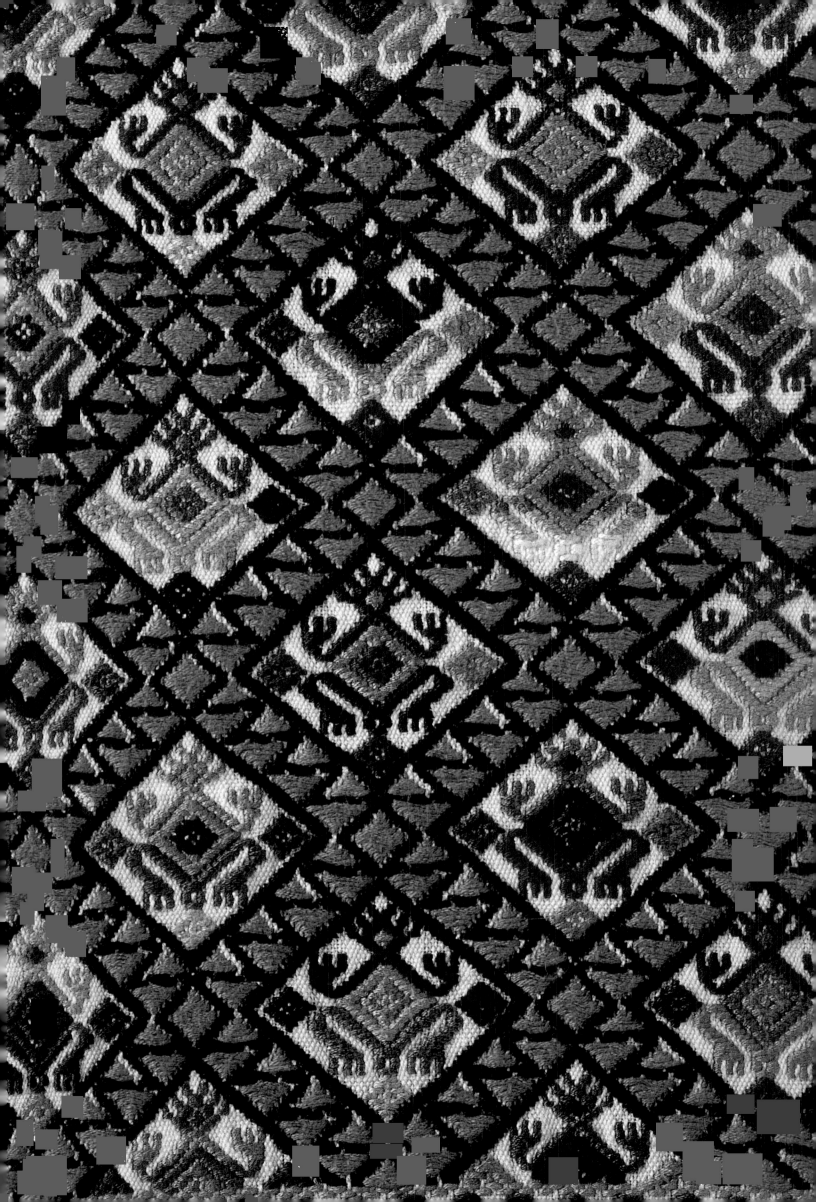

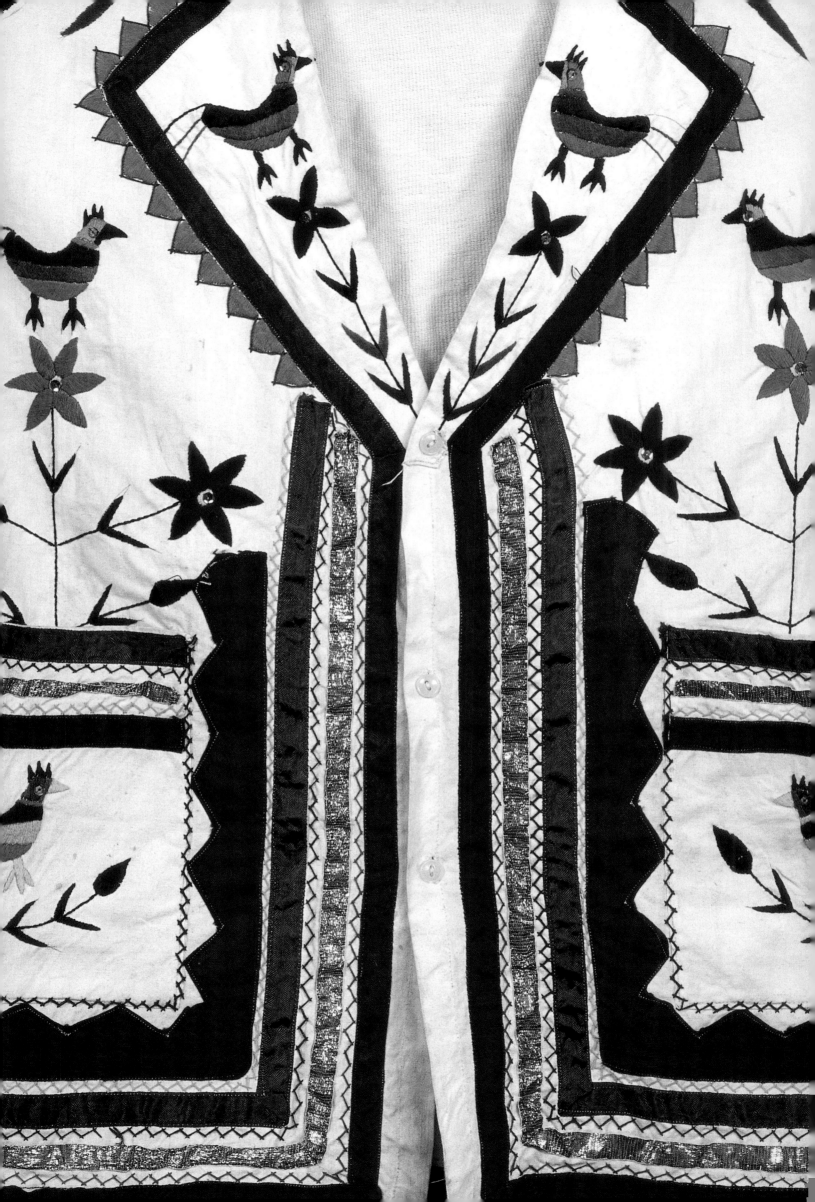

hierarchies and social order: the harmony between its customs and traditions, what belongs to it and what does not. The artisan's hand points, indicates and signals; it forces everyone, insiders and outsiders, to see what would not be otherwise apparent. ❖

Hands as Makers of Symbols

The artisan's hand tells myths: it weaves destinies and unravels everybody's origins. ❖

The historian of religions Mircea Eliade speaks of the symbolism weaving has in almost every culture. Many of his descriptions call to mind the symbolic meaning of this craft in the highlands of Chiapas. He says that weaving and spinning are the principles that explain the world's creation: "the moon spins time and weaves people's lives. The goddesses of fate are weavers." ❖

In a mythological poem, the weaver Lexa Jiménez López of San Juan Chamula describes how weaving was invented: "It used to be that yarn was made the same way as we make children now. The women made it themselves with the strength of their flesh. When the world began, they say the Moon climbed a tree. There she was weaving and spinning. [...] The Moon had her stick to measure the warp, her *comen* to measure the yarn. Her yardstick was long and stuck out of the top of the tree. When she finished spinning, when she finished using the spindle, she measured the yarn with her *comen*. She wove the red seeds of the brocade into the white fabric of a blouse. It was dawn up in the tree. She stretched out the warp up there. If it weren't for the moon, we would not know how to weave. She told us how to do it."[15] ❖

Ethnologists have the most complete understanding of the symbolic nature of folk art objects, which either have significance in their own right or partake of a larger religious whole. Thanks to the field studies carried out by these individuals, we have learned that symbols reveal profound aspects of the craftsman's reality and of the inhabitants of craft communities. ❖

Following in Marta Turok's investigative footsteps, Walter F. Morris, in his essential book *Living Maya*, explains that, "A huipil is a symbolic universe. When a Mayan woman puts her head through the neckhole, she emerges as the center of the world. The world's drawings radiate from her head and extend down the blouse's sleeves and across the bodice to form an open cross with the woman at its center. This is where the supernatural meets the ordinary. In the center of a world woven from dreams and myths, the woman stands between the sky-cosmos and the underworld."[16] ❖

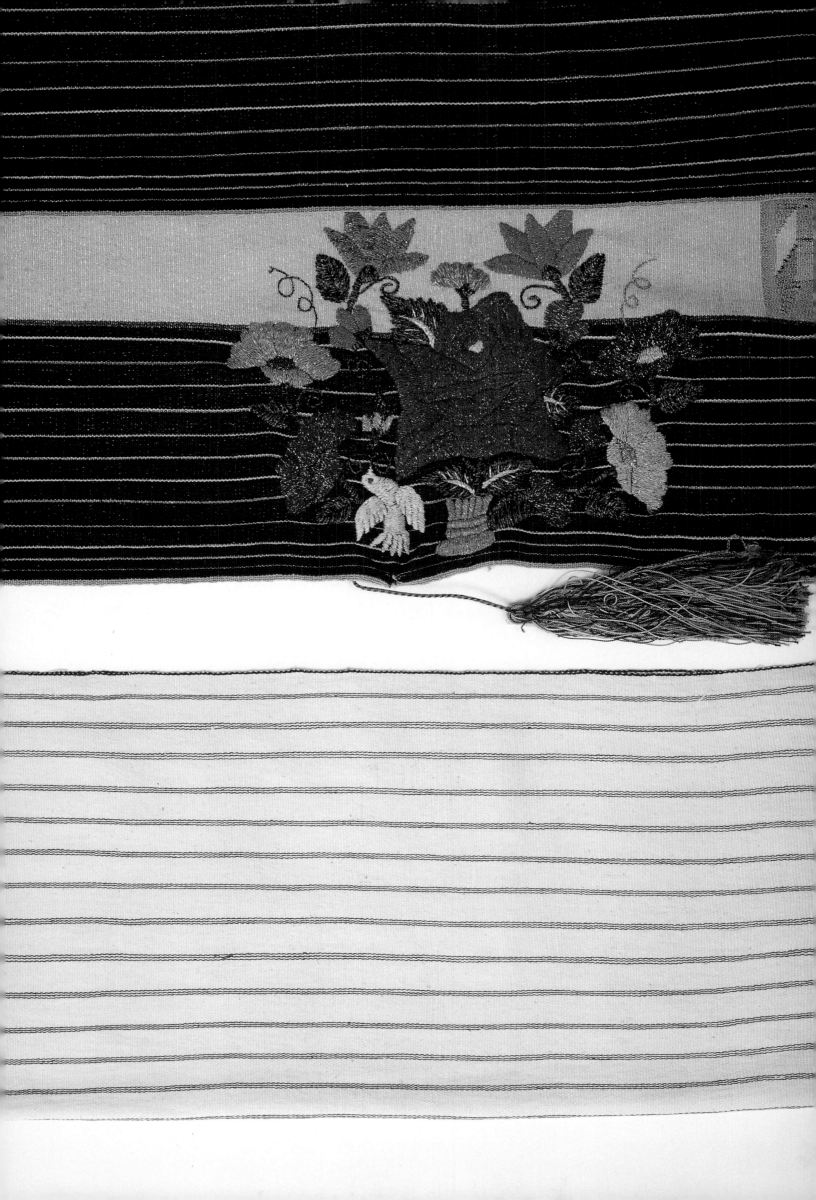

Both Morris and Turok have have contributed significant research that reveals a special perspective on the world that is contained in textiles. The same can be said of Alejandro de Ávila's work in Oaxaca. He argues that in order to have access to the symbolic level of certain garments it is important to approach the artisans and hear what they have to say about their work. It is necessary to explore what we might call their symbolic thinking. "Together, words and threads form myths." ❖

In *Living Maya*, Morris examines the mythical past of the Mayan people through their huipiles, as well as how mythology was influenced by the religious world of the Spanish. He deciphers some of the Mayan symbols that may still be found in embroidery, and explains how Catholic beliefs and rites were assimilated through weaving. In the end, we face an enormous symbolic cloth which have been woven and embroidered with history, myths, rites, dreams and everyday experience. ❖

Marta Turok's essay "The Textual Textile" is a guide to understanding a ceremonial huipil from Santa María Magdalenas, a community in the municipality of San Pedro Chenalhó where Tzotzil is spoken, and where every piece of embroidery has a cosmological and syncretic meaning. "Since the Virgin taught our women how to make designs and write on cloth, they shall take the word, our word, to the children of the children of the *Batz'i vinik*, who are true men. [...] A huipil consists of three webs: the middle piece or 'mother' and the sides or 'arms.' Together they describe our universe where I—a fertile woman— am at the center. For the fiestas we decorate crossroads, springs, the hillside and the inside of the church with garlands of bromeliads and sedge. I also weave a garland around the huipil's neckline, and the entire brocade forms a large cross on the shoulders, chest and back."[17] ❖

With their hands, weavers transmit wisdom and preserve a culture. (In Oaxaca, when speaking of a certain myth, an inhabitant of Usila said it was so important it was written on the huipiles.) Weavers are people who use threads to represent their culture's symbols in cloth. But they also creatively transform external influences, foreign objects and unknown materials, appropriating them and integrating them into their culture and their textiles. ❖

They lie between the real and the supernatural world, at the heart of space and time. They are the earth's representatives in that sacred space. Thus, they are invested with the special authority that they have acquired thanks to their merits and their experience in transmitting and disseminating their spirituality. They are the

ones who dress the Spanish Virgin in Mayan costume, and confer on her the status of being the authentic bearer of a tradition. They use textiles to draw connections between different historical eras of short or long duration. When the statue of the Virgin in Magdalenas wears a hundred-year-old huipil under one that was woven for her just recently, this tradition is seen to be both ancient and contemporary. The past renews itself in the present. When teaching their daughters to weave, the weavers of Chiapas and Oaxaca transmit not only the techniques of their craft but also the secrets and traditions that conform it: the meaning of life. ❧

I will mention just a few of Turok's and Morris's findings regarding the symbolism of certain designs. In the diamond shape that represents the cosmos—which the weavers in Magdalenas depict as a cube with three visible planes—the earth lies between the heavens and the underworld. This motif derives from the Mayan notion of the world as a square; at its center is the sun, which also represents Jesus Christ. ❧

There is a smaller diamond at every corner of the world. The upper and lower diamonds are connected to the sun, and this union represents the sun's trajectory from east to west. In order to represent the universe, at least twenty-four rows of diamonds are required, but the ninth and thirteenth rows need to be marked with a line. There are thirteen steps between the earth and the heavens, and nine separating us from the underworld. The ancient Mayas believed the underworld had nine levels, and that the heavens had thirteen.[18] ❧

According to anthropologist Irma García Isidro, huipiles in San Felipe Usila, Oaxaca, have a special figure called 'uo at chest level. This word has no meaning in the current language, but it might have meant "dawn" at one time. 'Uo is represented as a rhombus, and at its center is a shell symbolizing the sun: the power of life. This shell provides the soul with the means to fly to the sun with one's last breath.[19] ❧

How many other crafts of the different cultures of Mexico share a common symbolism? The huipiles of Magdalenas and Usila have similar symbols but very different embroidery. If we also studied textiles from other countries we might find similarities that would reveal many patterns in the way this trade is practiced around the world, on many different levels of analysis. ❧

Just as weavers in the highlands of Chiapas have learned to "move the universe," in some North African mountainous regions women

Huichol hat with chin strap. Woven palm, wool, feathers and cardboard. Jalisco and Nayarit, 1951. Ruth D. Lechuga Folk Art Museum.

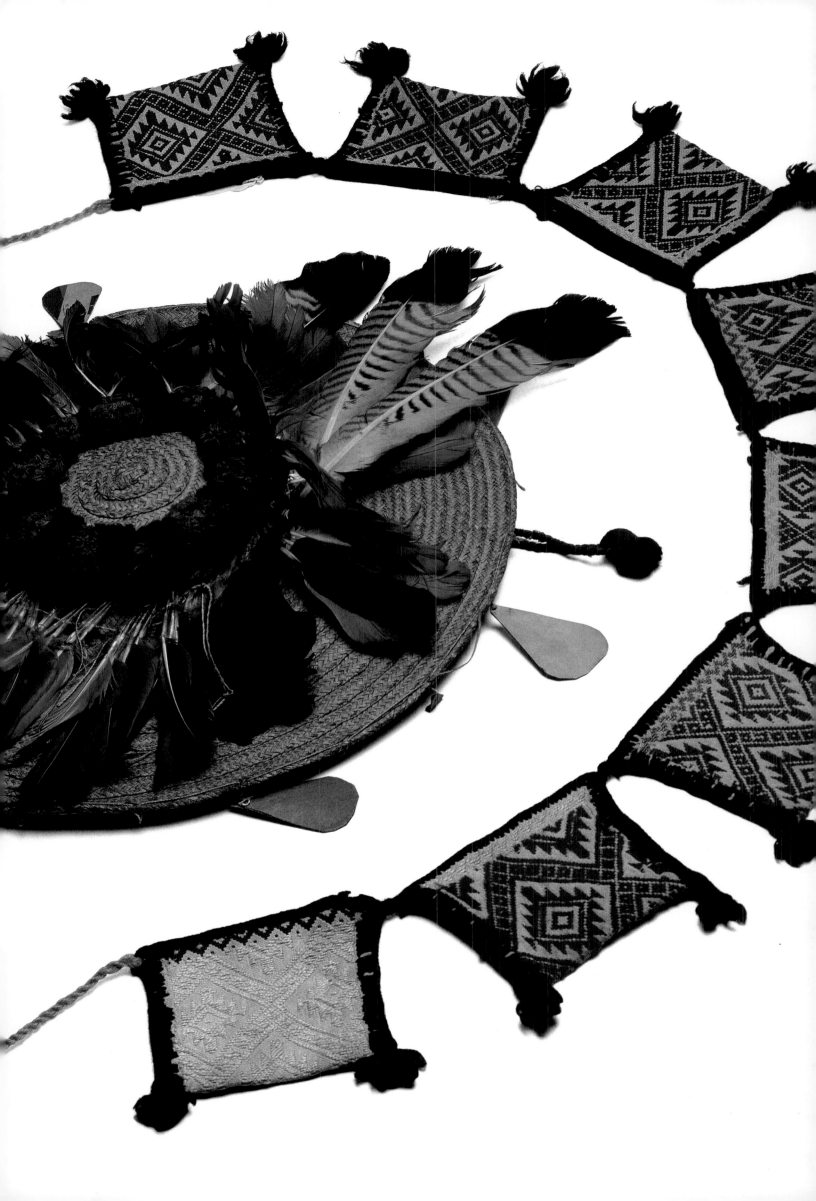

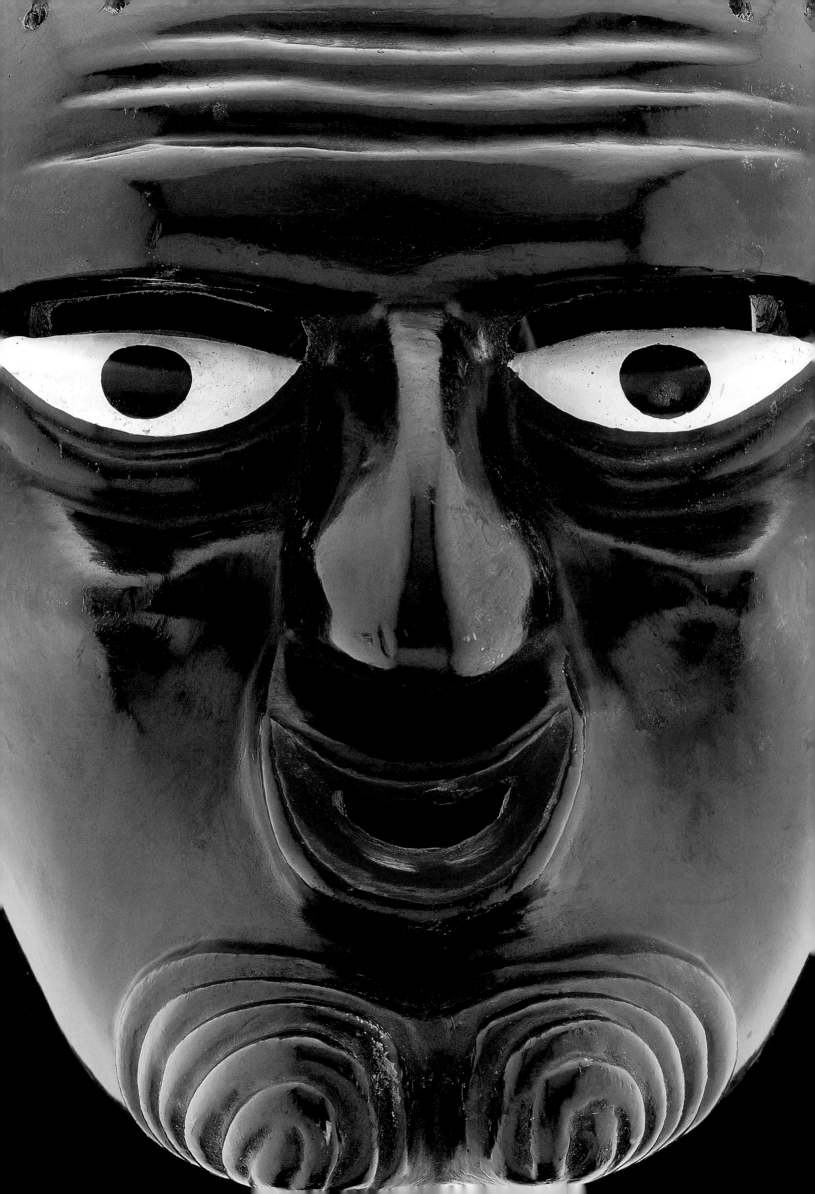

with looms do something similar: they use two horizontal strips of wood supported by two vertical ones. The strip on top is called the sky and the one below is the earth. These four pieces of wood also represent the universe. In universal mythology, the goddesses who preside over the natural cycles of life always carry weaving tools in their hands.[20] In the Chiapas highlands weavers are goddesses who decide not only days and agricultural cycles, but everything that comes into play in our destiny. ❧

In the textiles of Chiapas, myth and history intermingle, allowing us to perceive the Tzotzil concept of the world in multiple ways. In Ojitlán, something similar happens. Chinantec women from Usila and Ojitlán tell their ancestral history in their huipiles, and cover themselves with symbols that promote the preservation of their customs and of their world-view. The ethnolinguist Bartola Morales has studied these textiles in detail. Based on first-hand accounts from the weavers, she compiled the Chinantec names for the different designs embroidered on huipiles, along with their mythical implications. Different levels of reality are not distinguished in them. ❧

The supernatural is an integral part of daily experience. Threads join the body to nature and to the universe. When these garments' stories are recounted in the form of words, something emerges that could even be considered a kind of fantastic literature. Embroidery as a form of writing unleashes in its creator a flood of marvelous images associated with myths of incalculable age. Weavers use myriad images to describe a mythical reality because that reality is presented to them in multiple and contradictory ways. It is therefore easier to use images that can be seen and interpreted varyingly than to try to explain the concepts. ❧

Alejandro de Ávila has done intensive fieldwork in areas of Oaxaca where a similar pattern emerges, with designs based on polysemic images. For example, the two-headed eagle that appears in the embroidery of many towns in Oaxaca represents a fundamental figure in the mythology of some communities. In many of these towns it is related to the story of the sun and the moon. ❧

We can see this, for example, in a version of the story that Ávila recorded in Chilixtlahuaca, in the Mixtec Region. The two-headed bird had devoured many people, so the twins—who also appear in Mayan mythology and that of other ancient cultures of the world—dug seven holes and set them on fire. "The eagle was trying to kill them and kept falling into the holes, until it was burned in the seventh one. The twins pulled out its eyes, but a mosquito

had stung one of them and it had lost its gleam. The twin that had the dull eye wanted the shiny one that his brother had kept. This brother refused to give up the eye, but every time he tried to drink water, it evaporated. To quench his thirst, he agreed to trade his eye for his brother's. Some time after this, the twins met an attractive woman on her way to a contest dressed in a beautiful huipil. ❧

"One of the twins challenged his brother to have sex with the woman. They gave her a fruit that put her to sleep and the brother tried to rape her but realized that she had a *vagina dentata*. He broke the teeth with a rock and penetrated her. The twins then fled and they became the sun and the moon. When the woman woke up, she realized what had happened and, furious, she flung her bloody huipil to the earth. Since then, women have been cursed with menstruation." ❧

An equivalent of this myth can be found in Ojitlán. Here the bird has from two to seven heads and also devours people. It is defeated by the twins who also pull out its eyes in order to become the sun and the moon. This myth has many versions in different towns in this region of Oaxaca.[21] ❧

If we were to compile all these versions of the myth about the sun and the moon and those involving other figures from indigenous mythology, we would have an infinite kaleidoscope of symbols. There are countless images that turn up in the designs or embroidered figures of the textiles as a product of the weavers' imaginations. ❧

In the case of the sun and moon myth, all the characters are supernatural and yet the story is told as if it were real. These images are connected to a larger communal sphere that involves songs, history, illnesses, cures and agriculture, though weaving is always at its center as an indigenous tradition that has always existed. It is as if everything that is significant in life had to pass through the weavers' hands. ❧

By emphasizing the importance of the symbolic level of meaning in folk art I want to point out that it is not only accessible through academic erudition. Rather, it constitutes another way of approaching the

Mixtec tiger mask. Juxtlahuaca, Oaxaca.
10 x 8 x 4 1/2 in.
Ruth D. Lechuga Folk Art Museum.

Opposite page
Otomí Pharisee mask for Holy Week. Treated, painted fabric and ixtle fiber.
El Doctor, Querétaro, 1991.
66 x 8 x 9 in.
Ruth D. Lechuga Folk Art Museum.

Page 70
Mask for the Dance of the Old Men. Carved, lacquered wood and incrusted teeth. Uruapan, Michoacán, 1975.
Ruth D. Lechuga Folk Art Museum.

Page 71
Miniature mask from Cuaula, State of Mexico.

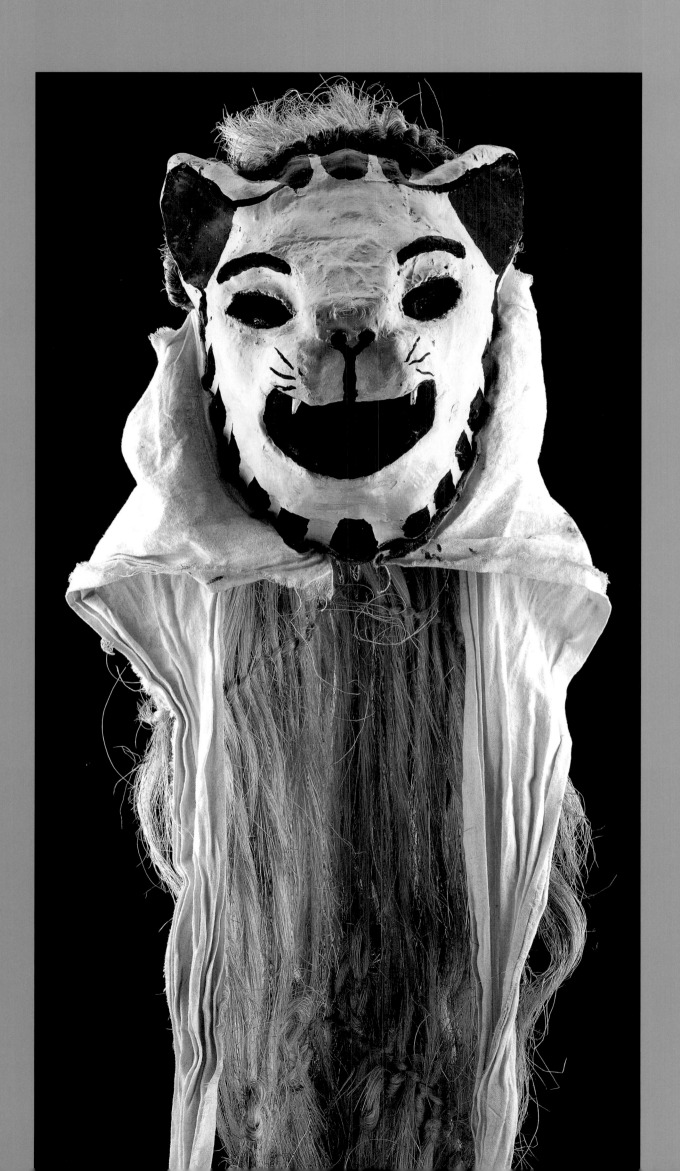

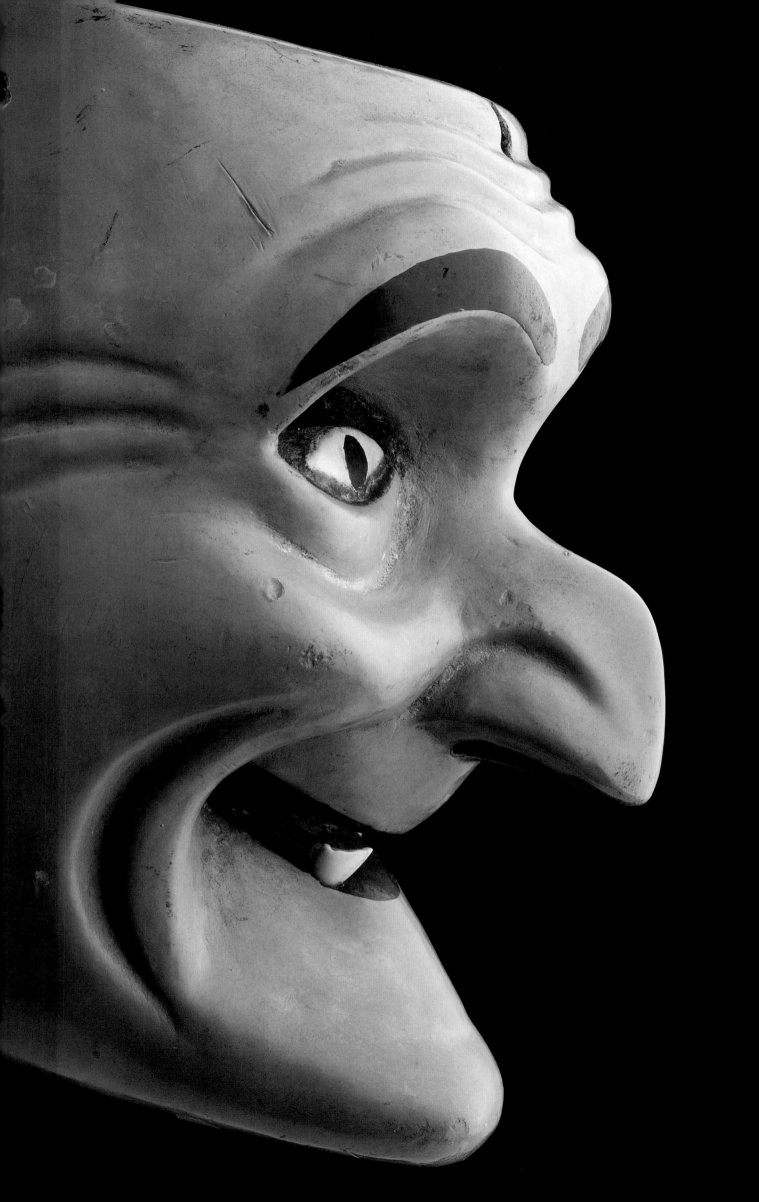

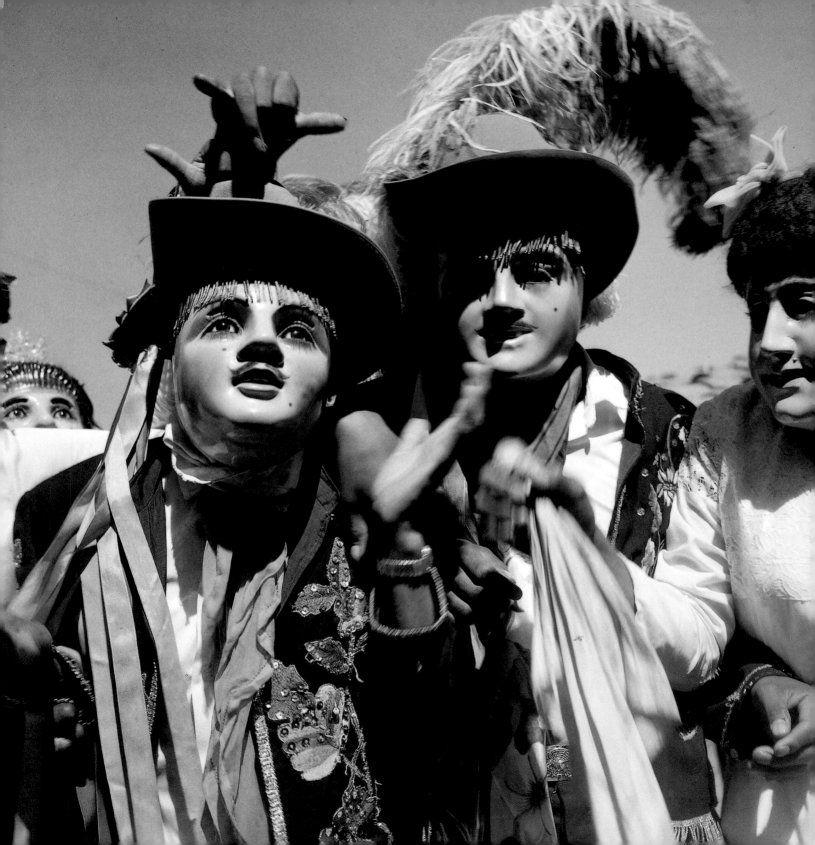

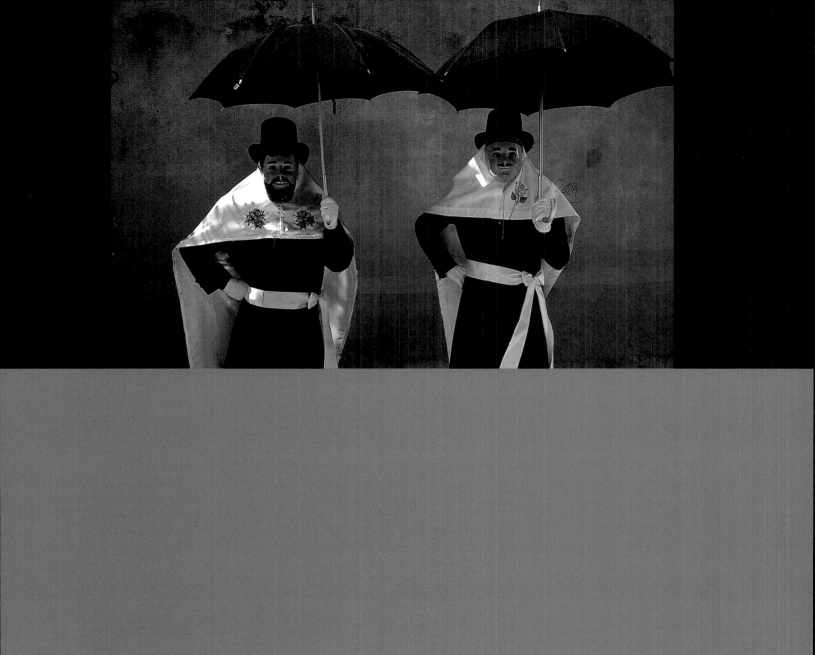

complexity of this art and its makers. It is an alternative approach, which requires interdisciplinary efforts in order to be truly comprehensive. ❧

In this regard, a historian needs the help of anthropologists, specialists in art and religion and perhaps even psychologists, because the field is full of subtleties and complexities and has many sources of information that need to be analyzed. ❧

In the universe of folk art there are many objects invested with some kind of magic or sacredness. They are used in different religious rituals and have acquired special powers. Many of these pieces have been the subject of various studies. Related to textiles, *tlacoyanes* are cords that women use to tie their hair into beautiful braided hairdos, and they have a ritual function in some cultures. The midwives of Santiago Atitlán in Guatemala tie these cords around the bellies of pregnant women, so that by mimesis, the spiral shape of the uterus can be regulated and the babies can emerge in the proper position.[22] ❧

Perhaps one of the most interesting ritual objects to be found in Mexico are those used for *limpias*, or healing rituals. Known as *cuadrillas*, they consist of series of clay figurines representing a cast of characters including the sick person, certain saints, musicians, animals and natural elements such as water, fire and wind. ❧

In Metepec, in the State of Mexico, these cuadrillas are only used when the healer believes the patient is suffering from *aires*, and tells him he needs to buy the set in order to use it in the ritual. The patient must bring a number of things to the ceremony: music, food and so forth, as if for a party. The figurines are rubbed against the patient and are then given to the healer's assistants, who dance with them. After this the figurines are placed in a newly woven basket and are taken somewhere, usually to a hillside, to be buried or simply left there. Since these figures have a humorous aspect, people often confuse them with toys. ❧

In Tlayacapan, Morelos, the cuadrillas differ in terms of color and number from those of Metepec. There it is thought that a *mal aire* (evil wind) comes from the anthills where the *chicaclina* snake also lives. This animal, along with the ants, causes the illness. ❧

Unfortunately, there is no documentation of what each cuadrilla figurine represents, and when and where these healing rituals have been practiced. The same is true of a number of folk art pieces that are no longer being made, and that lose not only their form but also their meaning. For example, when Seri baskets are being woven, they can take on a spirit called *coen*. If the weaver hears a

Opposite page
Paragüero
("umbrella man")
at the Carnival in
Papalotla, Tlaxcala,
2003.
Photo: Jorge Pablo
Aguinaco.

Page 72
Carnival characters
in Tepeyanco,
Tlaxcala, 1971.
Photo: Ruth D.
Lechuga.

Page 73
Paragüeros at
the Carnival in
Papalotla, Tlaxcala,
2003. Photo: Jorge
Pablo Aguinaco.

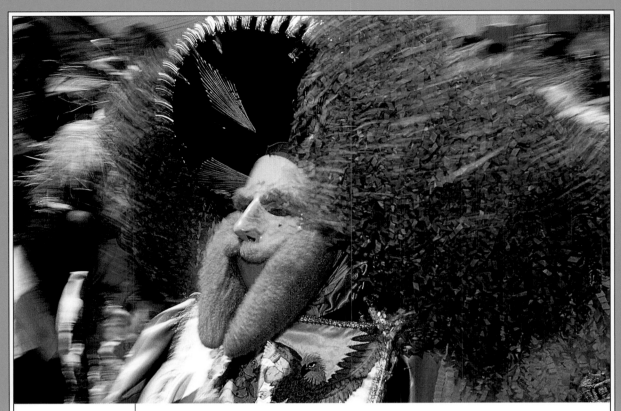

Dancers at the
Fiesta of Atlixcáyotl.
Atlixco, Puebla,
2003.
Photo: Jorge Vértiz.

Page 76
Dancers at the
Fiesta of Atlixcayótl,
Atlixco, Puebla,
2002.
Photo: Jorge Pablo
Aguinaco.

constant shrill sound as she perforates the materials with a punch, she knows it is the *coen*, and she knows that she will have to appease that spirit's fury because it may even kill her. She fills the basket with mezquite-flour biscuits and balls of cactus flesh. When she hears the sound again she throws these contents to the ground, and they are then picked up and eaten by the people around her. The goal is to create a festive environment to soothe the spirit.[23] ✣

It is important that we trace the existence of all these special ritual objects in even the most remote regions of the country, in order to write an exhaustive history of them. ✣

It is the artisan's hand that weaves the invisible fabric of symbols in Mexico—one that is vast, labyrinthine, dense and fascinating. It is an elusive hand that is not always acknowledged and that escapes our notice because its fingerprints point to hidden constellations. ✣

Hands that Tie the Local to the Foreign

The hands of artisans are open to other cultures and try to enrich their own. How is a craft's development affected by the outsider's gaze? Is there a transformation in the artisan's self-image when he or she meets an unfamiliar witness? What happens when both gazes cross? Textiles in Mexico are the crystallization of the very heart of our imaginary. They are also an interlacing of collective imaginations, both of the indigenous peoples who made them —at an individual and collective level in the case of Chiapas and

Oaxaca—and of the individuals who contemplate them, whether or not they belong to the culture. ❖

The anthropologist Walter F. Morris discovered that there is a coherent cosmic vision in the highlands of Chiapas, and in some way, he contributed to the preservation of this culture. When he realized that weavers had started to incorporate figures such as Mickey Mouse and kangaroos into their work, he was horrified. Basing his arguments on the Mayan tradition, he convinced the women to continue using motifs based on things in their natural environment, as their ancestors had done for centuries. ❖

Morris's advice to a cooperative of approximately 800 weavers called Sna Jolobil (presided over by Pedro Meza, one of the few male weavers in the region, born in Tenejapa and fluent in both Tzotzil and Tzeltal) had two possible outcomes. One was not very desirable: mass-production, which would inevitably lead to low-quality weaving and designs. The other, which is what the weavers indeed chose to do, was to revitalize their designs based on their knowledge of the past and their natural environment. Thanks to their commitment to renovation and their high standards of quality, they found a market that was willing to pay them more for their work. Today, the Sna Jolobil cooperative sells its weaving as works of art. It has received support from numerous national and international agencies, but is still wholly administered by the members of different weaving communities. It has a president, a treasurer and a number of members whose duties include visiting the communities, ensuring that things are being run smoothly, and organizing workshops, competitions and other events. ❖

For years, Morris had been learning their languages and studying their traditions and cosmovision. He had assimilated codes different to those of his own culture and in turn contributed his own interpretations and insights which enriched and improved the weavers' work. ❖

It is clear that the weavers in this region of Mexico feel that they are the bearers of a rich universe that comes from a very distant past. And the American anthropologist's vision helped them become aware of their tradition, through their work and many conversations. ❖

Together they worked on reinventing the way they made and conceived of textile art on a daily basis. They set up a mirror in which artisans could see themselves in the eyes of the Other, the foreigner. This vision defines their trade. This weaving of images and

Maringuilla, the only female Carnival character. She represents the Malinche, Hernán Cortés's first Indian wife. Fiesta of Atlixcáyotl, Atlixco, Puebla, 2003. Photo: Jorge Pablo Aguinaco.

Traditional mask of Maringuilla (Malinche) with glass eyes and natural eyelashes. Puebla, 2003. Photo: Jorge Pablo Aguinaco.

practices, this knot of converging mentalities that becomes fruitful for Mexico's folk art is, in itself, a phenomenon worthy of being studied by historians seeking to expand their field. ❧

It is interesting to observe how these outside influences not only give meaning to a trade and a way of life, but can also revolutionize artisans' lives and work to such a degree that we can now find people like Pedro Meza, the president of a successful cooperative, traveling frequently to New York, London and Canada to demonstrate his skills. Besides being a tireless advocate of the textile tradition in Chiapas, his contact with broader realities has made him into a great specialist in the ancient techniques of weaving and brocade, and the meanings of indigenous costume in the Chiapas highlands. His own work has been enriched by his contact with a range of perspectives from different cultures. In this play of reflections, the collective imagination has gathered the strength to affirm its differences. ❧

According to this craftsman, the desire to achieve harmony between man and his environment is the main reason for the creation of a whole symbology of textiles. It is a way of representing the

79 ❧ MARGARITA DE ORELLANA

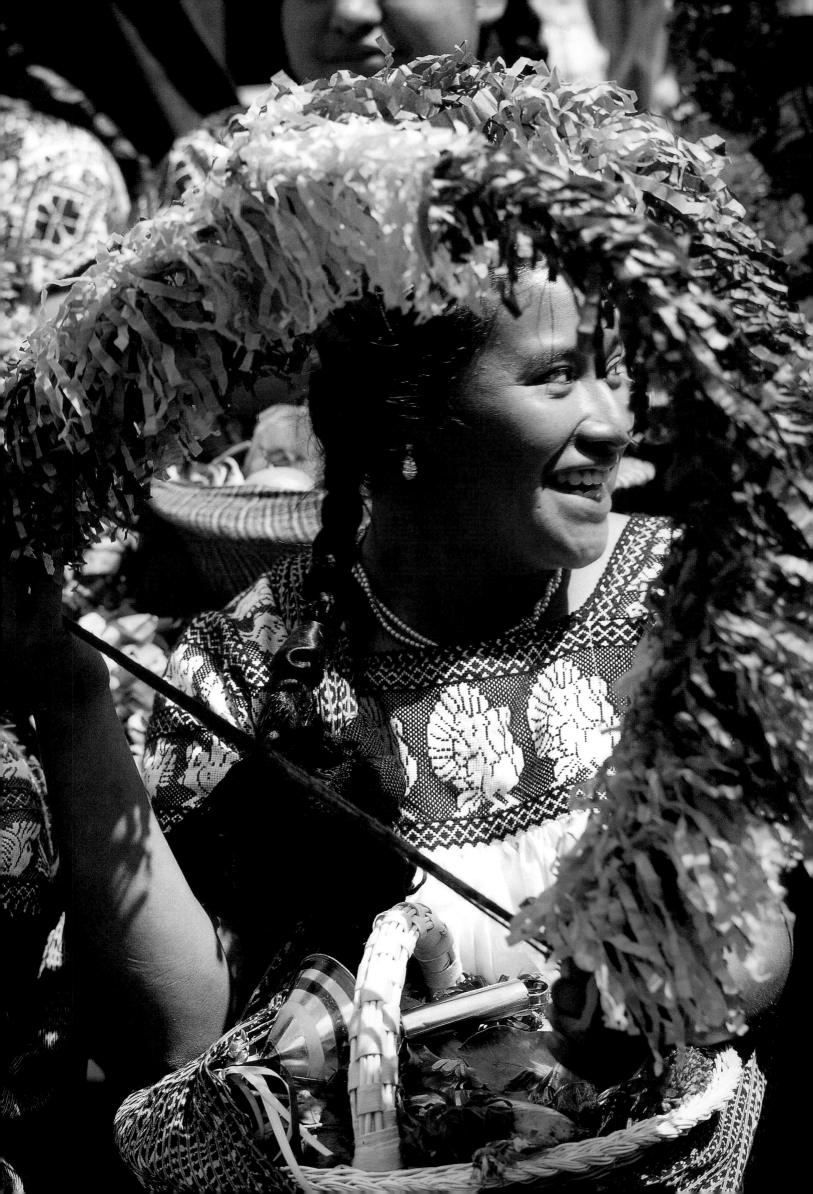

geometry of time and space, and of rediscovering a vision of the universe. Meza collaborated with Morris at one point, reproducing almost 1500 designs whose symbolism was being studied by the anthropologist, and making them available to weavers and a specialized public. Thanks to this collaboration, Meza wove and designed huipiles inspired by Mayan paintings and stelae, in an effort to re-create the apparel of indigenous nobles and to salvage its designs from oblivion. ❧

Bringing formal elements from the past into today's apparel has had a strong emotional impact not only on Pedro Meza, but also on all the members of Sna Jolobil. This has made the cooperative a very cohesive group, giving its members a sense of importance for their role in reviving aspects of their ancient culture. These artisans are fostering a vital commitment to their craft, and in this way, keeping textile art alive. ❧

In Oaxaca there is a Zapotec town, Teotitlán del Valle, that for centuries has been devoted to weaving rugs. It has a large export market and the quality of life there is improving. In the 1950s, it began exporting to tourist areas around Mexico, and in the 1960s and 1970s, to the United States and Europe. In the late 1970s, a French merchant in Oaxaca began commissioning the weavers to make rugs with designs taken from Picasso and other famous painters. Since then, thousands of foreign buyers go to Teotitlán every year to commission all kinds of rugs. The intense business relationship that the inhabitants of this town have established with foreign importers, especially from the United States, has influenced their designs and their colors. ❧

The merchants and weavers of Teotitlán can easily describe how American tastes have changed in the last twenty years. Many confess they do not understand these tastes, but that they want to make whatever sells. But when they are asked what they prefer, and what they consider to be the finest quality weaving, they always refer to classic Zapotec designs. Their preferences are connected to a very strong historical identity that has always been based on their textiles. Therefore, foreign buyers have to adapt to their peculiar ways of doing business, as these artisans will generally place ritual obligations before their work. Many buyers choose to adapt but others have resisted acceptance of the Zapotec culture entirely.[24] ❧

In this case, the more contact craftsmen have had with foreigners, the more they have retreated into their own idiosyncrasy. They have not abandoned their traditions; on the contrary, as time goes by, they affirm them even more. They are convinced that their mission

as weavers is a legacy from their ancestors, whom they cannot disappoint. ❧

In the 1970s, the great painters of Oaxaca, such as Tamayo and Toledo, advised the weavers on technical matters and colors. Around this time, work of superior quality was beginning to be appreciated again, and an effort was being made to use natural materials and dyes that had fallen into disuse. ❧

Arnulfo Mendoza, one of the best representatives of the Teotitlán tradition, has begun studying other ancient textiles from Mexico, such as the ancient *sarapes* of Saltillo, adding imagination and originality to his own tapestries. He is also very committed to teaching the trade to the children of his town, with the same rigorous standards that he follows himself. ❧

A happy but fleeting example of the transformation of an entire community a few decades ago is that of Taxco. More than merely acting as a consultant, William Spratling—who was quite familiar with the history of silver in Mexico, and had acquired the special artistic sense of those who worked the metal—introduced a design program that revolutionized the trade. He established workshops where silversmiths combined ancestral techniques with modern design. Indeed, many of the great silver-workers in Taxco, such as the Castillo family, took part in this project. This wasn't the first time something like this had been undertaken. Many similar experiments involving foreign craftsmen had been attempted, but their results were catastrophic. This revolution in silver ended many years ago, and today Taxco lives off the memory of its golden years. But that encounter among silversmiths had a social and economic impact that would mark the history of folk art in Mexico. ❧

Chloë Sayer, a tireless British supporter of Mexican folk art, has also influenced the lives of artists who might never have had contact with other worlds so different from their own. Tiburcio Soteno of Metepec has been invited to the British Museum and the National Museum of Scotland, while his brothers have visited other countries where they have held workshops showing how they make their Trees of Life. Their horizons have been

Mortar.
Baked, painted
clay.
Atzacoaloya,
Guerrero, 1963.
9 $\frac{1}{4}$ x 4 $\frac{1}{2}$ in.
Diameter 30 $\frac{1}{2}$ in.
Ruth D. Lechuga
Folk Art Museum.

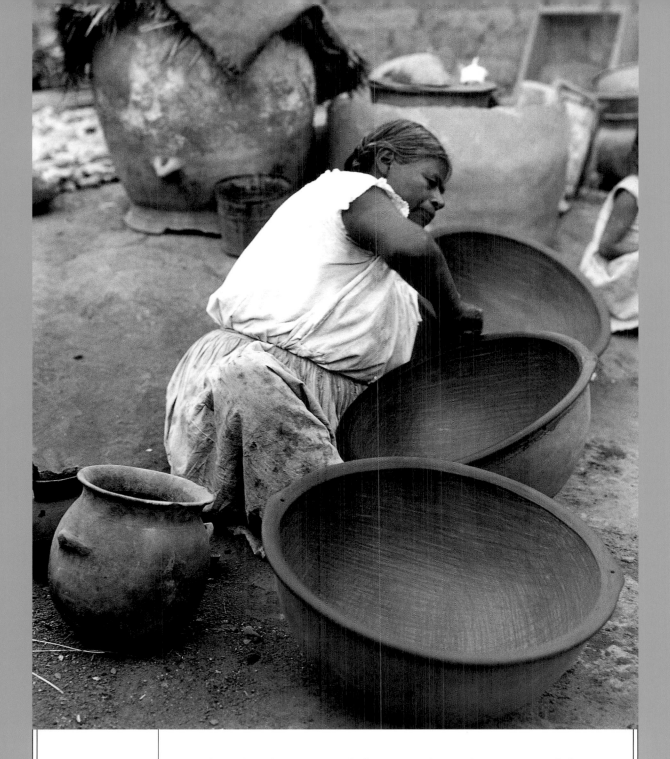

Potter.
Photo: Ruth D.
Lechuga.

broadened and contact with foreign cultures has improved their art, allowing them to innovate constantly without jeopardizing their traditions. ⁂

The vision of another American, Max Kerlow—who owns a store in Mexico City—transformed the craft production of Ameyaltepec, Guerrero, and later its neighboring towns, all of them traditionally devoted to ceramics. The potters gave up clay and began painting on *amate* paper. In 1960, Pedro de Jesús, a painter from Ameyaltepec who sold pottery, was commissioned by Kerlow to decorate some wooden statues. As he was well-paid for this, he later returned with his brother Pedro and a neighbor, Cristino Flores. The three were given sculptures to decorate. During the

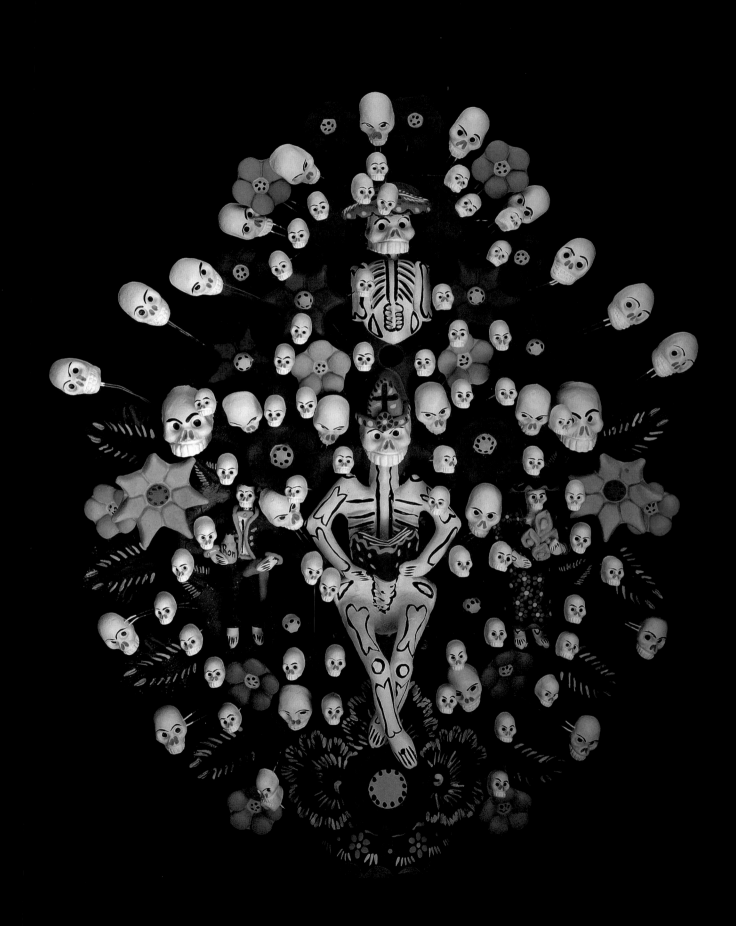

Opposite page
José Vara.
Tree of Death.
Metepec, State of
Mexico.
Collection of
Horacio Gavito.

Pages 86–87
Lydia Quezada C.
Ceramic pot
with matte black
decoration.
Mata Ortiz,
Chihuahua.
Native & Nature
Collection.

latter half of 1962 they painted in the back room of Kerlow's shop, and soon found a new occupation: painting on *amate* paper, for which they developed a narrative style. This was the beginning of a new art form that soon spread to other parts of the country and was exported to the United States.[25] ❖

Perhaps the most radical example of the intervention and exchange of various people's imaginations can be found in a remote town of Chihuahua that once seemed doomed to poverty and depopulation. In a short period of time it became a productive community of more than 300 families of potters, whose work at times is valued in thousands of dollars, and who are hard-pressed to meet the demand. The success of this small town is the result of an outsider who caught a glimpse of something that was not immediately apparent to others. I am referring to the town of Mata Ortiz, Chihuahua. ❖

One day in 1976, American anthropologist and art historian Spencer Heath MacCallum came across the work of an unknown potter in a shop in a town in New Mexico. The owner of the shop didn't know who had made it, but said he was sure it had come from Mexico. MacCallum bought three pots and took them home. He put them on a shelf and looked at them for days while thinking that somewhere in Mexico there had to be an extraordinary artist. He decided to go look for that potter. ❖

He traveled through the vast state of Chihuahua with photographs of the pots, asking every person he encountered about the artist who had made them. He got to Nuevo Casas Grandes and from there, took a dirt road that led him to the town of Mata Ortiz. ❖

It seemed an unlikely birthplace for such an important artistic movement. Work opportunities were scarce and the young people were emigrating in droves. However, following the directions he had been given, MacCallum reached the house of Juan Quezada, who was surprised by such an unexpected visitor. He was even more surprised to see photos of some pots he had made a few months earlier. ❖

He showed his visitor other pots he kept on top of a wardrobe, and MacCallum had no doubt this was the same artist who had made the pieces he had bought in New Mexico. They were thin-walled and very light. Thin black lines crisscrossed the pots to form symmetrical shapes painted in red and black. Quezada told MacCallum he could make even better pots but that it took him longer and no one was willing to pay more. MacCallum offered to pay him in advance and came back two months later to pick them

up. From then on a business relationship was established between them, one which would change Quezada's life as well as his family's and that of the entire town of Mata Ortiz. ❖

The most surprising aspect of this case is that this ceramics movement was not based on traditional handicrafts with a practical function, whose aesthetic qualities are secondary. In the Mata Ortiz area, no one had made ceramics in over 500 years. It was not an indigenous community, but rather was made up of families who had immigrated from elsewhere. The Mata Ortiz phenomenon can be defined as a sophisticated contemporary movement with roots in the pre-Hispanic culture of Paquimé.[26] ❖

What would have happened if Spencer MacCallum hadn't met Juan Quezada? Would the same artistic quality have been achieved? Like Morris in Chiapas, whose interests improved and increased textile production, MacCallum triggered the improvement and rapid growth of an art form that would provide the community with the sense of identity and pride it was lacking. ❖

MacCallum had lived and worked in Mexico as a teenager, volunteering as an assistant archaeologist at sites such as Teotihuacán and Monte Albán. Like Morris, he had assimilated a different code and had learned to appreciate this difference. He not only gave artisans access to a market, he also formulated a language that would help decipher this movement. He worked with Quezada for eight years, and later, in 1983, merchants and tourists began to trickle into town. Demand for these ceramics kept growing, so many families stopped working in the fields and devoted themselves to pottery. When MacCallum had first arrived, only eight people besides Quezada made ceramics on a part-time basis. ❖

Thirty years later, there are more than three hundred families in Mata Ortiz who earn a living by making ceramics. At least thirty potters have gained worldwide recognition, and they seem to be just gaining momentum. In many ways, this is an exceptional phenomenon whose development was exceedingly fast, because thirty years is very little time when speaking of the lifespan of a craft. Mata Ortiz is an unusual case in the world of folk art. Perhaps it would not be such a bad thing if this kind of exceptional situation were to occur more often. ❖

❖

In this brief reflection, we have considered handicrafts from four different angles, and asked them many penetrating questions. We have considered

This page and opposite
José Quezada T.
White clay pot with polychrome decoration repeated twice.
Mata Ortiz, Chihuahua.
16 ¹/₂ x 8 in.
Private collection.

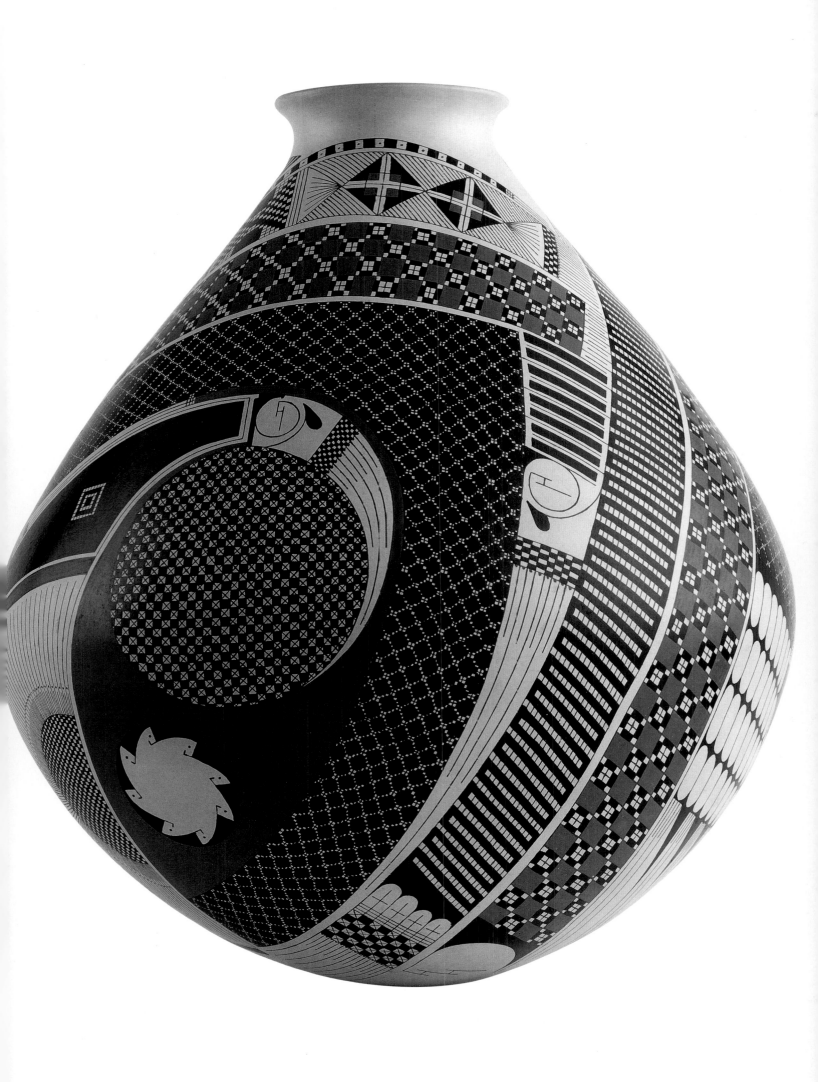

This page and opposite Humberto Ponce Ávalos and Blanca Almeida Gallegos. Pot with checkered polychrome decoration.
11 1/2 x 8 1/2 in.
Private collection.

Page 93
Man dressed in traditional clothes from San Pedro Chenalhó, Chiapas. 1993.

Pages 94–95
Women of the Puebla Sierra at the Fiesta of Atlixcáyotl. Atlixco, Puebla. 2002.
Photo: Jorge Pablo Aguinaco.

their aesthetic dimension in order to analyze their forms; their ethnographic dimension in order to analyze their function within the community; their symbolic dimension, to analyze their ritual or everyday meanings; and their intercultural dimension in order to analyze their effects on the life and imaginary world of a community in the short, medium and long term. The artisan's hand creates forms, indicates functions, practices rituals and opens itself naturally to other cultural worlds in order to enrich its own. Thus, each artisan's hand is in fact four hands. ❖

The questions we have posed to folk art and to the hands of artisans provide us with the multiplicity of answers that this creative phenomenon requires in order to be studied as a rich aspect of Mexico's cultural history. ❖

My eyes are drawn back to the Olinalá tiger that has hung impassively on the wall while I have written these pages. The mysteries of the handicrafts with which I live seem somewhat less baffling to me now. But their meanings and their beauty do not cease to dazzle my senses. ❖ TRANSLATED BY MÓNICA DE LA TORRE. ❖

[1] Octavio Paz, *In Praise of Hands: The Contemporary Crafts of the World* (New York: New York Graphic, 1974): 17–24.

[2] Gerardo Murillo (Dr. Atl), *Las artes populares en México* (Mexico City: Secretaría de Industria y Comercio, 1922).

[3] Octavio Paz, *op. cit.*

[4] Alejandro de Ávila, "Weavings that Protect the Soul," in *Textiles from Oaxaca, Artes de México* 35 (1996).

[5] *Folk Art: The Ruth D. Lechuga Museum, Artes de México* 42 (1998).

[6] *Ceramics from Tonalá, Artes de México* 14 (1991).

[7] Irmgard Weitlaner Johnson, *Design Motifs on Mexican Indian Textiles* (Graz: Academische Druckv and Verlagsanstalt, 1976).

[8] Alejandro de Ávila, *op. cit.*

[9] Alfonso Alfaro, "In Praise of Opulence, Distance and the Lamb," in *Textiles from Chiapas, Artes de México* 19 (1993).

[10] Calixta Guiteras Holmes, *Los peligros del alma* (Mexico City: Fondo de Cultura Económica, 1952): 33.

[11] Bartola Morales, "Imagination Embroidered with Words," in *Textiles from Oaxaca, Artes de México* 35 (1996).

[12] Bartola Morales, *op. cit.*

[13] Ruth D. Lechuga, *El traje indígena de México. Su evolución desde la época prehispánica hasta la actualidad* (Mexico City: Editorial Panorama, 1982): 36.

[14] Ricardo Martínez Hernández, *K'uk'umal chilil, el huipil emplumado de Zinacantan* (Chiapas: Casa de las Artesanías, 1990).

[15] Lexa Jiménez López, "Cómo la luna nos enseñó a tejer," in *Textiles de Chiapas, Artes de México* 19 (1993).

[16] Walter F. Morris, *Living Maya* (New York: H. N. Abrams, 1987).

[17] Marta Turok, *Cómo acercarse a la artesanía* (Mexico City: Plaza y Valdés-SEP, 1988).

[18] Marta Turok, *op. cit.*: 47.

[19] Alejandro de Ávila, *op. cit.*

[20] Jean Chevalier and Alain Ghurbrant, *Dictionnaire des symboles* (Paris: Laffont, 1974).

[21] Alejandro de Ávila, "Hebras de identidad: los textiles de Oaxaca en contexto," in *El hilo contínuo* (Los Angeles: The Getty Conservation Institute and Instituto de Fomento Cultural Banamex,1998): 132.

[22] Nathaniel Tarn and Martín Prechtel, *Constant Inconstancy: The Feminine Principle in Atiteco Mythology. In Symbol and Meaning beyond the Close Community. Essays in Mesoamerican Ideas* (New York: Institute for Mesoamerican Studies-State University of New York, 1986): 443.

[23] Richard Stephen Felger and Mary Beck Moser, "The Spirits of Seri Baskets," in *Basketry, Artes de México* 38 (1997).

[24] Stephen Lynn, "Export Markets and their Effects on Indigenous Craft Production: The Case of the Weavers of Teotitlán del Valle, Oaxaca," in *Textile Traditions of Mesoamerica and the Andes: An Anthology* (Austin: Texas University Press, 1991).

[25] Jonathan D. Amith, *La tradición del amate* (Chicago and Mexico City: Mexican Fine Arts Museum-Casa de las Imágenes, 1995): 60.

[26] Walter P. Parks and Spencer H. MacCallum, "Mata Ortiz: A Ceramic Renaissance," in *The Ceramics of Mata Ortiz, Artes de México* 45 (1999).

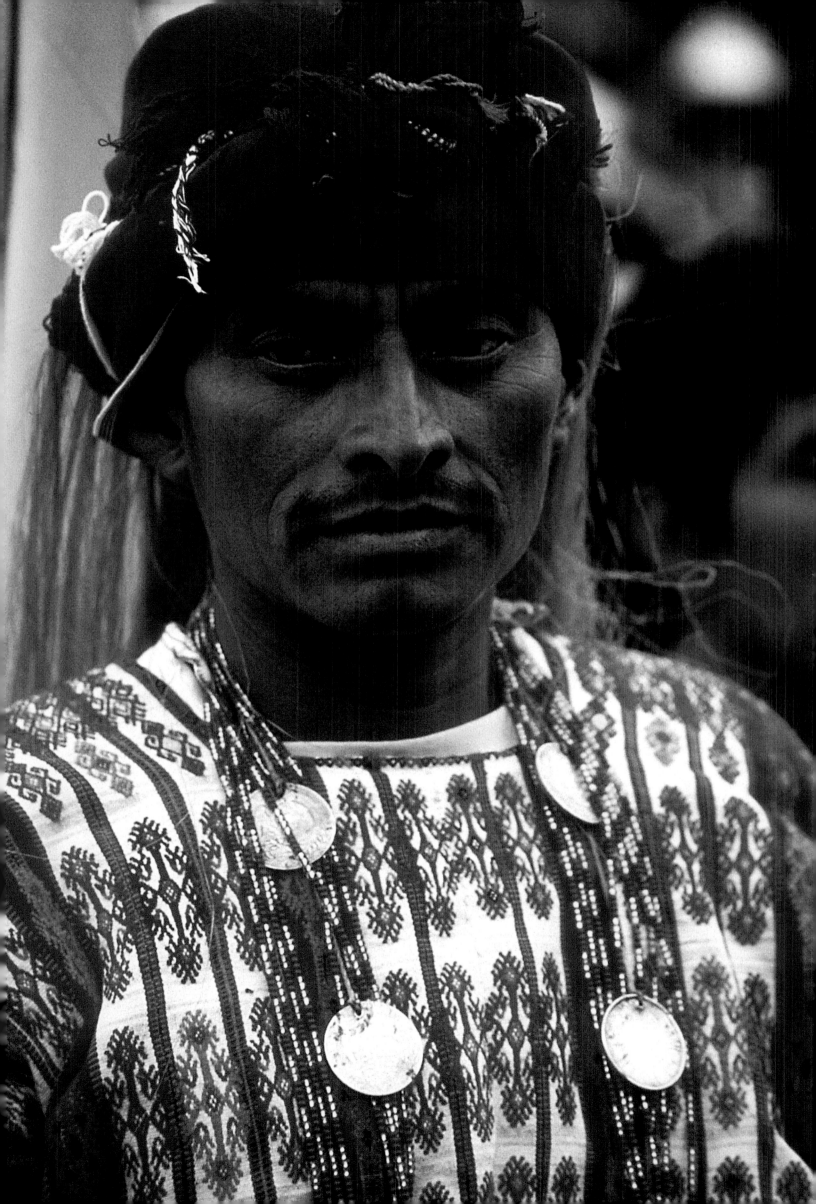

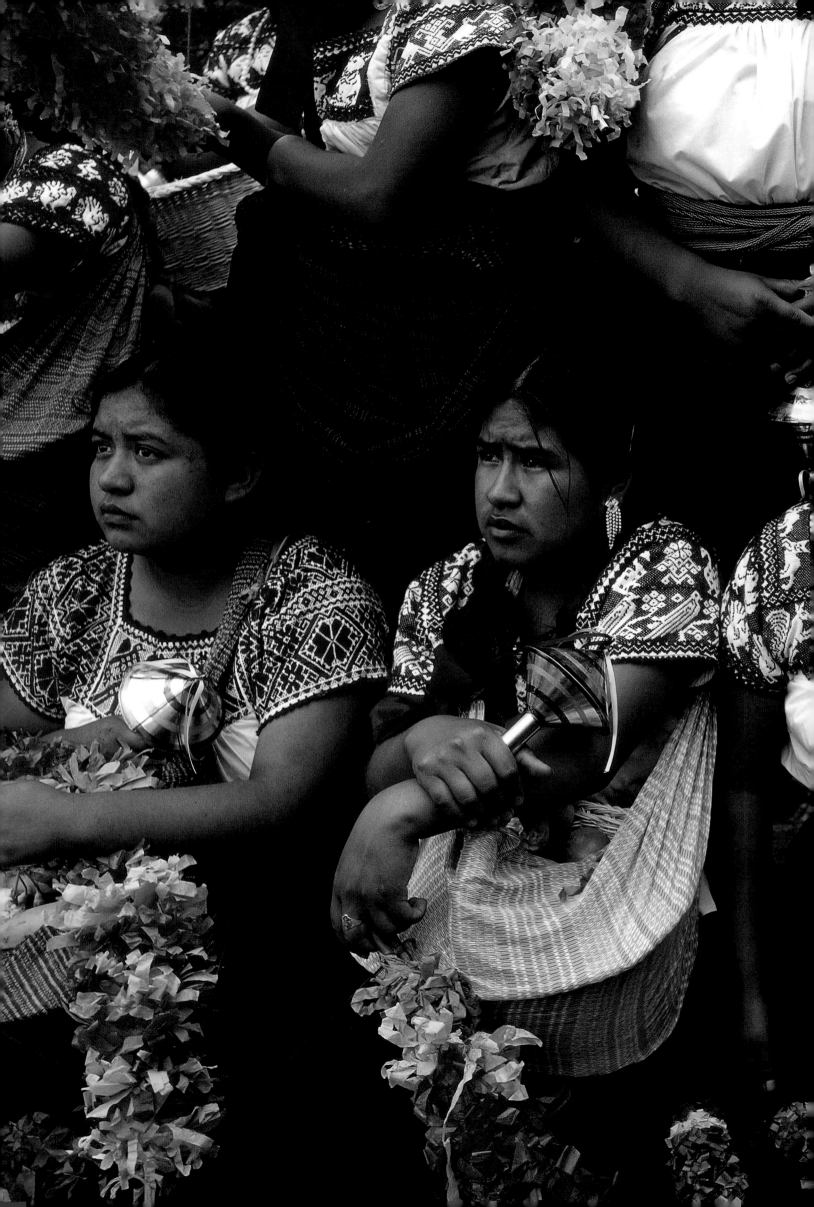

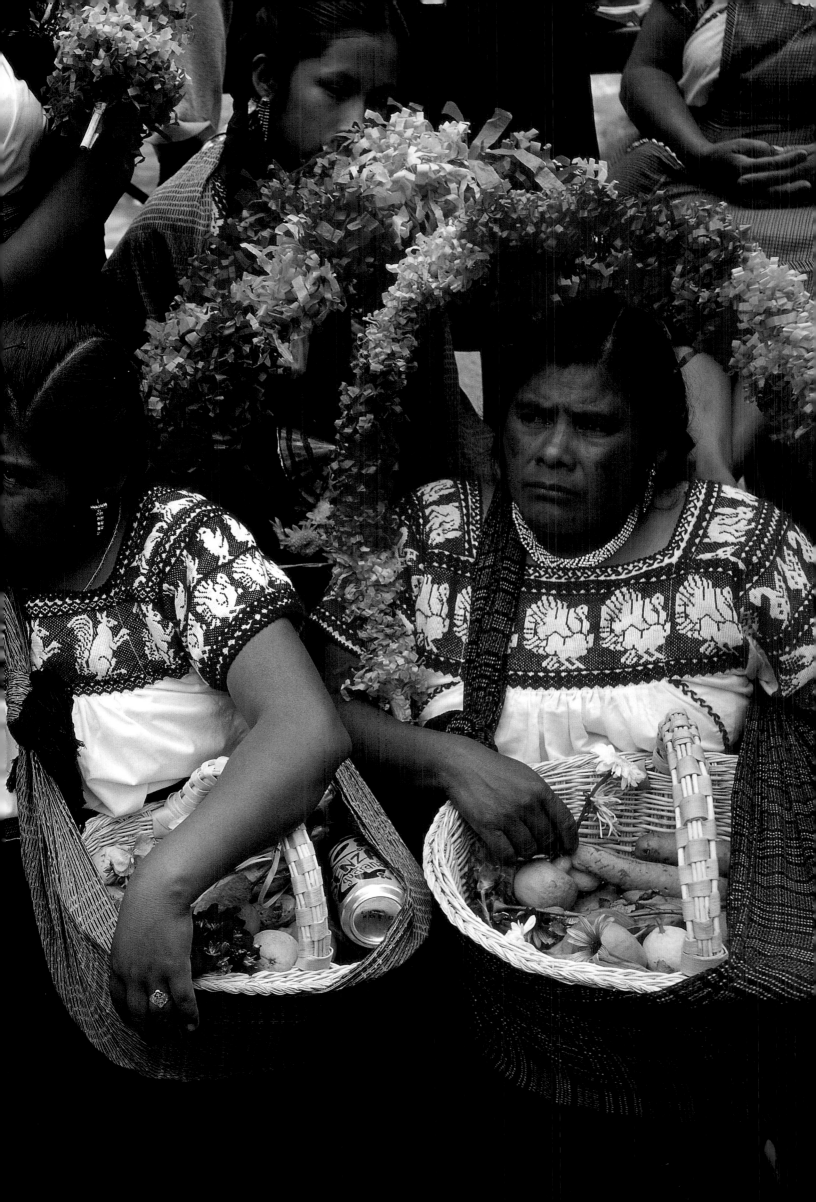

Terra Incognita

Alfonso Alfaro

Iɴ ᴀ ᴄᴏᴜɴᴛʀʏ ᴡʜᴇʀᴇ ᴜɴᴇxᴘᴇᴄᴛᴇᴅ sɪᴛᴜᴀᴛɪᴏɴs ᴀʀᴇ ᴄᴏᴍᴍᴏɴᴘʟᴀᴄᴇ, ᴏɴᴇ of the most startling events to occur in Mexico in the late twentieth century is itself an enigma: the way the country's educated sectors and cultural majority were baffled by how rural community issues burst onto the scene of national debates. ❖

What is extraordinary is not the intrusion itself but the stupefied public opinion it provoked. Why are the educated elites and the middle classes so helpless when faced with problems whose intricate nature makes them seem unsolvable? Why has the nation not yet recovered from its surprise? Why is an organism as cohesive and elaborate as Mexican society so vulnerable to a series of tensions whose scope is so local, so circumscribed and seemingly in the minority? ❖

This bafflement is the consequence of a success story: the nation has finally managed to become a society whose cultural frames of reference are primarily modern. Following the blueprints laid down by the powers that have exercised control over Mexican culture—France in the eighteenth century and the Anglo-Saxon world since the nineteenth—our country has expanded the domains where the reason of the Enlightenment dictates ideal precepts, where the yearning for transparency replaces the acceptance of hermetic historical laws (apparently written by Providence), where the zeal for efficiency turns the tendency toward ritual expenditure and gratuitous acts into an aberration. ❖

This process has accelerated, especially since the Mexican Revolution: in the twentieth century, the country underwent urbanization, industrialization and entered the realm of globalization. ❖

Wealth is no longer produced to be partially consumed (i.e. destroyed, burned up in the sacrificial offerings of traditional societies) but rather consumed in the sense of "consumer goods." Individual aims acquire the value of an ethical priority; community space is subject to the validity of laws. ❖

It is true this transformation has not been homogeneous. Since the eighteenth century the proposals of Enlightenment-inspired modernity have trickled down, first seducing the elites and later the

This page and opposite Nahua mask. Carved, painted wood. Huejutla, Hidalgo. 6¹/₄ x 5¹/₄ x 3¹/₄ in. Ruth D. Lechuga Folk Art Museum.

Page 96 Cojó mask. Painted wood. Tenosique, Tabasco. 1989. 6³/₄ x 6¹/₄ x 5¹/₄ in. Ruth D. Lechuga Folk Art Museum.

Pages 100–101 Otomí cut-out amate paper figures for ritual use. San Pablito, Puebla. ca. 1970. Ruth D. Lechuga Folk Art Museum.

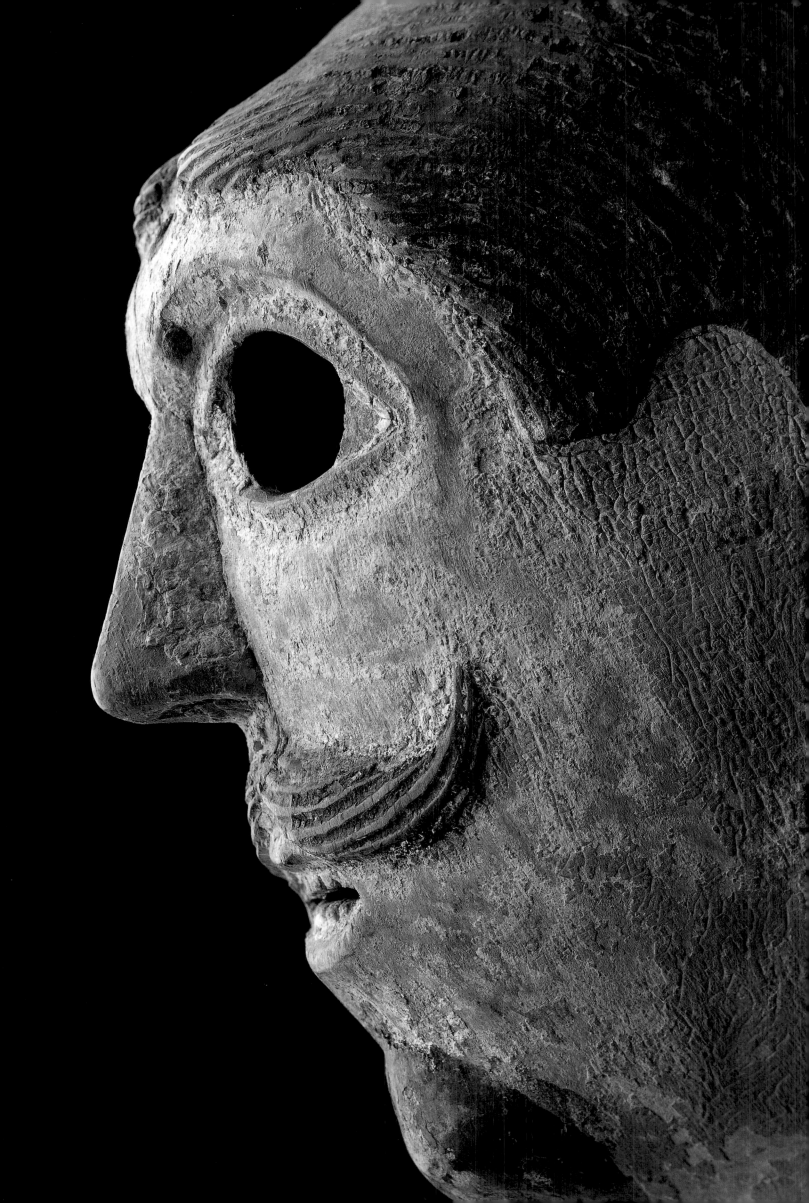

urban, educated middle class, and now constitute the mainstream, articulating the ambitions of a country whose majority aspires to join the worldwide system of economic, consumer expansion. ❧

However, in spite of the fact that they live in territory saturated by Western currents of thought (which have irrigated our land for over 200 years), numerous Mexicans continue to quench their thirst in other springs. The members of this large population, many of them unilingual Spanish speakers ostensibly identical to other Criollos and Mestizos, remain immersed in traditional social and cultural networks insofar as they have managed to resist the tide of Westernization. ❧

These societies (which Enlightenment logic regards as "pre-modern" and social-evolutionist dogma consider "primitive") are the loci for different future projects that deviate from, and, in certain respects, even oppose the prevailing one. Their goals diverge from those formulated by northern European societies influenced by eighteenth-century modernity, and bear a closer affiliation to another system of symbols and values rooted in Rome, Austria and Spain, one that gave birth to the post-Renaissance Western world's great alternative project: the art and culture that arose from the Council of Trent (a cultural movement called the "Counter-Reformation" in northern Europe). ❧

For many Mexicans—those belonging to the aforementioned large minority that continues to grow in size despite the fact that it represents an ever-shrinking proportion of the population as a whole—there exists an epistemology distinct to that of positivism, an economy that is not only about hoarding and consuming, and a life project that goes beyond the temporal limits of an individual's existence. ❧

The web of personal loyalties and collective aspirations created through a constant dialogue with a universe that lies outside history and beyond visible reality breathes life into the culture of urban neighborhoods and forms part of the daily experience of many of Mexico's rural inhabitants: mixing joy with tears to keep the presence and love of deceased relatives alive through the celebration of the Day of the Dead still makes sense to them. They feel that the large debts accrued by assuming the stewardship of a town or a neighborhood's patron

saint—which also grants them immense prestige among family and neighbors—is fully justified in terms of a life project; furthermore, they are sure that the mysteries celebrated during Holy Week and Corpus Christi are plausible explanations for the laws that govern the universe. ❖

Mexican populations situated on the fringe—of high technology, of urbanization, of formal schooling, of industrialization, of the formal economy—stand on shaky ground between two of the West's civilizing projects: the Tridentine and baroque Austro-Spanish world of the Habsburgs, and the modern post-Enlightenment world of northern Europe. ❖

The head-on clash between the two concepts of reality took place during the Enlightenment and had its resolution with the modern project's conclusive victory. The defeated model withdrew from the arena of intellectual and scientific debate but continued to flourish, entrenched and ignored, within popular culture in many regions, especially those that had once belonged to the heirs of Charles V of Spain. For over 200 years, Mexico's own rural areas have served as a shelter and hideout for a project formulated in its day as an attempt at a constructive answer to the great crisis that European religious conscience experienced in the sixteenth century, and as an effort to overcome the limitations of seventeenth-century rationalism. ❖

This other model for distributing economic resources and organizing social ties, and this other way of conceiving of daily life, history and fate have not completely disappeared today, despite having been thrown into a dead-end street, off the road to progress. They only became less manifest, less visible, so much so that the triumphant—i.e. modern—societies were soon convinced that the incorporation of marginal cultures within the mainstream of linear evolution was inevitable. Nevertheless, in the 1970s—before our country's so-called economic "crises" began recurring systematically— Octavio Paz noted that, "the 'other' Mexico, the undeveloped one, grows faster than the developed one and will end up smothering it." ❖

The twentieth century forced us to accept that social realities are more vigorous than attempts to understand, encode and dominate history. The Council of Trent's cultural project was defeated in a

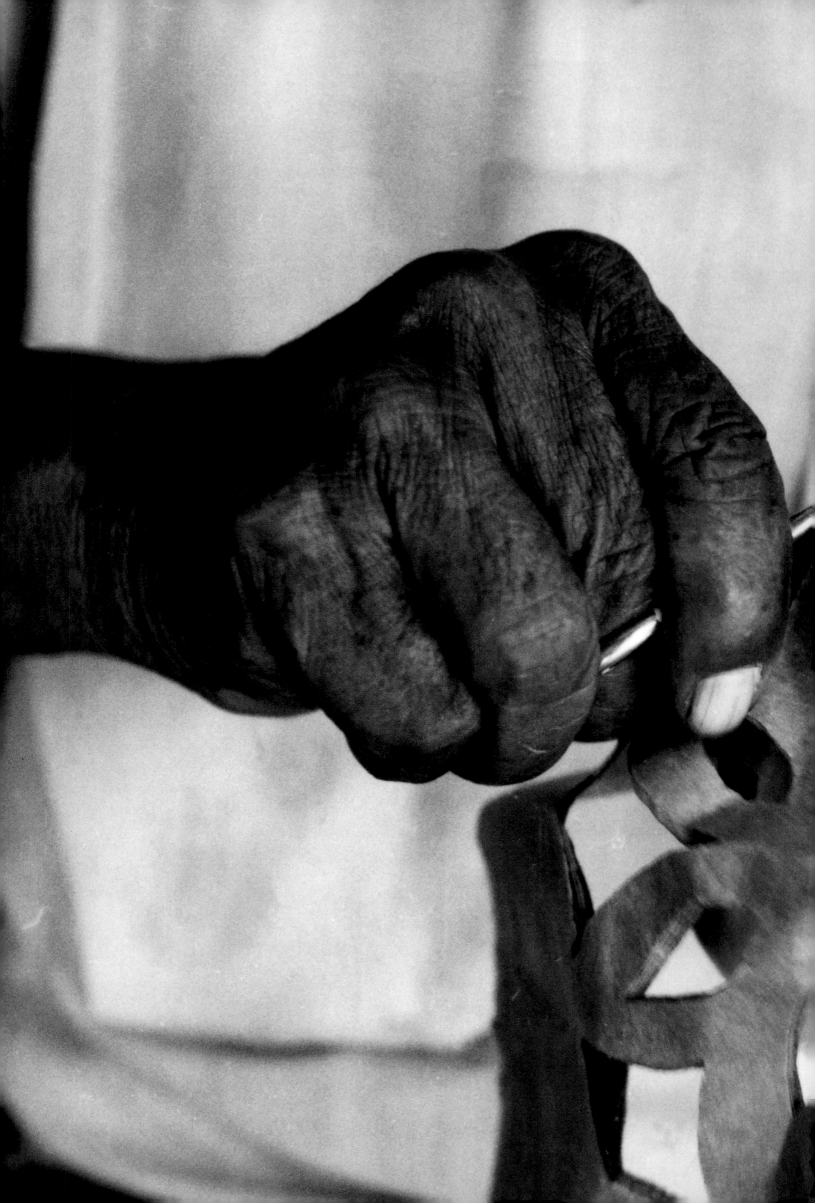

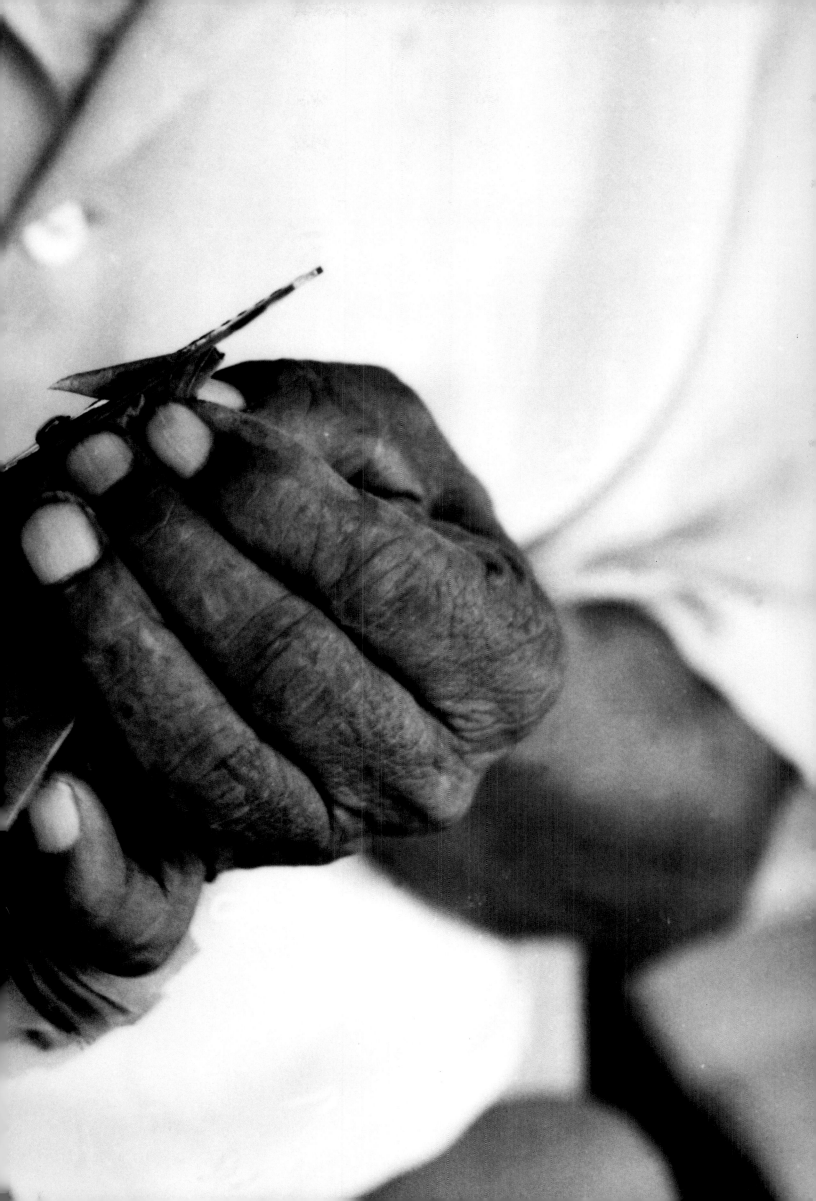

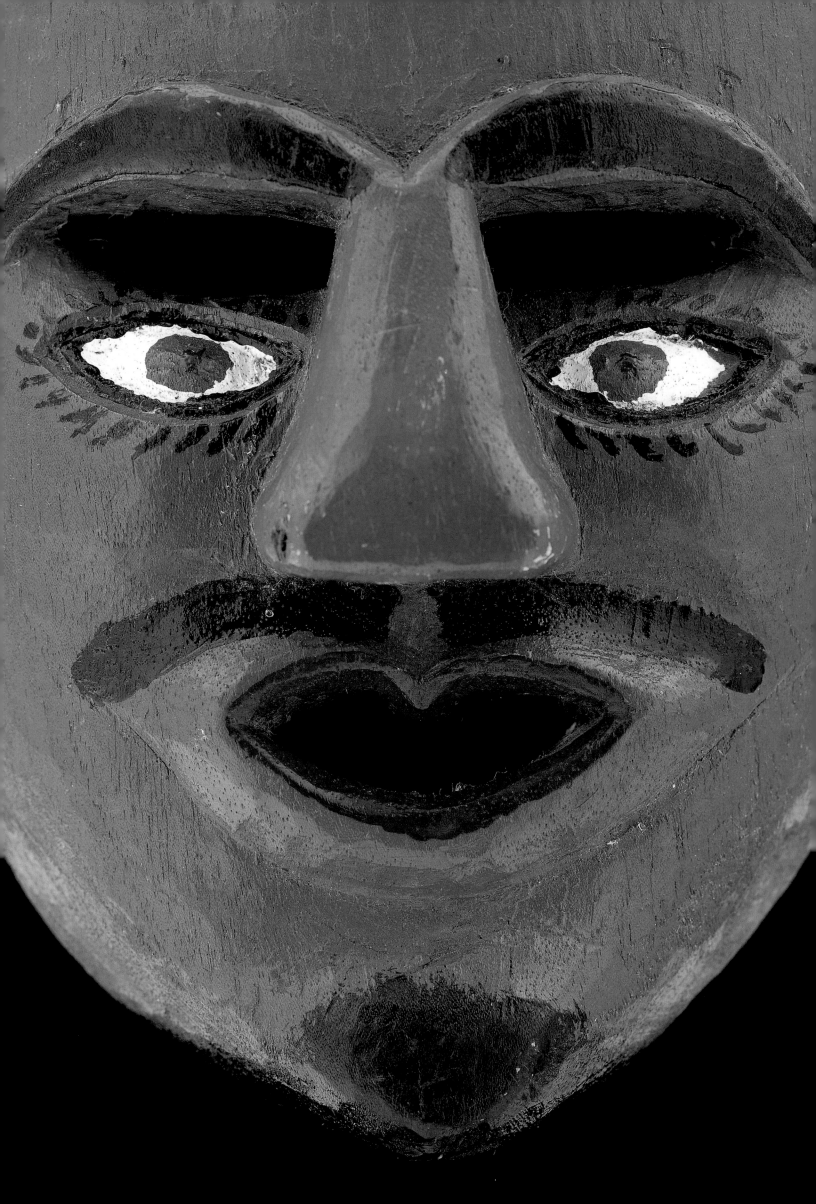

fight for hegemony over a whole civilization but has remained alive and has kept expanding for the last two centuries. ❖

Conflict and inequality already existed within pre-Hispanic societies long before the Spanish Conquest. However, contemporary indigenous communities have been profoundly transformed due to their now centuries-old incorporation into Western civilization (as can be seen in their systems of social organization, their symbolic frame of reference, their technology). The present situation is not about "natural" or "primitive" groups clashing with an "artificial" (modern) society; it is not about a pure and just world facing a decadent and corrupt one, or about a vital and generous people attempting to defend itself against an opulent and dehumanized economy (nor is it a conflict between "indigenous people" and "Mestizos"). It is simply about two cultural strains of a single Western civilization with conflicting systems of logic (the dominant current being less powerful than it thinks, and the subordinate one not as passive as it seems), competing and trying to survive, each invoking its own values. ❖

Mexican pre-modernity (or rather, "non-modernity") is primarily Tridentine though it bears many similarities to models of other traditional rural societies in the Hindu, Islamic and Buddhist worlds. ❖

For nearly ten generations, our country's educated elites—heirs of a long line of intellectual *habitués*—have perceived the baroque universe as an inanimate, mummified, gilded giant, and the existence of a parallel world with alternate aspirations and a project that does not share their precepts (the individual, reason, progress, consumption, expansion) because it has its own is deeply disconcerting to them. ❖

Perhaps it is just a question of how we look at things. Our country's more productive sectors—in their urge to accelerate the anxiously awaited transformation that will grant Mexico "the position it justly deserves" within the ranks of developed nations—have fixed their gaze on precisely those nations: on what they invent and reject, on what they do and stop doing. ❖

Their eyes have grown accustomed to seeing the ghosts of the rural and peripheral urban world—whether these be Spanish-speakers or not, most can no longer be called indigenous—as nondescript, blurry shadows, toiling silently at the bottom of the social pyramid. Concerned with building a future project, they have grown increasingly dismissive of a past that remains vital and relevant to this day. ❖

❖ ALFONSO ALFARO

On the other hand, Mexicans who have just recently joined the ranks of modernity (those living in the urban periphery, with little formal education) still gawk at mirages on a barely glimpsed horizon filled with promise, and try to break the ties that bind them to a precarious existence they only manage to leave behind with tremendous effort. Obsessed with distancing themselves from the exhausting and toilsome condition of their forefathers, they are also unable to calmly scrutinize that facet of Mexico that customarily speaks in a muffled voice: the dark side of our moon. They also try to efface some of the traits of the face we all see when we look in the mirror. ✣

Thus, because of their ways of seeing things, certain elites (especially the more productive ones) and certain sectors of the middle class (especially its new members) have great difficulty in perceiving the reality they are immersed in. The convulsions that rock those foundations of the social edifice—foundations that to them form part of a dark, inaccessible underworld—have a profound effect on their interests. But not even the violence of these convulsions is enough to modify their tropisms. They focus all their attention on their sole object of desire: the image of modernity and development—what their dreams are made of. ✣

Besides the ones we described, there exists another perspective. Full of curiosity and interest, this gaze is eager and surprised; it is conscious of the infinite distance that separates it from what it observes, but remains fixed by the fine threads of admiration and affection. This gaze is able to consider the lively, hidden world as a demanding object of study and as a subject for dialogue: this is the gaze of respectful Otherness. ✣

Thanks to this way of perceiving the Other, the great explorers and travelers—from Herodotus to Marco Polo—have enriched humanity's cultural and ethical heritage. For several generations, academics have attempted—though not always successfully—to encode this point of view in an ethnological system. ✣ Translated by Richard Moszka. ✣

Delfino Castillo Alonso. Molded and painted carnival mask with ixtle fiber beard. Santa María Ixtahuacán, State of Mexico. 10 ³/₄ x 6 x 5 ¹/₄ in. Ruth D. Lechuga Folk Art Museum.

Opposite page Carnival in Atenco, State of Mexico. 2003. Photo: Jorge Pablo Aguinaco

Page 108 Woman in San Bartolo Yautepec, Oaxaca. 1980. Photo: Ruth D. Lechuga.

Page 109 Mixtecs in San Pablo Tijaltepec, Oaxaca. 1981. Photo: Ruth D. Lechuga.

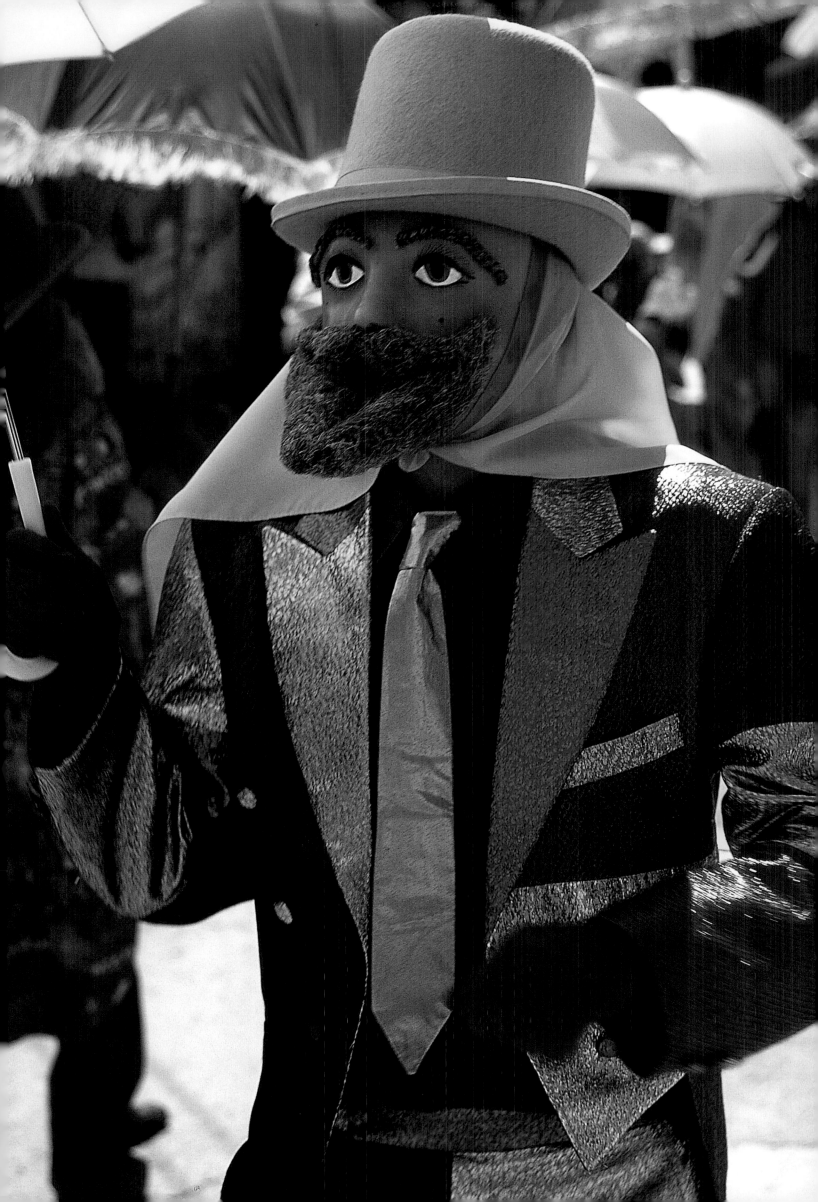

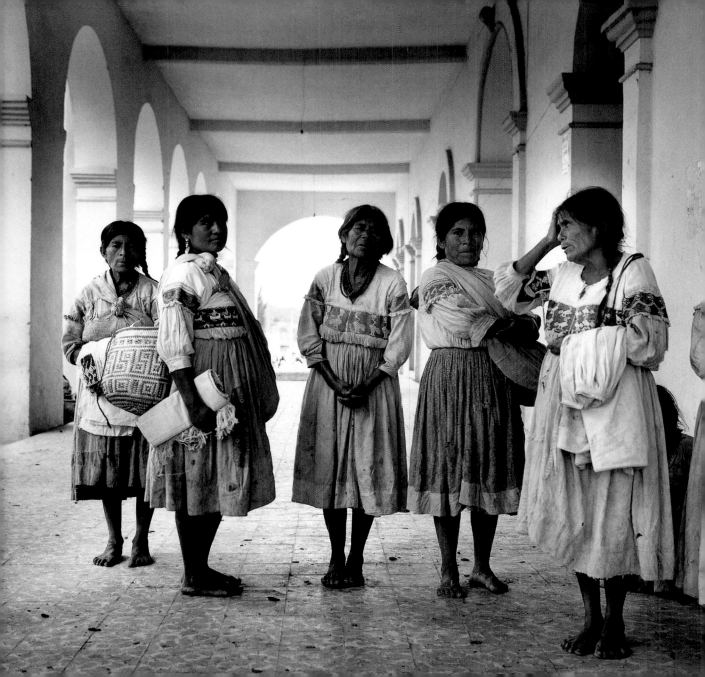

CERAMICS

CERAMICS OF THE FIVE SENSES ⚬

⚬*Alberto Ruy-Sánchez*

EVERY CRAFTED OBJECT HAS ITS OWN MAGIC, AN AURA OF GRACE THAT seduces and captivates. The beauty of some ceramic pieces may be the most immediate of these seductions, but by no means is it the only thing that attracts us. At the same time as it is of use to us in our everyday life, does a vessel not wield tremendous power, demanding our admiration and our silent, undivided attention? Clay itself is loaded with many different meanings: from the creation myth that God made man out of clay, to the proud nationalistic comparison between a Mexican's skin and the color of his or her land. The earthenware vessel called the *jícara* (styled on the gourd of the same name) was Mexico's emblem in nationalistic painting and literature of the 1930s and 1940s. For Europeans from the sixteenth century onward, and later for people in the United States, it became, in turn, an emblem of exoticism, of Otherness, of a "different" people who drank water from those vessels, who drew figures on them and buried their dead in them. So widespread did the use of this emblem become that the writers of the 1930s who criticized the use of nationalistic stereotypes in the literature of the period called it *literatura de jícarita*. And it was common for people to say that someone was as "sonorous as a clay pot" to applaud their openness and sincerity. ❖

Beyond their emblematic image, the different forms of Mexican pottery are the living expressions of an age-old creative tradition. Renowned art historian Herbert Read said that pottery is at once the simplest and the most complex art, given that its elemental nature is also very abstract. It does not imitate like sculpture does; rather, its forms tend toward an inert balance: "The Greek urn is the model for all classical harmony." And so, according to Read, pottery is such a fundamental art, so vitally linked to a civilization's needs and imagination, that it is only natural for a nation's character to be expressed through this craft. For that reason, "the art of a country and the delicacy of its sensibilities can be judged on

Opposite page
Pablo Ramos Cruz.
Clay jug with
petatillo decoration.
Tonalá, Jalisco.
$9\frac{1}{2}$ x $6\frac{3}{4}$ in.
Diameter $16\frac{1}{4}$ in.

Page 110
Modeled ceramic
bowl with traces of
polychromy.
Jalisco region.

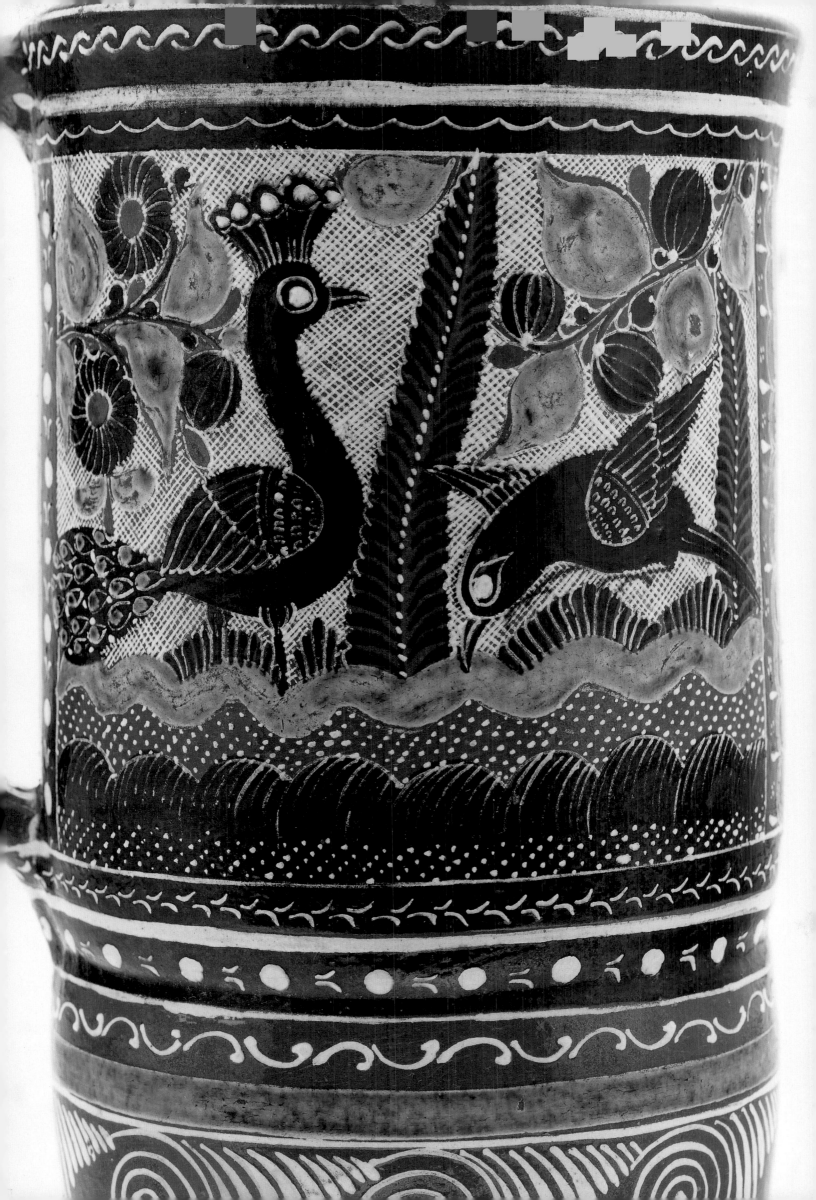

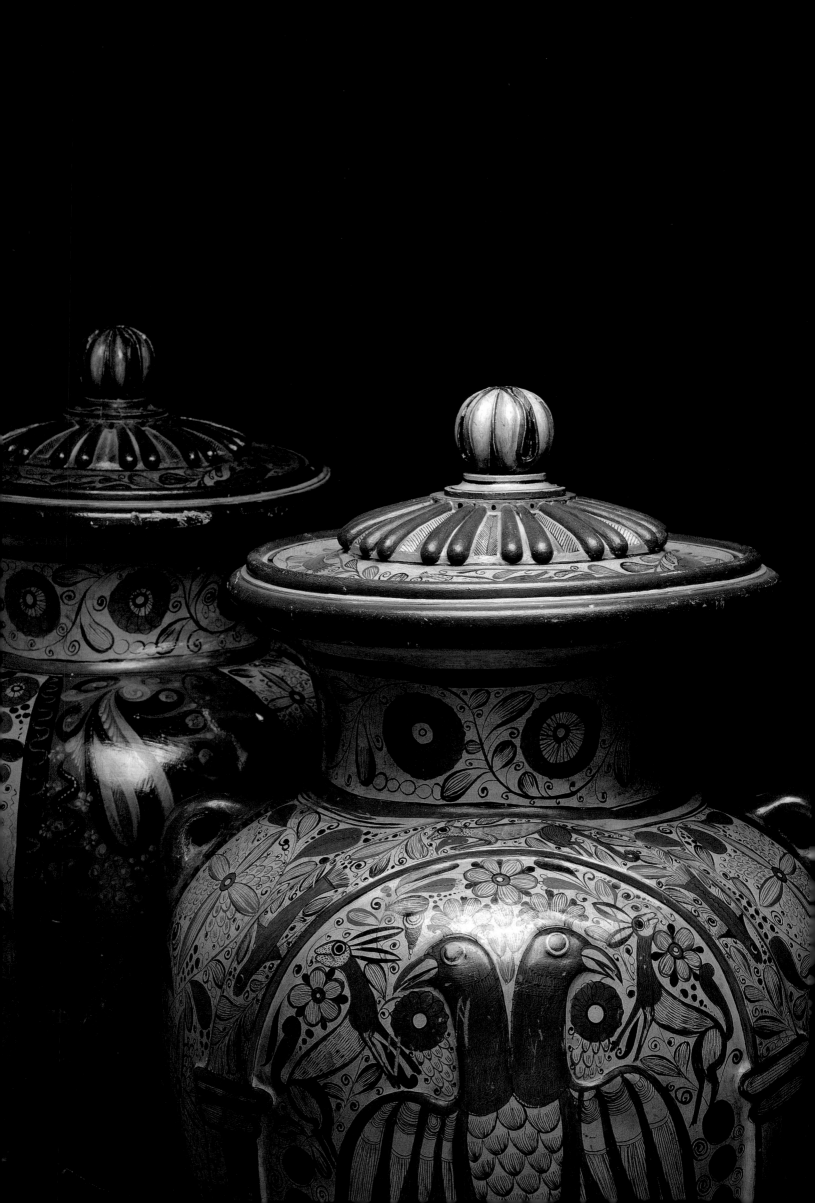

the basis of its pottery. That is a reliable criterion." In its pottery as in its cuisine, in its visual arts as in its poetry, the Mexican sensibility has "communicating vessels," and expresses itself as a living organism: at once changing and eternal. Its arts speak in multiple voices: one of these is the voice of clay, and one of its most interesting expressions is Tonalá ceramics. ❧

Tonalá pottery works its seductive powers on all of our senses. Its immediacy makes sight the privileged one, as we glimpse its forms, colors and drawings from afar. The pieces' marked and yet ambiguous naïveté gives them an air of simplicity, freshness and sincerity; in short, they are strikingly graceful and natural. The fauna and flora depicted on certain examples from the nineteenth and twentieth centuries—some of which feature quite intricate scenes—are reminiscent of Rousseau. The geometrical shapes on the non-figurative pieces are almost always very elemental. In some cases, certain motifs such as flowers have become virtual abstractions. In other words, they act as a kind of voice print for this kind of work in clay which Dr. Atl spent a lifetime deciphering and naming. ❧

Hearing and touch are other senses affected by this pottery. The earliest chronicles praise these pieces for their sonority and porosity, their delicacy and polished finish. And taste eagerly joins the senses flocking around the burnished clay, because it is said the water kept in Tonalá earthenware acquires a purer flavor, maintaining its spring freshness. However, the true guest of honor at this banquet is the sense of smell: Tonalá pottery was long known as "aromatic earthenware" because it gives off a very particular scent when filled with water, which some attribute to the mixture of clays, and others to the first finish applied to the pot before it is fired. The defenders of the first hypothesis argue that this accounts for the particular smell of Mexican earth after it rains. ❧

Europeans cherished this aromatic earthenware from New Spain. It was specially treated so that its fragrance could be preserved and shown off to guests. As one of those strange and exotic objects that aroused not only astonishment but a thirst for knowledge, it justly earned a place, if not in the dining room or in the kitchen, then as a parlor showpiece. ❧

It is no coincidence that Tonalá pottery is depicted in the *castas* painting of the viceregal period. These ceramic pieces epitomize the strangeness that circumscribed the American racial mixtures represented and classified in *castas* painting. Those pictures portray the features of that strangeness: landscapes, exotic fabrics and

❧ ALBERTO RUY-SÁNCHEZ

plants come together and are named. Tonalá pottery, nameless but just as exotic, appears in the background of some of these paintings. It is also a product of a "strange" mixture—as Europeans saw it—of ceramic techniques from both continents. ❧

In this sense, there are those who have argued that Tonalá ceramic ware is the quintessential Mestizo art, whereas Talavera ceramic ware from Puebla is a Criollo (or European-style) art. In the making of Talavera ceramics (a glazed earthenware which is fired twice), artisans use techniques that were unknown in Mexico before the arrival of the Spaniards. In the making of Tonalá pottery (a polished or burnished earthenware which is only fired once), artisans use a technique passed down from their pre-Hispanic ancestors. The drawings on the pots are also very different, in that those on Tonalá pottery are clearly folk art and seemingly more haphazard. Earthenware objects from Tonalá and Puebla are, by their very nature, images of that Otherness portrayed in castas painting. Both are products of a combination of very different traditions in pottery; it is for this reason that they epitomize what the historian Margarita de Orellana has called—as Lezama Lima did before her—"the fever of the imago in castas painting." In this respect, we might suggest that craft objects and their modes of representation are the concrete, imaginative expression of a social group. Just as pottery from Tonalá attracts our senses, so it sparks the imagination in different ways. ❧

The sense of taste in Tonalá pieces refers not only to the flavor of the water they contain. For a long time, Tonalá pottery has been eaten by those convinced of the healing powers of the clay, which is the reason that even shards are saved and sold. ❧

The imagination is kindled by yet another aspect of this ceramic tradition: the fact that even its manufacturing process is a detailed ritual with strong echoes of alchemy. The precise mixture of different kinds of earth is an essential part of the recipe. The aging of the clay is another. And artisans must be initiated in the difficult art of handling fire, of knowing how to "read" the color and size of the flame. All this among other special requirements make Tonalá ceramics a magical art. ❧ Translated by Charlotte Broad. ❧

Opposite page
Bottle.
Modeled clay, with
polychrome designs
over a slip.
Tonalá, Jalisco.
Nineteenth century.

Pages 118–119
Bowls.
Modeled ceramics
with traces of
polychromy.
Jalisco region.

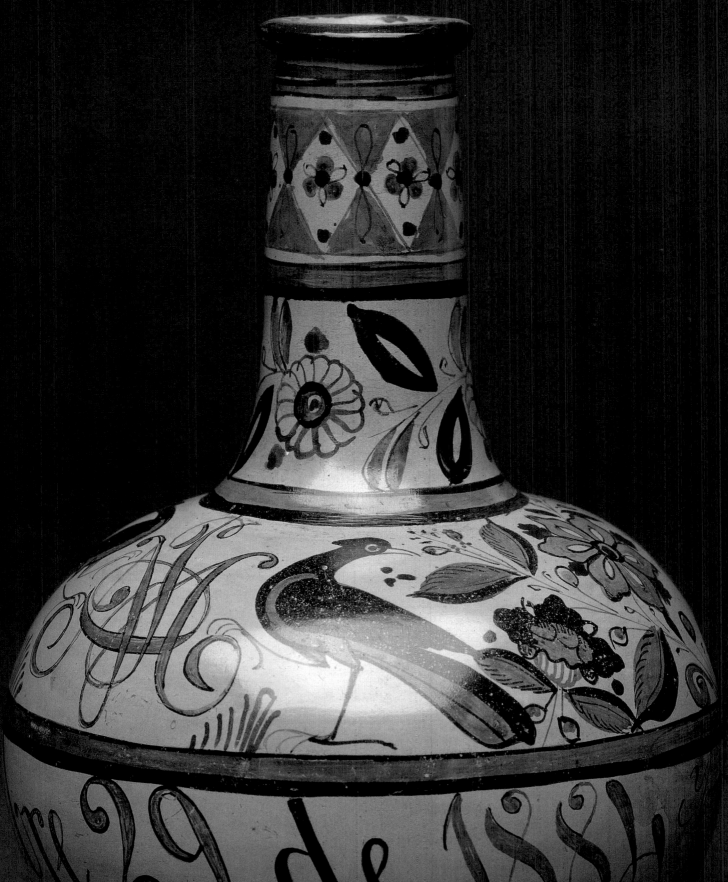

EARTHENWARE OF WATER AND OF FIRE ≫

≫ *Gutierre Aceves Piña*

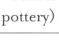

T ONALÁ HAS MADE POTTERY ITS MOST CHARACTERISTIC SYMBOL. In the late nineteenth century, the priest Jaime Anesagasti y Llamas referred to this village in his *Brevísimas notas de la historia antigua y moderna de Tonalá* (Brief Notes on Tonalá's Ancient and Modern History) as the "port for earthenware," to which "muleteers from faraway places" would come to buy ceramics. This eloquent statement indicates the great demand there was for Tonaltec pieces during the nineteenth century. However, this earthenware has been held in high esteem for a very long time, as travelers and historians from the seventeenth century onward have testified. It has come to the forefront during our century thanks to studies by Dr. Atl, Roberto Montenegro, José Guadalupe Zuno, Ixca Farías and Isabel Marín de Paalen, among others. Moreover, it has won renown at home and abroad for its variety, utilitarian features, decorative appeal and the high quality of its manufacture. ❖

Tonalá pottery is generally known in Mexico as "Guadalajara earthenware," since, as Dr. Atl put it, "ceramic styles take the name of the major city nearest to where it is made." This geographic designation is personalized in the case of Tonalá, however, since as Marín de Paalen writes in her book *Alfarería: Tonalá* (Pottery: Tonalá), published in 1960, "each potter is a specialist in one kind of earthenware and that is how he gains recognition among the inhabitants of the village. When recommending a particular artisan, they say, 'where the Basultos make earthenware of water,' 'where the Campechanos make basins,' 'where Emiliano Melchor makes pigs,' 'the Solís family that makes aromatic pottery,' or 'the Sésates with their *pintada en corriente* (painted pottery) and *petatillo* (basket weave pottery).'"

Urn. Modeled polychrome ceramic with burnished red slip. Tonalá, Jalisco.

Opposite page Clay gourd-shaped jug with "cinnamon" finish. Modeled ceramics with ivory slip. Early twentieth century. 13 ³/₄ x 8 in. Montenegro Collection, Instituto Nacional de Bellas Artes.

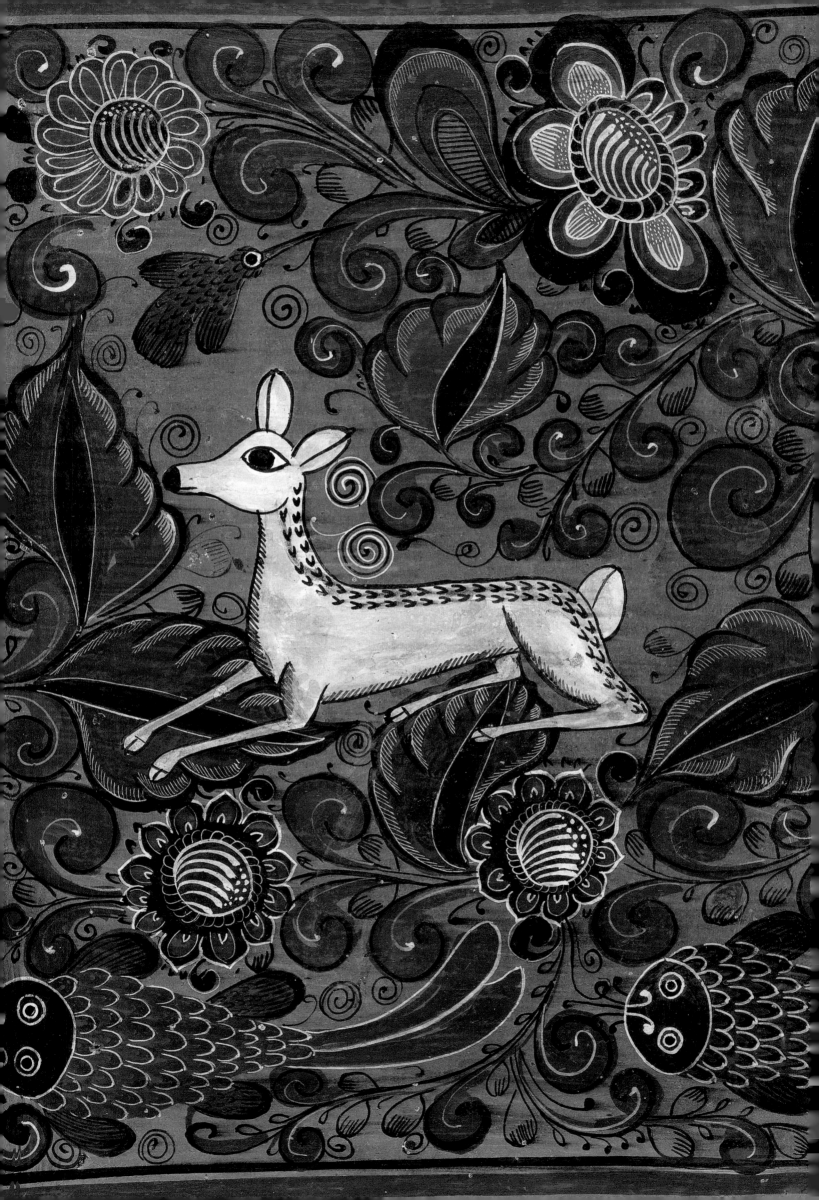

Both artisans and specialists in Tonalá pottery make a distinction between "earthenware of water" (*loza de agua*) and "earthenware of fire" (*loza de fuego*) based on differences in function and decoration. They are easily distinguishable by their finish: the former is made of burnished or greased clay, fired once, and the latter is bathed in *greta*, or glaze, and fired twice. As its name suggests, "earthenware of water" is for holding liquids. Burnished ware is the oldest variation of this type of pottery: a pre-Hispanic tradition, it is also known as "aromatic" (*de olor*) or "pitcher" (*de jarro*) earthenware. ✵

This is not only the most ancient but also the most famous style of Tonalá pottery, for its decorations and splendid polish—achieved by rubbing the surface with a piece of pyrite—and also for the flavor, fragrance and freshness it lends to the liquids it contains, and because of the fact that ingesting small quantities of it is said to have a curative effect. For this purpose, potters still make miniatures, which they try not to allow to harden too much when firing so they will "taste better." Pregnant women have a particular craving for fired clay. The potter Marcela Álvarez told us that when she was pregnant, she craved it so much that she would even get up in the middle of the night to look for some. Small bags of earthenware that had cracked on the way to the market at San Juan de los Lagos were even sold for this purpose. ✵

Though its existence was short-lived, a type of earthenware similar to the burnished ware in terms of its forms (jars, cups, bottles and so forth) was the "opaque" style with its two variants: flowered (*floreada*) and Aztec (*azteca*). These terms refer to the decorative motifs used: plants in the first case, and in the second, geometric frets introduced by the Murillo family in the early twentieth century. Since neither style is burnished, the pots acquire a matte finish after firing. ✵

"Flag" (*bandera*) and "cinnamon" (*canelo*) pottery are also considered earthenware of water. Their names indicate the colors used in decoration. They have been likened to burnished pottery as both have a similar finish, but the luster is obtained in this case by rubbing animal grease on the surface with a cloth before firing. This type of pottery is known as "greased" ware (*encebada*) to differentiate it from burnished ware. Juan Pila is one of the specialists with the most experience in "flag" and "cinnamon" pottery, and prides himself on obtaining an opulent gloss without the use of grease, by bathing them twice in a red slip made from red clay

✵ GUTIERRE ACEVES PIÑA

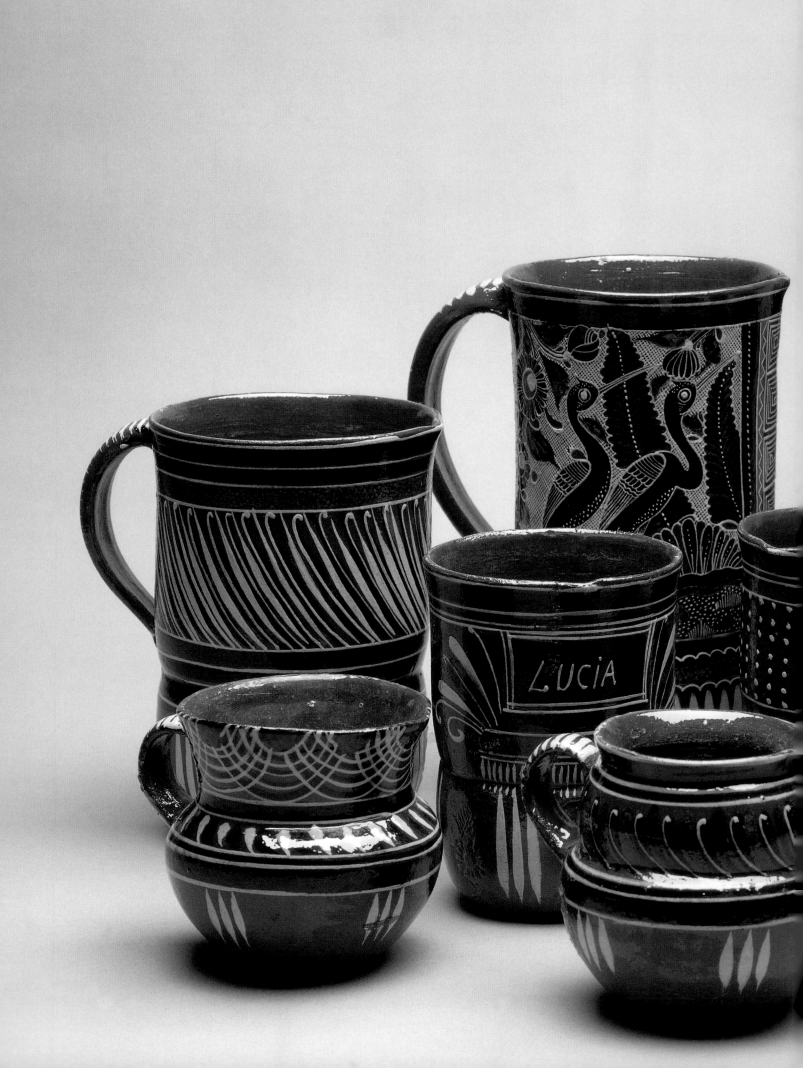

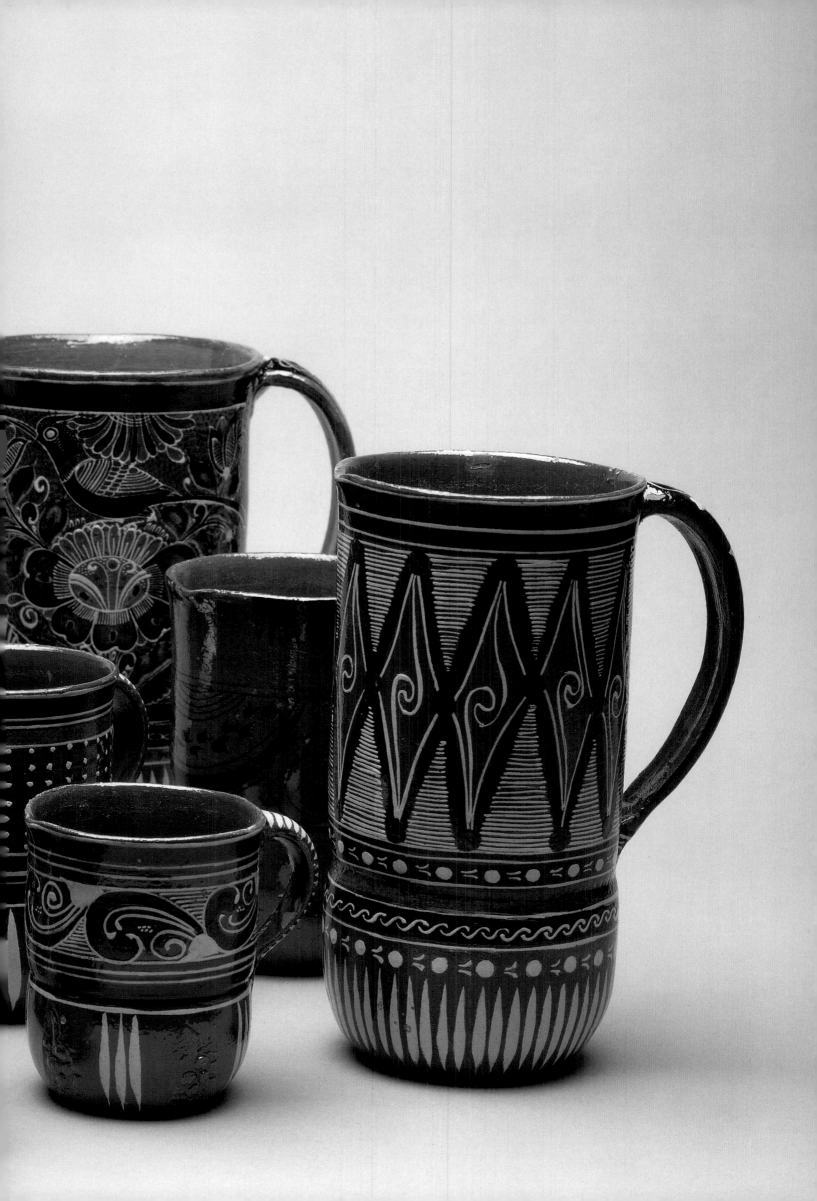

rich in iron oxide. The success of its preparation depends on the water used. Rainwater or spring water from Cerro de la Reina is preferred, because if tap water is used, the piece has to be greased. In the past, only a few potters, such as Zacarías Jimón—one of the "great decorators of vessels," in Dr. Atl's words—burnished this type of earthenware, a technique rarely seen today. ❖

The different kinds of jars and narrow-necked vases with plates typical of the "flag" style are decorated in white, with flower and animal motifs and names inscribed on them. Delicate patterns in green aniline are added after firing, completing the color scheme of the Mexican flag. ❖

The vessels and narrow-necked vases from El Rosario—known as "cinnamon pottery"—have the peculiarity of being decorated in sepia tones derived strictly from local clays. This rich color is obtained by painting and shading in a process similar to that used in the decoration of burnished pots. Artisans paint plant motifs over an ivory-colored slip (*matiz* or "shade"), and then proceed to paint over this with a thinner coat of the same slip (known locally as *azul* or "blue") which dulls the tone of the original colors. Subsequently, they outline and repaint the parts of the motifs they want to highlight. ❖

As with "flag" ware, the lustre on this pottery is produced by using animal grease, but it can also be achieved by burnishing with a piece of pyrite, like the "cinnamon" pottery made by the family of Nicasio Pajarito. Despite the great skill involved in producing these pieces, they are sold for a very low price ❖

Another type of ceramics that has fallen into disuse but was popular during the nineteenth and early twentieth centuries is the so-called *betus* style. It was used for making piggybanks and all types of water receptacles, including pitchers and large bottles, which were painted with different motifs including landscapes, animals and the Mexican flag's emblem with the eagle and snake. "They were painted using powdered pigments mixed with mezquite gum, which produces the most vivid colors. For example, the colors of the Mexican flag are undiminished," states Farías. The sharpness of the colors is owed to the fact that the paint is applied after the piece is fired, following which "a layer of

This page and opposite Casserole dishes. Modeled clay with red slip and glaze. Tonalá, Jalisco. 1991. Private collection.

betus varnish is applied, generally with the fingers. In other cases, aniline pigments are added to the mezquite gum, producing a transparency that is easier on the eye," adds Farías. ❧

Closely related to this style is the so-called "golden" or "yellow ware" (*loza dorada* or *amarilla*), no longer being produced today. Only a few samples of this type—made by Epifanio Maestro and his family—are still conserved. The golden color was achieved by applying berry juice, likely varnished with *betus* afterward. ❧

The burnishing technique was inherited from pre-Hispanic times, but the use of lead oxide to achieve the glossy finish was not. Glazing and the cylindrical kiln were Spanish additions to Mexican pottery techniques. The great variety in Tonalá pottery is due to the coexistence of these two ceramic techniques. ❧

As part of the glazing process, the pieces must be fired twice. After painting, they are cooked at a low temperature in preparation for partial or total glazing. The glaze melts when exposed to intense heat, giving the pieces their characteristic honey color and shine, while waterproofing them at the same time. The use of this technique permitted the fabrication of new kinds of ceramic objects that complied with the Spaniards' or Criollos' need to store alcohol or oils for cooking or industrial use. ❧

Glazed pottery is "earthenware of fire." It has been classified into three different genres, known as "cooking" (*de lumbre*), "ivory" (*matiz*) and "basket weave" (*petatillo*)—names that describe its intricate designs (always applied over a red slip) or the different purposes it serves. The "cooking" kind can be put directly on the stove to cook food, as the vessels only have painted designs around the edges. Free of lavish decoration, these clay pots and pans are known for their formal purity. ❧

The "ivory" kind is used for making tableware. As Isabel Marín de Paalen wrote, "plant and animal motifs and, typical of this style, national heroes and soldiers of the Independence struggle or the Revolution and heraldic eagles" are painted on it in white kaolin (known as *matiz* or ivory clay). ❧

The "basket weave" style is a somewhat more exclusive kind of earthenware. Tea and coffee sets, vases and complete dinner services are made in this style and lavishly decorated with "animals, flowers, plants, and in the background, a very fine grid of straight diagonal lines which gives this style its name."

127

According to Marín de Paalen, this style was invented by "Balbino Lucano and Magdaleno Coldívar, [...] those inspired and patient potters [in the late-nineteenth century] who, dissatisfied with merely decorating the 'ivory' earthenware with landscape motifs, decided to fill in the space between the images." ❧

A variation of the basket weave style, the "grained" or *granillada* stylehas hi ghlighted coloring and a pattern of dots instead of the grid of crisscrossing lines. Javier Ramos Lucano is a master in this style: he was inspired by his teacher Pedro Chávez, who in life was an outstanding decorator in the basket weave style. ❧

One object worthy of particular mention within the context of glazed pottery is the cup or mug, which in Dr. Atl's opinion, is the archetype of Mexican ceramics. Considered to be of low grade, they are the most inexpensive pieces. They are no longer modeled, their characteristic "waist" being made with wire when removing them from the mold. There are very simple ones in green and brown, while others are visually stunning, painted with teardrop, snake, spur, chain, spiral hook and macaroon motifs. ❧

The cups may be named for what they are designed to contain, for their size or for their shape: soup, stumpy, can, half-can, punch, tequila, monk's and chocolate cups, for instance. ❧

The "carved" cups are especially attractive given that besides their painted motifs, some are marked on the base using seals while the clay is still fresh. Those bearing common first names have always been popular souvenirs. ❧

In the 1960s, stoneware became another featured item in Tonalá pottery shops. Jorge Wilmot, the pioneer in this practice, succeeded in creating an innovative combination of Eastern and Tonaltec ceramic techniques. Wilmot's main concern was to revitalize the flagging interest in producing local burnished earthenware, and thus he enhanced its imagery with the bestiary so popular today: lions, cats, quails, turtles, pigeons and so forth. Subsequently, he devoted his time to trying to incorporate Chinese techniques into this popular Mexican earthenware tradition. His effort led to a vast and varied production of exquisite pieces. ❧

The enormous variety in Tonalá's pottery is thus the product of diverse traditions. Nevertheless, at the moment of its fabrication, artisans continue to focus on creating earthenware whose utility and beauty have carved out a niche in everyday life. ❧ TRANSLATED BY CHARLOTTE BROAD. ❧

THE WORLD OF TALAVERA

Alberto Ruy-Sánchez

Art is an escape from chaos…

it is the indetermination of matter seeking the rhythm of life.

HERBERT READ

TALAVERA IS A TERM SHROUDED IN MYSTERY, JUST AS IT REMAINS AN enigma why humans persist in extracting objects from the earth and painting them: varied objects that clink like muffled bells when struck together, and allure us with their beauty. ❖

The ceramic ware known as Talavera de Puebla is no doubt one of Mexico's most important traditional art forms. Historically, the art of Talavera is linked to certain spaces: the kitchen, the church and convent, the façade and interior of the home, as well as the workshop, where the age-old rituals of the craft are still performed. Like sculpture, this art is spatial; but it also possesses an internal space: that of the imagery represented on its surfaces. These spaces make up a world where reality and fantasy communicate; where hands that make and buy and sell are joined with hands that paint the shape of the artisan's dreams on a pitcher, or with hands possessively infatuated with a bowl. This is the world of Talavera: a world within our own world. ❖

One of the original natural settings for Talavera was the typical kitchen of the city of Puebla. The tiles covering the walls—and sometimes even the ceiling—and the platters of food ready for the table combine to form a "culinary architecture" where the interior space of the kitchen becomes a full-scale reflection of Puebla's typical dishes—richly flavored, colorful and unique. The tiled kitchen and glazed white ceramic dinnerware are a sort of echo chamber where the food is enhanced by the visual condiment of Talavera. Talavera is thus a pleasure for the eyes, added to the one afforded by the meal. And like food, it is a pleasure to be shared. ❖

A very different kind of kitchen—the traditional pharmacy—was literally lined with Talavera containers that were not only practical but often very striking. They were waterproof on the inside and were often inscribed—before firing—with the name of the herb or substance they would contain. Or, if the jars had been made on

Talavera tile.
Tin-glazed
polychrome
ceramic.
Franz Mayer
Museum.

Opposite page
Talavera pitcher.
Puebla.
Mid-nineteenth
century.
13 ½ in. high.
Franz Mayer
Museum.

Pages 130–131
Detail of Talavera
basin.
Tin-glazed ceramic
painted with lead
blue.

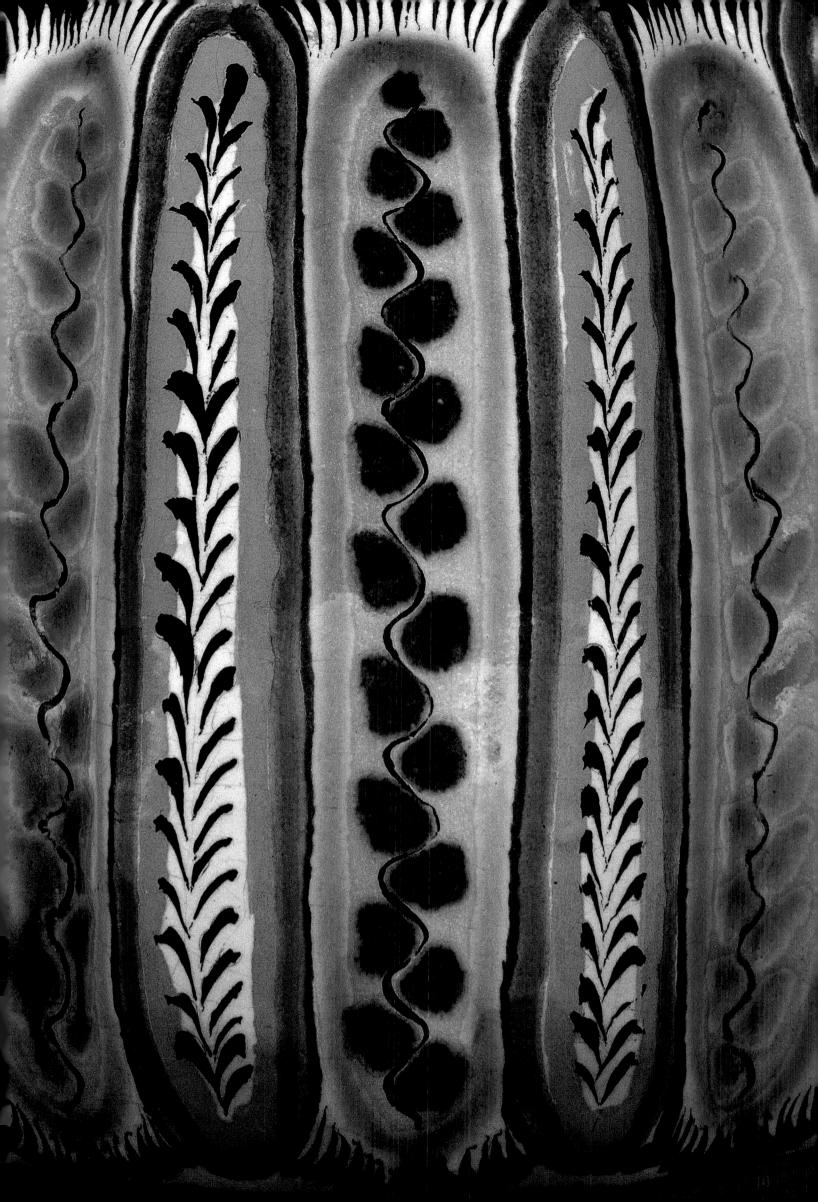

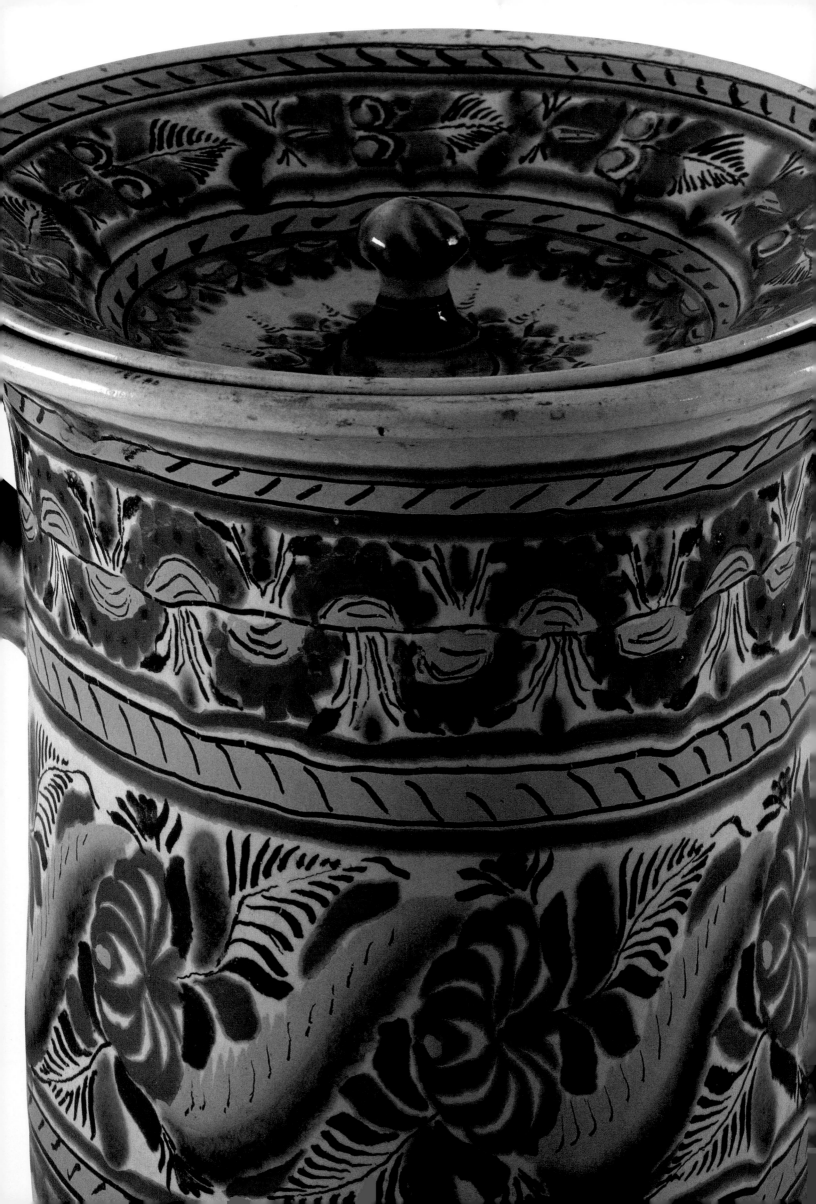

commission for a particular convent's pharmacy, they would feature the emblem of that religious order. ❖

Indeed, churches and convents were also natural settings for Talavera. Both housed an incredible variety of objects like the basin that was used for both the ceremony of baptism and the banal, day-to-day washing of hands or feet. A community's sacred as well as profane gestures employed the Talavera of churches and convents. Though modest, this glazed earthenware provided a sort of vivid centerpiece for the communal life of the cloister. Outside, church façades were tiled with Talavera in an attempt to reflect the wealth of gold covering their altars. These façades truly project the splendor of Talavera. ❖

In the city, homes were decorated with Talavera in much the same way that their owners might wear their finest clothes. It not only showed off the wealth of each house, but also the owners' modesty or eccentricity. Though a building's Talavera exterior might have resembled its inhabitants' clothing, the pieces inside were usually a manifestation of the collector's spirit: whether a bowl beside a painting, a basin beneath the portrait of an ancestor, giant vases among books or pitchers inevitably filled with flowers. All these unveil certain hidden associations, fixations and obsessive relationships to particular objects and forms—a network of meanings that usually only the collector himself can decode. ❖

Without a doubt, Talavera attests to Mexico's cultural and ethnic diversity, given that every blue-and-white bowl made in the potters' workshops of Puebla subtly combines Arab, Spanish and Mexican elements in its techniques and forms, offering silent testimony to a heritage expressed through sight and touch. ❖

TRANSLATED BY JOHN PAGE. ❖

❖ ALBERTO RUY-SÁNCHEZ

TALAVERA: ITS NAME AND MANUFACTURE ≈
≈ *Luz de Lourdes Velázquez Thierry*

Eighteenth-century chronicler Mariano Fernández de Echeverría y Veytia described the different types of ceramics produced in the city of Puebla, indicating that Talavera was the finest. "The workshops producing the white earthenware called Talavera that can be found within the city limits are even more distinguished. With white clay, they make all kinds of pieces that are so polished and original, so finely glazed and painted that they are just as good as any imported from Europe, of which they are perfect copies." ❖

Today, tin-glazed pottery from Puebla is still referred to as Talavera, though no one seems to agree about the origin of this term. Some writers claim it was given this name in honor of those potters from Talavera de la Reina in Toledo, Spain, who introduced the technique in Puebla. Resorting to oral tradition, some scholars have affirmed that Dominican friars in Puebla did not find indigenous pottery satisfactory for tiling their monastery, and asked the branch of their order in Talavera de la Reina to send members who could teach local potters the art of tin-glazed ceramics. There are no documents, however, to support this belief. The common opinion is that Talavera was given its name simply because it imitates the style produced in Talavera de la Reina. ❖

The most recent theory is that the term was first used in 1682 when clauses were added to the Ordinances laid down by the potter's guild in Puebla. One of the clauses stated that, "fine pottery should imitate earthenware from Talavera," which is to say that "the objects should be so similar that only with great difficulty can one tell the original apart from the copy." Other scholars claim, however, that none of these theories or legends proves why pottery from *Puebla* is called *Talavera*, and have consequently insisted on the term majolica or white earthenware. ❖

Majolica was the Italian name given to glazed pottery from Majorca, and soon came to designate all ceramics fabricated using the same

Opposite page Basin with scene of women playing music and hunting. Tin-glazed ceramic painted with lead blue. Mid-seventeenth century. Diameter 25 $\frac{1}{4}$ in. Bello Museum. The bottom bears the initials "CS" of the renowned ceramicist Diego Salvador Carreto, who helped draft the 1653 Ordinances of the Potters' Guild.

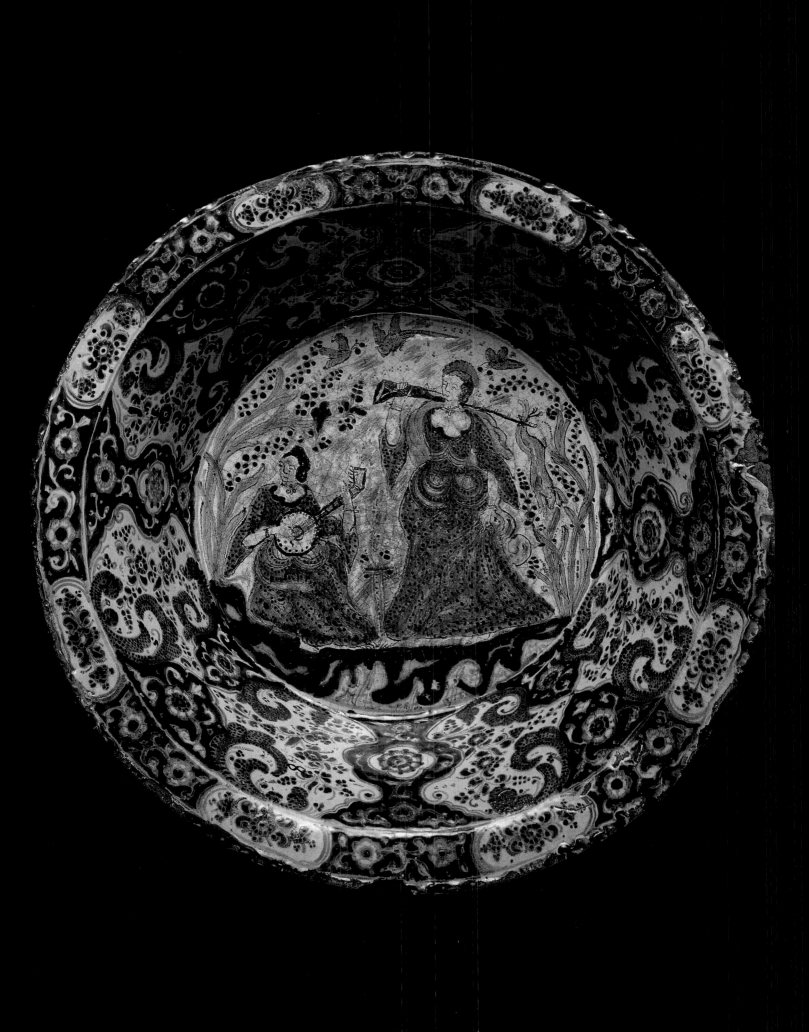

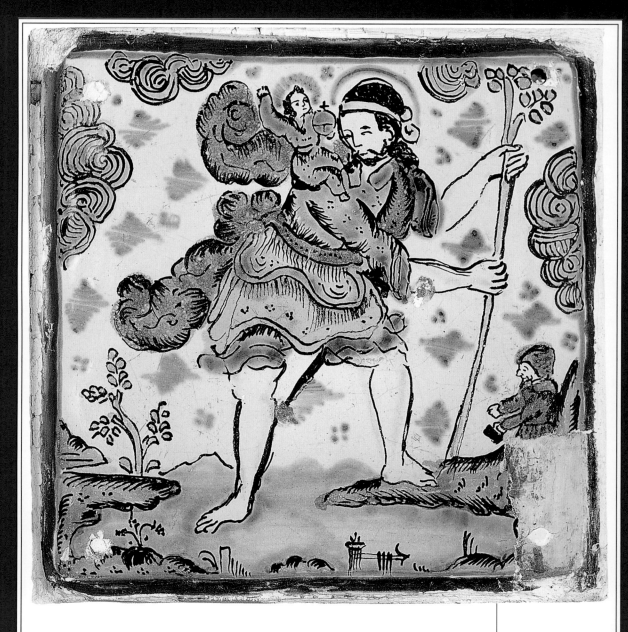

technique. Though the term Talavera is no longer used in Spain, it is still very much alive in Mexico, especially in Puebla where potters continue to use essentially the same methods as their ancestors. ❧ Indeed, the techniques involved in the making of Talavera have hardly changed at all since colonial times. Potters used two kinds of clay: a black variety extracted from deposits on the hills of Loreto and Guadalupe, and a pink clay which was found near Totimehuacan. Once the clays had been sifted to rid them of all impurities—such as plant matter and pebbles—they were mixed and then left in water tanks "to rot." The plasticity and quality of the clay improved the longer they were left in the tanks. ❧ Before the potter could work the clay, he had to remove all excess water. He then placed it on a brick floor in a covered area where he treaded on it barefoot to achieve an even consistency. ❧

This page and opposite Talavera tiles. Polychrome ceramic. Franz Mayer Museum.

This process, called wedging, was finished off by hand, and the clay was then divided into lumps of different sizes: the bigger ones were called *tallos* (stalks) and the smaller ones *balas* (bullets). The potter worked the smaller lumps on the wheel to create various objects, and used molds for making tiles. Once the pieces were completed, they were left in a closed room for a long period to make sure they dried evenly. They were then fired in a wood-fueled kiln. ❧

After this firing—which lasted from ten to twelve hours—each piece was examined carefully for imperfections or uneven firing. They were then covered with a white glaze—with a tin and lead base—which gave the enamel finish to each piece. According to seventeenth-century Ordinances, the proportion of glaze to be used was one *arroba* (twenty-five pounds) of lead to six *arrobas* of tin for fine ceramics, and one *arroba* of lead to two of tin for ordinary white earthenware. ❧

Once the glaze had dried, the pieces were decorated with different designs. The Ordinances also defined the range of colors to be used, which varied depending on the quality of the ceramics. Potters prepared paints from various mineral pigments. ❧

Pieces were then ready for the last firing which took up to forty hours. The colonial potter was all too aware that any number of pieces might be lost during this firing, so he would say a prayer as he lit the kiln and another as he stoked it with logs for the last time. ❧

TRANSLATED BY CHARLOTTE BROAD. ❧

TRADITION AND FANTASY MOLDED IN CLAY ꩜

꩜ *Luis Mario Schneider*

Noble and valiant trade, first among the rest,
for in the crafting of clay, God was the first potter
and man his first vessel.

FOLK VERSE

ᴵ IT IS IMPOSSIBLE TO DETERMINE EXACTLY WHEN THE CERAMICS OF
Metepec—one of the four or five Mexican towns known for
their beautiful and original pottery—began to burgeon. Without
venturing precise dates, one could say that it was in the 1950s that
we saw the transformation of a strictly "pots-and-pans" town into a
versatile and artistically creative community. ❖
In his important study *Metepec, miseria y grandeza del barro* (Metepec:
Humbleness and Grandeur in Clay), Antonio Huitrón delved
into the development of this pottery from its earliest days to the
1960s. He reports that this potters' community extracts its clay from
neighboring villages such as Ocotitlán, San Felipe Tlamimilolpan
and Tlacotepec. While this activity was once carried out with
donkeys and carts, motorized vehicles have since replaced them.
Two kinds of clay are to be obtained from the mines: red clay which
is hard and fine, and yellow clay which has a sandy texture. Huitrón
explains in detail the mixing technique and the equipment and
tools of the trade: grinding stone, sieve, stone slab, wheel, molds,
mallet, scraper, polisher, cutter, stamps or engravers, brushes, the
kiln, fuels and aniline paints. The manufacturing process is also
described: the preparation, grinding, kneading and molding of the
clay, and the drying, decorating, firing, glazing and cooling of the
finished piece. ❖
According to Huitrón, artisanal pottery in Metepec is a family
trade, an occupation that is handed down from generation to
generation. The potters are usually men, and the trade is generally
passed on from father to son. However, women are not excluded
from this activity. The heavy demand for pottery has led to a
marketing structure which emerged from the family production
system, though owners will often employ salaried craftsmen in their
workshops. As "middlemen," these businesses represent a break

Opposite page
Early example of a
Tree of Life.
Clay painted with
aniline.
Metepec, State of
Mexico. ca. 1940.
Ruth D. Lechuga
Folk Art Museum.

Pages 140–141
Mermaid painted
with aniline.
Metepec, State of
Mexico. ca. 1950.
9 1/2 x 8 1/2 x 4 3/4 in.
Ruth D. Lechuga
Folk Art Museum.

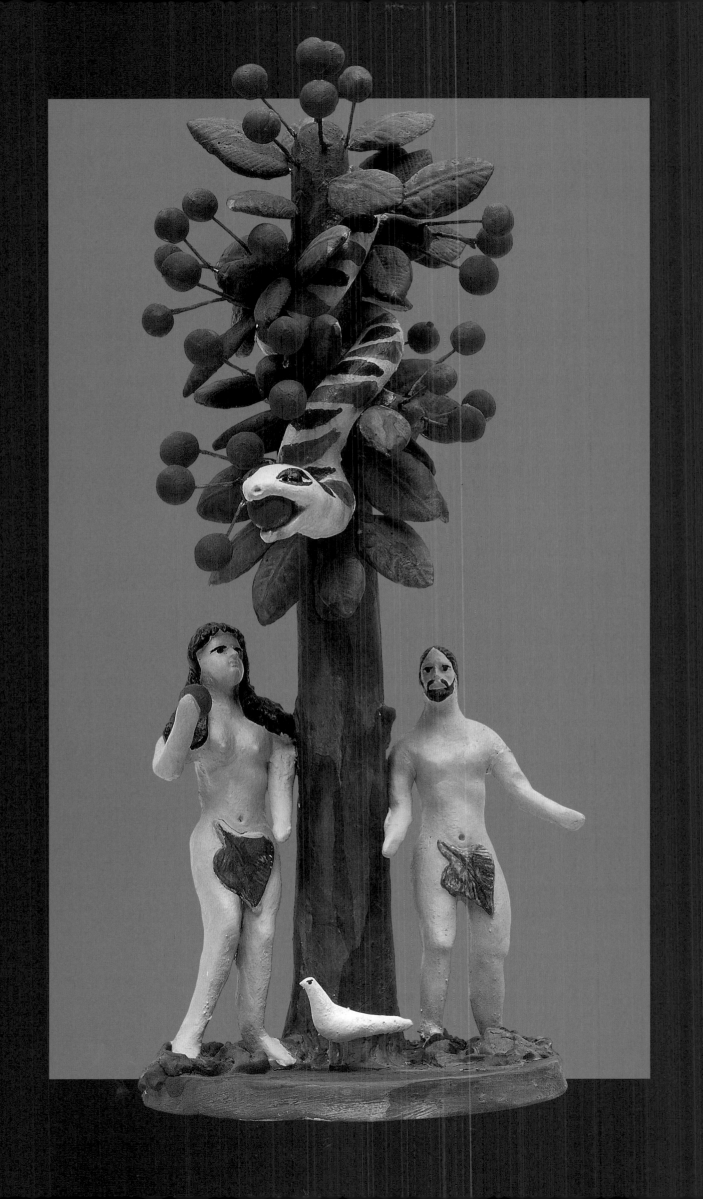

with the long-standing tradition of personal dealings between artisan and buyer. ❖

These facts were confirmed through conversations with several local artisans who furthermore confided the tricks of the trade that come with years of experience. They mentioned, for example, that to simplify the kneading of the clay, they first spread it on the highway outside their workshops to be flattened by the tires of passing vehicles. The wide range of today's synthetic pigments has also helped facilitate their work. ❖

Curiously enough, within the immense range of designs and ornamentation, each family has its own specialty. There are craftsmen who concentrate on a certain type of crockery, others manufacture only pots, while the rest produce *juguetería* ("toys"), a name the townspeople use for all sorts of ritual, decorative or artistic sculptures.

Of these, crockery is produced on the most commercial scale, monopolizing sales at traditional markets. Prevalent among items of classic design are vessels of all shapes and sizes: pulque jugs, dishes and platters in a variety of sizes, cups and pitchers, the indispensable and time-honored chocolate kettle, large bottles or demijohns, trays and even fancy turkey-roasters. ❖

According to the prevalent division of labor, Lázaro León Hernández's specialty is the production of pulque pitchers. Like his father before him, this seventy-two-year-old artisan has been working since he was eight. Throughout his many years of experience he has polished his craft and given his work a very personal touch. His pulque jugs come to life in the many different variations he makes of them. Most have spouts in the shape of different animal heads (horses, bulls, elephants and rabbits) or even traditional Mexican cowboy and cowgirl figures, depicted with their distinctive sombreros. Attached to the body of the jug as a handy afterthought are anywhere from two to five plainer cups (depending on the jug's size) hanging from the same number of hooks, meant for drinking the jug's contents. Jug capacities range from a pint to almost five gallons. ❖

They are nearly always glazed bright yellow, black and green. They also feature a subtle bird, flower and leaf decoration that does not

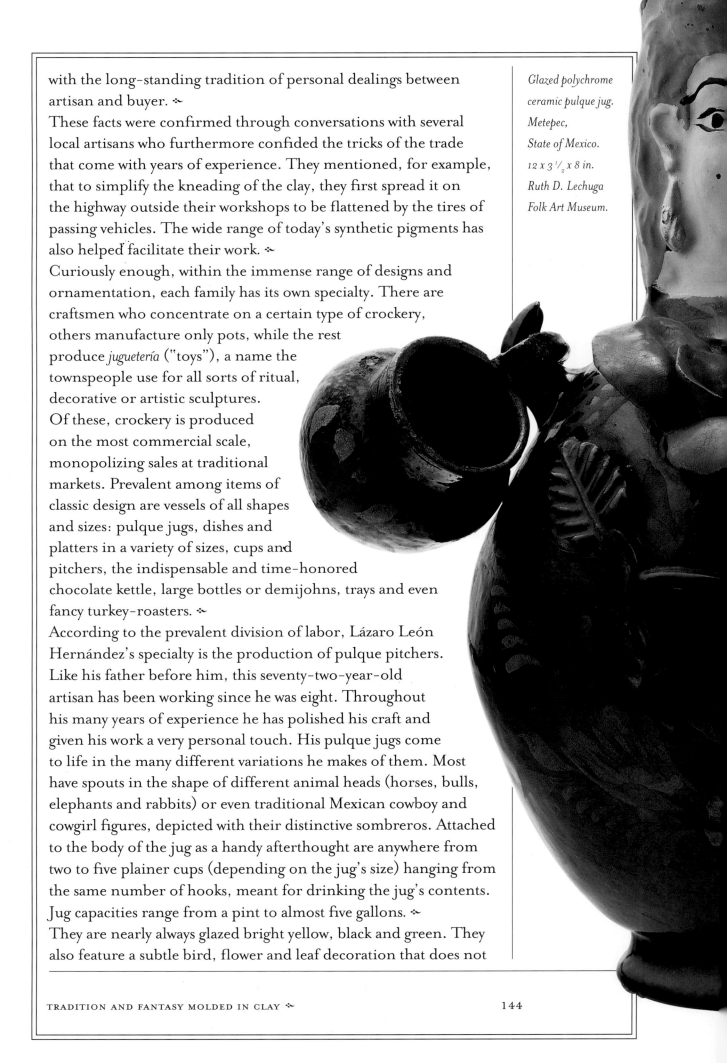

Glazed polychrome ceramic pulque jug. Metepec, State of Mexico. 12 x 3 1/2 x 8 in. Ruth D. Lechuga Folk Art Museum.

distract the viewer's interest from the main motif, leaving enough room for an inscription. Lázaro León has a sizeable repertoire of inscriptions: "Souvenir of Metepec for my mistress" or "Souvenir of Metepec for my *compadre*," for instance. At the customer's request he may add a verse or two: "Souvenir of Metepec/ with its little hill on the side/ I'll never forget its pulque/ or its crispy, hot pork rind." Another descriptive rhyme reads, "Liquor of green plants/ you would have me fall/ you are my doom/ you'd surely have me crawl." In 1993, the style, quality and excellence of León's work was rewarded with the Metepec Prize in the Folk Art category. ✢

Metepec offers a universe of pots in every shape and size—even the monumental specimens to be found in young Celso Camacho Quiroz's studio. His grandparents taught him a manufacturing process that begins with a large clay "tortilla" base from which a meticulously woven coil is built up. The piece is crowned with two or four handles bearing a so-called "Chinese" motif. The result is a glazed pot standing more than five feet tall, which in the words of its maker, would be equally adequate as a bathtub as for cooking chicken in *mole* sauce. ✢

Gardening supplies are another utilitarian line in great demand, with flowerpots in an endless variety of styles and sizes. Enrique Mejía Noriega, who has been making them since the early 1950s, rattles off a litany of shapes and models: cones, cylinders, planters with undertrays, rectangular or square jardinières, tubs, pots with iron rings, tripod pots, fretted pots, hanging pots, pots with flat backs for fixing against a wall, "basket weave" pots, and many others. The garden category also includes three-tiered fountains that feature flocks of doves perched decoratively around the sides of their bowls. The fountains are generally unpainted and can also reach monumental dimensions. For example, the ones manufactured by Felipe Ramírez Carrillo and Trinidad Nava Jiménez exceed five feet in height, with the diameter of the lower bowl measuring seven and a half feet. ✢

In the domestic category, we find the work of Andrea Estévez who has designed sets of dinnerware since the early 1950s. One of her

designs features 120 pieces for twelve place settings. The customer has ten different designs to choose from: Easter flower, Star, Chrysanthemum, Birds, Four-Leaf, Aztec Calendar, Corncobs, Deer and Roosters. Andrea Estévez has won numerous prizes for her creative work. ✣

Metepec has acquired great fame for its artistic pottery—a rare combination of interpretation and imagination, decoration and religious symbolism. There are infinite forms and colors in this place where syncretism shares space with a realism that mingles with the world of dreams. Foreign elements of different origins have come to Metepec and been assimilated, transformed into something truly original through the artisans' creativity and inspiration. ✣

Metepec's Trees of Life (*árboles de la vida*) range from the miniature to the enormous, and are renowned the world over. Their symbolism is open to many interpretations, but conveys the harmonious coexistence of biblical imagery with native flora and fauna. ✣

Trees have had some kind of symbolic significance in virtually every time and place, from legendary Asia to modern Western civilizations. Trees form part of myth, a cosmology in which they represent verticality, fertility and abundance. In Christianity, the tree has always symbolized a Paradise on Earth, the Garden of Eden where humanity was created and consummated its union in accordance with the divine scheme of the forbidden fruit. ✣

The Tree of Life in Metepec is a narrative sculpture of ingenuous fabrication. It is often made in three levels, always arranged from greater to lesser, top to bottom. In its most classic manifestation, the figure of God the Father appears on the first level, in the tree's crown. In the middle, the story of Genesis is presented with Eve on the left, Adam on the right, and the serpent coiled around the tree with the apple or simply tempting the woman. In the third, at ground level, the couple appears fleeing the earthly abyss. The entire tree is a frenzied baroque depiction of a Garden of Eden abounding in leaves, flowers, fruits, animals and stars. ✣

There are artisans who include other details. Some portray humanity's creation, with God the Father accompanied by two angels, each bearing trays with clay and tools

Lázaro León Hernández. Donkey-shaped pulque jug with spout. Glazed and painted clay. Metepec, State of Mexico. 1994. 12 ³/₄ x 9 x 7 in. Ruth D. Lechuga Folk Art Museum.

for the Creator to model man in his image. In each of these representations of salvation and condemnation, Saint Michael the Archangel plays an important role, which is why he is placed amid the central foliage in many trees. The coloring depends on the style of each individual workshop; some trees are extremely colorful, while others are more sober, left unpainted to expose the terra-cotta color of natural clay. ❧

In Metepec, the Tree of Life represents an intimate symbiosis because it refers to the biblical myth of Adam and Eve's banishment as well as to the earth's fertility. To the pre-Hispanic mind, this meant dying to be reborn, like the earth in its passage from winter to spring. ❧

The Tree of Life corresponds to the Tree of Death, an obligatory analogy in a country such as Mexico, where death becomes a celebration of offerings, though without losing the sense of tragedy and grief. It is a strange attitude in which irony, humor and mockery act as a sort of exorcism, an intimate revenge which Mexicans exact through this tree. In plainer versions, the figure of God the Father is a habitual presence, while a large skull is prominently placed on a lower level, surrounded by small skeletons involved in everyday activities. ❧

The ornamental exuberance and intricacy evident in the Tree of Life reach a paroxysm in the Noah's Ark tree, which has the ultimate intention of creating a joyous hymn to life. Between the ancient ship and the figure of the Eternal Father there abound miniature animals—both real and imaginary—and human figures, not to mention a cascade of flowers and fruits, cosmic elements, angels and cherubim. This grand array does not dissimulate the horror of the abyss but rather depicts salvation from the Great Flood in hallucinatory excess. ❧

Other popular compositions in Metepec consist of suns, moons and eclipses. The sun king is a decorative piece that irradiates the joy of existence and may be glazed, painted or natural clay. There are singing suns, suns with mustaches, smiling suns… all clear examples of the artisans' creative ability. The moon receives similar treatment. Whether full, waxing or waning, she is always coquettish, adorned with flowers and red lips that always seem to express her love for the sun. Although the sun and moon are sometimes depicted united in an eclipse, the female personification is always dominant. ❧

❧ LUIS MARIO SCHNEIDER

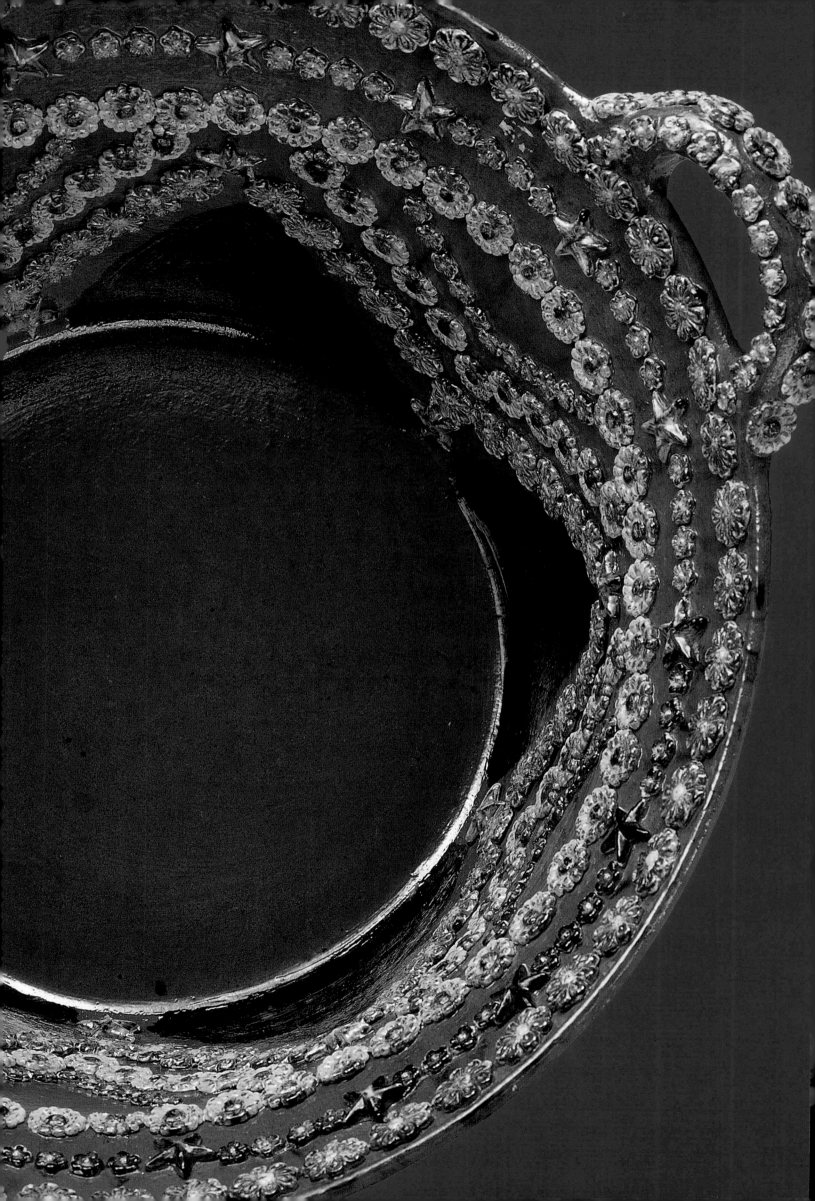

The artisans of Metepec have fallen under the spell of many different beings. These figures may be painted or plain, standing alone or forming part of a larger piece, wearing crowns or flowers and palm fronds. But they are inevitably shown facing forward, with a dreamy look in their eyes, displaying their ecstatic opulence within a naïve setting. ❖

Up to this point we have described what might be called classic Metepec pottery. But the interaction of traditions from different regions of the country is also felt in Metepec. Take Manuel León Montes de Oca, for example: known for his reproductions of erotic figurines from ancient Mexico, his fondness for the Mexican past has led him to imitate the ceramics of western Mexico, Colima, the Mayan regions (basically steles and vessels), as well as masks from Teotihuacan, tiny female figures from Tlatilco and smiling Totonac faces. ❖

Recognition should also go to Raúl León Ortega for his extraordinary creativity. Since the early 1990s he has been producing polychrome sculptures under the trade name Raúl Rock. His fantastic, surrealist repertoire combines dreams and reality, in much the same way as the craftsmen of Ocumicho, Michoacán. His designs are unique pieces that blend the divine and the diabolic, the erotic and the mystical, the subconscious and a most unusual poetics. ❖

In Metepec, the artisans' pride in their work is visible even in the streets of their town, where they have called attention to themselves by erecting monumental examples of their work as urban ornaments. In the same way that any modern city is graced by contemporary urban sculptures, Metepec places its Trees of Life on display, along with the trees at the Monday Market, and the masks, animals, suns, moons and crosses crowded into plazas, parks, avenues and modern urban projects. ❖

Metepec is a town of true artisans, with people the color of clay, who have clay in their blood and a flair for the chimerical. It is a town of traditional people who take pride in an art shaped by their own hands. ❖ Translated by Carole Castelli. ❖

❖ LUIS MARIO SCHNEIDER

A LOVER OF CLAY ◐

◐ INTERVIEW WITH TIBURCIO SOTENO

◐ *Chloë Sayer*

AN EXTREMELY TALENTED ARTIST WITH AN UNUSUAL IMAGINATION, Tiburcio Soteno was invited to London in 1992 to give workshops at the Museum of Man (the ethnographic department of the British Museum). This visit coincided with the exhibition, *The Skeleton at the Banquet: The Day of the Dead in Mexico (1991–1995)*. Several examples of his work were included in the exhibition and were very well received. Other pieces created by him can be found in Italy, France, Germany and Spain. In June 1995, he was named "Maestro of Maestros" when he received the National Modesta Fernández Award in Metepec. In the same competition, his thirteen-year-old son Israel received first prize in the youth artisan category. ❖

CHLOË SAYER: How did you learn your craft and from whom?

TIBURCIO SOTENO: My training began when I was young. I have nine siblings: five brothers and four sisters. I'm the youngest of the men and all of us work with clay. When I was little, I used to watch my brothers working. I liked to imitate them and when they'd knead the clay, I always wanted to help out. The thing is, they used to play with me. I started out playing games with clay and to this day, I'm still playing. ❖

C.S. Tell me about your mother's role. ❖

T.S. She was the most important person to me, because if she hadn't existed, there wouldn't be any craft production in Metepec… maybe some casserole dishes and pots and that kind of thing, but nothing like this. Her adoptive aunt and uncle taught her to work with clay. It so happens there was an outbreak of black smallpox at my grandparents' house. My mom was the youngest and they sent her to stay with her aunt and uncle so she wouldn't catch it. They didn't have any children. They made little donkeys for Corpus Christi and whistles, so their nickname was "the Whistlers." She filled the void they felt because they had no children of their own. She started to work with clay, as if it were a game, too. My mother's father was Rafael Fernández, and her adoptive uncle was Tito Reyes. ❖

Opposite page
Tiburcio Soteno
with one of his
Trees of Life.
Metepec,
State of Mexico.

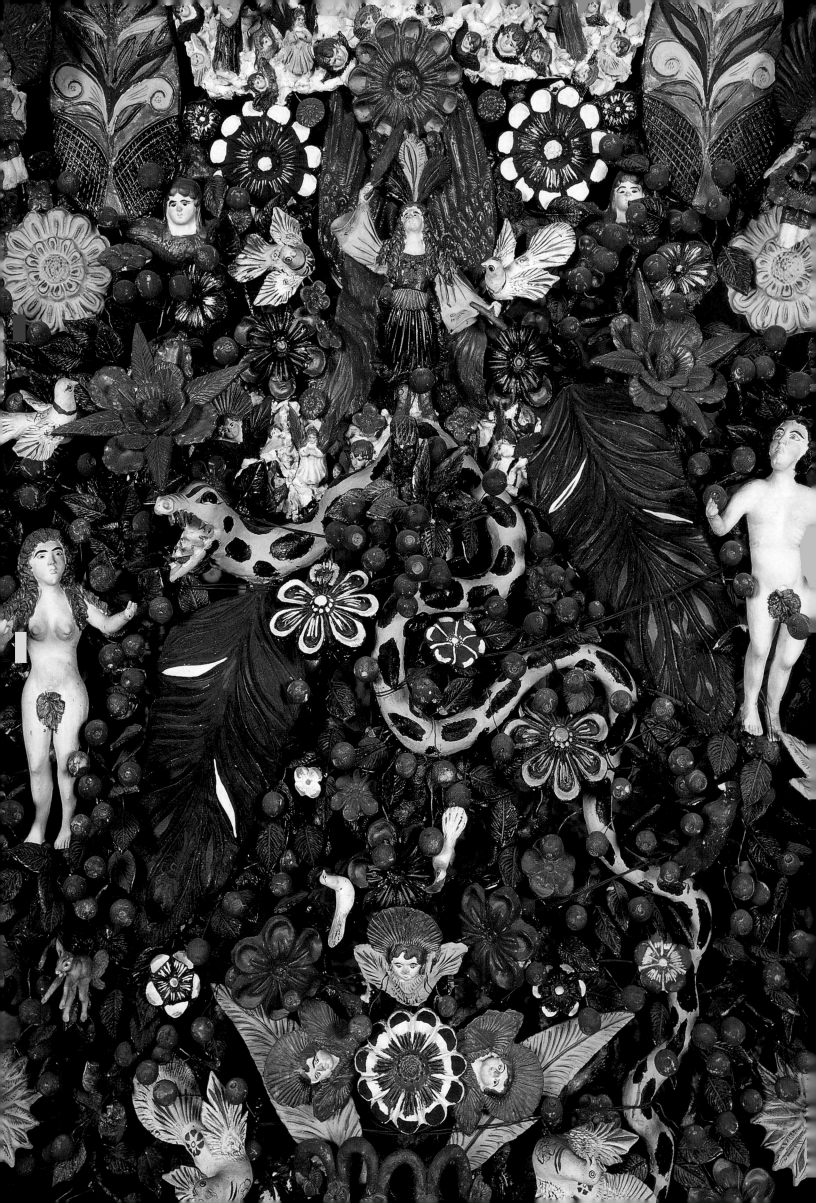

Opposite page
Tiburcio Soteno.
Tree of Life.
Baked and
painted clay.
Metepec,
State of Mexico.
Dolores Olmedo
Museum.

Here in Metepec, Tito Reyes and Juana Fernández were the ones who began making this kind of pottery. As a young girl, my mother began to develop her own ideas: she made Nativity scenes, Christ figures and Crucifixion scenes with soldiers, and gradually began to revolutionize the craft. She married my father, who was a mason, and he built the domed kilns. Then my older brothers and sisters were born: Mónico, Carmela, Alfonso, Estela, Víctor, Pedro, Manuel, myself, and then Teresa and Agustina. They started selling their pieces as a different kind of pottery. They weren't just flowerpots, casserole dishes and jugs anymore, but something ornate, something fancy. They used to go to the Folk Art Museum on Avenida Juárez in Mexico City, walking all the way down Reforma carrying their work. ❖

C.S. How did they paint the pieces? ❖

T.S. They used very old techniques. The white was made with chalk, which was ground and then boiled in water. It was mixed with water-based glue while boiling, so it would stick. The smell was at once pleasant and unpleasant. The painting was done with aniline but without lacquer: there were the *fuchinas* or *cochinas* [referring to their strong smell]. ❖

My mother told me that when Diego Rivera came, he showed them how to make more resistant painted finishes. It bothered foreigners to get paint on their fingers when they picked up a piece—it would mix with their sweat and rub off. It seems he was the one that recommended lacquers and other paints. That revolutionized painting here. The originals are actually anilines diluted in alcohol, applied directly to the piece. The ones that were painted white took on a kind of bitter smell over time. I remember all those odors well. That's what our life as artisans was like. ❖

C.S. What happened later, when you were older? ❖

T.S. When I was a kid, I didn't have wood or plastic toy cars. So I made some for myself out of clay. Later, when I was nine or ten years old, I remember they used to tell us at school, "We're going to do the history of Mexico." And I was always game, saying, "Let's do it in clay!" I would make models of cannons and soldiers and horses with clay that exists naturally around here, because I was afraid that I would get in trouble if I took clay from home. We used to get it from that hill over there. And I could work with the clay, just as it was. I remember we used to pile up the balls to make little walls, just for fun. One of my brothers-in-law, Evaristo, used to challenge me, saying, "So you think you know how to work with clay?" And I'd say, "Well, yeah." And he used to trick me into

making something, saying, "I bet you can't make a horse." "What do you mean, I can't make a horse?" I'd answer. So I would make one. By the time I'd caught on, he'd already made molds of the horse. I did it for fun, but it was work for him. ❖

Meanwhile, we were still busy in the workshop. I remember that when we painted with gold, Pedro would do it very quickly. By then I already wanted to work on my own projects. But they would tell me, "Go put gold on the kings' crowns." And with a thick, ugly paintbrush, I'd have to paint the crowns gold and other things that I didn't like doing. I painted without rhyme or reason. Pedro did all the fine work that I was also able to do. When I turned thirteen, I painted some suns or pigs on commission, and some flowers with anilines. Pedro got back in the afternoon and he got a little jealous. "So, are you trying to impress me or what?" Then he said to me, "So what is this? Why'd you do it?" "Because I can do it too," I told him. Of course he wasn't really mad at me, that's how we got along with each other—just fooling around. ❖

I remember that's how I started doing decoration. Alfonso found out and, when Pedro wasn't around, he'd tell me, "Decorate this" or "Decorate that." Later, when he saw that I'd done some very pretty flowers on the large Tree of Life pieces, he'd leave the whole base for me do to. The base was completely smooth. I'd do my flowers and when I finished, he'd shake my hand firmly and call me "Maestro." It felt really good. ❖

C.S. And your mom was still working... ❖

T.S. She kept on working for the competitions, but she devoted herself more to the figures for the *cuadrillas* (sets of clay figurines used in traditional healing practices). The cuadrillas have a special meaning for me, because I remember that even though we were very poor, my parents tried to make sure we had meat for dinner on Saturday or Sunday. They had one customer for the cuadrillas, a very misterious character. When he'd come to order one, I'd immediately associate that with a party. That's because the day he picked up the cuadrillas, there would usually be soup made with beef and hot peppers. The customer would arrive with a *chiquihuite* (a handleless basket) to carry the pieces. They'd send me for soft drinks. It was a party, something fun. They'd invite him to eat with us and drink pulque. He told us that the pieces were used to heal people. I don't know if they had any effect or not, but that's how it always happened in our house. ❖

C.S. Your parents continued to make cuadrillas and, little by little, so did the rest of you... ❖

Opposite page
Tiburcio Soteno.
Tree of Life.
Baked and
painted clay.
Metepec,
State of Mexico.
Dolores Olmedo
Museum.

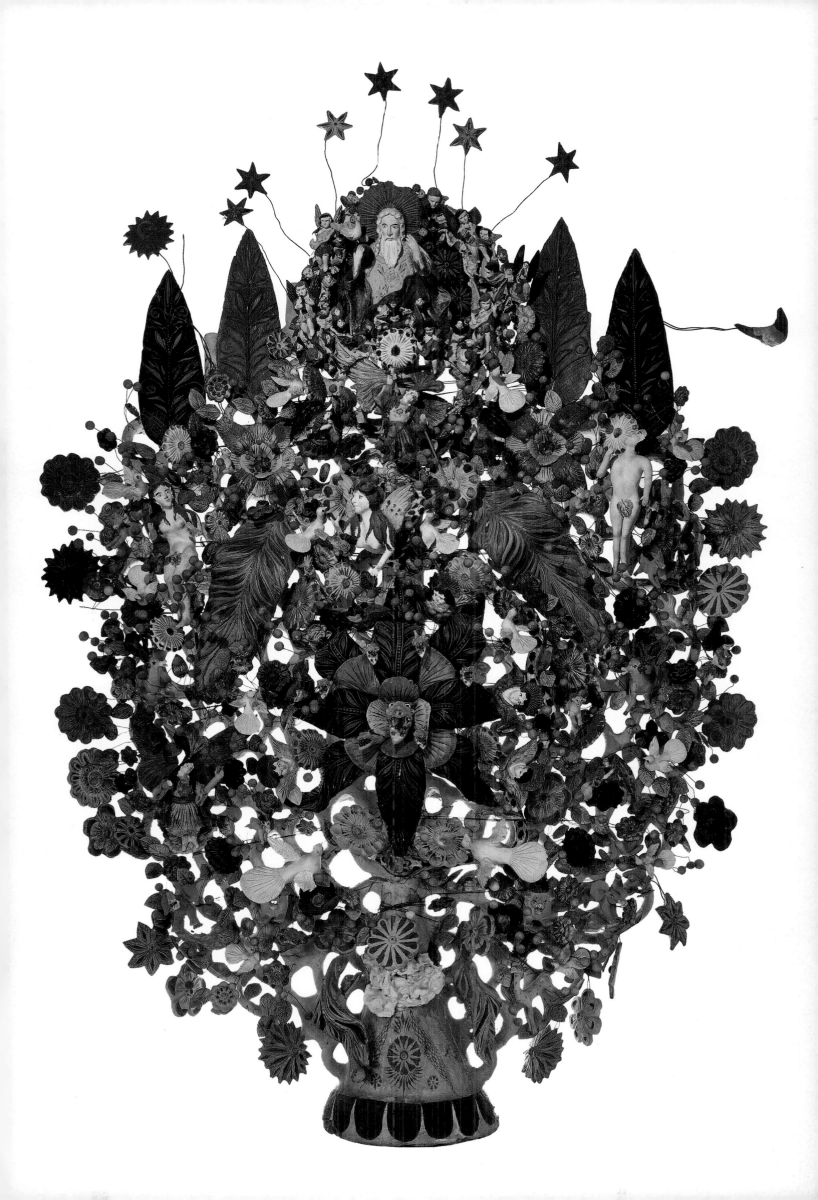

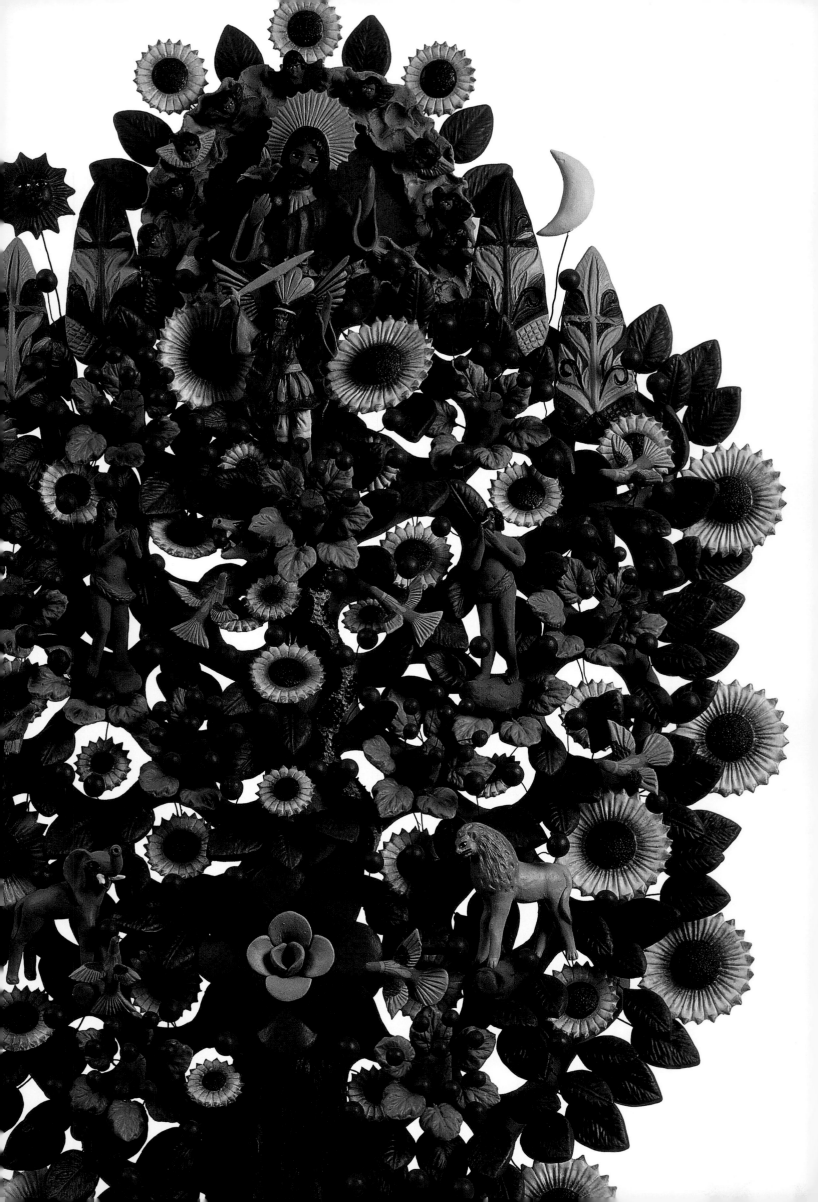

T.S. Yes, the work was gradually divided up. My brothers started doing the Trees of Life. We worked with Alfonso a lot of the time, making huge trees, sixteen to twenty feet tall. ❖

C.S. Do you remember your early pieces? ❖

T.S. I started making small trees especially for the Feast of Saint Isidore, as a matter of fact. I put my little teams of mules or oxen for Saint Isidore and corn on those trees. But one of the first significant works was a mule team that Alfonso presented in the saint's honor at a festival: I had done the team's crest on the plaque. I think I was about sixteen or seventeen years old. I was in junior high. It was very satisfying because he won first place, and, since we were all in on it together, he said, "We all won!" He represented us and won. I kept on making volcanoes, little houses, corn and all that kind of work, which was very time-consuming. The border would be done with nothing but *grecas*, or stepped frets, and it took me a long time. I would go to school, come home, and get to work right away. Alfonso never worked me too much. He'd say, "Well, give me a hand… do this. It turns out really well when you do it." He always encouraged me to do things well. ❖

C.S. Did you keep working with your brothers? With Alfonso? ❖

T.S. We did all the important pieces together, Alfonso, Pedro and I. We always let Alfonso represent us in competitions because he was the oldest. I got married when I was twenty-one, and was still working with Alfonso two years later, but it wasn't easy to live that way. I remember we sold a huge tree with mermaids, now on Avenida Juárez. And just by doing one tree about five feet tall, I earned my independence. I was paid for the small tree, although I had also worked on the big one—my brother gave me the money for the small one and that was a big step. With that money, my wife and I bought a bed and a dresser and went to live on our own. ❖

C.S. What happened then? ❖

T.S. I worked on my own, but not a lot. Things happen in life, you know. I mention this because it's part of what I teach my children. I love soccer, and I'd leave work to go play. Then I fell into the rut of never having any money: my daughter had no shoes, neither did my wife. Later I had an argument with my parents. "What's to come of your life? You're slacking off," they said. Today I tell my children there's no such thing as poverty or economic crises or anything, but there is such a thing as laziness. If you work—at anything—you'll always be able to eat. Then I asked my brother Víctor for a job. He was general supervisor in a beer can factory. I got an education at that factory. I started as a sweeper

and really suffered. Today I tell my children a boss is always going to be ordering you around. It was a sad thing, unpleasant, but I suffered through it out of necessity. Then came a time of self-improvement. After being a sweeper, I became a machinist, then an assistant lubricator, and I moved my way on up the ladder. The course made me a third-class mechanic. I'm good at it. I taught myself how to make nuts and screws. After seven years at the factory came the national economic crisis in 1984. They gave me my diplomas and my letters of recommendation so I could start off at another factory as a mechanic. But I went back to working with clay, to make some important, competition-quality pieces. Now I try to make each tree different from the one before. I do repeat some pieces, but they don't give me the same satisfaction. ❖

C.S. Do you think your style has evolved? ❖

T.S. I think I keep improving it a little every day. I try to learn from everyone, I still learn from my fellow workers, or sometimes from the people who tell me: "I don't like that," "I don't like this color," "Why did you put that in?" or, "Why don't you give it a smoother finish?" ❖

C.S. What has been your inspiration? ❖

T.S. I'm inspired by many things that form part of my life—playing, friendships, my dreams. Naturally, dreams are often very hard to make a reality. There was one time that I dreamed I was standing beside Christ, on the upper left-hand side of his cross, and I saw a lot of angels flying around in a huge empty space. I tried to make this piece but I didn't know how to represent the angels in the sky. Besides, I had to be there, just as I had been in the dream. I remember perfectly the gigantic Christ with his arms wide open. I did the work, it turned out very nicely, but I felt I hadn't managed to capture my dream. ❖

C.S. How important are the Bible and religion to you? ❖

T.S. The Bible is part of what my mother taught us. When she made us go to church and learn our catechism lessons, it was important for us to be still. I remember one day before my first communion I wanted to play with my yo-yo. I had barely started to play when she tugged on my ears. "Come on, you've confessed now, and you can't be doing whatever you want." ❖

Then I started to think that the things inside the church were very important and I started to see the saints differently. Instead of getting upset, I found it

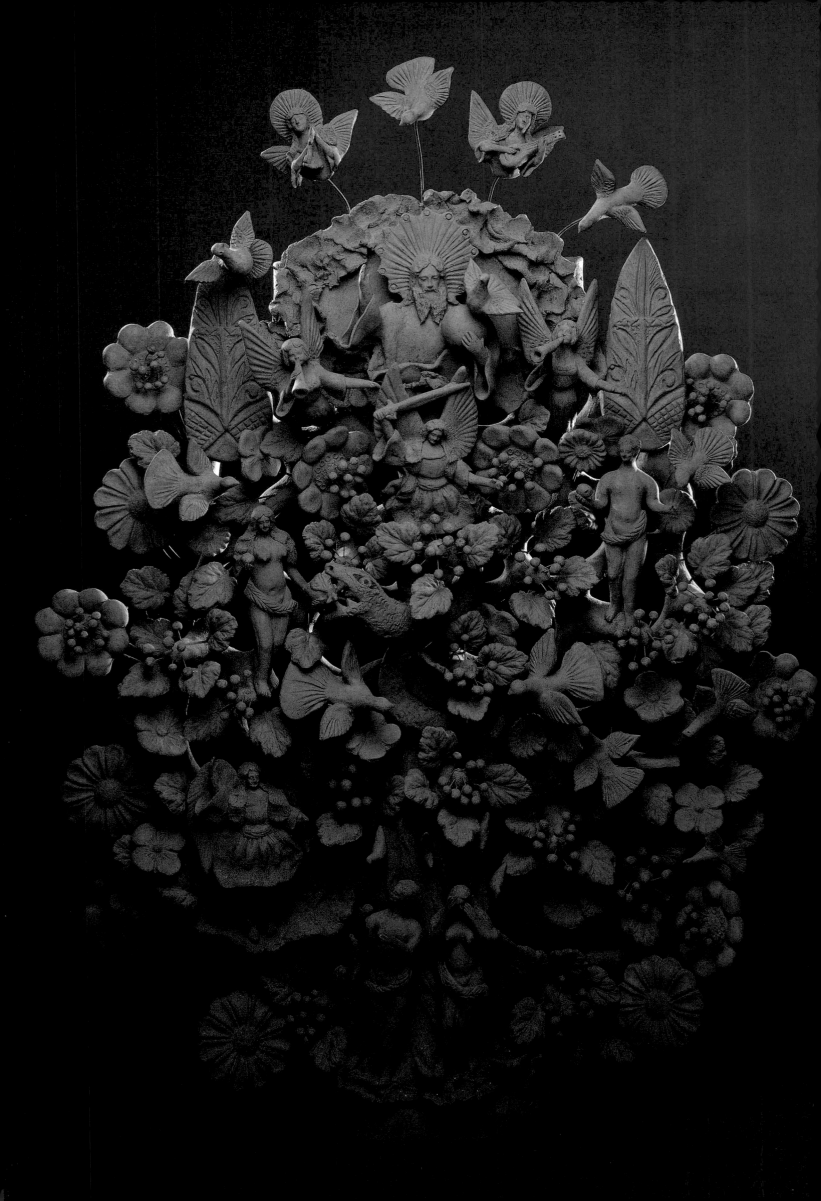

enjoyable to go into churches to look at the saints. Naturally, I feel very insignificant next to the great masters, because I see the faces of the saints as incredibly perfect and I doubt I'll ever achieve that, I don't know. When I go to churches and museums, I realize that museums are inspired by churches in many ways. I take this as the basis for my work. I look at illustrations, or I come up with my own ideas and do it in my own fashion. ❖

C.S. How do you come up with your ideas? ❖

T.S. Sometimes I try not to think about the ideas. That's how it happened with one tree I was doing a rush job on. That one's gone to Italy, by the way. The theme was the Conquest of Mexico. I had no idea what to put on top to finish it. I thought to myself, I don't know how to finish it and I sure am not going to leave it as is. So I wrapped it in plastic and tried to forget all about it, but it was always at the back of my mind. I remember that I woke up at around three in the morning and started turning things over in my mind. "What am I going to do?" I wondered. All of a sudden, an idea occured to me, and I got up immediately and finished the tree, in about an hour. I was satisfied with it and went back to bed. When I woke up, there it was, finished. I tell my kids I get help from my elves. ❖

There are some pieces that I destroy when I'm almost finished because I get a better idea. My wife gets mad and she says, "You've worked on it for so many days already, just to wreck it before it's done?" But I just didn't like it, and once I've completed another piece, I feel satisfied. But then, there are also things I think of beforehand and those get done very quickly. ❖

C.S. Does it hurt to part with a piece? ❖

T.S. Frankly, yes. There are some small pieces I like. I get to admiring them, then I scratch my head and wonder, how did I manage to do this piece? They are pieces I've struggled with, where I've managed to achieve a high level of quality and then I have to get rid of them. ❖

❖ CHLOË SAYER

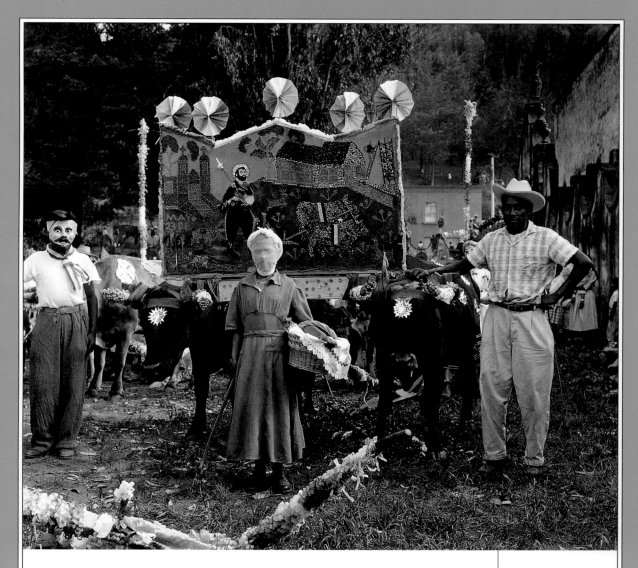

C.S. Tell me about your relationship with François Reichenbach, the French cinematographer who lived in Mexico for a time. ❖ T.S. He was a fan of Mexican crafts. A little old man, a coyote, as he used to say. I met him through Adrián Luis González. I asked Adrián, "Why did you bring him to meet me?" And he answered, "He came to my house and said he wanted to meet the best artisans around." I realized I already knew him. I had seen him at my brother's place but I hadn't wanted to horn in on his clientele. ❖ So Reichenbach saw my work and liked it so much that he bought a couple of pieces right off the bat. Since they were very different, he came back in a few weeks and told my brother, "Alfonso, I want to go to the place where I bought these pieces." They had to bring him to me. From then on, we were on pretty friendly terms. As well as seeing him as a customer, I saw him as part of the family. Besides, he paid me well. Why should I deny that? Every few weeks or every month he'd come and buy at least a hundred dollars' worth. He was an elderly man, and I liked him just the way he was. I'd see him and

Fiesta de los Locos.
Metepec,
State of Mexico,
1951.
Photo: Ruth D.
Lechuga.

wonder, just what is this frail little old man spending his money on? He's nuts, I thought to myself. But I knew he was my friend. ❖

One day, something happened to change the relationship. He arrived with his granddaughter, who was about eight or nine years old. And he asked me if she could touch the clay. I said, "Of course she can, come in, sit down." So I sat her down and she started to work. I gave her a tiny little tree when they left. Mr. Reichenbach was so impressed that he got out, gave me a hug, and said, "I want to bring you something, this is just incredible." I told him to bring anything he wanted. So Saúl or Israel said, "Bring him a watch because he never knows what time it is." The next time he came, he didn't just have a watch for me, he had one for each of my kids and for my wife, too. ❖

Later the bond became even stronger. I used accompany him on trips. One day in Mexico City, he laughed at how I'd agree to everything. We were going down the Periferico or Viaducto, and traffic was very heavy. He said, "It's faster this way, isn't it?" And I said, "Yes it's faster." "But there are a lot of buses, aren't there?" "Yes, there are," I answered. Then he said, "You keep saying 'yes' to everything, and meanwhile, we're getting ourselves lost." ❖

C.S. Whatever became of the Divine Comedy you were going to do years ago? ❖

T.S. When Fatima and I opened the workshop, I asked Carlos Espejel, "Why don't you finance me for a month or two to see just how far I can get in developing the Divine Comedy?" I started to make the plaques and only managed to do four in four weeks. A customer came to the house and my father sold them; rather, he gave them away. Those same customers came back and asked my nephew Oscar how much those plaques were worth. "About one million pesos." "Are you serious? They sold us those plaques for forty pesos." "But, who?" "An old man, he was right here." ❖

C.S. Did you feel bad? ❖

T.S. No, because I respected my dad's decision. ❖

C.S. Who are your customers? ❖

T.S. I've mostly worked directly with buyers. For example, I met a symphony orchestra director from Mexico City who came to commission a work on the Virgin of Guadalupe. I included all the instruments of a symphony orchestra in the image, and angels, too. I even portrayed him as an angel and he really liked that. I try to do each job better than the one before because I believe that it will lead to the next one. My mother used to say, "It's just clay and all you have to do is make it over again. Do it more cheaply." If she could see me now, and how much I get for these pieces, she wouldn't

believe it. I don't know what she'd do. I realized that there were very few of us who could do this type of thing and that there are people who can pay for it. ❧

C.S. And what does the future hold in store for you? ❧

T.S. Here in my workshop, I'd like to do the universe on the ceiling, stick it all up there. On one wall, do the life of Christ, on the other, the history of the world, all in clay. The only problem is, a lot of money is needed to do that, and someone else would have to support me or my family, which is a little difficult. ❧

C.S. How would you define yourself, as an artisan or as an artist?

T.S. It don't think I've reached the category of artist. I'd like my work to last forever. I believe I'm not an artist yet and probably not even a potter, just a lover of clay, always fooling around with clay. I like to play so much that sometimes I feel like a little kid. I do some things that make me say, "Well, this one I made out of pure mischief, and this one I did in my sleep." I always have the impression that it's just a game, and it's very satisfying to know I am able to support my family that way. ❧ Translated by Michelle Suderman. ❧

Mermaid.
Baked clay painted
with aniline.
Metepec,
State of Mexico.

Opposite page
Casserole dish
handle. Twisted clay
with polychrome
paint and glaze.
Metepec, State of
Mexico. 1985.

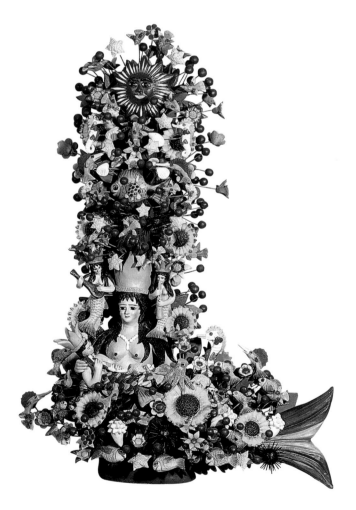

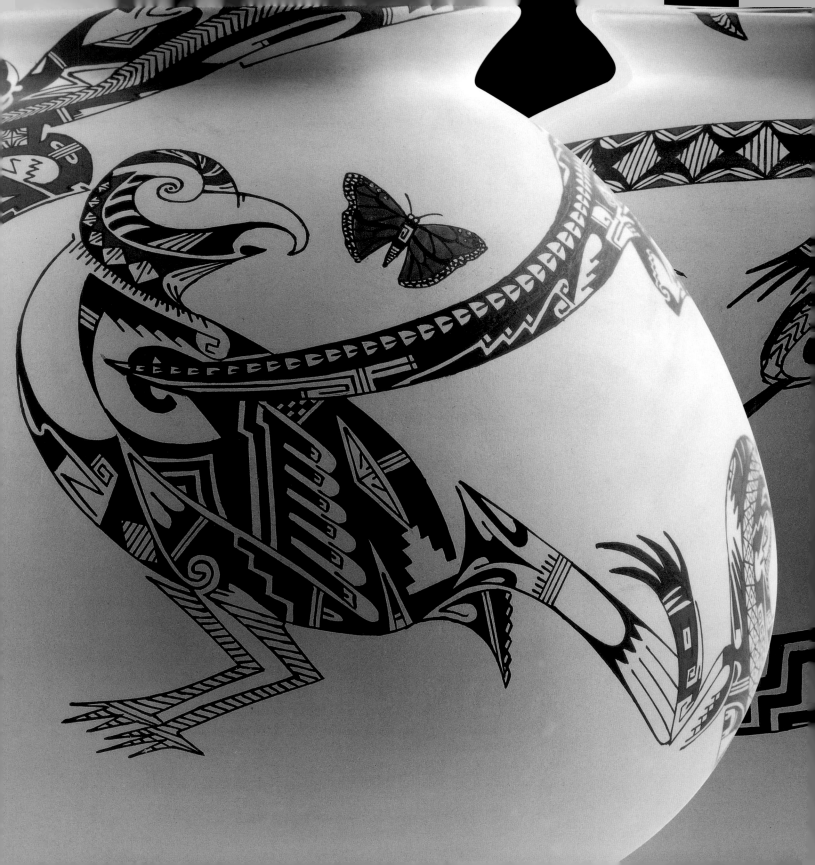

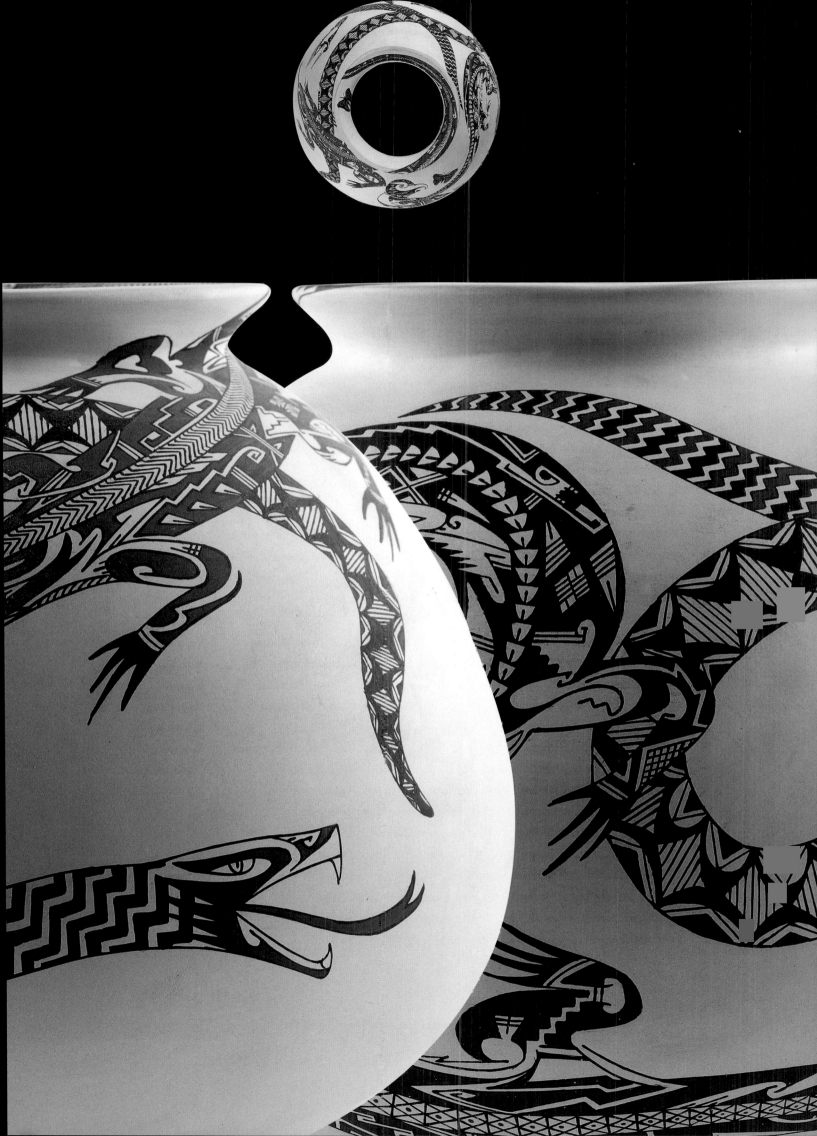

THE ALCHEMY OF CLAY ∽

∽ Bill Gilbert

Any discussion of pottery-making in the village of Mata Ortiz, Chihuahua, must focus on the work of Juan Quezada. Starting from the simple assumption that some ancient pots he had found must have been made from local materials, he began a period of creative experimentation that eventually resulted in a complete process for creating polychrome painted pottery. ∻ Wanting to make pottery of the highest quality, Quezada first used the purest clays he could find in the Palanganas riverbed. These clays were too plastic and all of his pots cracked in drying. The clue to solving this problem came from the ancient potsherds, which on close examination, revealed sand content in the paste. Quezada had initially attributed this to carelessness on the part of ancient potters, but was puzzled when he noted that the grit was present even in fragments from the finest ceramics. So he experimented with adding sand to his own clay and found the pots no longer cracked. ∻

As time went on, other technical problems surfaced. Clays along the riverbed were frequently contaminated with lime deposits. With changes in humidity, the lime expands causing tiny spalls in the surface of the pots—pops and blisters that develop long after the pots have been fired. ∻

In search of a lime-free clay, Quezada experimented with numerous sources along the riverbed and on the hillsides. His earliest successful clay bodies used a mix of clay and sand temper which he ground from stone similar in color to the clay. The sand temper provided the unfired clay with strength and controlled its shrinkage, but also made it impossible to burnish the pot to a smooth surface. ∻

Mata Ortiz pottery comes in a range of clay colors, the most common being white, red, orange, yellow, *mezclado* or mixed, and black. Potters consider the white clay to be

This page and opposite Damián Escárcega Quezada. White clay pot with decorative motif repeated eight times. Mata Ortiz, Chihuahua. 17 x 11 in. Private collection.

Pages 166–167 Manuel "Manolo" Rodríguez Guillén. Four views of a pot with snakes and alligators. Mata Ortiz, Chihuahua. 14 x 11 in. Private collection.

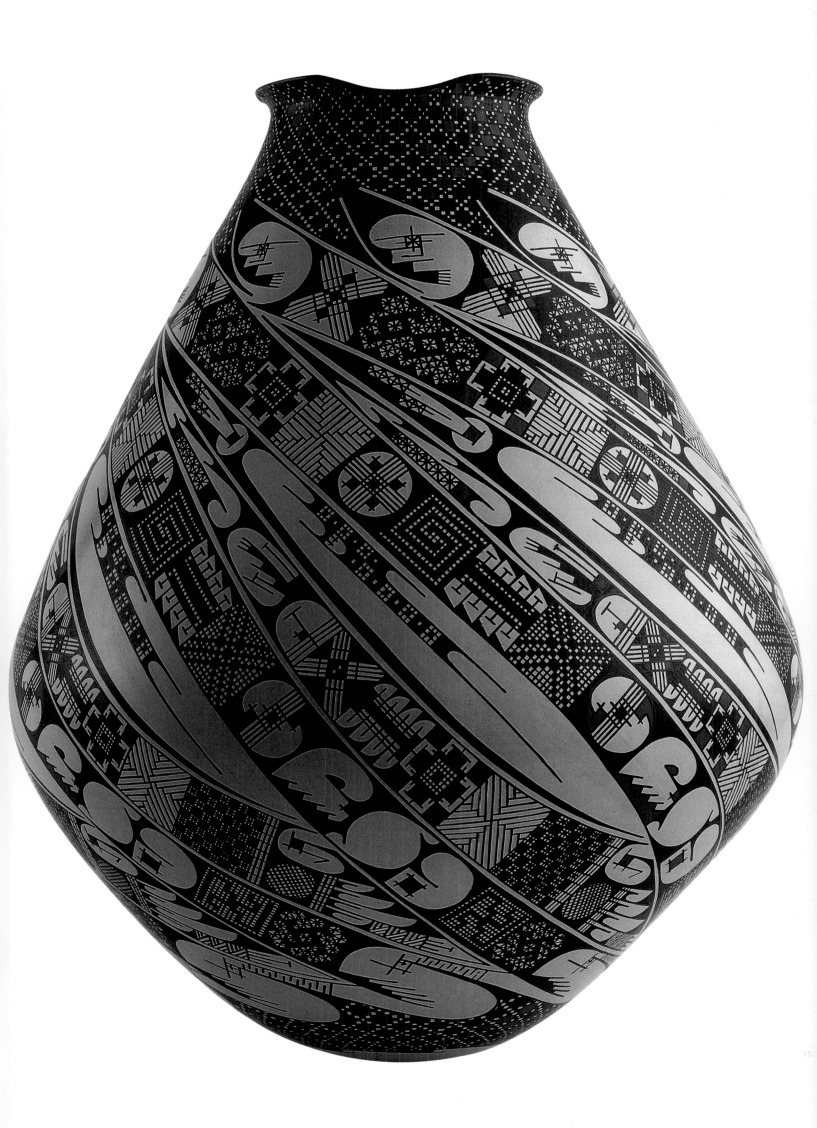

the most challenging to work with. At least two distinct white clay bodies are used. One is obtained from a very pure but non-plastic deposit from the hillside east of the village, and produces the whitest pots. It is difficult to handle, however, and only the most skilled potters use it in its unaltered form. The second is a mix of clay from the former deposit and another one, often a beige clay from the Anchondo area. The combination produces a more plastic clay that fires to a cream color. Juan Quezada's pots are made from the pure white clay. Héctor Gallegos and Graciela Martínez use a relatively pure mix that produces a beautiful cream color, while César Domínguez and Gabriela Almeida produce ecru- or beige-colored pots with a much higher Anchondo clay component. ❖

Yellow clay is the most common type in the area. It is also the easiest to work, being both plastic and strong. It is used in large quantities by the potters in the Porvenir district for the production of their characteristically large pots and distinctive black ware. The red clay in its pure form is considered too plastic for easy handling. Pots made of this clay tend to shrink excessively and crack. Olga Quezada and Humberto Ledezma have mastered the use of this difficult clay to produce deep red pots that are consistently paper-thin. While there are naturally occurring orange clays, the purest color is made by mixing red and white clays. This clay body is less prone to the excessive shrinkage and cracking displayed by the red clay. The finest work being produced with this clay body are the large round pots of Roberto Bañuelos and María de los Ángeles López. ❖

The *mezclado* clay body is made by partially blending two or more distinct clays. Small balls of each clay are pounded together to form a usable clay body. When the pot is sanded the striations of the different clays are revealed. Juan Quezada's brother Reynaldo, the first potter in the village to sand his pottery, is credited with this innovation. On finding one day he did not have enough of any one kind of clay to make a pot, he mixed together different clays. Even so, he would not have made his discovery had he not sanded the pot after drying, thus removing the homogeneous outer layer to expose the clay marbling beneath. Pilo Mora has gone on to produce some remarkable work based on this technique. ❖

There are three distinct processes for making black ware in the village. Each black is the result of a specific method of firing that will be discussed later. This is by no means the extent of clay colors used in Mata Ortiz. Nicolás Quezada is said to be the first potter to create a

❖ BILL GILBERT

rose-colored clay body. Héctor Gallegos
and Graciela Martínez experiment with
a salmon-colored clay, as does Gerardo
Cota. José Quezada is known for his work
in a gray clay. And Juan Quezada continues
to lead the way developing pure yellow,
purple and charcoal clay bodies. ❖

CONSTRUCTION

To hand-build a pot, potters begin by rolling
out a thin clay slab or *tortilla*, and pressing it into
a shallow, dish-like plaster form. After trimming
the excess from around the edge, they form a large
clay coil and join its ends to make a ring the same size
as the circumference of the mold. They lay this large annular
clay roll on the mold and join it to the pot all the way around.
By repeatedly pinching the roll between thumb and fingers, they
force the clay upward to form the walls. They refine the overall
shape, smooth out the surface and make the walls uniformly thin by
scraping the outside of the pot with the serrated edge of a hacksaw
blade while supporting or pressing it from the inside with their
fingers. For a large pot, potters may add a second clay roll on top
of the first, and to form the lip, they add a relatively small one. The
last step, after perfecting the final shape with the serrated edge, is
to smooth the surface with the non-serrated edge of the blade. ❖

SANDING

Quezada's practice originally was to paint the pot while still wet.
He was not satisfied with this method, however, finding that in
his rush to complete the painting before the pot dried he did not
have sufficient time to mentally develop his design. Consequently,
in the early 1980s, Quezada began to experiment with clays with
a naturally occurring, very fine stone content. With these new
clays he was able to change his process significantly, eventually
developing a method of sanding, burnishing and painting on dry
clay. This enabled him to accumulate a number of pieces and then
concentrate on painting them with no need to hurry. ❖

In this new system, Quezada now sanded the dry pot using first 100
and then finer 200 grit sandpaper. He coated it liberally with oil
and then lightly with water before polishing it with a smooth stone
or a deer bone to complete its preparation for painting. When the
painting was complete, he applied a small amount of oil to the pot

Damián Escárcega
Quezada and
Elvira Antillón.
White clay pot
with polychrome
decoration
repeated five times.
Mata Ortiz,
Chihuahua.
10 3/4 x 12 in.
Native & Nature
Collection.

Opposite page
Detail of a blue and
black pot.
Mata Ortiz,
Chihuahua.
Photo: Diego
Samper.

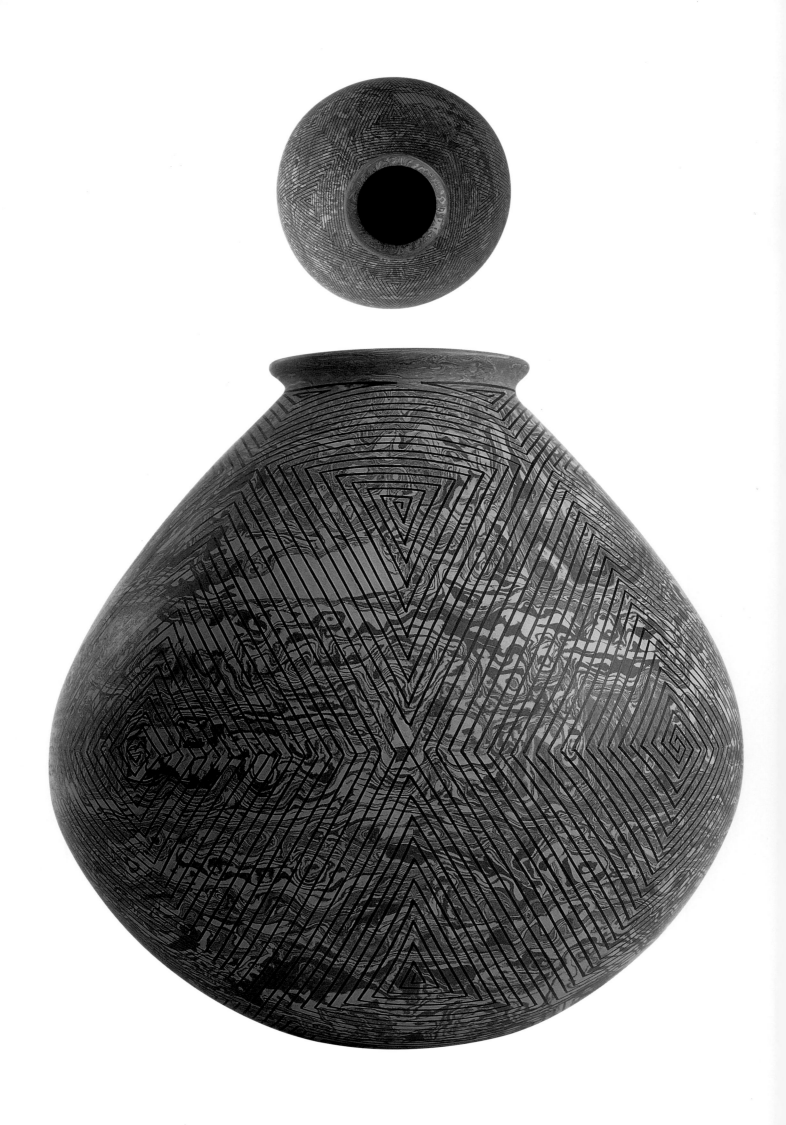

and then burnished the paint to a high gloss finish. Painting directly on the clay body rather than over a thin layer of slip also results in richer colors. ❖

PIGMENTS

Quezada considers the development of his paints to have been the most challenging part of his entire ceramic technology. They are made entirely from minerals and clays gathered from the local hills, and his palette, like that of the ancient Casas Grandes culture, is primarily black and red. He experimented with a wide range of materials in formulating them. "Older people here used to say the ancients painted with mule's blood! So, ignorantly, I started to add animal blood or even human blood," Quezada comments. ❖

Today, potters in Mata Ortiz all use manganese from the same mine for their black paint. They refine the paint by repeatedly mixing the manganese in large amounts of water, allowing it to settle and then taking only the finest particles off the top layer. The manganese from this deposit contains enough clay for the paint to adhere to the pottery without any additional binder. Quezada adds a small amount of ground copper ore to the manganese to ensure the paint will not turn brown in a hot firing. "I was never at ease with pure manganese because as the temperature rises it starts to lose its blackness, so that when the piece is fired, the black paint turns brown," he comments. "I began looking for black minerals and after experimenting for awhile, finally found one that stayed black. That day I didn't even want to stop work and go home! It was what I had been looking for. I ground it, added it to the manganese, and it came out pure black, without the luster being burnt off." ❖

Although the potters all use the same source of manganese, the black paints display a wide range of quality. The best artists have a very dark black paint that becomes shiny when polished, giving the pot a perfectly smooth surface. In the early 1990s Gerardo Cota developed an extraordinary black paint that he polished with a piece of nylon stocking. Perhaps the finest black currently used in the village is the one produced by Héctor Gallegos. ❖

Both Quezada and Gallegos have stunning reds based on mixing ground iron ore with red clay. There are numerous variations of red paint in the village, since the artists use their own personal blends of materials. The most prized are the purest reds, not muddied with brown earth tones. ❖

❖ BILL GILBERT

In recent years a variety of colors have been added to the pottery of Mata Ortiz: blue, green, yellow and purple. The older potters are not interested in these new colors because they are not part of the Casas Grandes heritage and are not made purely from minerals in the local environment. The younger generation, on the other hand, has embraced this development wholeheartedly as a means to create a more contemporary style. Manuel Rodríguez was one of the first to expand his palette, mixing slips of a variety of shades. More recently, members of the Ortiz family such as César Ortiz and Eli Navarrete have created distinctive styles based on multicolored designs painted on a black graphite surface. ❖

Painting

The technical perfection of their painting and the complexity of their designs place the Mata Ortiz potters among the world's foremost ceramic painters. They create fine line work by applying pigment with a brush two to three inches long, made from ten or twenty strands of a child's hair. Juan Quezada and his brother Nicolás experimented with bird feathers and all types of animal hair before settling on human hair. Before beginning to paint the artists divide their design fields into two, three, four or more equal parts by making marks on the pot's lip and base. They then paint the designs freehand. They fill in spaces with a short, thick brush, and retrace the outline to sharpen the design's edges. ❖

In ancient Casas Grandes pottery and most examples of Pueblo Indian pottery, the pot's design field is contained by two horizontal bands which separate the body from the lip and the base. One of Juan Quezada's most radical innovations was to eliminate these horizontal bands and paint the entire pot. His designs thus became much more curvilinear and his distinctive style emerged. Many potters have followed his lead, creating what he calls a sense of movement which is easily distinguished from the more static designs of the ancient Casas Grandes style. Quezada's nephews Mauro Corona and José Quezada have each developed styles based on these innovations. ❖

Some younger potters have gone a step further and eliminated the repetitive design symmetry of Casas Grandes from their pots. Manuel Rodríguez paints his work in a freeform style that evokes M. C. Escher and Op Art. Leonel López has perfected a sgraffito technique with which he carves scenes of the natural world over the entire surface of his pots. ❖

Painting is clearly the skill most prized in the village, and pots made through a collaboration between potter and painter are usually

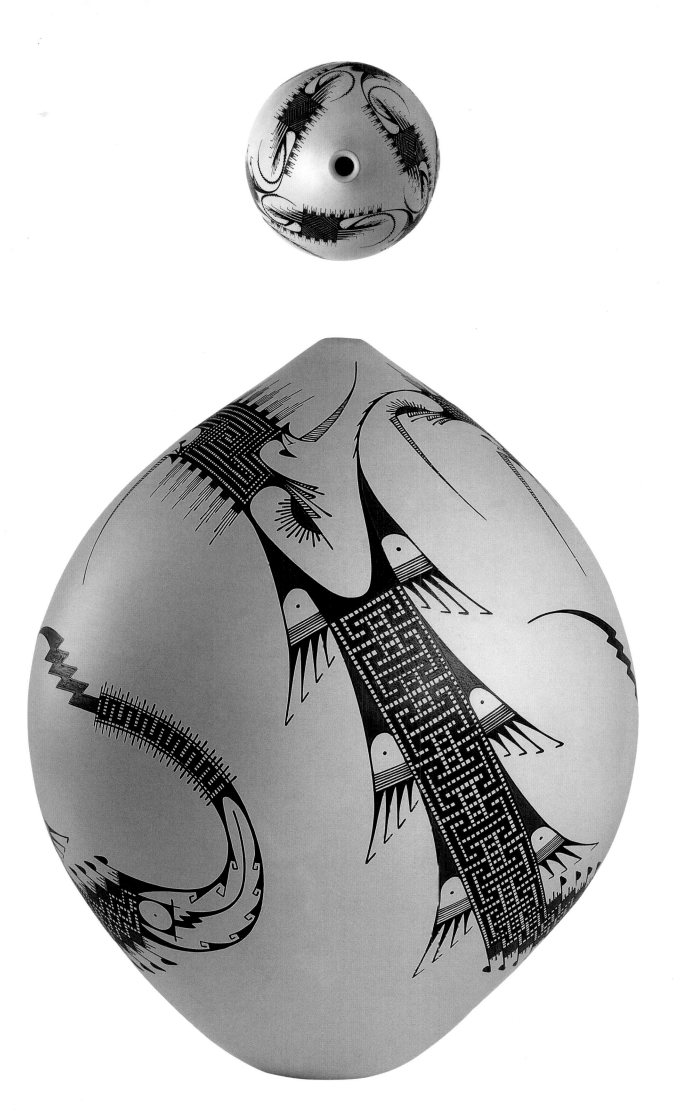

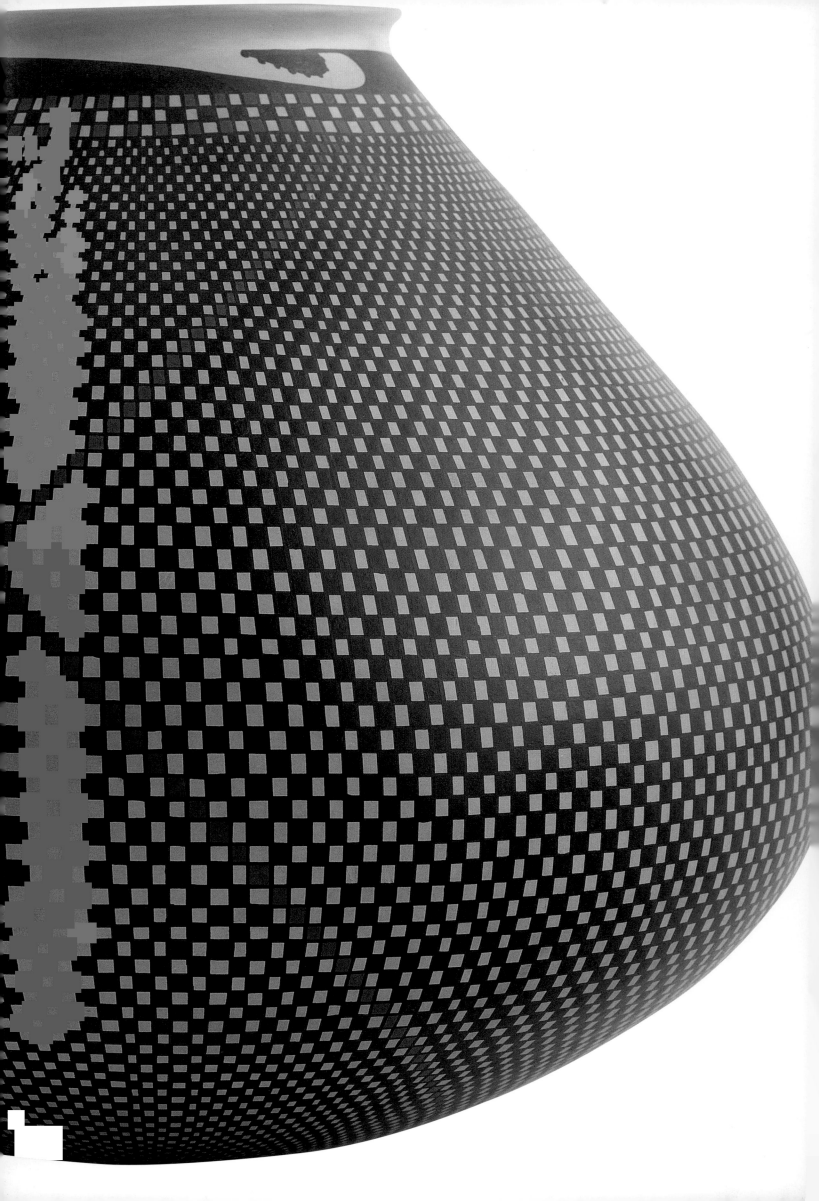

signed by the painter. In recent years it has become quite common for artists to purchase unfired pots from other potters and paint them with their own designs. ❖

FIRING

A major obstacle Juan Quezada faced was how to fire the pottery safely at a constant temperature and in an atmosphere that protected the clay and paint colors. His earliest attempts were with wood and charcoal that he and a friend brought down from the mountain. Charcoal was placed in a container holding the pot, and then the container was swung continuously back and forth in the air. The heat was so intense the whole container caught fire at one point, burning their clothes and sending sparks everywhere. "If we didn't like the results," Quezada recalls, "we'd say, 'we won't even earn enough for new pants!'" ❖

Next Quezada tried firing on the ground with the pot surrounded by a wire cage to keep the wood away from the pot. However, metallic fumes from the wire cage discolored the pots. Finally after much experimentation and ruined pottery, he discovered a method that produced an even temperature and bright colors. He fires his pots singly or in small groups on the ground covered by an inverted clay pot or sagger which protects the pots from rapid or uneven rises in heat that can affect the colors. This method of firing is still used throughout Mata Ortiz though—as with all stages in the process—each potter has added his or her personal adaptations. ❖

Cattle manure has always been the fuel of choice in Mata Ortiz. However, increasing number of potters in the area and a lower cattle population due to drought have produced a severe depletion of this resource. In recent years many potters have switched to cottonwood bark, but there is also a growing shortage of that resource. Most artists feel the bark burns cleaner than manure and therefore is better for white pots. Several potters have experimented with pine and cottonwood, with varying results. ❖

Increasing shortages of "natural" fuels are causing some artists to consider using electric kilns. Although quite common among the Pueblo Indian potters of the southwestern United States, electric kilns are viewed by U.S. traders and writers as non-traditional and therefore less desirable. ❖

BLACK FINISHES

To fire black ware, one or more pots are placed on a bed of finely ground manure and covered with a

❖ BILL GILBERT

metal bucket pressed down into the dirt to seal the chamber. Next, the outside of the bucket is completely covered with cow manure or bark. Finally the pile around the bottom is doused with kerosene and lit. The fire burns intensely for around thirty minutes. The crumbled manure inside the bucket smolders, creating a smoke-filled chamber. The carbon in the smoke penetrates the open pores of the red-hot clay body. As the chamber cools the pores close, adhering the carbon to the pot's surface, thereby creating the black finish. ❖

In 1995, a collector asked Quezada to replicate a large gray-on-black pot that he had made fifteen years earlier for Spencer MacCallum. He agreed, but decided to experiment with a different process. Quezada formed the new pot with red clay and buffed the surface with a cloth instead of with a stone. He then painted designs in a white slip and fired it in a sealed metal bucket. The result was a beautiful, satiny black pot with gray designs. Quezada's son Noé and daughter Mireya have followed their father's lead by producing beautiful large pots in this style. ❖

Perhaps the most important innovation generated outside of the Quezada family is the black-on-black finish created by Macario Ortiz. Having placed his signature in pencil on the bottom of a pot, Macario Ortiz noticed that the pencil lines turned a brilliant black on firing. He decided to experiment with covering an entire pot with graphite before firing. The graphite provides a metallic surface that creates a much stronger contrast with the painted designs than pottery that is merely burnished. This innovation, which swept the neighborhood of El Porvenir and soon spread to other parts of Mata Ortiz, produces a highly dramatic effect and commands a ready market. ❖

Although burnished black ware was common in the ancient Casas Grandes culture, it was never painted. Juan Quezada's youngest sister Lydia was the first potter in Mata Ortiz to create painted black ware. ❖

Despite the many challenges and transformations, the work done in Mata Ortiz has conserved its power to astonish. Juan Quezada's example as an experimenter and innovator has spread throughout the village as other artists work to establish their own aesthetic signature. On a purely technical basis the work is equal to any hand-built pottery in the world, but in terms of its aesthetic merit, it covers a wide range as some artists move toward trends in contemporary fine arts while others adhere to the traditional roots of the Casas Grandes culture. Change is very rapid, making it difficult to predict how the work will evolve in the future. One thing is certain: whatever direction this movement takes, it should not be lost from sight. ❖

THE SOUL OF A POTTER᠘
᠘ Interview with Juan Quezada Celado
᠘ *Marta Turok*

T he voice of Juan Quezada Celado—architect of the so-called "miracle of Mata Ortiz"—rings with an unmistakable northern intonation, and with such force that it seems to issue from the depths of his soul. Slight of build and with heavy black eyebrows, Quezada sports a thick head of hair flecked with gray, lending him an air of distinction. He dresses cowboy-style: boots with pointed toes, jeans, checked shirt and a Texan hat. His house is made of adobe, as unaffected as are he and Guillermina Olivas, his wife and lifelong companion, with whom he has had eight children. ᠅
There are two display cabinets in the living room—one covering an entire wall and another smaller one. The first is full of pottery made by Juan Quezada and his children Noé, or "Junior," and Mireya, or "Nena," who have also chosen the potter's craft. Most of the pieces are commissions awaiting delivery, and a minority are ones waiting to be sold. The small cabinet contains diverse objects presented to Quezada, including pots made by his pupils from the United States. On one wall hangs a framed woodcut of geometric designs, which he made during one of his trips to California where he ran summer ceramics workshops at the Idyllwild School of Music and Arts from 1982 to 1990. ᠅
Marta Turok: Do you still travel to the U.S. every year to teach? ᠅
Juan Quezada: I don't have the time anymore. It's very important for me to go to events, whether small or large, well organized or not. But right now I have a lot of commissions and a lot of people waiting. Some are impatient and others very calm about it. Sometimes they come and leave a deposit to ensure they will receive their pots. But they get tired of me telling them to wait. It's tough on me as well. You work and work, just to comply with half your promises. That's why it's so important that other people from Mata Ortiz also get involved. It's good for the whole village. The same is true if they go to a pottery event in the United States. ᠅

Opposite page
Juan Quezada C.
Red clay pot fired by
reduction with
white decoration.
Mata Ortiz,
Chihuahua.
8 x 8 in.
Private collection.

M.T. Nevertheless, courses are organized right here in Mata Ortiz now, isn't that so? ❖

J.Q. This summer we've set up four, right Guille? [She corrects him: there will be five.] They will be given at private homes on loan. We always start out as strangers at these workshops, and by mid-week we're all one big family. I like them a lot because I'm exposed to new ideas coming from people I don't know. ❖

M.T. You have always shown concern for the village—you discovered all this and always encourage the others. ❖

J.Q. I find it highly satisfying that a family can live off pottery for a year, or two or three, as a result of my efforts. The longer they endure, the greater my satisfaction. And when a pupil of mine makes better pots than I do, that is a source of pleasure rather than envy. We're all human and have feelings, but never to the point of someone saying, "Oh, how I envy him." ❖

Around here we take clay from wherever we find it. We live on communal land, though I'm sometimes offered clay from private land. But here one takes whatever there is. Up in the hills, they were thinking of joining forces to charge us. I said to them, "This is the best thing in the village, so why do you want to go around doing that kind of thing? How much are you truly going to get out of it?" It'll cost them more to put guards up there. ❖

It's nice to spend time with someone who shares one's profession and likes it. It's not the same as with a paid worker. An owner can work from sunrise to sunset without getting tired because he has another kind of faith. But a worker doesn't share the same dedication, he is only there to get his day's wage. ❖

M.T. Well, Juan, for some it's work and for others, the minority, it's a means of expression. ❖

J.Q. I see everyone wanting in, but not everyone has a potter's soul. There are people who do cultivate it, who are interested in it, but very few. When are they going to spend a whole day looking for clay? You tell me. For many it's only a job. Some of us think about the art and others about the money. For instance, when I asked Noé, "What do you think about when you're making a pot?" He said, "The money, of course." Lots of people think about improving their work, but only to earn more. When I show a piece or someone looks at it, I watch the reaction: sometimes it's feigned, sometimes it's real. I keep an eye on everything, you know? ❖

M.T. What do you think is the origin of your artist's spirit? ❖

J.Q. It comes naturally. I've had it as long as I can remember. I've enjoyed making things with my hands since I was six or seven years

old. At the time, no one knew anything about paints or sculpting tools. I sculpted and painted, and liked to make furniture as well —anything I could do with my hands. Ever since I was a kid, I have wanted to see people's reactions to what I show them. ❧

I did a painting once and showed it to my brothers and sisters. I was happy with it. A few days later, they told me a lady had come and bought it. But it wasn't true. They had fooled me and I felt awful. Later, when I was thirteen, I worked in wood—the hardest and most difficult kinds to work with. I used to sit by the window and my dad would yell at my mother, "Where's Juan?" She would always answer, "He must be somewhere making his figurines." It was something they couldn't understand. ❧

We had a little storeroom with whitewashed walls at home. The days I didn't have to go for firewood (my brothers and sisters and I took turns), I would go in there to draw. My greatest joy was doing paintings on the walls, then stepping back to look at them. When I was satisfied, I would wipe the paint off and do another one. At the time, I had no idea that this would become my life's work. I didn't think about pottery—I wasn't even aware of it. There existed a belief that treasures appeared during Holy Week. And as a boy, I heard they were found in "painted pots," but that some of these had skeletons in them instead of treasure, so not everybody was interested. ❧

I made a living gathering firewood—I had to live somehow. I'd go up into the mountains and into caves, with donkeys to carry the load. Since the poor things had to eat and rest before coming down, I would leave them for an hour or two and go into the caves. I found lovely pots there, some whole, others I glued together. I brought a few back with me and someone remarked, "Those are painted pots!" I was fascinated by the patterns, and wanted to make one myself. I never thought of making my living that way. It was very hard because I had never seen a potter at work. I began to experiment with clay, paint, brushes and firing methods. Just in terms of the brushes, I experimented with feathers from all kinds of birds, and hair from every animal. I was fighting a war. I learned to handle the clay, to prepare it and polish it and all that. And when I began to produce my first pieces, I showed them around but got no reaction. People around here already knew I was doing this, but didn't have much to say about it. ❧

M.T. What motivated you to sign your pieces? ❧

J.Q. In the first place to avoid legal problems. Once they came looking for me because they thought I was making copies of ancient pieces. I was fascinated by the idea that people then could make

Opposite page
Juan Quezada C.
Clay pot with black
decoration.
Mata Ortiz,
Chihuahua.
8 x 8 in.
Private collection.

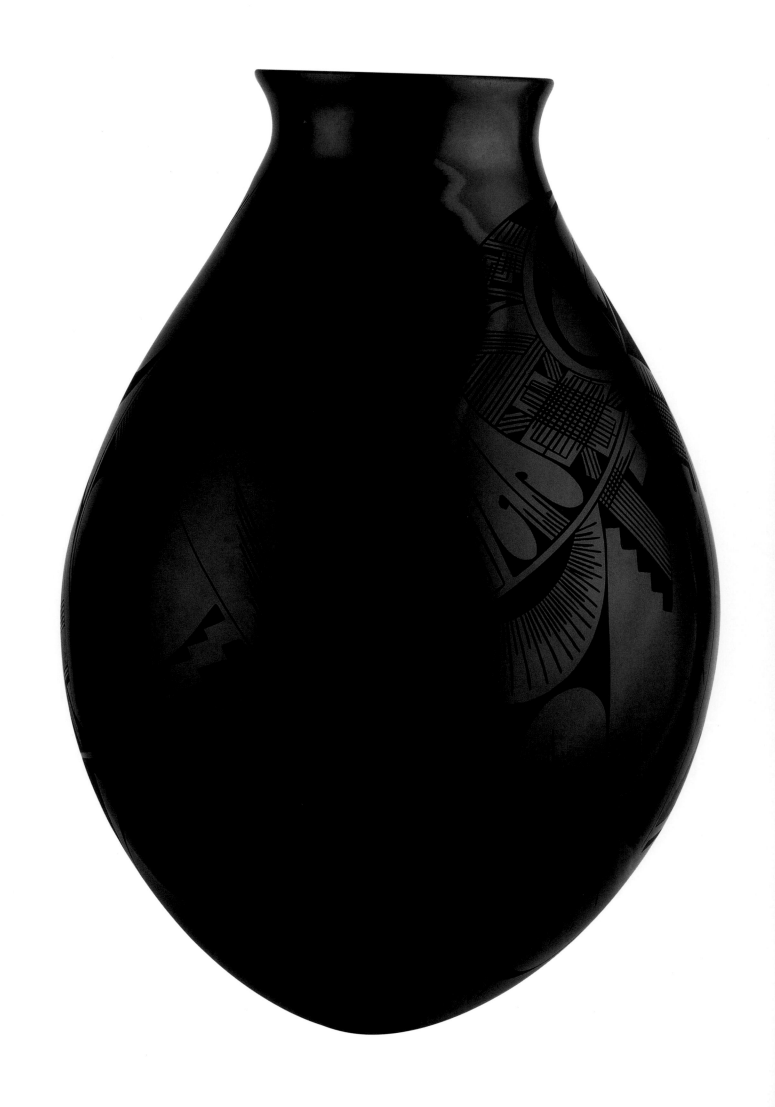

such beautiful things with what was around them. When the pots began to turn out right, I started paying attention to the form, the mouth, how I was going to decorate each one. Each pot speaks to me in a different voice. Then it occurred to me that each potter should sign his work to show who made it. ❖

M.T. The decoration you use has evolved over time. Which style is the most difficult? ❖

J.Q. In the beginning, I decorated the whole pot. Then I thought I only needed to do half of it. At first the lines were straight, in the Paquimé style. But little by little I loosened up and began to do less design with more movement. In recent years, I have come to use a minimum of lines and still feel satisfied with the finished product. I think it's harder to paint that way and that's why I study the pot a long time before beginning the design. ❖

M.T. What should be most important for young people who are just beginning to work with clay? ❖

J.Q. They shouldn't be satisfied with the first thing they achieve. They should go further, fall in love with the clay, go out and find the deposits. I've just found a vein of purple clay. I go looking for every color of clay—white, rose, orange, and now purple. They should experiment, do tests so they can accomplish more than the first generation of potters. What's making the village famous even abroad is the quality—that must never be lost. Anyone can look inside oneself and discover a personal style. We have no reason to copy—we are all free here. I know some people are now using graphite and commercial pigments. I can't speak for everyone, but I believe that much of the magic resides in this respectful but always forward-looking encounter with our ancestors. That would be it. ❖

TRANSLATED BY JOHN PAGE. ❖

❖ MARTA TUROK

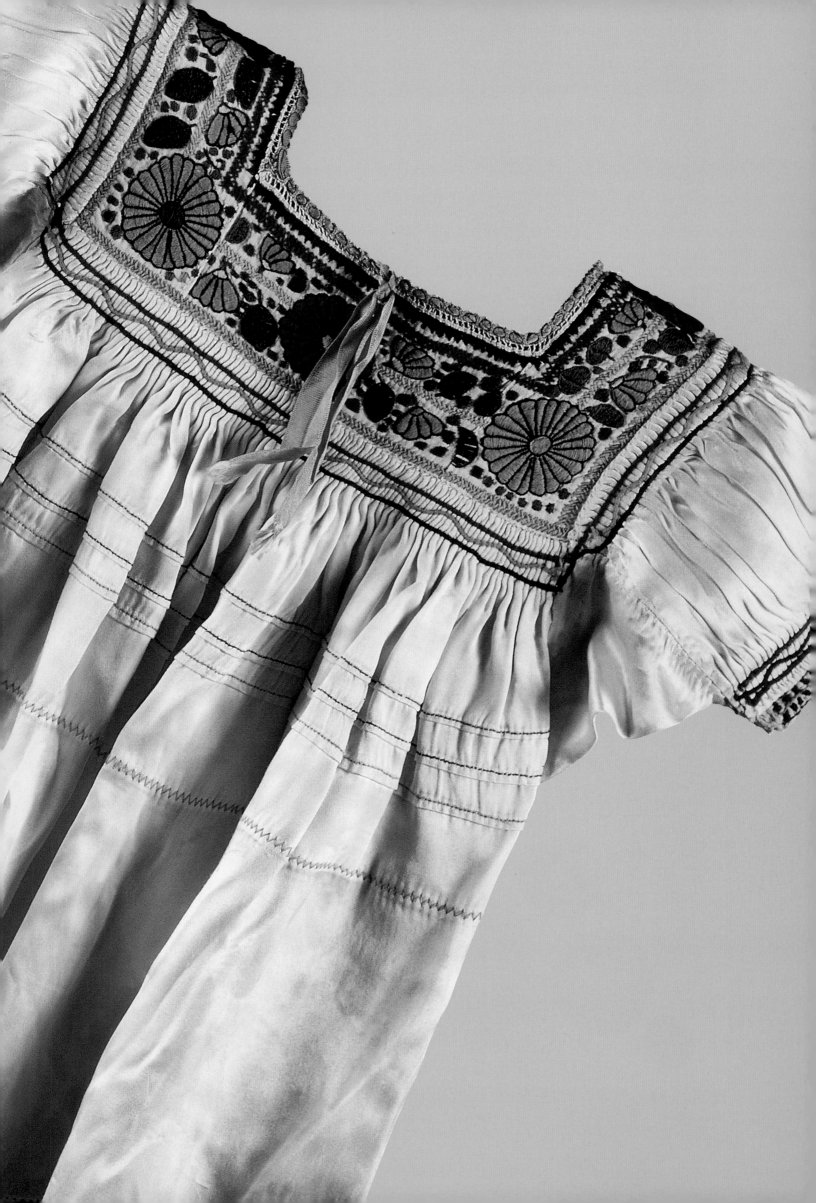

TEXTILES

HOW THE MOON TAUGHT US TO WEAVE ∾

∾ *Lexa Jiménez López*

It used to be that yarn was made the same way as we make children now.
The women made it themselves with the strength of their flesh.
When the world began, they say the Moon climbed a tree.
There she was weaving and spinning, up there in the tree.
"You should weave," she told the first mothers.
"You should spin," she said. She taught them to weave from up there.
That was the origin of weaving. That was the origin of brocade.
The thing is, we didn't even know how to card wool. She taught us that too.
She had her cards up there, and her loom and her spindle.
I'm not sure if she had her sheep up there in the tree with her.
Maybe she did.
The Moon had her stick to measure the warp, her *comen*.
 To measure the yarn.
Her *comen* was long and stuck out of the top of the tree.
When she finished spinning, when she finished using the spindle,
 she measured the yarn with her *comen*. She wove the red seeds of
 the brocade into the white fabric of a blouse. It was dawn up in
 the tree. She stretched out the warp up there. If it weren't for the
 moon, we would not know how to weave. She told us how to do it.
She made her cloth, her frame. She cut the branches of the tree to make
 her loom. If it weren't for that we wouldn't have learned to grow.
That is how our ancestors learned.
She carded, spun, wove and that is how weaving began.
She said, "This is how I will do it so my daughters might learn."
What was in the tree is now the Moon.
 She climbed higher and higher up the tree,
And then she climbed up the *comen* like a ladder,
 and she stayed up in the sky. Or she probably leaped up there,
 using the branches as a slingshot.
We still have her loom. It stayed with us. The Moon left us her huipil
 when she left. She left her loom and her machete.
The stewards take care of them and at fiesta time we take out the
 huipiles that the Moon was wearing when she made the world.
They are so big that we cannot weave anything like them.

TRANSLATED FROM TZOTZIL INTO SPANISH BY AMBAR PAST, AND FROM SPANISH BY MICHELLE SUDERMAN.

Opposite page
Petrona López
Chavinik with
María Gómez
Hernández of
San Juan Chamula,
Chiapas.

Pages 190–191
Blouse from
Aguacatenango,
Chiapas.
Hand-embroidered
satin.
Pellizzi Collection.

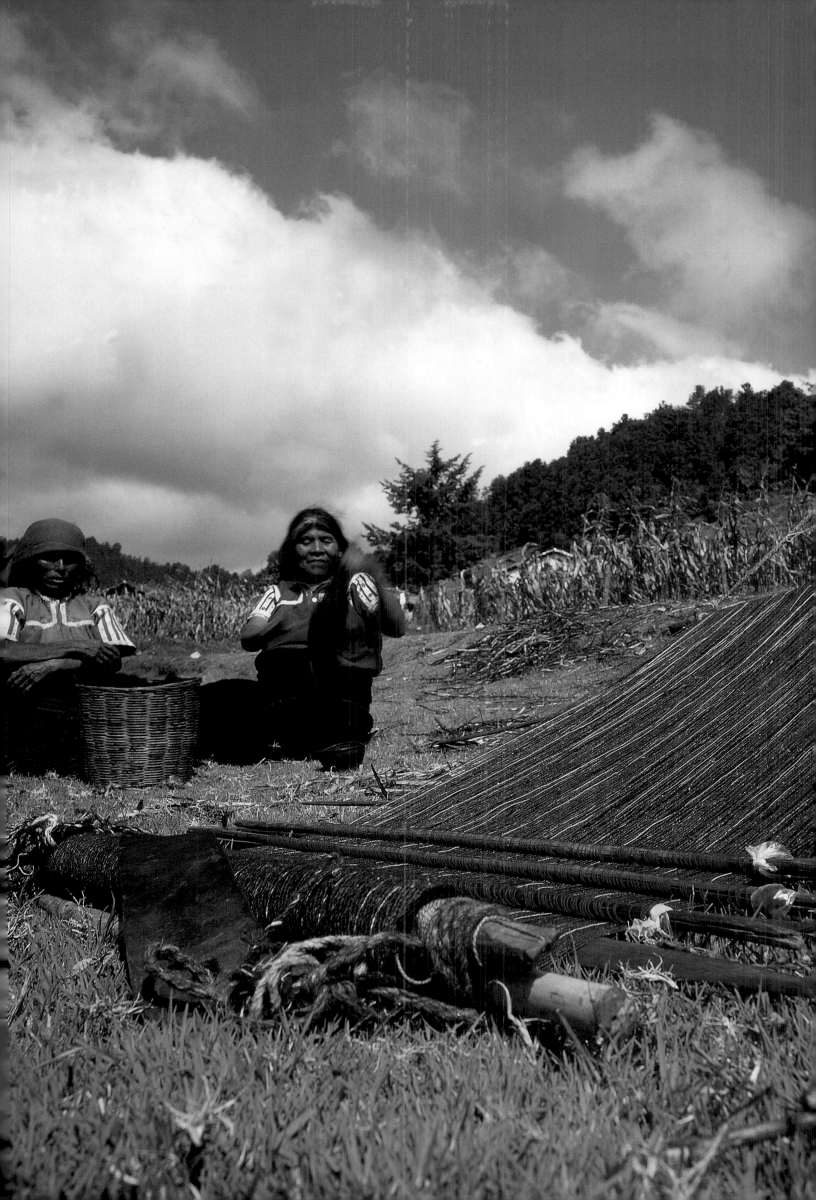

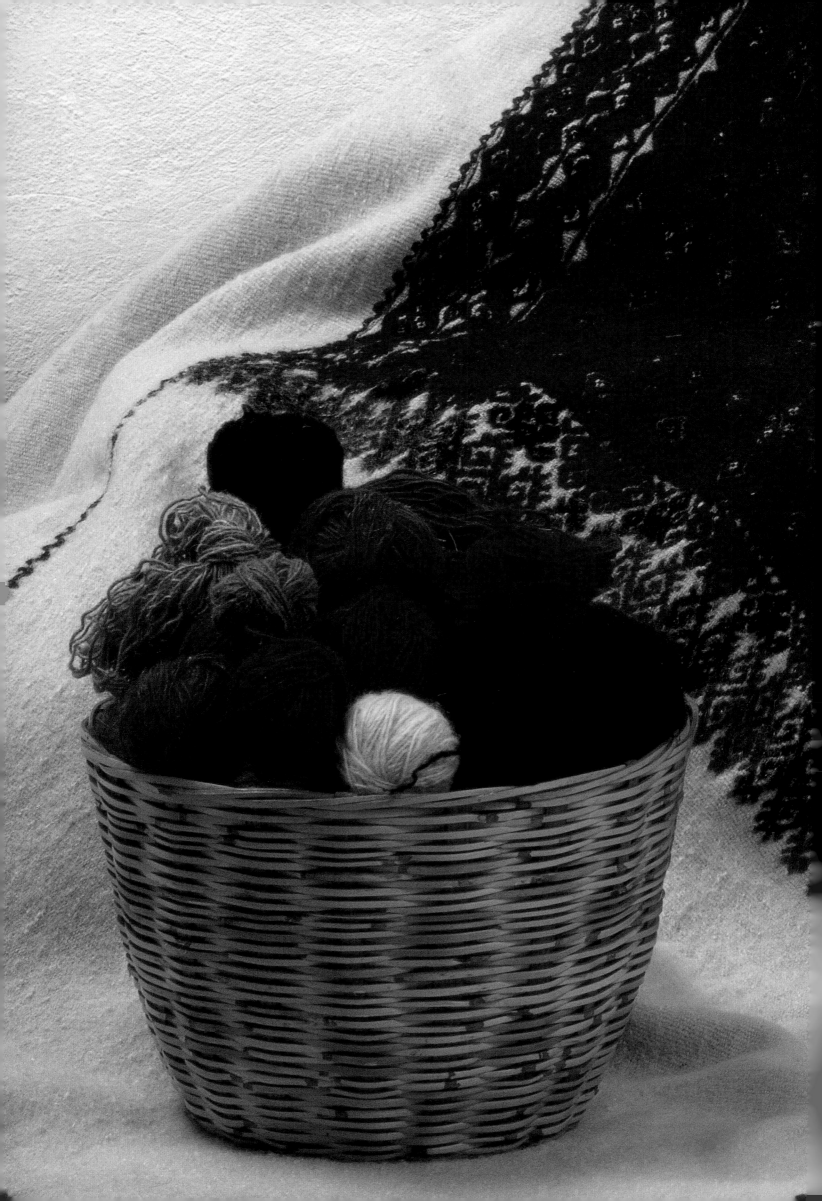

A WEFT OF VOICES ∾

∾ *Margarita de Orellana*

Tʜᴇ ᴡᴏᴠᴇɴ ꜰᴀʙʀɪᴄꜱ ᴏꜰ Cʜɪᴀᴘᴀꜱ ꜱᴘᴇᴀᴋ ᴀ ᴘᴏᴡᴇʀꜰᴜʟ ᴀɴᴅ ʙᴇᴀᴜᴛɪꜰᴜʟ language. For the most part, it is a coded language—just as traditional cultures usually seem to us. But deciphering the secrets held in these exquisite forms is an adventure that is well worth our while. One feature of what has come to be known as New History (a current initiated in France during the early twentieth century) has been to include precisely those historical subjects that conventional historians have deemed ineloquent. ⋄

Textiles from Chiapas relate ancient and modern histories to anyone who is willing to listen. They speak of indigenous peoples concerned with upholding their customs in a contemporary setting. They speak of cultures, and of the image different peoples hold of themselves and of others. They speak of the way of thinking in a part of Mexico where a tradition of creating beauty is a daily practice. ⋄

The first part of our journey consisted of visiting the towns where these fabrics come to life, and listening to the people that make them. The first place we visited was Venustiano Carranza on the lower slopes of an imposing mountain. We were looking for Pascuala Calvo Solana, a weaver teaching the craft to young girls at the cultural center. We were told she had gone to the market, but we soon came across her on the street carrying an enormous bundle of flowers on her head. She was dressed in a navy-blue blouse with fine white embroidery and the customary *enagua*, a local wrapped skirt with brightly colored embroidery on the seams joining the webs of fabric. She had made it herself. "The enaguas originally made here in Venustiano Carranza are more heavily embroidered when they are meant for going to Mass. We wear the plainer ones to the market or at home. The designs are small nopal cactuses (in Tzotzil, *pe toc*) and scorpion tails. The traditional enagua is decorated with birds, whereas the cactus design is more frequent in modern

Opposite page
Antique feathered
huipil from
Zinacantán,
Chiapas.
Traditionally worn
for weddings.
Pellizzi Collection.

Pages 194—195
Chamula ceremonial
huipil.
Woven on a
backstrap loom,
embroidered with
wool yarn dyed with
indigo.

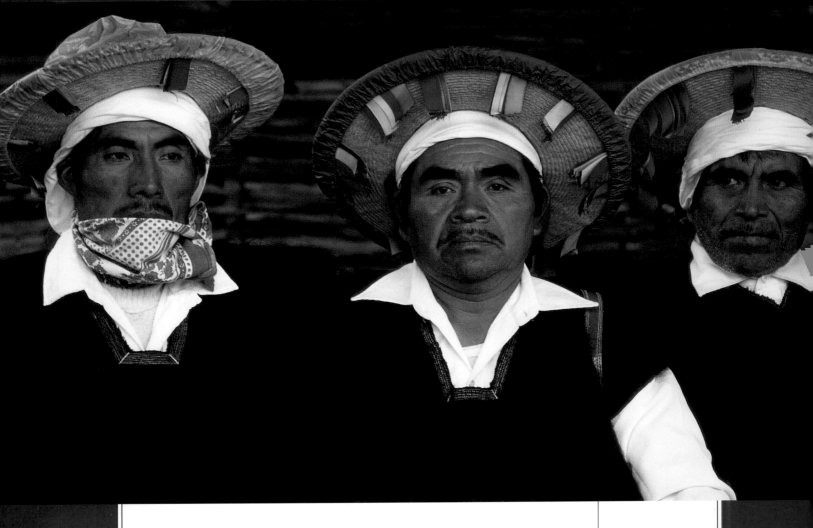

versions. It takes one month to weave a skirt; three to embroider it.
We send them to San Cristobal de Las Casas to be dyed." ❖
The conversation focused on the importance of preserving the
textile tradition. Calvo Solana was adamant on the need for
young girls to learn the trade well, remarking that, "I'll never
stop wearing traditional costume. I've always said that I'll die
true to myself." In the streets of Carranza we see very few
men wearing the traditional clothing that has the same
weave as the women's *huipil* tunic. The shirt is made of
a thin white cloth with rows of white embroidery. The
long pants are embroidered with red-and-green figures
in the shape of peanuts. As to this handsome costume, she
commented, "The complaint we have with our men is that
they don't want to wear that clothing anymore. They say the
caxlanes (Mestizos) make fun of them. Others won't wear it
because they are studying away from home. Today, clothing
for men is being modernized. The colors are changing. The
men no longer care if it features the original design." While

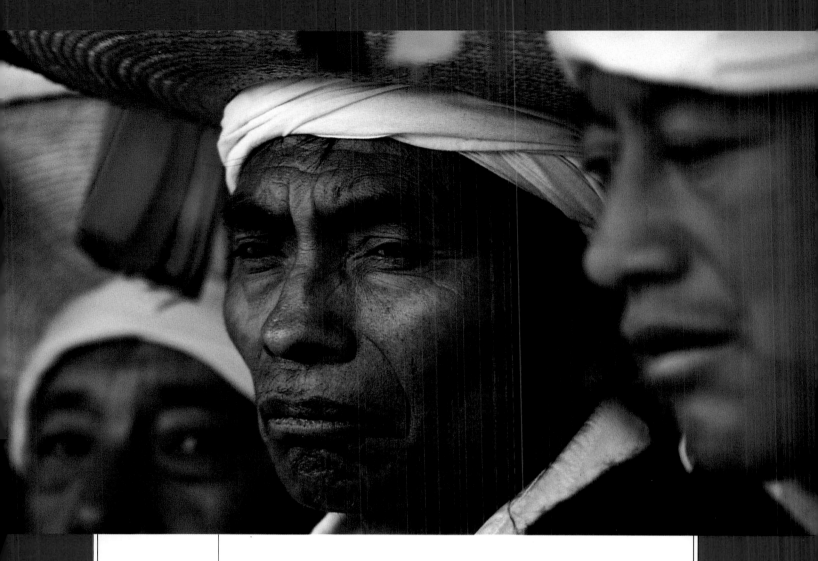

showing us the tools of her trade in the sunny patio of her home, Calvo Solana told us that she had not learned weaving from her mother, which is the custom. "Maybe it bored her, or maybe she never had the chance to learn. By the time I was five I was dying to learn. I went to see my aunt—she was slim and fair, with green eyes— and I told her I wanted her to teach me, but my mother scolded me and slapped my hands. Gradually I learned to embroider a bird, a worm or a small hill, until I could do everything." Pascuala Calvo Solana has entered her work in a number of competitions and she has won several prizes for her embroidery. ❖

The following day we found ourselves in a very different place from Carranza: San Juan Chamula. On the way there, we could see the blue splashes of the women's *rebozos* (shawls) dotting the fields in the distance among the vegetable gardens, or as they tended to their sheep. Many women also tie another square shawl around their head; these feature red tassels at each corner. Juan Gallo, resident artist and the director of the cultural center, was waiting to take us to see Petrona López, who is referred to locally as "The Lady Steward

of San Sebastián," in view of the fact she held that office together with her late husband. Bit by bit, Juan Gallo translated what she was saying. In a sweet, singsong voice, she sang the Tzotzil prayers dedicated to Saint John the Baptist, Saint Rose and the Virgin of the Rosary. Juan tells us that among Chamula Indians, the latter two are venerated as goddesses. They were the first ones to weave and it was they, he says, who taught the craft to the Chamulas. The women often dream that either Saint Rose or the Virgin is explaining how to embroider a special design. They light candles in their honor and pray that the fabric they weave will please the man for whom it was made, or that he may sell it quickly at a good price. According to Juan Gallo, something happened to Petrona López that is not infrequent among weavers in Chamula. When she was fourteen or fifteen years old, López dreamt that her thread kept breaking and that her fabric was all wrong, despite her many years of experience. Not long after those dreams, she realized she had mastered the art of weaving, because her dream was in fact contrary to reality. ✧

Upon showing us López's loom, Juan Gallo mentioned that in Chamula, sheep are practically sacred. They are neither slaughtered nor eaten, but may be sold to another family. Care is taken to ensure the animal is content and satisfied, for otherwise it will not produce good wool. If a ewe falls ill, the people of Chamula pray to the holy shepherd and offer him salt so that the animal will not die. And before a lamb is shorn, it is thanked for its wool. ✧

When the conversation drew to a close, we bought cold drinks for all the weavers, including Petrona López, who in fact sells them. The mountain sunshine is deceitful. The cold air and bright sun are a dangerous combination that burns the skin without your even noticing. We said our goodbyes to Juan Gallo and the weavers. ✧

We left Chamula taking the road to San Cristóbal and as we rounded the first mountain, we came upon a surprising town: Zinacantán. There, the blue of the Chamula *rebozos* is replaced by a mass of red, pink and yellow shawls. There was a small enclosed valley dotted with nurseries blooming with all kinds of flowers, especially chrysanthemums, gladioli and carnations—the same species of flowers that are embroidered in vivid colors on the men's ponchos. Pascuala Vázquez Hernández, a nineteen-year-old weaver, told us that bachelors are unsparing in the use of flowers on their ponchos. Married men, however, prefer to use more sober attire. Another way to distinguish a bachelor from a married man is by the length of the yarn attaching the pompoms to his poncho, as bachelors generally wear longer ones. ✧

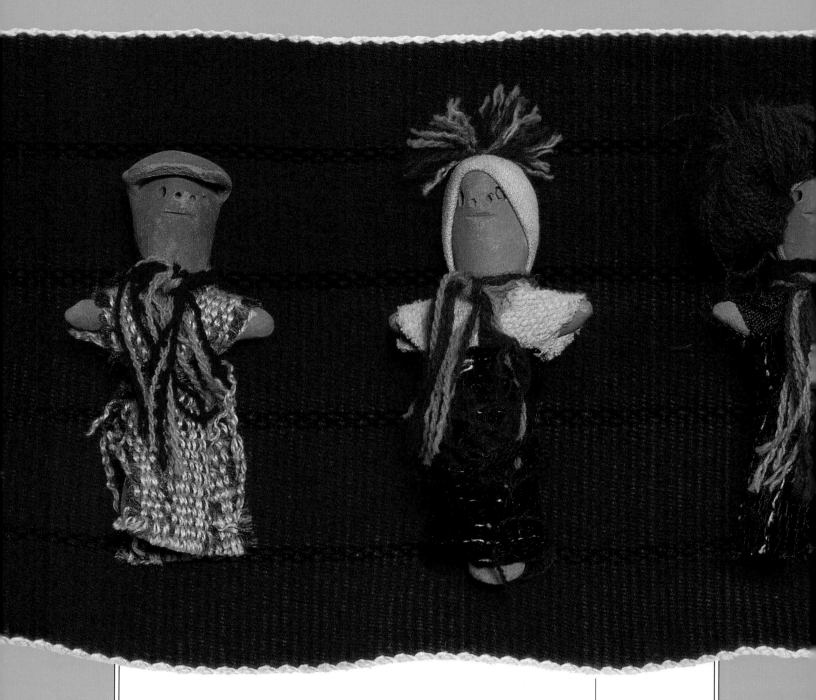

As she went about her weaving in a neat courtyard at her mother's house, Pascuala Vázquez Hernández gave us an account of what happens when a baby girl is born in Zinacantán: "When a mother is in labor, we fetch the midwife. If the baby is a girl, we place all the tools around her: the loom, the machete for cutting wood, the mortar, and so forth. After bathing the newborn in water sprinkled with bay leaves, the midwife returns the tools. We burn some incense and drink *posh,* the ritual alcohol of this region. Then we have a meal to celebrate the birth." Pascuala's mother, Agustina Hernández Pérez, was watching us from the kitchen, separate from the rest of the house, which is divided into well-defined areas. The courtyard was lined with plants. The colorful clothes hanging out to dry brightened the scene even more. With the arrival of Petrona

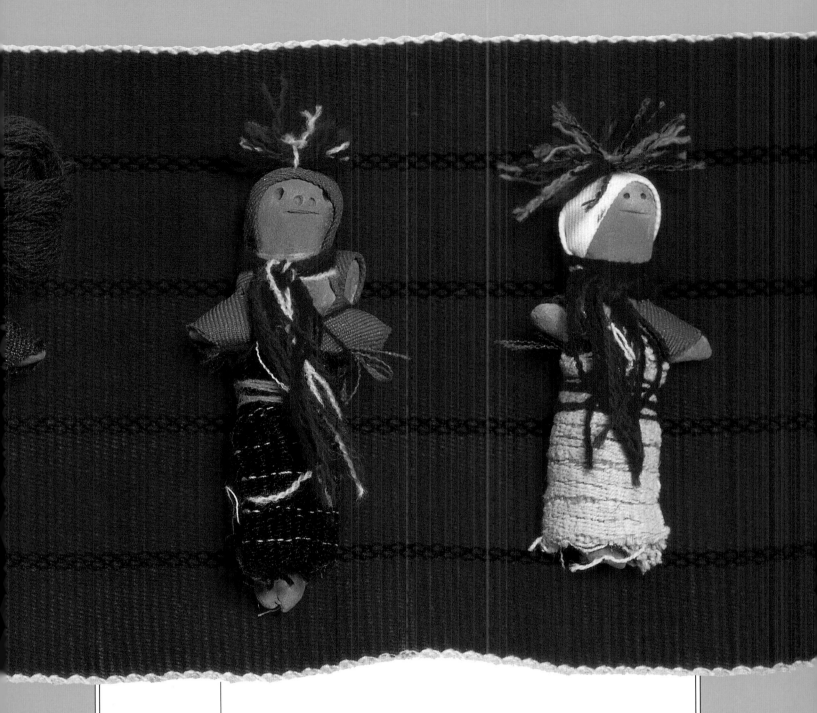

Dolls made of clay and dyed wool, by girls from San Juan Chamula, Chiapas.

—Pascuala's sister, who had had more contact with outsiders— the conversation began to flow readily, for she is more fluent in Spanish. Petrona Vázquez remarked that she prefers to wear very vivid colors. She had been weaving since the age of twelve and "now that she is old" (twenty-eight), she had mastered her trade. She proudly took out her wedding dress: "My mother made this bridal gown. These are hen feathers. We only use the whitest ones because the yellow ones make the huipil look dirty. First they must be washed thoroughly, then dried. Later the loom is set up and the cloth is woven with feathers and all." ❖

In his book *K'uk'umal chilil. El huipil emplumado de Zinacantán* (The Feathered Huipil of Zinacantán), anthropologist and photographer Ricardo Martínez Hernández states that the feathered huipil is woven in

the purest Aztec style and that in the sixteenth century it became a fundamental part of ceremonial attire in the highlands of Chiapas. Today, Zinacantán is the only place where this tradition is preserved. Martínez Hernández also mentions that this huipil symbolizes a proper marriage. "The use of hen feathers is representative of a highly domesticated person. This is because hens have wings, but are unable to fly. They move on two feet but are fenced in, as they depend on humans for food. And even when allowed to run free, they remain close to home. That is precisely what is expected of a bride." The same huipil, however, plays a completely different role in the fiesta of Saint Sebastian of Zinacantán, which commemorates the last victory of the Zinacantec Indians over the Spanish conquistadors. The *alférez* (assistant stewards) of San Lorenzo and Santo Domingo who have completed their yearly duties wear the *k'uk'umal chilil* to represent Spanish women whom they consider vain and materialistic. The character they portray is a commentary on the behavior of women deemed unfit for marriage. Through the use of humor they refer to the kind of values to which the women of Zinacantán should not aspire. ❖

Woman wearing a ceremonial huipil. Amatenango del Valle, Chiapas.

Taking leave of Petrona, Pascuala and their mother, Agustina, our next stop was San Pedro Chenalhó. As we traveled deeper into the mountains, the air became thicker, the light softer and the scenery more spectacular. After having our faces burnt by the Chamula sun, we began to enjoy the delicious coolness of the mountain humidity. Chenalhó lies in the cleft formed by two parallel ranges. It was four in the afternoon, and the hills were veiled in clouds. Scarcely a sound could be heard from the small town. We had no trouble finding Me Peshu, María Pérez Peso, an experienced local weaver who is older than the others. Some years ago her work was shown at the Smithsonian Institution in Washington, as part of an important international exhibit of manual arts. She could not speak Spanish, but a young girl, Paulina Santis, kindly translated for us. Me Peshu's husband received us in his customary *natil k'u'il*, a long garment open at the sides with very short pants held up with a leather belt. Me Peshu told us how she embroiders a huipil using woolen yarn dyed with different plants. She also sang the prayers that she intones as she weaves. Her grandmother taught her the trade, so as an adult she often prayed to her grandmother whenever she had difficulty weaving. In Chenalhó, there is a belief in the closeness of departed souls who offer comfort to those who pray to them. On All Saints' Day—when the dead return to visit the living—Me Peshu always honors her grandmother. ❖

San Andrés Larrainzar is another important weaving center in the Chiapas highlands. Our visit coincided with the San Andrés fiesta. A procession had left a neighboring village very early that day bearing a wooden effigy of the Virgin. At approximately eight in the morning, we saw them arrive, sustaining a brisk pace and carrying a wooden box which contained the statue carefully wrapped in *petates* (straw sleeping mats). They announced the arrival of their patron with firecrackers and music. We made an effort to keep up with the pilgrimage, but had to stop halfway up the hill. An impressive cloudscape resembling a vast lake surrounded the procession with a mystical aura. The pungent smell of pine, damp earth and burning wood infused the air. Upon reaching the edge of town they removed the statue of the Virgin from her box and placed it on a litter. ❧ She was dressed in a gorgeous huipil with diamond-shaped mirrors hanging from her neck. The fabric billowed voluminously on the statue, as it had been dressed in several layers of huipiles. Underneath were the huipiles that had worn out with time and use. The Virgin is the true keeper of the weaving tradition, for she preserves the designs that have passed from one generation to another. Later, the effigy was paraded through the central plaza and finally taken to the church. ❧ In his book *Living Maya*, Walter F. Morris tells us that in San Andrés a saint will sometimes appear before a woman requesting a new

❧ MARGARITA DE ORELLANA

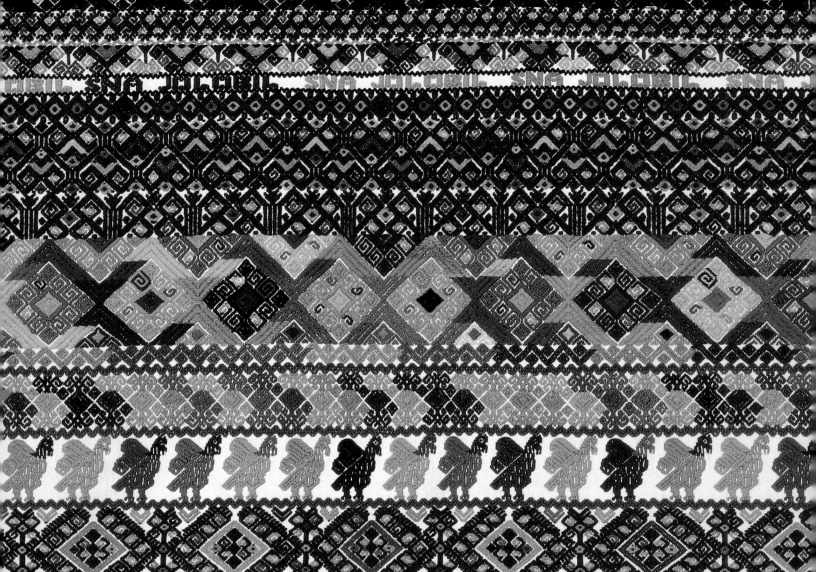

Opposite page

Embroidery sampler.

Chiapas highlands.

huipil, and she must heed the vision's request or risk falling ill. When this happens, the woman always weaves a huipil for the saint as an act of devotion. ❖

We watched the procession from a house known as Sna Jolobil, which means House of Weaving. With 800 members, this is one of the largest cooperatives in the Chiapas highlands. Here, many weavers work at preserving the tradition and selling textiles. That day, there was a work meeting attended by many of them. It was quite an experience for us to watch them debate in Tzotzil, all of them dressed in such an elegant, dignified manner. Thanks to Pedro Meza Meza, president of the cooperative and in many ways, a custodian of this tradition (as we will explain later), we were able to interview several of the women. We began with Micaela Gómez Hernández and Micaela Díaz Díaz. The former has served as mayor and judge of San Andrés, and the latter, during her husband's lifetime, served as second *alférez*, chief and steward. They took turns describing their experiences. They informed us that in San Andrés, girls between the ages of twelve and thirteen are no longer considered children. "Once they have learned to weave, they are no longer *olol*, or little girls. By that age they can sow corn. We make clothes for our men: trousers, capes, shirts. As a couple, we look better if we are both well-dressed." Recalling Morris's comment on dreams, we asked them if they weave in their dreams. "Our spirit weaves while we sleep. Sometimes we dream we are learning or teaching something we have never seen before. We also see beautiful designs that we often forget upon waking." ❖

Andrea Hernández López approached us. By the time she was fifteen, she was already making huipiles whose design was very sophisticated. She told us how she asked the Virgin to grant her the gift and the grace to become a good weaver. But she also requested something special: the ability to converse well and to speak eloquently in public. And she repeated her prayer for us: "Please, grant me your sacred voice, your sacred gift, your sacred blessing, your sacred wisdom." Andrea Hernández López would achieve what she expressed in her prayers. She wanted to be accomplished: to accept responsibilities and to know how to assume them. In fact, she became alderwoman and steward together with her husband. All three women expressed regret at the fact that we could not communicate in the same language. We assured them that their weaving spoke fluently in an invisible language through which we could understand one another. At that, the women nodded and laughed contentedly. ❖

A New Defense of an Old Tradition

An exceptional figure in the world of Tzotzil and Tzeltal weaving in Chiapas is Pedro Meza Meza, native of Tenejapa. He became interested in the art of weaving from a very young age. Not only did he become proficient in the craft—something uncommon in these parts, where few men weave—but also learned its significance, creating designs that come to life on the loom. He has devoted himself to reviving and promoting ancient weaving techniques, brocades and symbols of indigenous attire in Chiapas. ⁂

Meza opened many doors for us into the fascinating world of these textiles steeped in poetry. He told us, "I think the language of textiles is a traditional art, but it is also a creative one. It is the culminating point of Mayan culture. I imagine it began as a result of human observation. That is, the different weaving techniques emerged thousands of years ago after close scrutiny of barks and animals' nests and webs. The need for protection from the cold obliged human beings to invent the weft and the warp. Many years after this first stage, textiles became more elaborate: the shapes of everyday things began to be woven into cloth, including animals, plants and other forms found in nature. But a need also arose to capture things from the inner world so as to satisfy the human spirit. These creations were probably individual at first, and then collective. During the Mayan Classic period (AD 300–600), ceremonial textiles reached their peak of splendor. Each piece expressed a vision of the cosmos through a combination of threads, colors, shapes and symbols. To my mind, this manner of creating textiles is not one set form, but many patterns. Anyone can keep them alive. From these patterns, new designs and combinations can be created. It is an art form. Indigenous cultures today are particularly interested in preserving and recreating ancestral designs

Huipil from San Andrés Larráinzar, Chiapas. Woven wool dyed with aniline. Pellizzi Collection.

and techniques. Textiles are the religion that reaffirms our identity and our respect for Mother Nature." ✢

It was clear that Meza had spent many hours reflecting on the various implications involved in the art of weaving. He has his own ideas on the symbols of each huipil. Textile design is like a poem to him—each one has its own value. To achieve harmony between humanity and Mother Nature is the main reason for creating an entire system of symbols that are woven into textiles. It is a way of representing the geometry of time and space, of recreating an entire concept of the universe: a cosmology. Meza has produced huipiles with designs inspired by Mayan paintings and stelae, especially those of Yaxchilán, in an attempt to recreate the clothing of Mayan nobles and to use ancient designs for modern huipiles. Hence, the art of weaving is kept alive. ✢

In answer to our question as to why weaving is a calling, Meza responded, "Those who are not Christians, those who believe in the Sun say, 'I became a shaman because it was revealed to me in a dream.' And the idea begins to take shape in their mind. Often, the following day they may find themselves helping a *curandero*, or shaman, so as to begin their initiation into that science. The same is true for weaving. The goddesses created weaving: they were the first teachers of the art. In dreams, they reveal our duties. Weaving is an art that belongs almost exclusively to women, which is why they know more. In Tenejapa, weaving is beyond the comprehension of men; it is too difficult. While a man may cultivate the land, provide for his household or carry heavy loads, it is virtually impossible for him to live without a woman. Even the male authorities of the towns fail to perform their duties properly if they don't have a woman at their side to share in those tasks." ✢

His words prompted our curiosity about his own past. We asked him how he became involved with textiles, how he became convinced of the importance of this art. Without hesitation, he replied, "My mother followed a tradition without stopping to wonder why. She inherited what our ancestors left her. It was important to her because clothing was a necessity. Not only that: how was she supposed to have felt good about herself wearing such plain attire? She wasn't the only one: everyone felt it was an obligation. The finer the weaving, the more respect the weavers awakened in others. Although they also ran the risk of inciting envy. For some, weaving was a way

of bettering themselves; for others, it meant making a quick sale to someone unfamiliar with the rules of the trade." Meza went on to recall his own upbringing: "As far back as I can remember I always tried learning this difficult art by weaving any kind of thread I could lay my hands on. Boys are not allowed to weave, much less to take any of the yarn the women use to make their huipiles. In my house, boys were forbidden to go near a woman's loom because they would get sick if they got tangled up in it, according to my mother. She also used to say that if a boy put his head into the loom, he would eventually find himself drinking plenty of corn *atole* because the threads are starched in corn gruel. However, when she began to notice my tremendous curiosity, she put me to the test one day, saying, 'Take this yarn. If you finish this little bag like the sample I'm going to show you, I think you'll soon learn what weaving is all about.' The design was simple enough. I understood it and I quickly began to combine colors and shapes." ✛

Years later, Meza finally mastered the craft. Though he sold bags, looms and other articles, he was still unaware of weaving's significance. "It was like living in a forest. Everything in it is ours: it belongs to us. Yet we never wonder about its value or where it came from. Those questions surfaced later." Pedro now devotes his life to seeking answers to those questions. For years he has lived immersed in the complex language of textiles. He is enthusiastic about his work and his passion is contagious. As long as his energies are channeled into weaving, this art form is unlikely to disappear. I think the ancestors of his dreams were very clear about one thing: Pedro Meza was to be a warrior, defending the memory of his forebears armed with a loom. ✛ Translated by Carole Castelli. ✛

THE TEXTUAL TEXTILE ∾

∾ *Marta Turok*

THERE'S A FLOWER CALLED THE MAGDALENA. ITS LARGE PETALS LOOK like the designs on a *huipil* worn by an image of the Virgin Mary. Its smaller petals are like the towels that little girls make for the Virgin when they first start weaving. The flower is very pretty, like the huipil the Virgin was wearing when the world was created. ∾ Standing by the tree, the Virgin was weaving her designs because she has clever hands, as do her children. She was talking to them, saying, "Be obedient and work." To the men she would say, "Make haste and grind the corn for your tortillas, haul the water and when you finish, start weaving your clothes. Watch how I spin the cotton with the spindle and how I set up the loom. I want you to remember me, to dress me, to write the history of our people so that it not be forgotten." ∾ So our ancestors thought, "Since the Virgin taught our women how to make designs and write on cloth, they shall take the word, our word, to the children of the children of the *Batz'i vinik*, who are true men." That's why when we make the Virgin her gift, we talk to her so that our hands will work deftly and she will touch our hearts. This is what we say:

How great is your holy land, Virgin Mary,
I am with you once again, here in your holy land.
I am in Glory with you,
because you have given me your three graces,
because you have given me your three blessings.
You instilled your blessings in my body,
in my holy body.
My blood tells me so.
I want to learn the sacred craft.
May the Virgin's fingertips
benevolently touch my heart,
broaden my understanding, my mind....
May she bless the tips of the shuttles.
I want to learn her texture....

Pages 213, 214, 216 and 217 Ceremonial huipil used to dress a statue of the Virgin Mary. Magdalenas, Chiapas. Cotton yarn and natural dyes. Collection of Sna Jolobil.

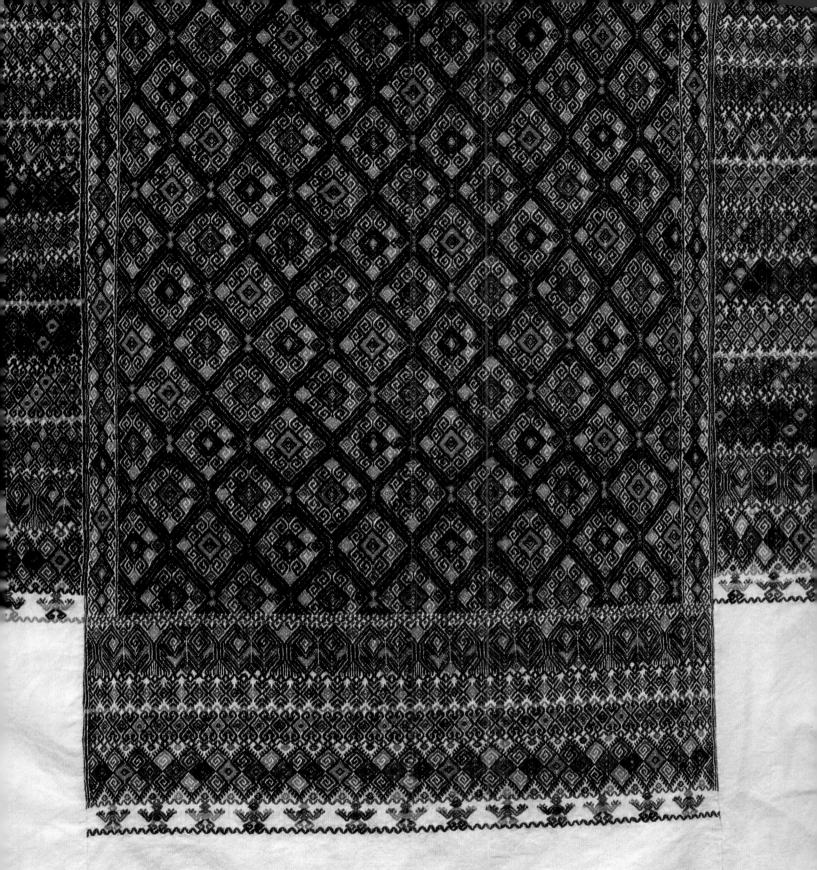

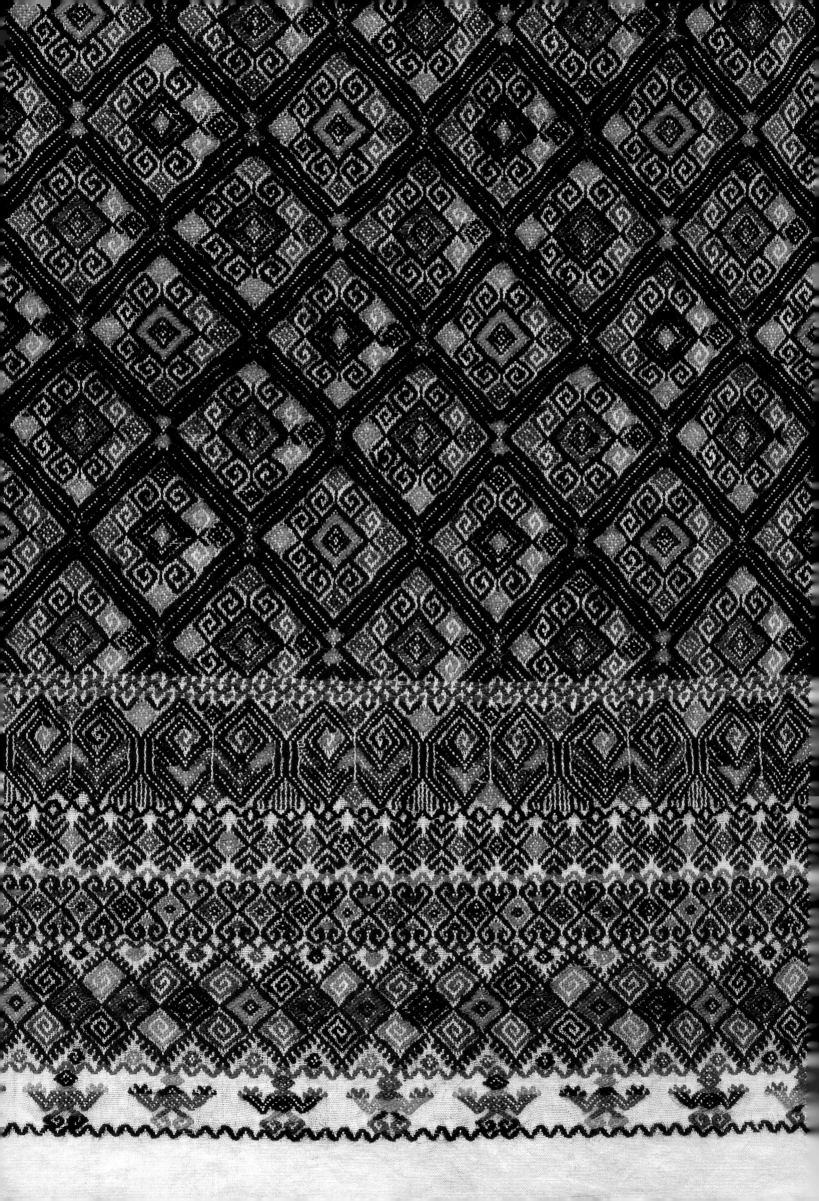

I bring you my ball of thread.
With a flower that I bring you…
Give me your three graces,
Give me your three blessings.
Let me see all your fields and gardens,
Let me see all your miracles,
Throw off your huipil, Virgin,
And cover envious eyes…
With your outer garments, block the view
of whoever is looking at me.
May all your blessings be given in flowers. ❧

Here in the town of Santa María Magdalena we weave all the clothing worn by women, men and children, such as tunics, enredo skirts, blouses and sashes. But the finest of all is the gala huipil, a loose tunic, worn by both mothers and daughters as well as the wife of the *alférez* (assistant steward) and our mother the Holy Virgin Mary Magdalene. Many women know how to weave sashes, but it takes a special kind to learn to weave a huipil. Only a few families have the ability, such as we the women of the Álvarez Jiménez family, the Z'o't'ul family, and Juan Vázquez's wife. ❧

That's why every year, when Festival time draws near, the alférez and his wife show up to rent a huipil from us in exchange for four bottles of liquor: two when they pick it up and two when they return it. Now that my daughter has grown up and learned the craft, I am teaching her to weave a huipil and telling her its history and the secrets it holds. ❧

A huipil consists of three webs: the middle piece or "mother" and the sides or "arms." Together they describe our universe where I—a fertile woman—am at the center. For the fiestas we decorate crossroads, springs, the hillside and the inside of the church with garlands of bromeliads and sedge. I also weave a garland around the huipil's neckline, and the entire brocade forms a large cross on the shoulders, chest and back. ❧

Do you see the many rows of a diamond-studded design on the center web? This represents the cosmos. Each diamond contains the world, which for us is like a cube with three planes: the earth is on a plane between heaven and the underworld. ❧

At the center of each plane is the Sun, Our Lord Jesus Christ, who accompanies us every day on his passage from east to west, as well as at the solstices, to tell us when to plant and harvest. He is also with us at the sacred corners of the world and in the cornfield where the *vashakmen* stand and support each plane. ❧

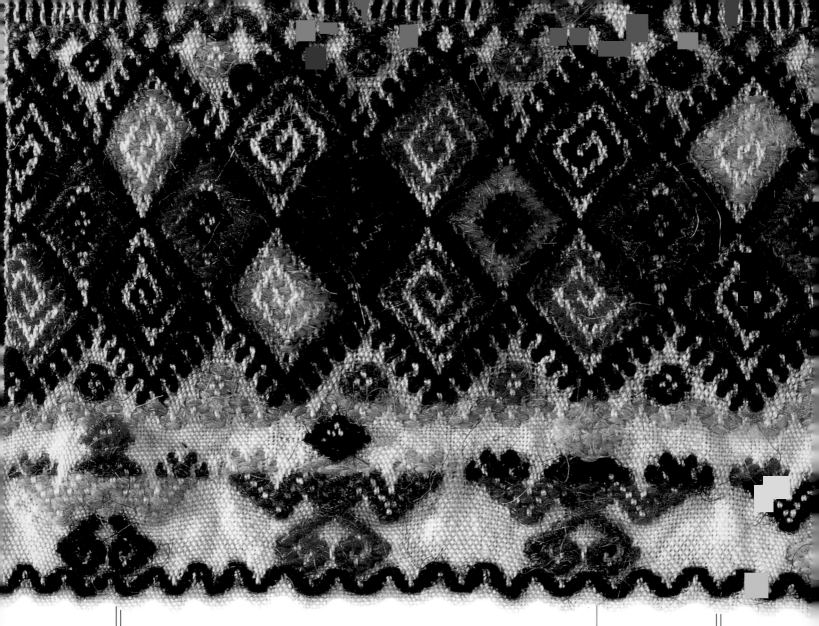

Like corn kernels and the cardinal directions of the diamond-shaped world, a huipil is painted red, black, yellow and white. That is why we plant so many cornfields, so Our Lord may pass through them all. ❖
Have you counted the number of rows in a diamond-world? There are twenty-six in each one. Rows nine and thirteen are marked with a line. There are thirteen steps from earth to heaven, and nine steps from earth to the underworld. ❖
Whenever Our Lord is resting, the stars light our way and herald the dawn, which is why they go around the edges of the world. Consequently, they are placed up the sides of the central panel of cloth. On his way Our Lord passes through many towns, so on a huipil, in the rows beneath the world, we must let him know with three designs who is asking for his blessing. First we will tell him we are from the Magdalenas community, that our symbol is death (bat-buzzard-worm)—because the black wind blows through here—and that the design is called Crown. ❖
Secondly, we will tell him that it is the Álvarez Jiménez women who are with him in his holy land. For this purpose we use a bee figure

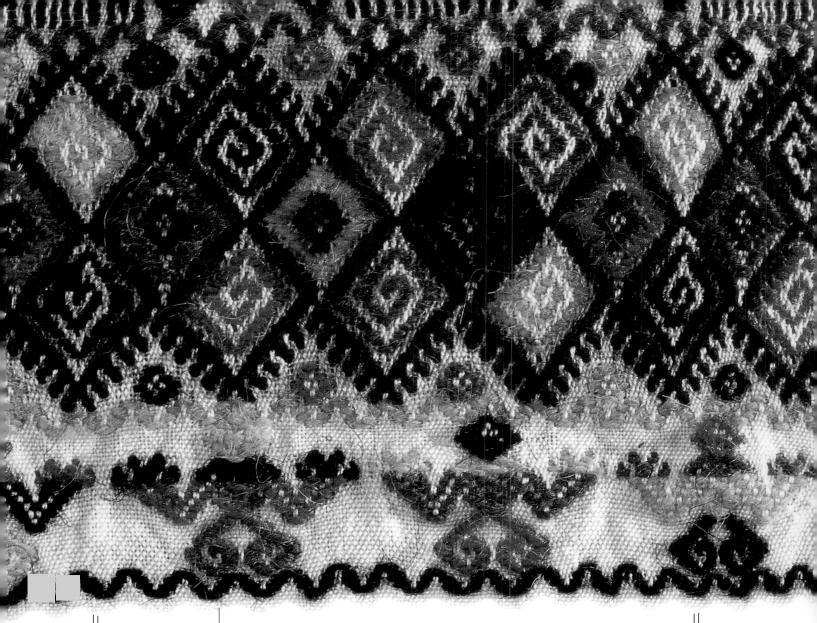

we call "The head of Our Lord Esquipulas on the Holy Cross."
This design reminds us of the fact that bees are cotton seeds that
Jesus Christ scattered under a tree, that we women create man from
a seed, and that Our Lord of Esquipulas, in our town church,
performs miracles. Finally, we each have our own personal design.
I use a variant of the star design. You will use a different one. ❧
Sometimes Our Lord and the Virgin do not listen to us, despite
the prayers of so many communities! A stronger voice is needed
to speak on our behalf. So on the back of the huipil in the very last
row we ask the Master of the Earth (*Yajval Balumil*) to intercede for us.
This is what the center of a huipil looks like. ❧
If we have already talked about the world, the community, our
family, and identified ourselves as weavers, what else do we pray
for? Remember that when the world was created, the Virgin told
men to plant their cornfields, so we must pray the corn will grow
and that we will not die of hunger. The bromeliad, food of the
gods, appears at the neckline, while corn and beans, food of man,
appear on the sleeves. ❧

The agricultural cycle of corn and beans, shown as yellow and black seeds, begins at shoulder level. They keep growing, row by row, down the sides of the sleeve, until they are ripe. And to reach that stage, we need plenty of water, plenty of rain. ❖

The Master of the Earth lives in an underground cave and controls life, wealth and death. We place him just beneath the flourishing cornfield. ❖

The Lord of Rain, or Angel, forms clouds with the help of his children. While the clouds beat the cotton, he transforms it with thunder. And so on. Finally, there's the messenger of these lords, the toad, who, like any good servant, waits at the entrance to his masters' cave. He is our closest intermediary because it is easier to converse with him. Moreover, whenever he appears in the village we know he is forecasting rain and it is as if he were bringing us an answer. One day we will become masters of the earth once more; we will no longer be the servant at the entrance to the cave. Consequently, you must include many, many toads because they are like us. The agricultural calendar lasts 360 days, consisting of twenty eighteen-day months, and the ritual cycle lasts 260 days, divided into twenty thirteen-day months. The toads are placed in groups of twenty to represent the months, the Master of the Earth with his servant toad is represented eighteen times, nine on each sleeve to symbolize farming days. The Angel appears thirteen times, six on one sleeve and seven on the other, standing on each step to heaven and marking sacred days. ❖

Wherever these three figures appear, add small green flowers, because this is the color of water, living plants and life. ❖

Snakes slither between the rows of designs, separating cycles and characters, while also joining them together. An example is the plumed serpent (*Bolonchón*) which meanders between earth and cosmos, or the small snakes that take care of the cornfields and the Lord of the Earth. Sometimes only a trace is left of the route where they have passed (*Be chon*), and sometimes their route is thorny (*Ch'ix*), but they are important to the message in our huipil. ❖

This is how the huipil ends, and where your work—your apprenticeship—begins. To fulfill your pledge you will weave and offer the Virgin your best huipil; you and your husband will take on the job of ceremonial hosts and you will accompany the Virgin at festivals wearing another huipil that you have woven. When I die you will bury me in my best huipil, and in this way we shall pass on our words through the daughters of the daughters of true men...."

❖ Translated by Carole Castelli. ❖

Opposite page Pascuala Hernández, weaver from Zinacantán, Chiapas, using a backstrap loom.

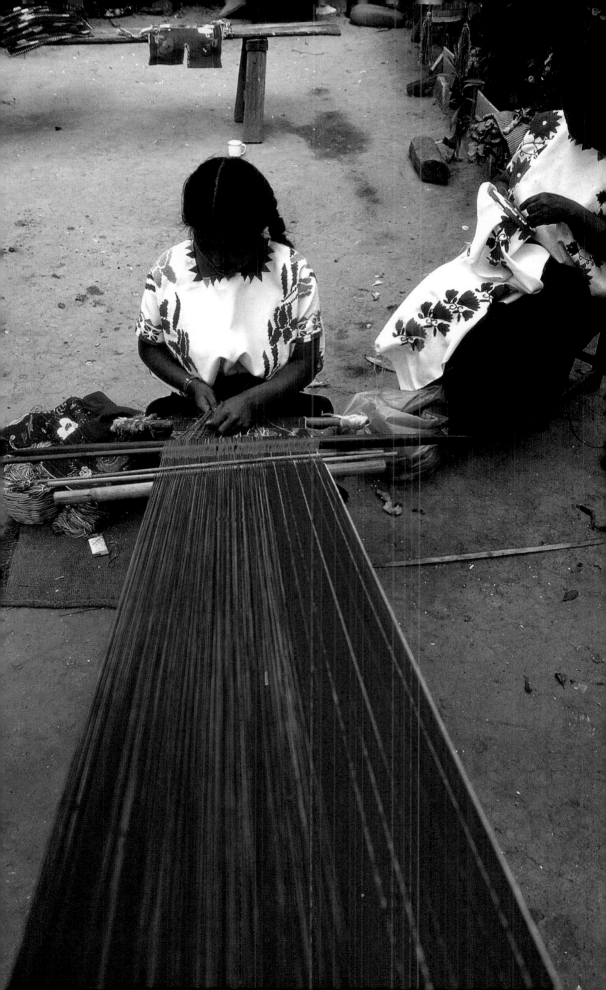

FLOWER WOMAN
Sna Jolobil

Mother in flower
Your first daughters
Your first daughters
Want to weave their shawls
Want to weave their jackets
So they do not feel the cold
So they do not feel the rain
Work yourself until death
Place in their heads
Place in their hearts
Place in their hands
Place in their hearts
The three spindles
The first three spindles
The first three cards
The first three pots
The first three dyes
The three branches of ambrosia
The pages of the three books
The three colors of the letters
Your first daughters
Your first daughters
Want to learn
I want to learn
Ancient mother in flower.

*Opposite page
Drawings by children
from Tenejapa,
Chiapas.*

This poem was originally written in Tzotzil. Reproduced from *Bon*, a pamphlet on the art of using dyes, published by Sna Jolobil, an association of indigenous craftswomen. Translated from the Spanish by Michelle Suderman.

THE ANATOMY OF A TEXTILE TRADITION ㇐
㇐ Irmgard Weitlaner Johnson

The indigenous textiles of Oaxaca exist in an extraordinary diversity of colors. In their design, they display an extensive range of techniques as well as refinement and beauty. Some motifs are varied, others take very conventional forms, while still others exhibit a charming simplicity, humor and imaginative quality. ❧ This brief essay focuses on details from nine outstanding pieces of traditional weaving representing six different ethnic groups in the state of Oaxaca. ❧

Their selection was principally based on six characteristics. First, all the textiles were handwoven on a backstrap loom. Some are composed of finely spun cotton threads, as in the case of the antique huipil tunic from the coastal area of the Mixtec region, while another of the selected pieces was created entirely from handspun silk, cultivated in the area around Huautla de Jiménez. In other areas, silk was used exclusively for embroidered designs or brocade. ❧

Another important selection criterion was the weaving method, for example the weftwrap openwork technique and the discontinuous weave gauze technique whereby a section of selected warp threads is woven in and out of the weft. Two of the most complex weaves known, they are unfortunately no longer in use. ❧

We also took into account the use of traditional dyes employed since pre-Hispanic times such as that derived from the *Purpura pansa*, a type of murex or mollusk used by the Huave and Chontal Indians, and by weavers of the Lower Mixtec, as well as that derived from the cochineal insect (*Coccus cacti*) utilized by the Chontals and the Mazatecs. ❧

Several pieces were selected for their uniqueness as traditional clothing, notably in the case of the Huave huipil, the Mazatec *ceñidor* (sash) and the Chinantec *paño* (head covering). ❧

The particular purpose of certain pieces was also taken into consideration, such as the ceremonial function of the tablecloth

Opposite page
Antique Chinantec huipil for weddings and fiestas.
Valle Nacional, Oaxaca. Collection of Irmgard W. Johnson.

Pages 222–223
Antique handwoven Zapotec huipil. Santiago Choapan, Oaxaca. 1943. Collection of Irmgard W. Johnson.

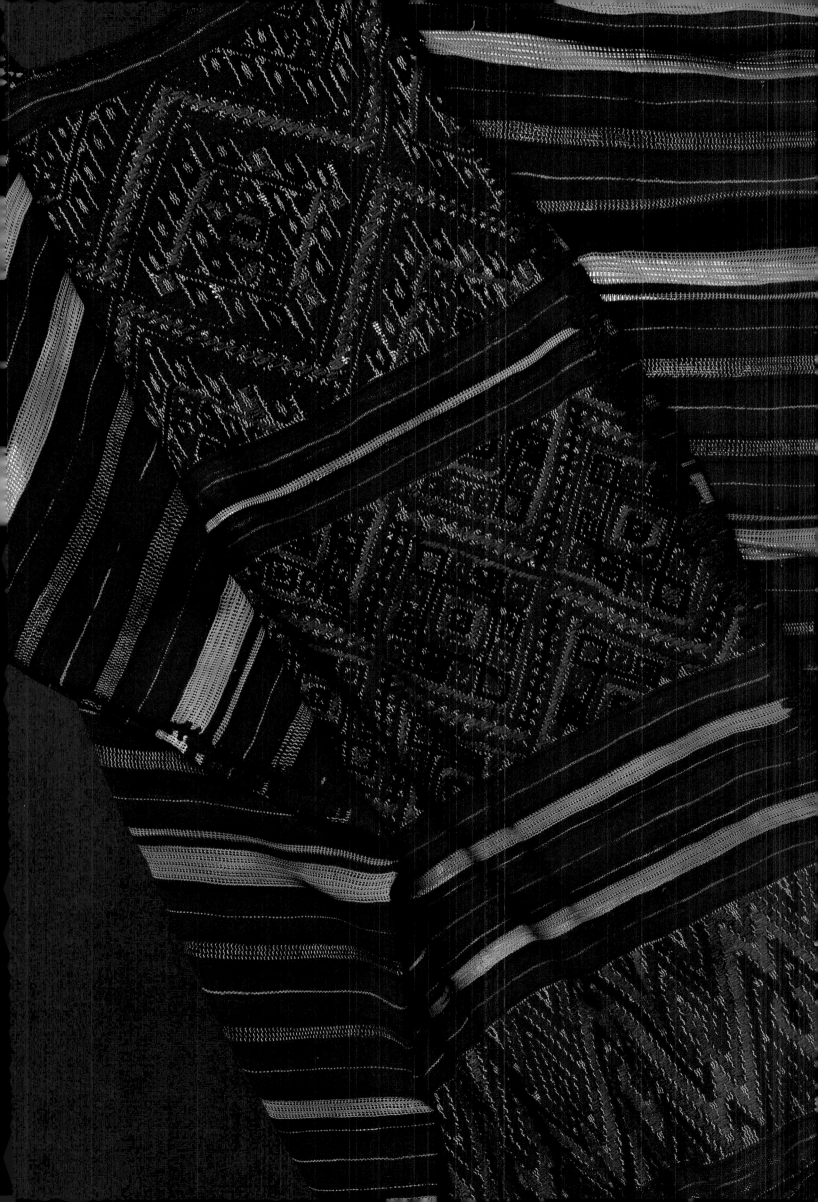

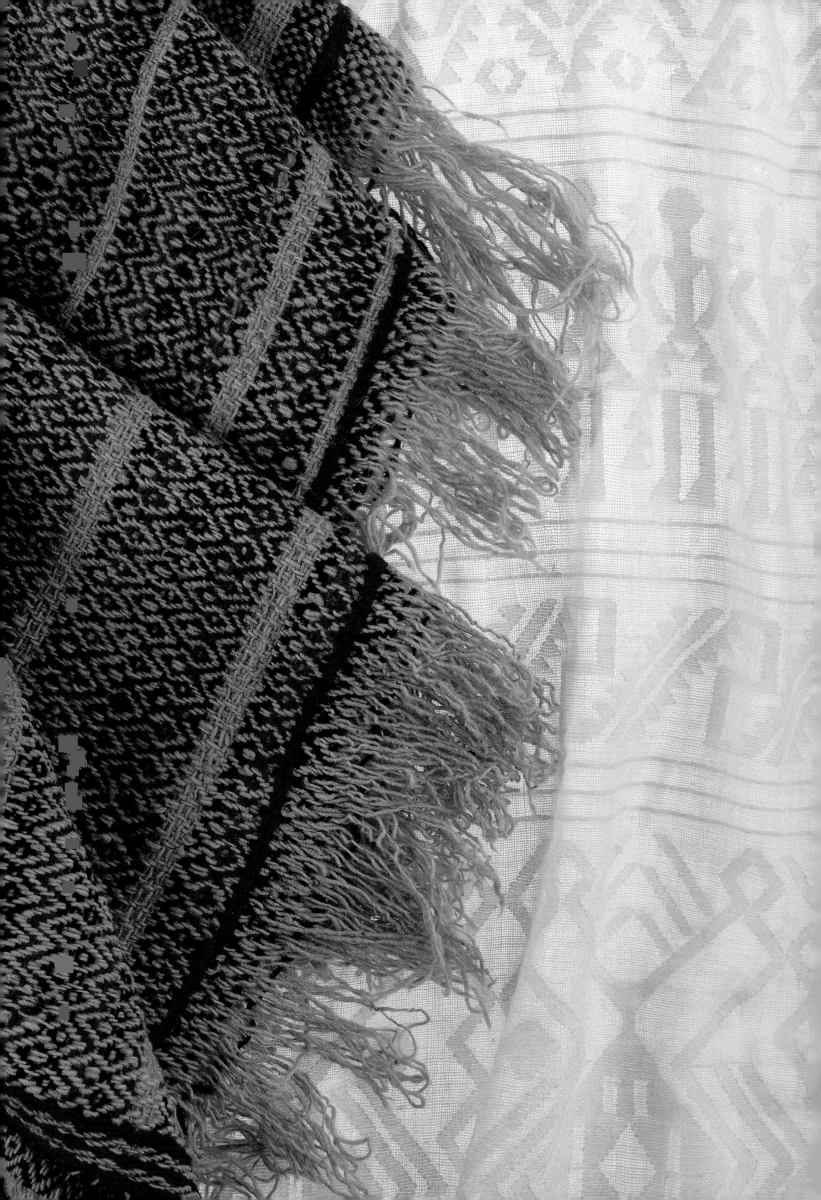

from the Chontal region, used as an altar cloth, or the showy length of textile that acted as a Chinantec sampler. ❧

Finally it is important to point out some ancient designs that have survived as special decorative elements in these textiles, notably the two-headed eagles found in brocade work on Zapotec huipiles from San Bartolo Yautepec and on the white-on-white brocade huipiles from the Lower Mixtec region. This design was also created with weftwrap openwork as featured on huipiles and some men's clothing from Santiago Choapan, as well as in embroidery below the neckline of Mixtec huipiles from the Jamiltepec region. ❧

Not all contemporary motifs are of indigenous origin. Some are copies of well-known European designs such as the crowned two-headed eagle. ❧

Among the Mazatecs, the presence of the butterfly as a textile motif is particularly interesting for its likely relationship to pre-Hispanic traditions. To this day the Mazatecs identify the butterfly as the soul that leaves the body. They believe that the souls of the deceased have permission to come to this world once a year on All Saints' Day and the Day of the Dead to visit their family. This is the period when butterflies are most abundant in the area and the Mazatecs consider it a sin to kill them. It is indeed extraordinary that the otherwise conservative Mazatecs from Ayautla decorate their clothes with traditional butterfly designs. Here we are dealing with a clear case of the survival of pre-Hispanic symbolism. ❧

One of the most typical motifs of Mesoamerican indigenous art is the *xicalcoliuhqui*, or stepped fret, of which there are innumerable variants and degrees of stylization. There are various theories on its origin and meaning. According to José Luis Franco, the intrinsic importance of the *xicalcoliuhqui* resides in its form, in the fact of its dual nature. The word itself means "a twisted ornament for decorating gourds." ❧

Ancient Mexicans called the S-spiral or double spiral *ilhuitl*. Broken down into its phonetic elements, the word means "fiesta day." This design can be found woven into Chinantec huipiles from Chipiltepec and embroidered on huipiles from the communities of Valle Nacional and Ojitlán. ❧

In the pre-Hispanic period, color was linked to the four cardinal points. The most common version places yellow in the East, red in the North, blue-green in the West and white in the South. Today, however, there is little information on color symbolism in the textiles of Oaxaca. One probable example of surviving symbolism has been noted among the Mazatecs of San Pedro Ixcatlán.

❧ IRMGARD WEITLANER JOHNSON

According to Gonzalo Aguirre Beltrán, during pregnancy, women always wrap a red *faja*, or woven sash, around the waist to protect themselves from evil. ❧

Another traditional decorative element used by various ethnic groups is the small rectangular ornament just below the neckline of the huipil, seen on Chinantec attire in Ojitlán. An interlacing transverse band is common in Mixtec huipiles from Santa Catarina Estetla, while the Zapotecs of Yalalag adorn their costume with a thick plait sewn beneath the neck opening. Embroidered horizontal bars appear on the Zapotec huipil from San Bartolo Yautepec and an antique embroidered huipil from the Mixtec coastal region. All of these variants are without a doubt related to the traditional rectangular motif that dates from the pre-Hispanic era and is frequently illustrated in period codices. It also appears in miniature on some huipiles found in a cave offering in the Upper Mixtec region. Today this element represents the continuity of an ancient tradition though its original significance is largely unknown. ❧

The *ceñidores* of Huautla de Jiménez, the traditional huipiles from Valle Nacional, certain white cotton garments from Pinotepa de Don Luis and the Chontal cloth are examples of textile types that have unfortunately disappeared from the weaving tradition. ❧

Others, such as some antique huipiles from San Bartolo Yautepec, have been reintroduced, although contemporary versions do not display the same quality. Despite the extreme complexity of the situation, pieces such as these should be conserved and efforts must be made to keep indigenous textiles from disappearing. ❧

Chinantec Weaving from Valle Nacional

Antique huipil for weddings and fiestas (page 225). The fabric is a combination of plain weave and brocade patterning on a gauze ground, using white cotton, red and blue threads, as well as yarns of various colors. Created on a backstrap loom, the three sections of cloth are linked by a blue-and-red decorative band. The most profusely ornamented section is the central panel which features concentric lozenges and hook-shapes in a complex polychrome design. The side panels are outstanding for their finely worked horizontal bands created from a plain weave in red cotton alternating with narrow bands worked in white gauze weave. Whenever the weaver would finish one of these luxury garments, she would dye the white bands an attractive blue color with indigo. This sort of gala huipil is an example of the traditional "red" style of Valle Nacional, which seems to have disappeared completely from the weaving tradition. ❧

Opposite page
Traditional
Chinantec huipil.
Valle Nacional,
Oaxaca. 1934.
Collection of
Irmgard W.
Johnson.

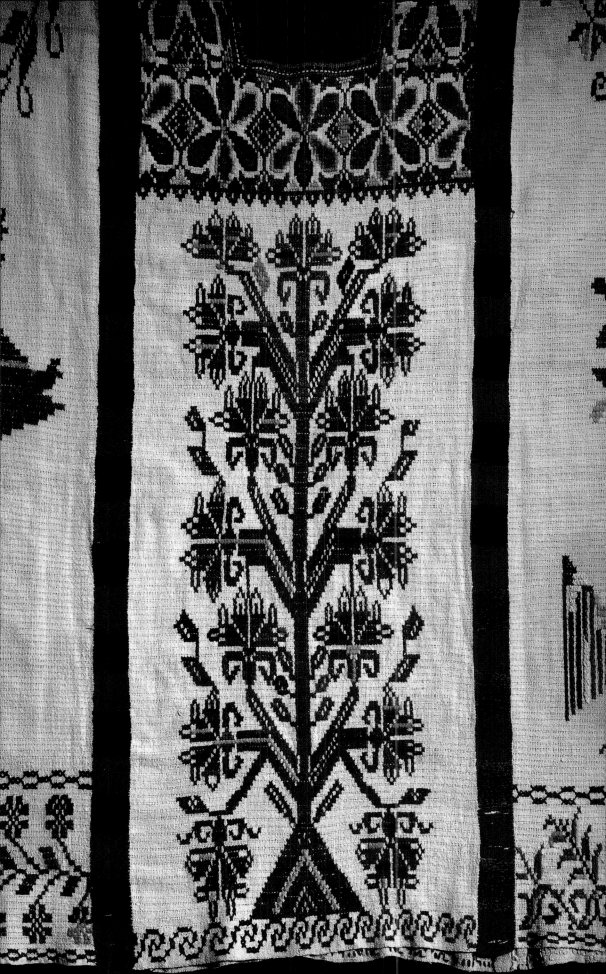

CHINANTEC WEAVING FROM VALLE NACIONAL

Traditional huipil used in 1934 (page 229). The three webs are woven from white cotton on a backstrap loom. The weave itself is a combination of narrow bands of plain weave that alternate with rows of simple gauze weave. The decorative motifs are embroidered in cross-stitch using the traditional red and blue with details worked in yarn of different colors. A broad decorative band covers the seams linking the sections of cloth. In this part of the Chinantla region, the most frequent design is a stylized plant emerging from a pot, adorned with flowers, leaves, birds and butterflies. This "tree of life" occupies almost the entire space on the front of the huipil. The sides of the garment feature isolated embroidery depicting large birds, stars, the *ilhuitl* motif, deer, monkeys and lions, as well as floral motifs and spiral designs. This huipil corresponds to one of the two traditional styles of Valle Nacional, the "white" style. ✀

CHINANTEC WEAVING FROM SAN FELIPE USILA

Antique paño used as a turban by elders, municipal presidents and community leaders during civic or ceremonial events (page 230, left). The textile is woven from red cotton on a backstrap loom. Various ancient motifs are featured in a finely worked weft brocade with yarn in shades of violet, wine, pink, green, blue and black. Five motifs make up the different sections: the group woven in the corners presents a two-headed eagle surrounded by four stylized butterflies while the sides of the huipil feature the two-headed eagle surrounded by inverted stepped frets. In the center of the cloth there is a large geometric design possibly representing the sun, surrounded by butterflies. Some of these motifs have symbolic names in Chinantec. The color combinations are extremely vibrant and the total effect is a truly beautiful work of art. ✀

CHINANTEC WEAVING FROM SANTIAGO QUETZALPA

Sampler woven entirely on a backstrap loom (page 232). The weaving consists of one section of white cotton decorated with bands of plain weave that alternate with rows or bands of gauze weave. Motifs are worked on a ground of varying texture in the same way as the ornamented sections of a huipil. The design is produced in brocade patterning, using thread dyed red and blue and yarn in various shades of violet, pink, green, blue and yellow, as well as other colors. There are transverse bands with two-headed eagles, and bands with stylized vines and flowers as well as rows of diamond patterns with scrolls at either end. The center of the sampler has an interesting zigzag

with serrated edges that suggests a plumed serpent. The
designs produce an effect of great intricacy thanks to
the vast range of colors used. This extraordinary
piece probably dates from the early twentieth
century. It is the only known indigenous
sampler in existence woven entirely
on a backstrap loom. ✢

Mazatec Weaving from San Bartolomé
Ayautla **Antique-style huipil made of
white cotton cloth woven on a backstrap
loom** (page 233). The weave is a combination
of plain and gauze decorated with brocade work and
embroidery. The lower part was woven in red thread using
a brocade technique. The overall design is of wide bands with
geometric and stylized plant motifs combined with a zigzag pattern.
According to Renato García Dorantes, a Mazatec from Huautla de
Jiménez, the plant shown is the corn flower. A row of birds worked in
brocade divides the two decorative areas. The upper part is profusely
embroidered by hand with curvilinear birds, flowers and leaves, in
red thread outlined in green. The central section bears a plant with
a flower emerging from the earth; clawed and crested birds appear
on either side. This design repeats throughout the rest of the upper
section. Antique Mazatec huipiles from Ayautla do not use silk
ribbons to frame the worked sections. ✢

Chontal Weaving from San Pedro Huamelula
Antique cloth, probably for ceremonial use (page 236). Vestiges
of wax indicate that this cloth could have been used to cover an
altar. It consists of two sections woven from white handspun cotton
on a backstrap loom. The design is made in brocade patterning
using violet and blue threads colored with *Purpura pansa* (murex) dye
and indigo respectively. A silk band was also introduced, dyed with
cochineal (*Coccus cacti*). The purple thread was dyed by the Chontals
themselves in the Astata region on the Pacific coast. We also know
that the Chontals cultivated the cochineal insect in the San Matías
Petacaltepec mountains in the municipality of San Carlos Yautepec.
The interesting geometric motifs, and the horizontal bands with
angular *ilhuitl* designs and outlined hook shapes, are clearly of
extremely ancient origin. This textile—which is in a very damaged
state, having been burned and then mended—probably dates from
the late nineteenth or early twentieth century. ✢

*Chinantec sampler
made on a backstrap
loom in the early
twentieth century.
Santiago
Quetzalapa,
Oaxaca. Collection
of Irmgard W.
Johnson.*

*Opposite page
Antique Mazatec
huipil made with
white cotton
cloth woven on a
backstrap loom.
San Bartolomé
Ayautla, Oaxaca.
Collection of
Irmgard W.
Johnson.*

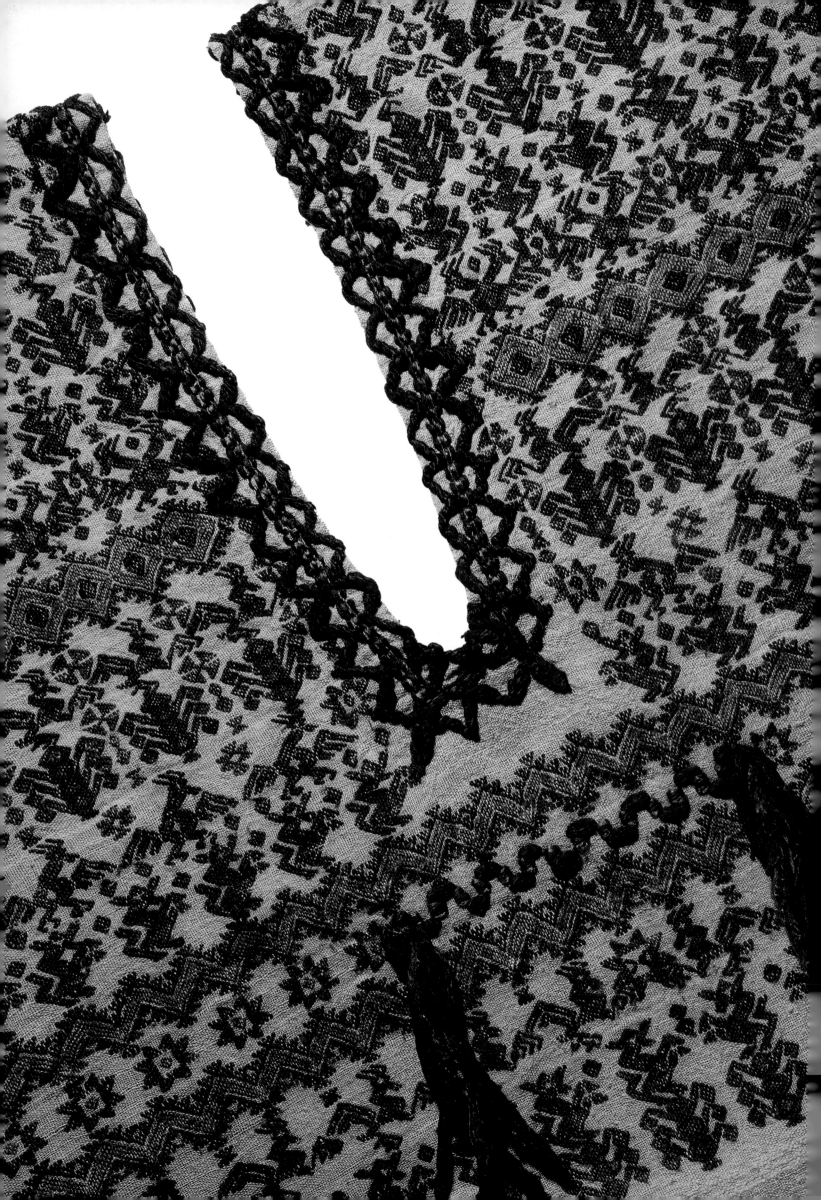

Huave Textile from San Mateo del Mar

Fine antique huipil woven on a backstrap loom from handspun cotton (page 237). The vertical bands are marked on the warp prior to weaving using thread dyed purple with murex. The marvelous brocaded motifs of waterfowl, deer, dogs and stars are similarly colored. Note the motifs introduced outside the main central section for no apparent reason—a common practice among certain other ethnic groups in Mexico. The fringe at the end of the central band is only found in Huave weaving and that of the Mixes of San Juan Mazatlán. This is a technically complex ornamental element requiring a special arrangement of the warp on the loom. The purple thread was purchased from the Chontals who dye it on the Astata coast and sell most of it during the Huamelula fair. Years ago and on festive occasions, the Huave women wore this traditional garment on their back in a rather extraordinary fashion. They would also use it occasionally as a shroud. ❖

Mixtec Textile from Pinotepa de Don Luis

Fine antique huipil handwoven on a backstrap loom (page 252). The background is white cotton in a plain weave, and the design is brocaded in thicker white cotton thread. Decorative motifs include the two-headed eagle, various human and geometric forms, and the *xicalcoliuhqui* and *ilhuitl* designs, both with toothed edges. The seams joining the huipil's three webs are decorated with antique silk ribbon. Today this kind of work is rarely produced. We do not know its origin for certain, even though there are various villages in the Lower Mixtec region where magnificent examples have been found. These extraordinary designs were also used in the past on the white huipiles worn by the Mixe group of San Juan Cotzocón. This huipil was once worn by an indigenous woman from Pinotepa de Don Luis for her wedding and as a head covering. ❖

Mixtec Weaving from the Coastal Region

Antique wedding or ceremonial huipil made on a backstrap loom (pages 242–243). The white cotton thread has been finely spun by hand on a traditional spindle and the delicacy of the weave is quite extraordinary. The textile is composed of plain weave with ribbed transverse bands. The three pieces of cloth that make up the huipil are joined with silk ribbon dyed a deep pink. The upper part of the central section is the most elaborately decorated, having a wide band woven with thick weft threads of scarlet silk. The oval neck opening has a beautiful decoration embroidered

❖ IRMGARD WEITLANER JOHNSON

with thick silk threads dyed scarlet red, pale pink and purple. The design combines stepped frets and concentric circles with varying effects, depending on the different color combinations. Beneath the neckline there is a horizontal band made from a ribbon on which motifs are embroidered in silk similar to those of the neckline itself. At either end, the ribbon hangs free as an additional adornment. This kind of banding has been used since ancient times, according to pre-Hispanic codices. It has been said that this extraordinary huipil comes from Santiago Ixtayutla, a Mixtec village on the coast, but in reality its provenance is uncertain. It probably dates from the late nineteenth century. This marvelous garment is unequaled. The extraordinary quality of its thread and weaving are comparable only to the extremely fine pre-Hispanic weavings found in Tlatelolco. ✦ TRANSLATED BY JESSICA JOHNSON. ✦

Antique Chontal tablecloth, probably with a ceremonial function. San Pedro Huamelula, Oaxaca. Late nineteenth or early twentieth centuries. Collection of Irmgard W. Johnson.

Opposite page Antique Huave huipil woven on a backstrap loom from handspun cotton. San Mateo del Mar, Oaxaca. Collection of Irmgard W. Johnson.

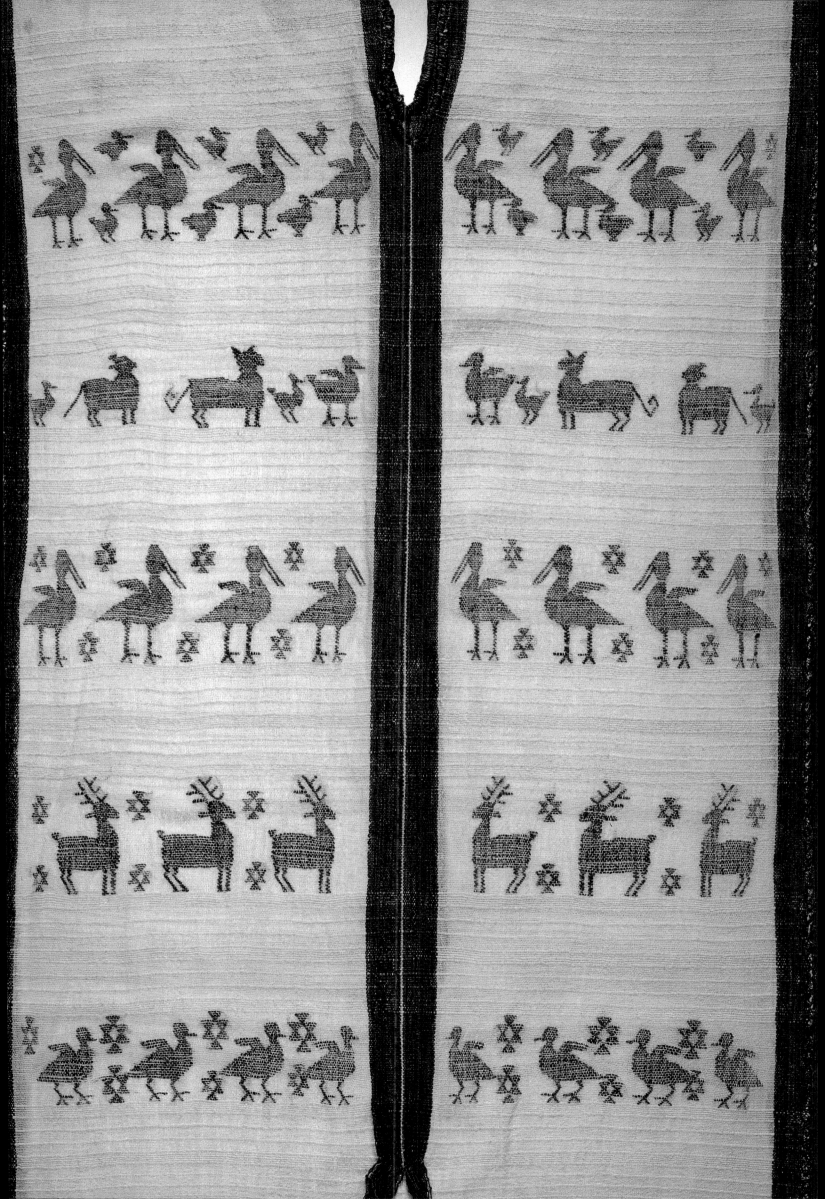

WEAVINGS THAT PROTECT THE SOUL

Alejandro de Ávila B.

Huipiles have a special design on the chest that is called 'uo. This name has no meaning in our language today, but it probably once meant "dawn." The 'uo is a rhombus, and at its center there is a shell that symbolizes the sun: it represents the life force and provides the soul with the means to fly to the sun with the last breath…

IRMA GARCÍA ISIDRO *Weaver and researcher from San Felipe Usila*

The 'uo is like a door: it is closed to protect the soul. When you die, the door opens and the soul leaves through it.

MARÍA DEL SOCORRO AGUSTÍN GARCÍA *Weaver from San Felipe Usila*

The threads of Oaxaca are interwoven in a thousand ways. Deft hands that spin, weave and embroider give rise to vibrant textures and designs. Just as their fibers and dyes are the most varied in Mexico, reflecting the region's extraordinary biological diversity, the technical sophistication of Oaxaca's textiles is unparalleled in the country, manifesting itself in the skillfully spun yarn and complex weave. Subtle as a spiderweb or rough as a net made out of agave cord, the threads of Oaxaca captivate the gaze. Chinantec women put it best: their brilliant huipiles "inebriate the eyes." ⁜

If at first glance the eyes become drunk with the intensity of the design, with patient observation we can go beyond the colors to derive a more gradual pleasure. With the aid of our fingers, we decipher the riddles in the threads, so as to understand how they have been interlaced to create figures and background. The ingenuity of the makers' hands is amazing. A second wave of curiosity moves the observer to ponder the significance of the woven images: we listen to the words of the wise women of the loom, we transcribe the motifs' names and etymologies, and we realize how some yarns (not all of them!) bind certain myths. We begin to distinguish fiestas from everyday life in the weave, and we contemplate with wonder the threads that connect the clothed body with the cosmos. ⁜

A third look reveals details of technique, design and interpretation that allow us to compare and contrast textiles from different communities, and even to make inferences about their history.

*Opposite page
Chinantec huipil.
Woven on a
backstrap loom and
hand-embroidered.
San Lucas Ojitlán,
Oaxaca.
Ruth D. Lechuga
Folk Art Museum.*

*Pages 238–239
Cotton sashes
dyed with natural
pigments.
Oaxaca.
Ruth D. Lechuga
Folk Art Museum.*

*Pages 242–243
Antique huipil
for weddings or
ceremonial use.
Woven on a
backstrap loom
with embroidered
appliqués.
Late nineteenth
century. Attributed
to coastal Mixtec
region, Oaxaca.
National Museum
of Anthropology,
Instituto Nacional
de Antropología e
Historia.*

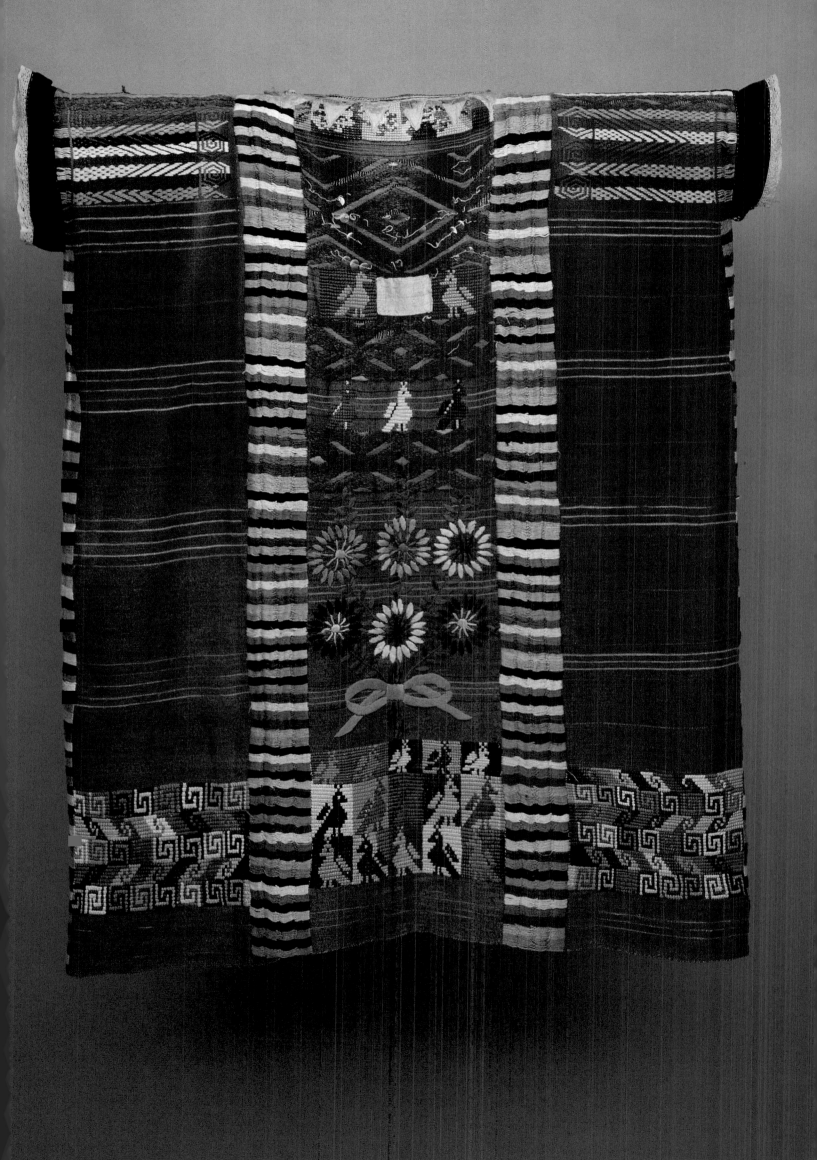

In the warp and weft, we discover evidence of a long evolution where there seems to be a balance between random changes and deliberate innovation. Bringing together various insights, we begin to appreciate how meaning and pleasure are created on cloth over time. The fourth moment is one of deeper reflection: we wonder why we are seduced by these threads, and begin to question how an outsider can perceive and re-create (or perhaps falsely interpret) the woven ideas. In an attempt to remain faithful to the weavers' discourse and their silences, we become convinced that any reading we may make of a textile as text will be unavoidably colored by our previous conceptions. But our fascinated eyes are not satisfied with introspection. We attempt to unravel the politics involved, as we try to visualize how textiles might differentiate gender and status, how they specify community affiliation and define ethnic identity—all critical functions in the life of a multicultural and unequal society. So let's take a closer look at some masterful weavings from Oaxaca, using this fourfold approach. ❖ One of the most moving and delicate of Mexican textile pieces is a huipil attributed to the Mixtec region (pages 242–243), currently in the ethnographic vault of the National Museum of Anthropology in Mexico City. The embroidered designs bear no resemblance to nineteenth-century Mexican samplers, nor to indigenous needlework of today. The composition is based on symmetrically dissected and opposing elements in contrasting colors, and represents a style that was not influenced by European figurative designs embroidered in running-stitch and cross-stitch, both of which became very popular in Mexico during the nineteenth century. On the other hand, the ribbon sewn horizontally below the neckline is analogous to the detail on certain contemporary huipiles from Oaxaca and neighboring areas. Historically, it derives from a short braid consisting of a few weft yarns intertwined with the warp to reinforce a woven neck-slit, as documented by miniature archaeological huipiles and some modern pieces. This reinforcement has become a decorative element that can be woven, embroidered or appliquéed in any number of ways. It is known by many different names in the indigenous languages of Oaxaca, some of which allude to its function as a distinguishing feature to identify the dress of specific communities. Bartola Morales tells us that in Ojitlán, the patch of ribbon sewn on the huipil is known by the Chinantec name of kï tsa kon wïn, which she translates as "rectangle of the people from one hearth"—meaning people with a common origin, which is what the people of Ojitlán call themselves. Morales refers to it eloquently as "the little flag" of the huipil. ❖

Woman's sash woven on a backstrap loom. Santo Tomás Jaliesa, Oaxaca. Ruth D. Lechuga Folk Art Museum.

Opposite page Enredo (wrap skirt) woven on a backstrap loom and dyed with cochineal. Mitla, Oaxaca. Ruth D. Lechuga Folk Art Museum.

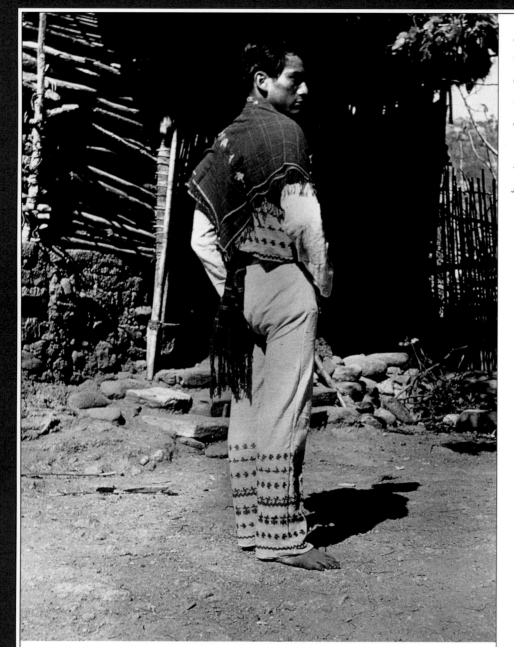

If we were to speculate a bit, we could imagine that the circular motifs embroidered on the huipil's ribbon might have some symbolic associations. They could be related to certain iconographic elements denoting nobility in sixteenth-century indigenous textiles and architecture, such as the borders with circular motifs illustrated in the Florentine Codex—known as *te:ni:xyo:* in Náhuatl—or the frieze with floral disks that adorns the House of the Cacica in Teposcolula. It is possible that the huipil's embroidered roundels had solar connotations, like other designs placed on the chest of some contemporary huipiles from Oaxaca. These suns made out of thread are related to the *to:nalli*—solar heat, daylight, the birthdate and hence the name and destiny of a person. The same root (Hispanicized as

tona) designates the component of the soul that is heat and vital force, and emanates from the chest cavity. In Mixtec, *ini* refers likewise to spirit, heart and heat. The invocations addressed to a newborn child, as recorded by Sahagún in the sixteenth century, express through metaphors that the gods have ignited the *to:nalli* within the baby's chest, by means of a drill that creates fire. As objects perforated by this instrument, beads made out of precious stones were regarded as an icon and seat of the *to:nalli*. One possible reading of circular designs like the *te:ni:xyo:* is that they represent the vital force of the nobility in the form of jade or jadeite beads.

We are tempted to find echoes of that symbolism in the roundels embroidered on the huipil. The red color on the chest would bolster the linkage between the weaving and the soul, for blood is an incarnation of the *to:nalli*. The etymology of the Náhuatl name for cochineal is "the blood of the cactus." The semantic field of *ini* and *to:nalli* encompasses sexual energy which raises the temperature and provokes blushing. Painting red on red seems to obey some powerful symbolic motivation. ❧

All speculation aside, we do not know who wore this magnificent huipil. We may presume that it was used by an elegant lady belonging to the old indigenous elite, whose descendants kept their land and privileges until the early 1900s in certain areas of Oaxaca. The fineness of the cotton thread—and the long months of effort that it must have taken to spin it so fine—seems to represent the work of women who were highly specialized in the production of luxury fabrics. It is perhaps a remnant of the labor that the *caciques* (chiefs) imposed on *macehuales* (peasants) as a tribute, as recorded in a number of colonial documents from the Mixtec region. Whether or not it is an example of the exploitation of women's work by the indigenous aristocracy, this garment's importance goes beyond local history as one of the most skillfully made Mesoamerican weavings in existence. The quality of the thread is comparable to the most delicate archaeological textiles found in the Andean region. Our sober huipil powerfully attests to the degree of mastery achieved by spinners and weavers in Oaxaca. ❧

❧ ALEJANDRO DE ÁVILA B.

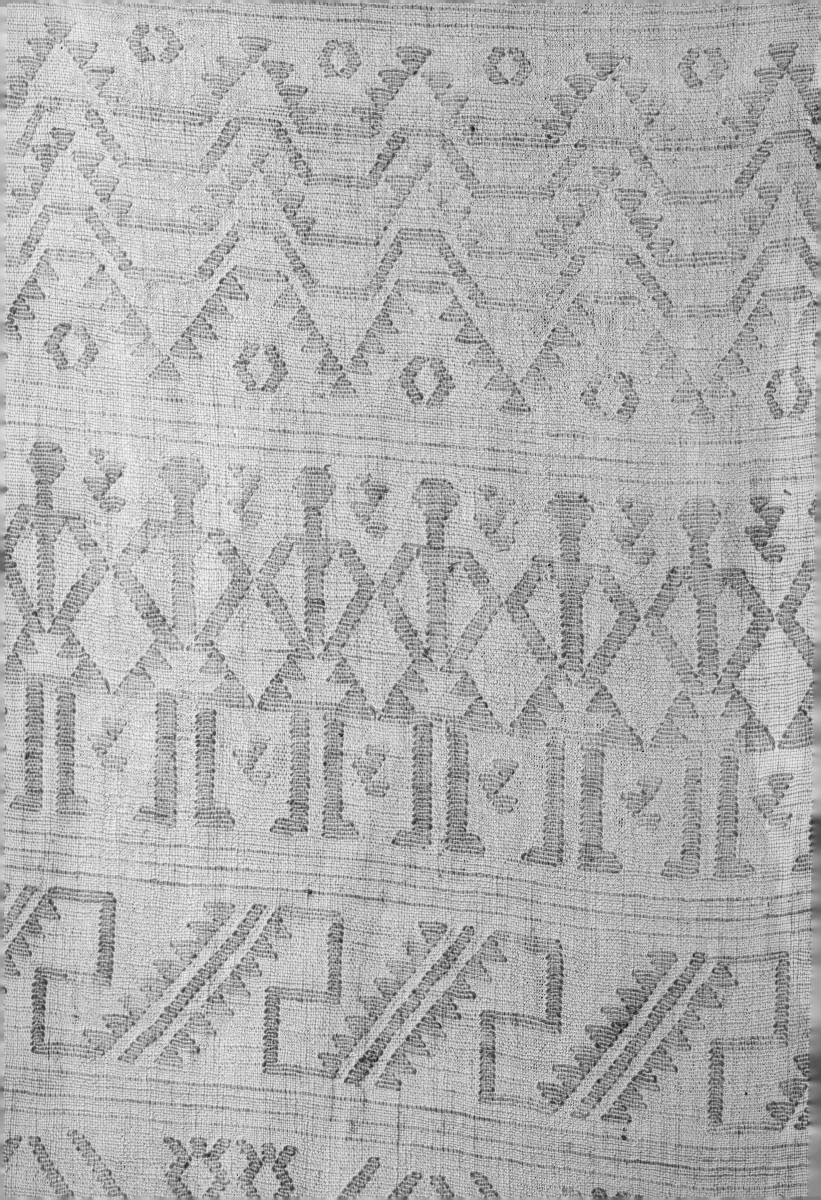

A Distinction to Be Respected

Another textile piece from Oaxaca that is quite technically impressive is a man's sash at the Franz Mayer Museum. It comes from the Mazatec massif, a karstic formation covered by coffee groves and cloud forest. It probably dates from the late nineteenth century. A beautiful headcloth at the National Museum of Anthropology—woven from silk with warp and weft stripes of the same hues as the sash (wine red is also the dominant color on the headcloth)—appears to be from the same area. A watercolor from the Porfirio Díaz era in the Martínez Gracida manuscript shows a man from Huautla wearing a similar kerchief. Sash and headcloth seem to have distinguished members of the council of elders—the men who wielded the greatest authority in Oaxaca's traditional government systems. Even though these fine textiles are no longer used, old men who have fulfilled their communal duties still wear a red scarf as a mark of distinction. It is tempting to see the ubiquitous red bandanna as a vestige of the *to:nalli*, indicating the dominant elders' vital heat. In some communities, the members of the council are believed to have the ability to cause injury, especially to children, because of the strength of their *tona*: they are "hot" and their gaze is "heavy." As if to fight back with the same weapon, coral beads and red ribbons and tassels are tied around the necks of babies and newborn animals as amulets against the evil eye. ⁕

The Most Exquisite Textile

Perhaps the most exquisite textile piece ever made for men in Mexico is an antique pair of trousers once valued at five dollars (according to an old remittance list), and that now form part of a collection amassed around 1900 by Zelia Nuttall, a renowned anthropologist who worked in Mexico during the Porfirio Díaz regime, and one-time owner of Alvarado House in Coyoacán. ⁕ Warp and weft are of white cotton, which has been very finely handspun with a spindle. The construction of the garment —which lacks a waist band or draw-cord but does have a fly and a wide tuck halfway down each leg—shows a marked difference from "traditional" white muslin trousers used in Oaxaca today. The plain-weave sections at the top of the garment lack the thicker weft stripes apparently reserved for women's textiles. The bottom part was profusely decorated with weftwrap openwork designs: splendid two-headed eagles bordered by elaborate vines. The trousers were probably worn as fiesta dress underneath overpants made out of leather or heavy cloth, as described in geographical accounts from 1777 or 1778 from several communities in Oaxaca, and as seen in

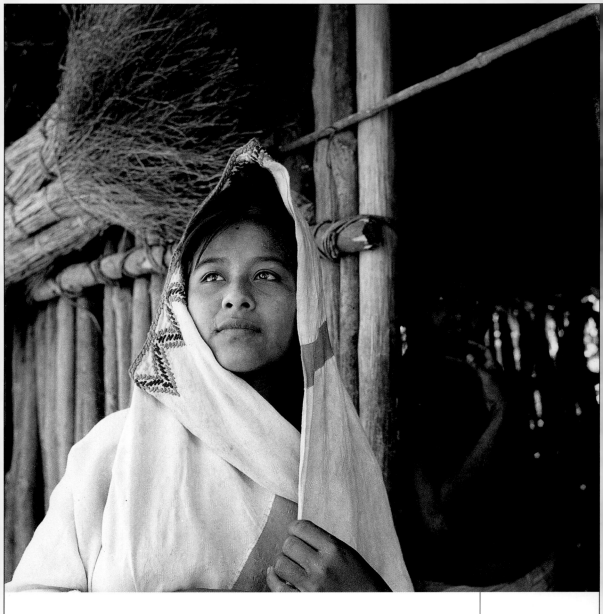

photographs taken in remote villages around 1900. The overpants, which were often quite short, protected the trousers' delicate weave and at the same time allowed the designs at the bottom to be seen. ❧ Leather or cloth pants and cotton breeches were a part of the men's attire of Spanish origin that was adopted in indigenous communities during the colonial period. The presence of weftwrap weave in this piece represents an interesting case of textile syncretism. Fragments of pre-Columbian weavings using this technique were found in the sacred *cenote* at Chichén Itzá and in the San José de Ánimas cave in Durango, in addition to some archaeological examples from the American Southwest. More than any other kind of weave, weftwrap openwork demonstrates the creativity of Mesoamerican weavers since ancient times: no pre-Hispanic examples of this technique are known from the Andean region, despite the fact that some

Portrait of a woman with a head huipil in Jamiltepec, Oaxaca. Photo: Irmgard W. Johnson.

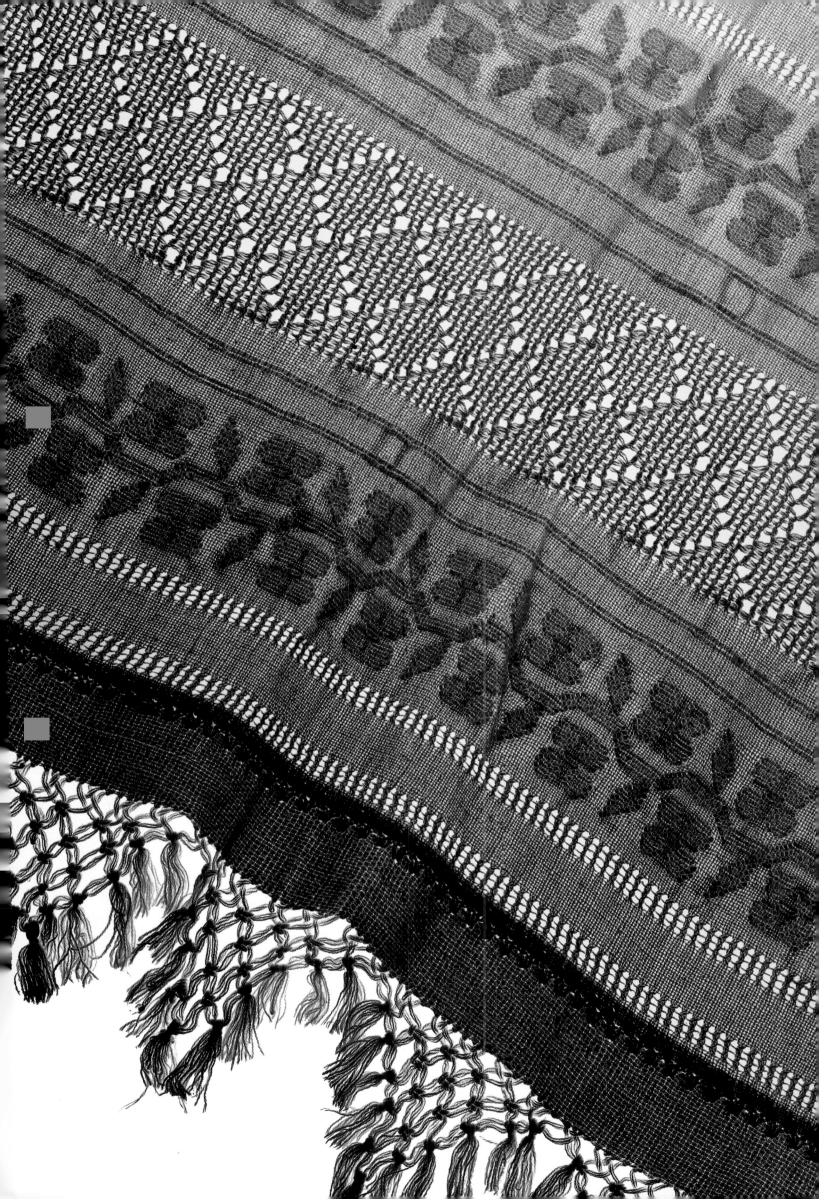

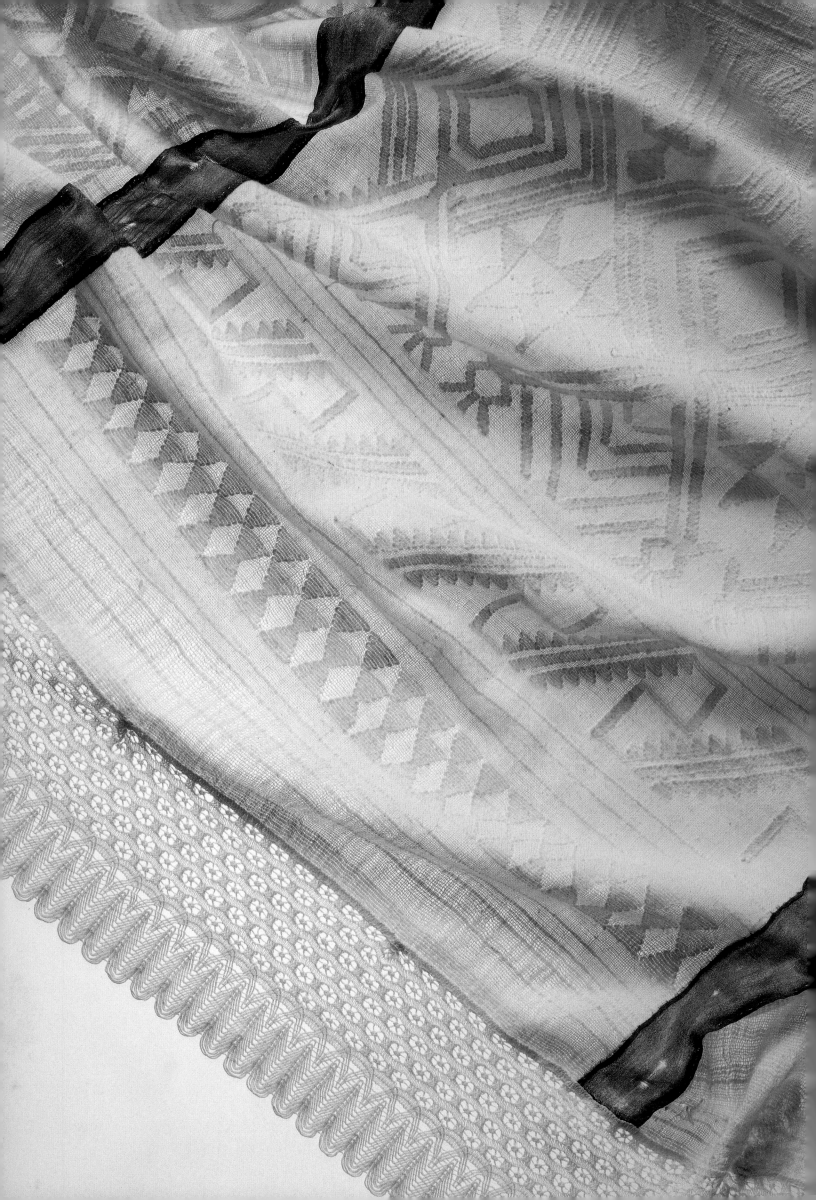

researchers have proposed that complex fabric structures, and perhaps all textile technology, originated on the western coast of South America and spread north. The presence of unique weaving techniques in Mexico casts doubt on such interpretations. Before we realized that the weave of an antique Mazatec sash from Ayautla is in fact weftwrap and not drawnwork, it was thought that the former technique was restricted to Choapan. In any case, it seems to have been conserved only in the northern part of the state until the early 1900s. Weftwrap openwork was still used around 1930 to weave gala huipiles in Santiago Choapan. ⁑

The Huipiles of Choapan

Santiago Choapan is a Zapotec town in the tropical rainforest of northeastern Oaxaca. The Choapan Zapotecs form a cultural and linguistic wedge between the Chinantec people to the northwest and the Mixe communities to the southeast. The weavings of this area are markedly different both from other Zapotec towns and from their Chinantec and Mixe neighbors. In our opinion, the white patterned huipiles from Choapan are technically the most complex textiles in Mesoamerica. In addition to wide bands of weftwrap openwork with elaborate designs, they exhibit narrow stripes of gauze with discontinuous wefts, creating a delicate, open texture amid the denser areas of patterned weave. In some cases, the weavers inserted stripes of double weft between the design bands; after washing, the thicker wefts puckered like crepe, varying the texture of the web even further. In the bottom part of the huipil, widely spaced lines of simple gauze break the monotony of the plain weave. The weavers seem to have been determined to vary the effect of light on the cloth, in order to compensate for the monochrome white color. ⁑ Choapan huipiles are generally of handspun cotton and always consist of two webs. The slits between the parallel wefts seem to confirm the weavers' intention to flaunt their ability to play with light on the threads. As if to convince us that the huipil is a study in transparency, the two webs are joined with lace or crochet, and the neck is lined on the inside with triangular points of white muslin that stand out against the woman's dark skin among the lively woven animal figures. ⁑ Certain photographs demonstrate how these marvellous fabrics were worn, but we know very little about them otherwise. It would appear that Zapotec weavers shared some of the same mythological referents as other groups in Oaxaca. It seems significant that the two-headed eagle always appears as a key figure on these huipiles, invariably occupying the upper register of both webs. Choapan's documented

⁂ ALEJANDRO DE ÁVILA B.

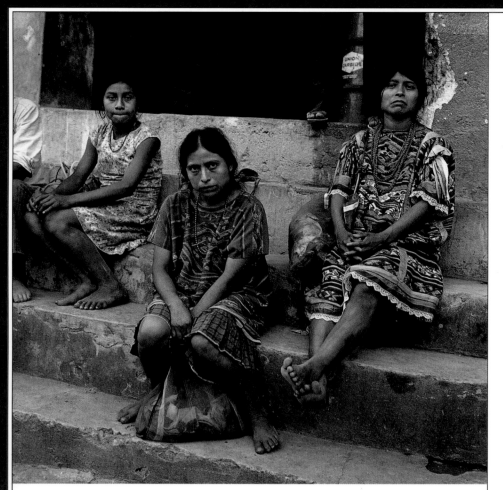

*Women of San Felipe
Usila, Oaxaca,
wearing their
traditional costume.
Photo:Ruth D.
Lechuga.*

design repertoire is relatively limited, but there seem to be variations
on other motifs as well. The eagles' rigidity contrasts with the
spontaneity of the dogs and turkeys further down on the huipil. ❖
The dominant position of this figure and its relative unchangeability
are not exclusive to Choapan. The two-headed eagle is a common
feature of the woven landscapes of Oaxaca, as in other areas of Mexico
(with the notable exception of Chiapas) and Guatemala. It is often the
design's focus of attention—three-web huipiles frequently display it
on the chest. Clearly, the Habsburg coat of arms—as the ruling house
in Spain at the time of the Conquest—was implanted powerfully on
indigenous imagination. It undoubtedly took advantage of the graphic
consonance with the insistent duality of ancient Mesoamerican art
and religion. The two-headed serpent—the *ma:qui:zco:a:tl* on the stone
for human sacrifices and its association with blood and *to:nalli* come
immediately to mind—was perhaps its most immediate antecedent. ❖
At the same time, the spread wings could have identified the royal eagle
with the winged figures depicted on the chest of some pre-Hispanic
sculptures, such as the two-headed pectoral worn by the warrior
emperor on the Stone of Tizoc and the stylized birds or butterflies on
the breast of the Tula *atlantes*. These winged designs have been interpreted

Chinantec huipil.
San Felipe Usila,
Oaxaca, ca. 1935.

as representations of the vital force, related to the livid blotch in the shape of a butterfly that often appears on the back of a corpse when laid face up. The phenomenon, due to the differential gravitation of blood, appears to indicate the imprint left by the soul as it abandons the body. As it was woven on the chest of the huipil, the imperial eagle seems to be related to representations of the living soul. Rather than an instance of syncretism, it is tempting to think that weavers subverted iconographic colonialism in their favor. As we shall see, in some areas of Oaxaca the two-headed eagle has a key mythological role associated with textile designs. However, the motif is also woven on the breast of huipiles in communities where the same cosmological role is played by a serpent. The interpretation of winged designs as the soul's image and shield may help explain the ubiquity of the Habsburg eagle in Mesoamerican textiles after the Conquest, independent (we believe) from subsequent, geographically more restricted mythological reincarnations of this figure. In the case of the weavers of Choapan, we do not know whether the protagonist in their oral tradition was the two-headed eagle, as in Chinantec myth, or the monstrous snake of Mixe narrative. ❖

CHINANTEC WEAVING

In the same way that Choapan huipiles are technically the most sophisticated weavings we know from Oaxaca, the textiles from the central and western Chinantec region display the most diverse and complex designs. Most of the Chinantec habitat is a very wet, mountainous terrain, originally covered by tropical rainforest and cloud forest. The dense vegetation of the area seems to have

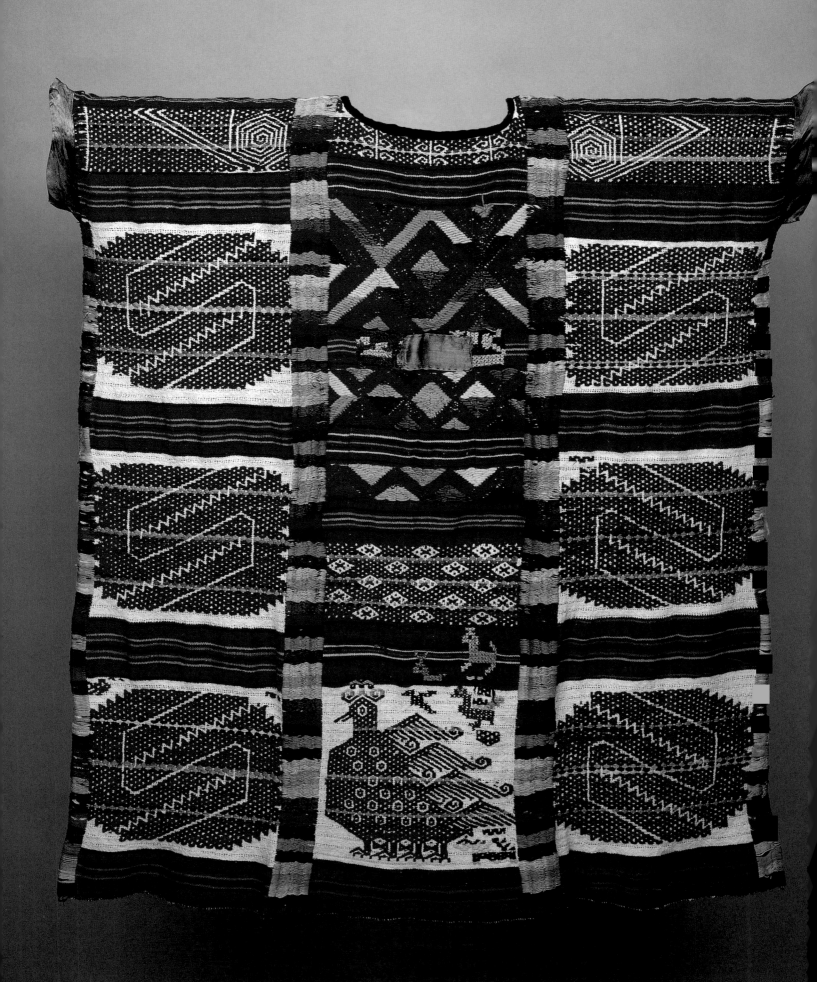

Below left
Embroidered
Mazatec huipil.
Jalapa de Díaz,
Oaxaca, 1976.
Below right:
Mazatec huipil
woven on a
backstrap loom and
embroidered.
Huautla de Jiménez,
Oaxaca, ca. 1950.
Both from the
Ruth D. Lechuga
Folk Art Museum

Opposite page
Chinantec huipil.
San Lucas Ojitlán,
Oaxaca.
Ruth D. Lechuga
Folk Art Museum.

favored the development of an intricate style of design, where red is once again the dominant color. In older huipiles, the warp and the white weft are of handspun cotton, substituted by machine-spun thread in more recent weavings. The red weft is always industrial thread, dyed with synthetic colors. ✧

Thanks to the extraordinary research done by Irma García Isidro in Usila and Bartola Morales García in Ojitlán, we have a series of accounts by elderly Chinantec weavers, faithfully transcribed and translated, evoking the magical inspiration of their art. Let us focus for a moment on some comments recorded by García Isidro, beginning with the two-headed eagle. We find it on the chest, again, of the old white huipiles, and just below the *'uo* in many of the red weft huipiles. It stands out defiantly on women's headcloths. The elders in Usila associate this design with stories relating the origin of the sun and the moon. Many groups in Oaxaca share the basic plot of this myth, which is linked closely with some passages of the *Popol Vuh* of the Quiché Mayas in Guatemala, and more distantly with the *Legend of the Suns* recorded in Náhuatl in the Valley of Mexico soon after the Conquest. The main characters are the twins who are adopted by a weaver (Lady Paca—a kind of large rodent— for the Chinantec people) whose husband is a deer. After killing the deer, the twins engage in a series of adventures. They manage to defeat a large monster (generally an eagle or serpent with two or seven heads) and take out its shiny eyes, with which they ascend into the sky to become the Sun and the Moon. ✧

The death of the monster reminds us of the scene in the *Popol Vuh* where the male twins Hunahpu and Ixb'alanke vanquish Seven Macaw: wounded by their blowgun, the bird dies when they take out its eyes and teeth. After many unforeseen events, Hunahpu and Ixb'alanke rise to the sky as Sun and Moon. In Oaxaca, the twins (a girl and a boy in several versions) fight over the brightest eye before they begin their heavenly course. Sun, strong and tricky, gains possession of the bright eye in exchange for giving water to Moon, who is dying of thirst because the springs dry up every time she comes near them. An old man from Usila interviewed by Irma García Isidro said that the two-headed eagle is related to the differentiation of personality and power between men and women. Before their encounter with the monster, he says, the twins were indistinct: "The eagle is strength, which is why the boy's sex was defined, [so] that the man is stronger than the woman, because it's the opposite from Adam and Eve—here it's the boy who

deceives the girl, he takes the eye from her." This comment reveals
in the woven design what may be traces of resentment due to gender
divisions in social life. The prominence of the eagle in women's
textiles from the Chinantec region may have something to do with
these connotations of the motif. ❖

The shininess of the eye and the moon's thirst frequently show up as
themes in the cycle of the twins in Oaxaca. The relationship between
the monster in the myth and the two-headed eagle on the huipil is
articulated by other weavers, like the Chinantec women in the nearby
town of Ojitlán, and also the Mixtec women of Citlaltepec and
Chilixtlahuaca in Guerrero. But in Usila we find a more
complex interpretation, which connects the sun with other
woven designs. In the words of the same man, "This
story is so important that it's on the huipiles." Irma
García Isidro has outlined etymological and graphic
links between the sun and the 'uo—the design of
concentric lozenges brocaded on the chest.
In her interviews, elderly weavers associate
the rhombus with the four cardinal
directions, which are defined by
the trajectory of the sun. Their
identification of the central "snail,"
however, does not allude to the apparent
movement of the sun in a circle, as we might
think, but rather to the blowing of a conch shell as the
most powerful sound known, once used to convoke the
townspeople. The intensity of the sun's light and heat, and
the resonance of the conch, give rise to a woven metaphor. ❖

The spiral within a lozenge seems to have a long history as a
solar symbol in Mesoamerica. It appeared in Olmec sculpture:
Stele 21 from Chalcatzingo depicts it within the jaws of the earth
monster, below the figure of a woman—a representation, perhaps,
of the sun's entry at dusk into the netherworld in the west, the female
direction in Náhuatl. The association of this motif with the sunset
on the stele would seem to prefigure its position on the huipil as the
exit of the soul when the woman dies. It cannot be a coincidence
that the 'uo in Usila and analogous lozenges on the huipiles of other
Chinantec and Cuicatec communities, as well as similar designs
among other groups (especially the diamond or rhombus motifs
brocaded on the chest and back of ceremonial huipiles of the Tzotzil
and Tzeltal Mayas of Chiapas), is absent from men's textiles. In the
majority of these cases, the design contains spirals or hooks as salient

elements. Curiously, in Usila the solar snail is not identified with the spirals but with a small central diamond. ❧

One of the master weavers cited by Irma García Isidro refers to the frets of the 'uo (called mkei, a term of obscure etymology) as "life buds, life itself." Between one hook and the next, she counts each step in the design as "one life," referring to each stage in a person's existence from birth to death. Counting the steps, her fingers go up the weave following life's progression until they reach the snail, where the soul ends up when the body dies. In the 'uo, García Isidro finds references to a numerical symbolism of seven and nine. The weavers associate the number nine with the days of prayer observed after a person dies, while seven is related to the number of years that a deceased family member is remembered in ritual. It is how long a person's soul remains on earth in the form of a faint light that becomes ever weaker until it disappears altogether on the seventh anniversary of the person's death. Seven years is also how long a soul will survive after a person falls ill from "fright" and loses it. Within that period, the person can be cured by digging in the earth to recover his or her soul. After seven years, the sick person dies. To prevent the loss of their soul, frightened people are patted on the back and are advised to inhale below the collar of their clothes. A woman inhales through the 'uo of her huipil to retrieve her soul. Otherwise, the soul descends through the feet and enters the earth, which retains it. If we return to the moment of agony, there is no contradiction between the soul's departure toward the sun and its permanence on earth in the form of light: in Mesoamerican thought, the soul is a complex entity and different manifestations of it may exist at the same time. ❧

THE FLOWERS OF THE TONAS

Part of the soul's makeup is the person's alter ego in the shape of an animal, called tona in Oaxaca. At least one of the woven designs in Usila is linked with the tona—a double fret shaped like a z, commonly called "broken flower" ("uneven design" may be a better translation of the Chinantec name). María García Pantoja, an elderly weaver interviewed by García Isidro, identifies it as a "coiled snake," am'nisa: "The coiled snakes bring on the rain. [...] They are

found in the springs, they exhale a vapor, and that vapor creates the rainbow, it brings the rain. [...] Cloudbursts are also called *am' nisa*: they say, 'there goes the coiled snake.' When there are clouds, they say, 'it's because the snake must be there, the cloudburst is coming.' It's the one [snake] that goes into the streams, but it's born in the sea. It comes out of the sea when there's going to be a cloudburst. It goes into the clouds and falls down when the rain falls, it goes into the stream." A similar design is associated with lakes, floods and heavy rain in Ojitlán, according to Bartola Morales. The association of snake and water is not exclusive to the Chinantec region: serpents appear as cloudbursts and spring-owners ("mothers of the water") in many places in Mexico. ❖ In Usila, the "coiled snake" is considered the strongest tona: "It's the most dangerous one, hence the one that people are most afraid of." Perhaps because of this the "broken flower" is a prominent design on the red headcloths that in the past distinguished members of the council of elders. Oral tradition attests to the power of the councilmen's tona. García Isidro has recorded stories describing how the old men of the council would sacrifice children to ensure the success of major communal projects, such as roofing the church, hanging a new rope bridge over the river or building the great altars for Holy Week: "the men would go to some large stones called 'altar stones' in Chinantec. They were used to make sacrifices: not how we understand sacrifice, but by means of witchcraft. They would say, 'a prop is needed here,' and then drive a wooden stake [into the rocks]. As they drove it in, blood would drip down. The next morning the stone would be covered with blood, and some children were sure to die in the town. It was a magical sacrifice, by means of the *tonas*." While the "cut flower" brings back memories of ancient dangers to the souls of infants, another huipil design seems to favor conception. The weavers call it "crab's claw flower," and it consists of two paired horizontal vines, resembling European embroidery samplers. The zigzagging vines are woven with a half cycle displacement, so that two large flowers end up face to face one above the other at the center of the design. The whole composition is placed, significantly, in the section of the huipil that covers the abdomen. García Isidro quotes a weaver known as Doña María who relates this motif to a magic flower: "If a person found a mint flower, it was a very good sign. The person who wanted to cure [i.e. become a healer] stayed up all night on June 24 to see if they could

Cuicateca brocade napkin. San Andrés Teotilalpan, Oaxaca. Collection of Irmgard W. Johnson.

Opposite page Trique huipil woven on a backstrap loom. San Andrés Chicahuaxtla, Oaxaca. Ruth D. Lechuga Folk Art Museum

Pages 258–259 Left: Triqui huipil woven on a backstrap loom. San Martín Itunyoso, Oaxaca. 1955. Right: Mixtec huipil. San Martín Itunyoso, Oaxaca. 1980. Both from the Ruth D. Lechuga Folk Art Museum.

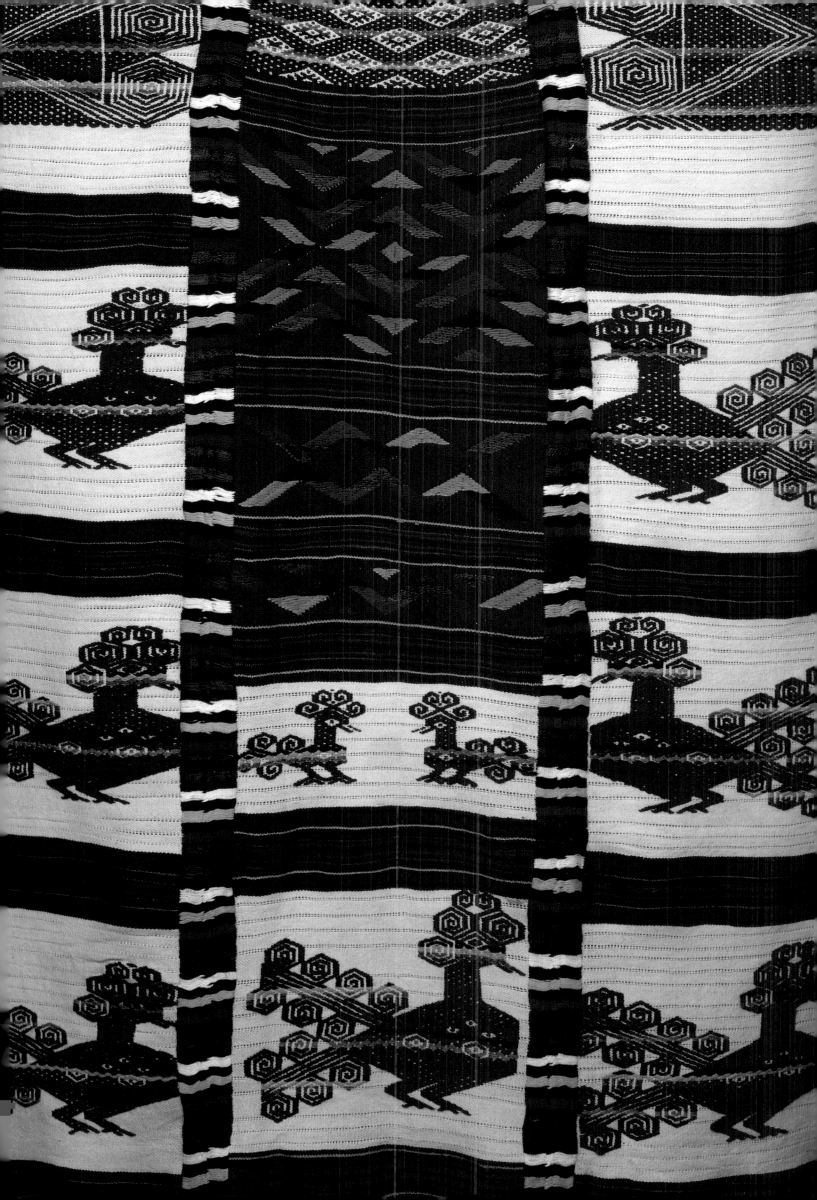

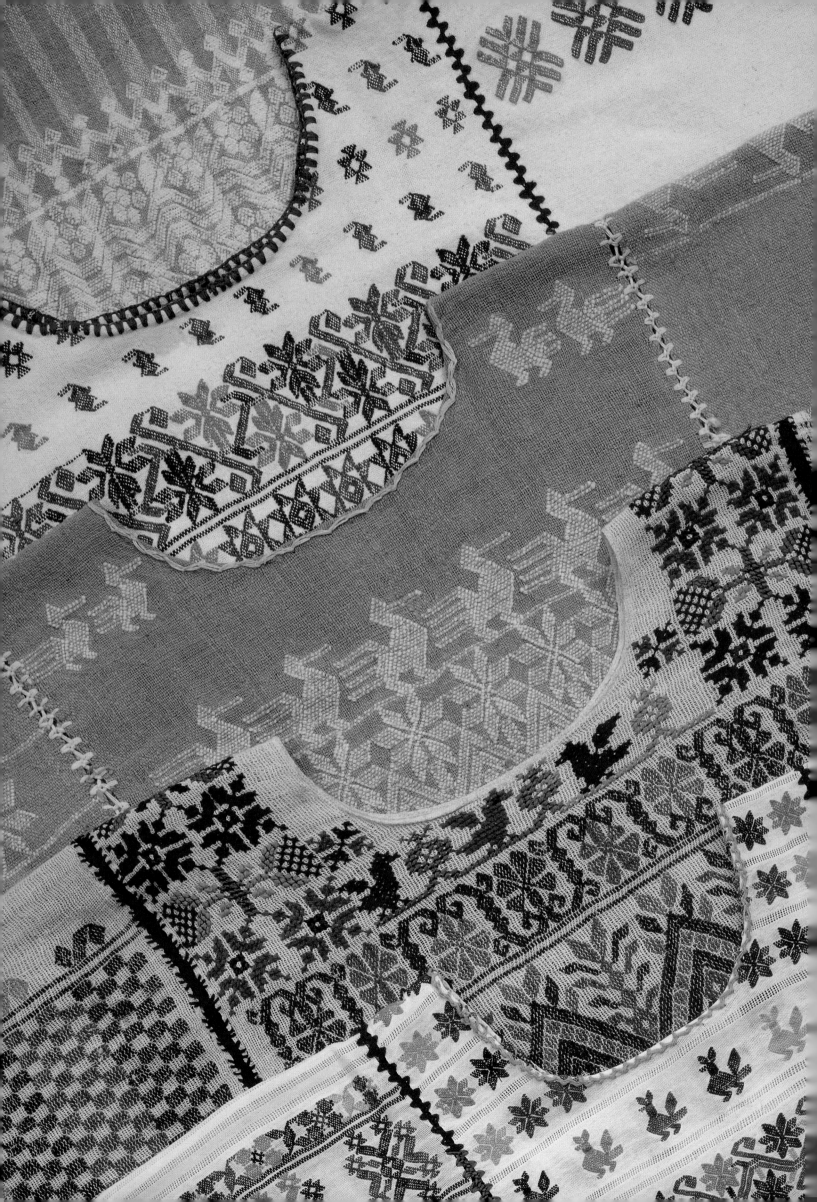

find the flower in the courtyard. […] Then [on the same date] women who could not have children would look for that flower and keep it [to conceive]. Even on the [huipil's] belly it's a double flower—they meet. They are a male flower and a female flower." June 24 is the day of Saint John the Baptist: "It's the day the tonas get together. They meet in the caves, they have a fiesta." The mystical flower of Usila is a species that was introduced from Europe, like the design that represents it. Just as the plant has been incorporated into the initiation of shamans and the fiesta of the tonas, the motif (which does not even remotely resemble mint) has been harmonized with other designs on the huipil, modifying its proportions and decorating it with Chinantec hooks. In their appropriation of a foreign motif, we can better appreciate the genius of the weavers, their imaginative prowess in giving the flower a partner, which is a beautifully subtle way to propitiate fertility. The woven metaphors rise to the level of visual poetry. ❖

Another figure on Chinantec textiles is also associated with a magic plant, in this case a native species. A motif which the weavers call "tree flower" [i.e. "tree motif"] sometimes appears on Usila headcloths. Guadalupe García describes it as a "tree of life," pointing to the tiny diamond-shaped spaces within the design: they indicate vitality. We see in this small detail yet another woven representation of the animistic principle. Usila weavers do not identify the motif as a specific plant. Comparing it with similar brocaded or embroidered designs on textiles from other Chinantec communities, however, we can relate it to the ceiba, the cosmic tree of Mesoamerican peoples living in the tropics. The lower part of the central web of white huipiles from Ojitlán and Valle Nacional displays magnificent figures which the old ladies call the "sacred tree." The Ojitec version is a dazzling labyrinth of spirals, crowned by five birds. Taking the role of *axis mundi*, the ceiba is a recurrent icon in pre-Columbian art starting with Olmec sculpture. It is associated with birds in contemporary textiles from various communities, especially in the Mayan area. ❖

In the Chinantec region the ceiba has cross-bred with the Biblical tree of knowledge. García Isidro tells us that in Usila, it is the tree of paradise. But it has not lost its references to an older meaning: to see yourself at the foot of the ceiba means that you feel close to death. The *tonas* take refuge in its branches when dawn interrupts their nocturnal journeys; turning into iguanas and lizards, they spend the day in the ceiba's canopy, to renew their travel when night falls. In the ceiba laden with *tonas* we can perhaps see a *chi:chi:hualcuahuitl* sapling—the tree that nursed the souls of dead children in the Mexica religion. ❖

❖ ALEJANDRO DE ÁVILA B.

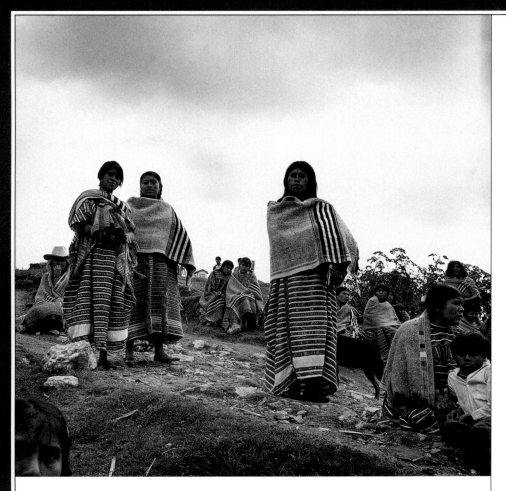

*Triqui women
wearing traditional
costume. Oaxaca.
Photo: Ruth D.
Lechuga*

*Opposite page
Trique huipil.
San Andrés
Chicahuaxtla,
Oaxaca.
Ruth D. Lechuga
Folk Art Museum.*

Two Zapotec Huipiles

Symbolic images do not abound in all weaving from Oaxaca. The
communities where women re-create the meaning of designs
seem to be in the minority. The textiles of San Bartolo Yautepec
are covered in small figures, but we do not find a single one that
takes us to the world of myths. San Bartolo weavers have a passion
for detail work that does not seem to go any deeper than the sheer
pleasure of this dizzyingly elaborate animation. ✛

Yautepec is a Zapotec community surrounded by dry tropical
forest in the mountains of the southeastern part of the state. Up to
the mid-1900s, the women of this town spun the thinnest cotton
thread and wove the finest huipiles in Mexico. They earned a bit of
fame in the 1950s when the actress María Félix wore a huipil from
San Bartolo in the publicity stills for *Tizoc*, one of the first Mexican
films to be shot in color. By that time the women of Yautepec had
stopped wearing their wonderful textiles in favor of the costume of
the Isthmus of Tehuantepec, but elderly women kept their huipiles
so that they could be buried in them when they died. For several
years, weavers continued to receive requests specifically for burial
garments. The conviction seemed to persist in San Bartolo that

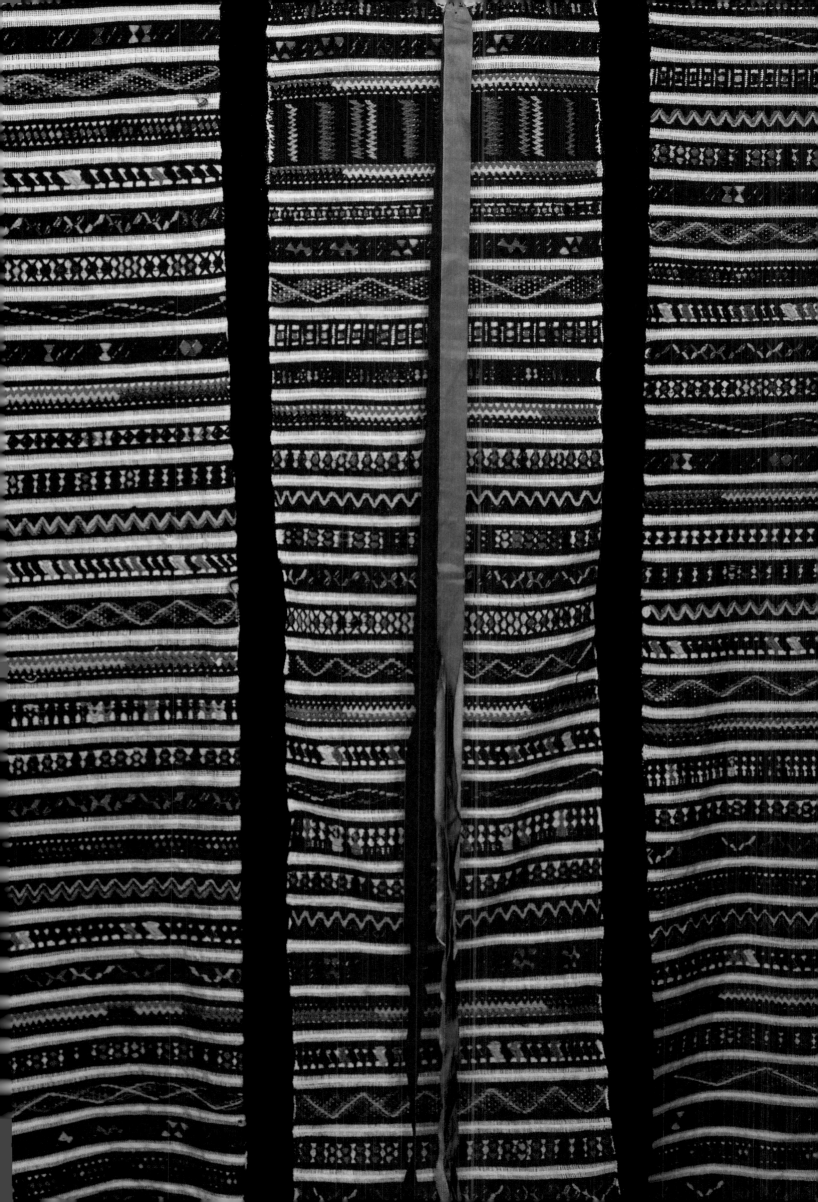

even though the body had changed its clothing, the soul should retain the community's traditional huipil. ❧

Two types of huipil were made in Yautepec. One was worn in the usual way, with the head going though the neck opening. It was rather long, and gathered at the waist over the wraparound skirt. The designs were woven only on the top section of the three webs. The second huipil was used to cover the head, letting it hang down the back. It lacked a neck opening, and designs were brocaded along the three webs only on the side that could be seen. Elderly women associated this garment with wedding attire. Both huipiles were ornamented with the same miniature motifs, brocaded in rows. Foremost among them are several animals, which the weavers list by their Zapotec names. There are roosters, hens, hawks (including a two-headed version), goats and grey foxes (both inspired, we believe, by the lion of Spanish heraldry, a frequent companion of the Habsburg eagle on Mexican textiles). The decoration embroidered below the neck, which derives from the braid-like reinforcement of intertwined wefts that we described earlier, is called *mdin*, "the mouse," likely because its loose ends resemble tails. The little tree-like motifs are *yag guier*, "pines." For the geometric designs we have only found names borrowed from Spanish. They include stepped lozenges and zigzags, sunflowers, stirrups and rickrack. ❧

An incredible profusion of designs sets apart a Yautepec huipil in the collection of Irmgard W. Johnson. San Bartolo weavers are known for their ability and dedication, but it seems the woman who wove this piece wanted to go to the extreme. No other huipil comes close to the density and perfection of its brocade. The figures' clean, vibrant colors seem to indicate that the huipil was never worn. Kept carefully for years, we wonder whether it was woven with the gods in mind, rather than for the admiration of human eyes. ❧

The extraordinary quality of Yautepec textiles poses an interesting theoretical problem. Generally we find that when a lot of work is invested in the weaving, it is the product of highly specialized labor groups. Whether they be enslaved weavers or privileged women who dedicate their leisure time to the loom, we associate fine pre-industrial fabrics with rigidly stratified social systems where female labor is equated with trade in luxury items. It is not easy to explain how a basically egalitarian community, with a mainly subsistence economy, can devote so much time and effort to making something for the peoples' own use. ❧

The exceptional fineness of Yautepec huipiles dating from the early twentieth century motivated a revival in the 1970s. The National Museum of Folk Arts and Industries provided scholarships to a group of young women so they might learn the skills of the last elderly weaver from San Bartolo. Thanks to that initiative, a dozen looms are operating in the town's courtyards thirty years later. In addition to huipiles and napkins, weavers today make blouses and pants for boutiques. They have put a neck opening into the huipil that used to be draped over the head, which seems to be the one that sells best. Their entire production is for sale, because even the Isthmus-style huipil has fallen into disuse in San Bartolo. Though it does not quite match the intricacy of their grandmothers' work, we believe that the production of Yautepec's best weavers continues to be the finest backstrap loom weaving in Mexico, and perhaps on the continent. Take, for example, a huipil woven in 1996 by Catalina Martínez López. The brocade weft is handspun silk, though the weaver had never used silk before. The dexterity with which she combined the colors and wove the designs speaks for itself. ❖

New Mixtec Textiles

In the Yautepec huipiles we have seen how an old style was revived for consumption outside the community. Other contemporary textiles from nearby areas display startling technical and design innovations strictly for local use, with the traditional rigorous standards of quality. Two Mixtec towns, Santiago Tlazoyaltepec and Tilapa, provide us with eloquent examples of the vitality of textile arts in Oaxaca. ❖ Tlazoyaltepec is located in the mountains that enclose the Valley of Oaxaca to the west. Cultivated plots intermingle with pine and oak regrowth on the gullied slopes. The community, one of the poorest in the state, supplies the city of Oaxaca with charcoal and rafters. The women spin and weave wool. Not long ago, they used warp-faced plain weave to make their black wraparound skirts and the dark two-web blankets worn by the men. Some of these garments, decorated only with stripes, have been kept as mementos. About mid-century, a revolution occurred: the weavers began making rugs on the backstrap loom, apparently influenced by the sarapes from Teotitlán del Valle. They adapted their spinning to the needs of

Chontal garment with chichicastle weave. Santa María Quiegolani, Oaxaca. Ruth D. Lechuga Folk Art Museum.

❖ ALEJANDRO DE ÁVILA B.

the new technique: high torsion for the warp, thinner wool with less tension for the weft. They spaced out the warp threads on the loom to be able to beat down the weft firmly. But the most dramatic change occurred in the decoration: a completely new design vocabulary emerged. The elderly men we interviewed do not know how the motifs originated, but they remember that in their youth the blankets had nothing but warp stripes: "they were cold." *Doo vita*, the "soft blanket" of tapestry weave, is warmer, they assured us. An older weaver provided the answer: "We invent the figures. They come from our hearts." ✧ Tlazoyaltepec designs are striking for their elegant simplicity. To look at their clean, compelling geometry, one would think that these are traditional motifs of great antiquity. The weavers use three colors exclusively: black (a synthetic dye), white (the natural color of the wool) and a grey or light brown (from dark wool mixed and carded together with white wool). They cleverly use sharp outlines in white against black to weave the main lines of the design. The contrast makes the motifs stand out powerfully, balancing the large areas of plain, drab background. The weavers economize their wool this way: dyes are expensive, and they obtain a larger amount of thread of one color by mixing dark and light fleeces. The most frequent design is a band of lightning at either end of the web. Midway down there is usually a third band with a different motif, and large vertical zigzags in the intermediate fields. Compact motifs composed of bars are aligned in the third band or scattered between the zigzags. Sometimes we recognize among them the letters O, T, and many S's. A young weaver smiled and said, "S for Santiago." The blanket wears the initial letter of the patron saint as if it were the town's trademark. On occasion we'll find entire words—"TUXTEPEC" or "TEPIC NAYARIT"—selected for the sheer pleasure of the letters. ✧

School appears to be the main source of inspiration for the weavers of Tlazoyaltepec. Unlike their neighbors in Santa María Peñoles, the stepped frets of Mitla and other motifs on Teotitlán sarapes do not seem to have caught their attention. Playing with the alphabet and the simplest elements of design, the women of Santiago have created textiles that are truly novel. Looking at them we sense a sophisticated talent that is fresh and without pretensions. ✢

The new huipiles from Santiago Tilapa transmit a similar feeling of happy spontaneity. This community is part of the municipality of Coicoyán de las Flores in the far west of Oaxaca. Tilapa's lands descend abruptly down a canyon between oak forest highlands and tropical pine woodlands toward the Pacific coast. The soil is severely eroded, as in other watersheds of the Mixtec region. Coicoyán and the neighboring municipalities of San Martín Peras, Metlatónoc and Tlacoachixtlahuaca (the latter two in Guerrero) constitute the poorest area in Mexico, according to a recent census. They include the country's highest percentage of people who do not speak Spanish. One of the most important social movements for indigenous autonomy today is rooted here. In this context of extreme poverty and ethnic conflict, textiles maintain a greater presence as markers of cultural identity than in other areas of Oaxaca. ✢

Communities in the municipality of Coicoyán and surrounding towns show great diversity in their dress. The women of some villages continue to wear huipiles woven on the backstrap loom; other communities have chosen embroidered chemises of a type that was popular in Mexico in the 1800s, while yet a third group opted for Victorian blouses and ruffled skirts. Young women in many localities now wear industrially manufactured clothes of bright colors and a peculiar tailoring style that continue to identify

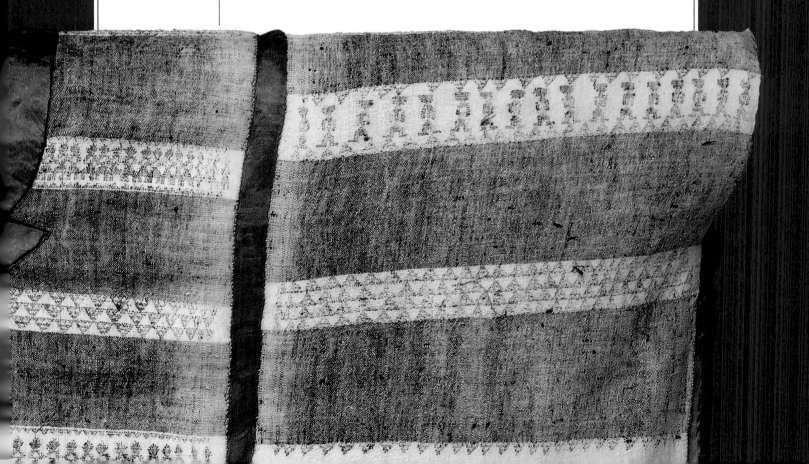

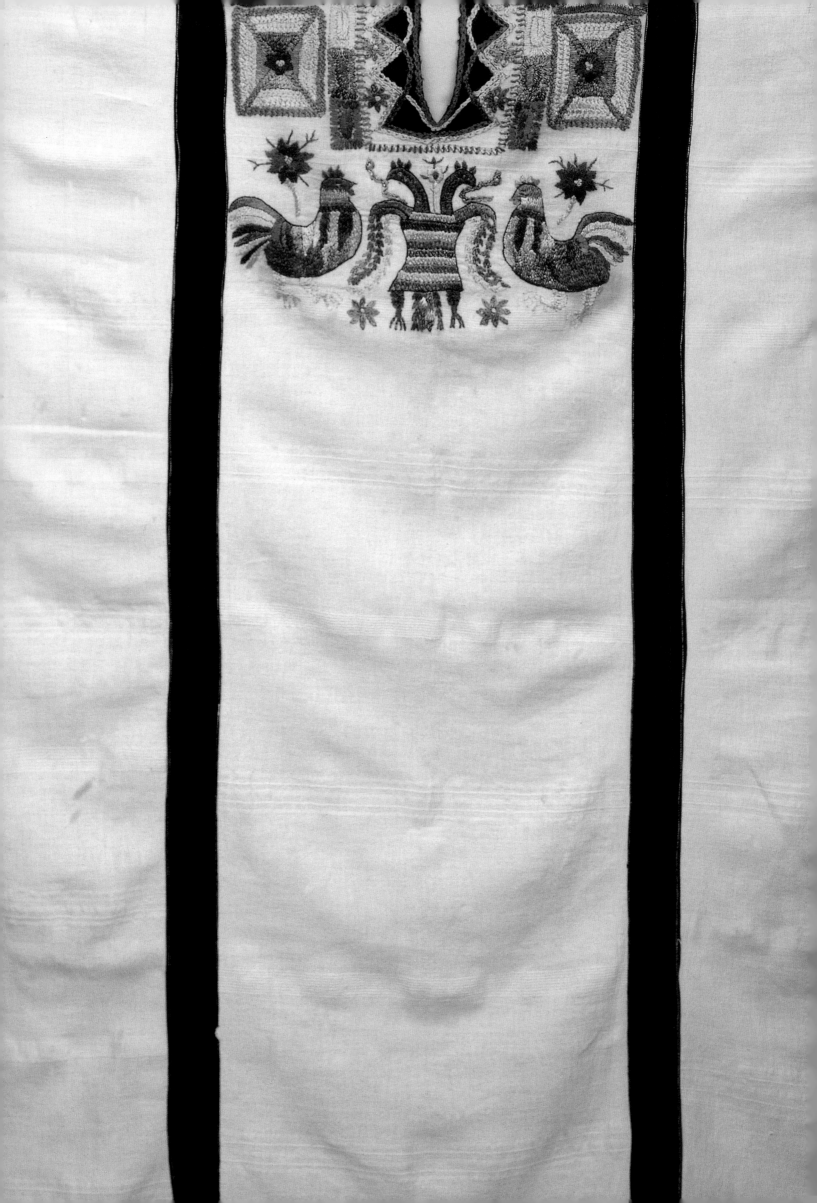

them as members of an indigenous community. But some of them have learned to weave and embroider in order to make garments for older family members ❖

One of the most beautiful huipiles we have seen from this area was made by a teenager from Tilapa for her mother. Instead of weaving it, she embroidered it in cross-stitch on white muslin, carefully reproducing the brocaded designs of old-fashioned huipiles. The embroidery thread is acrylic yarn, the cheapest material available. In the hands of this talented girl, designs were condensed and gained precision; she patiently embroidered the entire yoke on both sides of the huipil, which probably took longer to do than it would have to weave. Once more, we see a predominance of red in the designs. ❖

The young woman literally gave free rein to her imagination: she drew with thread a muleteer leading his mule train, with a large jug of flowers on the back of one of the animals. But she had another surprise in store. To the right, deliberately breaking the symmetry of the huipil (she did the same on the reverse), she embroidered a wreath that embraces two doves in love. Between the birds' beaks, we read in small letters—as if one were whispering to the other— "yes!" in English. The doves remind us that the Mixtec people are now a binational community, with more than 50,000 migrant workers residing in the United States. Somehow, a sample or a photograph of an American design arrived in Tilapa and caught her fancy. Bearing no prejudice, she has been able to integrate it harmoniously into her composition. In no way does the borrowing demerit her work; on the contrary, it makes it richer. Mexican crafts would benefit by the presence of more artists with such talent. ❖

The Loom and the Word

In classical texts of Western civilization, spinning and weaving are associated with the silence to which women are condemned. Loom and distaff are equated with submission, domesticity and weakness in the gender ideology portrayed by the *Odyssey* and other Greek texts. In Oaxaca, women speak forcefully through textiles. Time and again, the myths of origin—the classical texts of indigenous civilizations—recognize the power of cloth. We can cite, for example, some of the many versions of the saga of the twins: a young woman is weaving when she conceives Sun and Moon (Mixe). Once pregnant, she must weave the various layers of the sky with her loom, for the coming of the light is imminent (Chinantec). In the course of the twins' adventures, the weaving implements become the most prominent features of the landscape (Zapotec).

Sun and Moon kill the monster with shiny eyes by pulling on a thread (Chatino) or a woven red sash (Chinantec) around its neck. To begin time, they throw a ball of thread up to the sky and climb up the dangling yarn (Chatino). After reaching the sky, the face of Moon is marked by the weaving sticks hurled at him by a woman who was raped by the twins (both male in this Triqui version). Cursing them, she casts her bloodied cloth on the earth. Women have had menstrual periods ever since (Mixtec). The examples go on and on; few narrative traditions in the world concede so much significance to textiles. ❖

We have listened to Chinantec elders speak about woven designs, and have been moved by the lucidity and depth of their comments. Examining the two-headed eagle, they compare the sexual characterization of the twins with the biblical story of Adam and Eve, subtly proposing a philosophical dialogue about gender with Western mythology. Counting the steps of the 'uo, the fingers of the weaver show us how the stages of a person's life are conjugated in the design with a rhombus as a model of the universe: "The 'uo is a world, it is focused on the four cardinal points and lies at the center of the earth," explains Irma García. We are tempted to hear in these words a reflection on the unity of time and space, which is a revolutionary concept in Western thought. But the weaver has more to say about this: she relates the representation of the cosmos to the history of the body and the soul's transit through the design, implying that in her conception, the person as subject cannot be dissociated from the reality that person contemplates. We cannot take her comments as folklorish curiosities—these are images that give meaning to existence. ❖

We should note that a motif similar to the 'uo on the textiles of the Chiapas highlands has been interpreted as a model of the universe. A unitary representation of time and space also appears on brocaded huipiles from that area. Before Irma García's and Bartola Morales' brilliant investigations, however, we had no accounts from weavers to give credence to these notions. Critical readers will question how closely the weavers' comments represent traditional formulations, and to what extent they are a result of the unfamiliar context of the interview. Clearly, some of the explanations we have quoted may be individual interpretations, skewed perhaps by the question itself. But that does not diminish their inherent value as part of a conversation between members of the same community, carried on in their own language: we partake of it as listeners, not as interlocutors. ❖

Opposite page
Velvet Zapotec huipil
with embroidery.
Isthmus of
Tehuantepec,
Oaxaca.
Ruth D. Lechuga
Folk Art Museum.

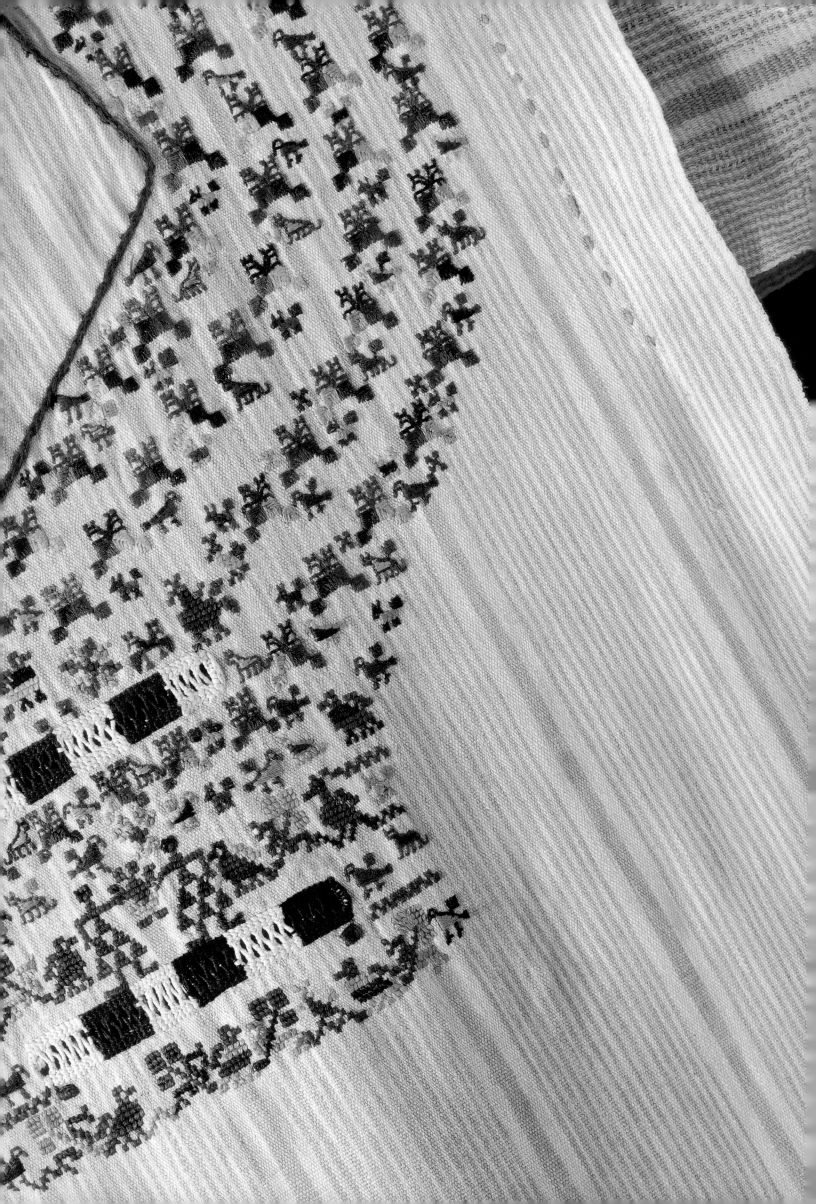

We hear strident political messages in the weavings of Oaxaca.
Indigenous women often seem to exalt their ability to create cloth
of better quality and greater visual impact than the textiles of
hegemonic society. The saturated colors of their huipiles stand
out at rallies and demonstrations. The slogans voiced during
the protests are not uniform: like the new designs, they mirror
the complexity of a time when ethnicity transcends national
boundaries. The political and cultural effervescence of the moment
brings into perspective the value of documenting the accelerated
pace of change in an ephemeral art. In recent years we have seen the
disappearance of fibers, dyes, techniques and design traditions in
different communities. Conservation and documentation of local
textiles have unfortunately been characterized by a lack of sensitivity.
Deteriorating on mannecuins in eternal museum exhibits, or
modeled by young women from the urban middle class wearing
eye-shadow and false braids, weaving has rarely received dignified
treatment. Such a vital art deserves better care. ✢
We have shown how weaving is a vital art in two senses, obsessed
perhaps with the duality of the eagle and the twins. We have tried to
capture some of the vitality of the weavers of Oaxaca, to admire for
a moment their energy and their desire to renew their work. But
weaving is also vital in another sense: of all the arts in Mexico, does
any other come closer to the soul? ✢

LIVES SPUN ON TEOTITLÁN LOOMS

Interviews with Manuel Bazán Martínez, Isaac Vázquez García, Arnulfo Mendoza

Chloë Sayer

The following interviews were recorded in June of 1996 in Teotitlán del Valle, Oaxaca. This thriving Zapotec town is famous for its woolen sarapes and other textiles woven on Spanish-style treadle looms. As these interviews show, traditional designs have been largely replaced by more recent innovations imposed by market forces. Since the 1960s, however, a few dedicated weavers have chosen to return to the natural dyeing methods of their ancestors.

Manuel Bazán Martínez lives with his wife, María Álvarez Martínez, in the center of town. Born in 1914, Manuel always combined agricultural labors with his work as a weaver, and was always greatly respected by his peers. In 1964, he visited Great Britain, where he demonstrated his skills. At the age of eighty-two, Manuel still continued to keep busy, despite his failing eyesight.

Chloë Sayer: Tell me about your childhood.

Manuel Bazán Martínez: When I was only four years old, I helped out with the wool. My father put us to work pulling it apart. He bought wool fleece and we examined it carefully, removing the dirt and sorting out the different colors of wool. All the black in one place, all the white in another, the yellow, and so on. When we had enough for a sarape, we gathered it all up and took it to the river to wash it. It took one day for sorting, one day for washing and another for drying it. The following day was for shaking it out and carding it in the sun. When I was very young, my father put me to work. He wove sarapes, but with different designs than those you see now. That's why it makes me sad to see the way Teotitlán's art has been lost. I don't see the designs of my grandparents anymore. Now, most of what you see are Navajo designs, and I don't like them. I continue to do what my father taught me. I started to weave sarapes when I was twelve. My father had four brothers: Juan,

Arnulfo Mendoza. Sarape with diamond motifs. Wool with silk-cotton warp. Teotitlán del Valle, Oaxaca, 1995. 47$\frac{1}{4}$ x 67 in. La Mano Mágica Collection.

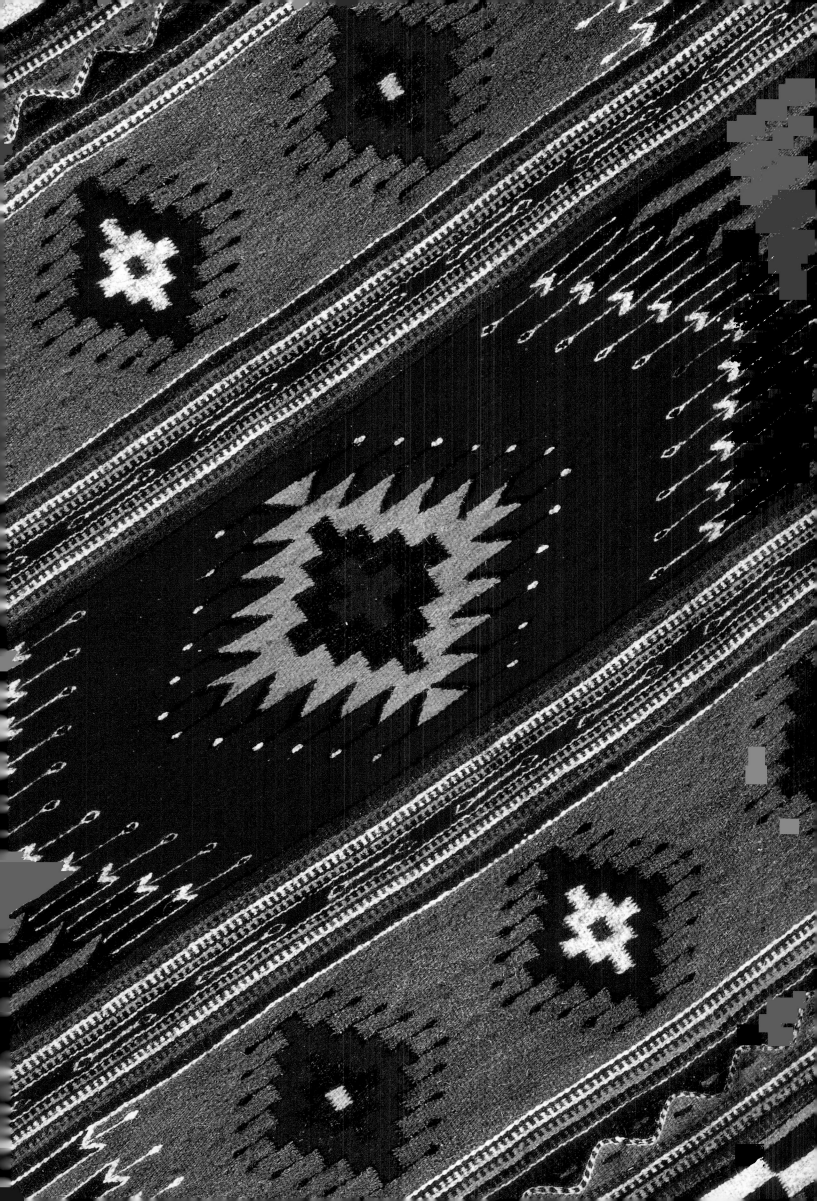

Eligio, Jerónimo and Francisco. Two of them would make wool rugs while the other two worked in the fields so there would be something to eat. The rugs had clover leaf, medallion, diamond, deer and horse designs. There are other simpler designs like the eagle. But, later, my father and my Uncle Eligio got tired of doing that, and started weaving rugs with pre-Hispanic figures. ❖

C.S. What year was that? ❖

M.B.M. I couldn't say exactly. But I remember what happened. What a shame! Who would have guessed that one day we would need to remember dates! So, they started to make the first small pre-Hispanic figures, and then later, *grecas* or stepped-fret designs. Gradually, they began making nicer and more complex idol motifs. They also used the Aztec calendar. They just kept trying new things, and started making large rugs. ❖

When I was ten or twelve years old, and was going to school, I wanted to weave. But my father wouldn't let me. He told me, "No, you're too young." But when they went to Mexico City to sell their rugs, I had my chance. The first time I tried to make a little rug, there were others working, so I watched how they did it and tried to copy them. I got started, counting the strings…. I knew all the movements on the loom! After setting up the warp, I put it in the loom. But I couldn't do it! I said to the workers, "Come on, how do you do this?" but they just made fun of me. They didn't want to teach me. So I got mad. I started with the border on my little rug. Too bad there weren't any cameras then, or you could see my first rug! The top part was really narrow because I pulled the yarn too tight. So, that's how it turned out—not so good! ❖

When my father returned, I hid the rug. But one day, when he was looking for something else, he found it and said, "And this? Who made this?" "I did," I said. He just laughed. "Didn't I tell you that you couldn't do it? You've got it all wrong. You pulled too hard here." There was this man, a French consul in Oaxaca, who got along well with my father and Uncle Eligio. He bought rugs. One day, my father showed him the little rug. When the man saw it, he said, "What happened, Bazán? What did you do to that rug?" My father answered, "It's Manuel's first rug—he made it when I wasn't around." He responded "So why don't you teach him? I'm going to buy it so that five or six years from now, I can show it to him." And, that's what happened. That piece of work is very dear to me. ❖

When I started doing idol designs, my father used Bristol board. He painted the figure he wanted, then cut it out and traced it onto the rug. The first time, I painted it, too. But after that, I did it by

memory. I just measured…. The workers couldn't believe it. And it worked. In fact, it turned out better than theirs. First I did an idol sitting down, then another one standing. ❖

C.S. How old were you then? ❖

M.B.M. Thirteen or fourteen. I was fascinated by rugmaking. So, I just kept teaching myself, since my father didn't have time to. He knew I could do it. Even when I had just started to weave, I never repeated a design. Always something different… I tried a lot of new things. Then I made a calendar that was three meters long. I copied designs, but from the rock carvings. When I saw something I liked, I'd just draw it. I always looked for different designs. I made things that people still admire today. I've done rugs with pictures of Mexican presidents. ❖

C.S. Have you always worked with wool? ❖

M.B.M. Using natural wool, you can make things in white, black and gray. But some people want things in colors, so we have to dye it. There was a very good aniline that some Germans brought to Oaxaca. Not like those you find today, because those colors never ran: we could wash them with soap, with the amole plant and the colors never ran. ❖

C.S. So, your father used aniline dyes? ❖

M.B.M. He also used natural dyes. He used cochineal, for example, which is the hardest to use, as well as blue and green dyes. He used leaves, dyes, limes… many different ingredients to obtain the colors he wanted. ❖

C.S. Who were your customers in those days? ❖

M.B.M. Everyone bought rugs then. But there weren't any Americans, like now. They're the ones who buy the most nowadays. They bring their own designs. ❖

C.S. Have things changed much? ❖

M.B.M. Yes, a lot. Before, there weren't any machines like now. Before, things were really made by hand! Now, factory-made yarn is used, not hand-processed yarn like I use. My wife helps me. We card the wool by hand, we spin it by hand. I don't work with factory-made yarn because when you wash it, instead of getting tighter, it gets looser. That's why people come looking for me. So, I spend my time making special things, reproducing paintings by Gauguin, Rivera, Escher, Vasarely… whatever the customer wants. When I went to Mexico City, I would always hear, "Don Manuel, can you do this?" "Of course," I'd tell them. And, it would have to turn out just right. Because if not, why bother? But now, everything's Navajo! ❖

C.S. Has your wife always helped you? ❖

M.B.M. Yes, a lot… Well, this is my life, and she likes making rugs. I would like to do more things, and I'm well-liked, so in 1978 or 1980, I was voted municipal president. When I was president, I was very lucky. I've been very lucky. ❖

❖

In this second interview, Isaac Vázquez García, born in 1935, told his story. Today his wife, children and other relatives all help out in the family workshop. Vázquez García specializes in the use of natural dyes. During his long career as a weaver, he has demonstrated his skills at the Denver Museum of Natural History and the Santa Barbara Museum of Art, both in the United States. ❖

Chloë Sayer: What is it you like about weaving? ❖

Isaac Vázquez García: It's a tradition. It's the work our ancestors did. And it's also the work that supports my family and my people. ❖

C.S. How did you learn? ❖

I.V.G. From my father. I was eight years old when I began. At the age of twelve, I knew how to weave very well. ❖

C.S. What kind of designs were used in your father's day? ❖

I.V.G. Suns, stars, deer, tigers and stepped frets from the Mitla ruins. My father sold to the buyer with the biggest monopoly in Teotitlán. Since there were no tourists then, this buyer distributed to different parts of Mexico—Saltillo, Mexico City, Puebla, etc. ❖

C.S. Was the work well paid? ❖

I.V.G. Hardly! It's better paid now. ❖

C.S. So you gradually improved your designs. ❖

I.V.G. Yes. In 1963, I met Rufino Tamayo and Francisco Toledo. That was when I was most interested in preserving ancient techniques. And even today, we still work with handspun yarn and vegetable dyes. My father worked with chemical dyes, but I didn't like to. I always had problems with red, so I studied what dye could be used and how to achieve a strong red. Tamayo told me he knew where to buy cochineal which could be used to achieve different tones of red. That's how I began to use it. ❖

C.S. Is it true you were one of the first to return to ancient dyes? ❖

I.V.G. Yes, there were two of us who used natural dyes: Fortino Olivera and myself. We were friends, but I was more interested in it. In 1963, no one paid any attention when I began to use vegetable dyes in the rugs. ❖

C.S. Where did you obtain the raw materials? ❖

I.V.G. Rufino Tamayo brought me cochineal from Peru. Francisco Toledo brought me indigo from Niltepec, Oaxaca. With their help,

I managed to come up with vegetable dyes, or pre-Hispanic dyes, as we called them. ❧

C.S. When did people first stop using indigo and cochineal? ❧

I.V.G. I think it was around 1915 or 1920, when chemical dyes were introduced. ❧

C.S. What other colors do you use? ❧

I.V.G. I use four basic colors: cochineal for red, or different tones of red; indigo, also known as *añil*, for different tones of blue; *huizache* (acacia) for an intense black; and rock moss for different tones of yellow. These four colors are then mixed with all-natural ingredients: salt, lye made from ash or lime. We don't use any synthetic products. ❧

C.S. And everything is done just by mixing the four colors? ❧

I.V.G. Different colors can be achieved by combining the basic ones. For example, to get green, moss is mixed with indigo—in other words, yellow with blue. And to get purple, cochineal is mixed with indigo—red with blue. ❧ It also depends on the color of the yarn. If you start with white, beige or gray wool and dye it, you can achieve different tones of green, for example. ❧

C.S. And is there plenty of wool? ❧

I.V.G. In this house, there's enough wool for my work. Not for a factory. But we work slowly—it's carded slowly, it's spun slowly. So, there's enough wool. ❧

C.S. Is it brought from far away? ❧

I.V.G. I bring it from the Nochistlán or Yanhuitlán markets. Many people from the Mixtec region come to sell wool, because there are a lot of sheep there. ❧

C.S. Who makes the looms? ❧

I.V.G. It used to be that weavers made their own looms. But they're made by carpenters now. ❧

C.S. Sometimes you use very wide looms. What is the widest? ❧

I.V.G. Three meters. I have even had four-meter looms. But there are very few clients who want rugs that size. There are more who want three-meter rugs. ❧

C.S. And who are your major customers now? ❧

I.V.G. My original work is sold in Santa Fe and Taos, New Mexico. I do original designs. I make very few commercial rugs. My relatives do that, my godchildren, nieces and nephews. ❧

C.S. How many people work here? ❧

I.V.G. Fourteen weavers. ❧

C.S. Tell me about your designs. ❧

I.V.G. I create ancient Mexican designs using only natural or pre-Hispanic dyes. The fact is that many Mexicans don't know the work of our ancestors. I'm interested in people learning about the work people did before and the colors. That's what I like about the ancient designs of Mexico. I've used codices, old designs and also some of my own. ❧

C.S. Is this red design a star? ❧

I.V.G. No, this represents the sun, done in red and black: cochineal for the red, and the black is from *huizache*. And the star is made with gray, black and natural white wool yarn. Because that's how weavers did it in the past. ❧

C.S. What are your goals for the future? ❧

I.V.G. My goal is to have a collection of ancient rugs. We have also spoken with people in the city of Oaxaca about developing a rug museum there. I have three or four rugs, and I would like to see a museum of ancient Teotitlán rugs. Because, the best rugs from here are taken out of the country and Teotitlán is left with nothing. ❧

C.S. Would it serve as an inspiration for young people here? ❧

I.V.G. Exactly, because ancient designs are being forgotten. Now people are making new designs. People come from the United States and ask for rugs with designs copied from the Navajos. I don't care for that, because we're in Mexico, not where the Navajos are! ❧

C.S. Is the Day of the Dead important here in Teotitlán? ❧

I.V.G. It's very important here. ❧

C.S. Do you include sarapes in the offering, as is done elsewhere? ❧

Chocho poncho.
Wool dyed with
indigo and
cochineal.
Coixtlahuaca,
Oaxaca.
Ruth D. Lechuga
Folk Art Museum.

I.V.G. No, never. But here in our house, we hang two rugs, one on each side. ❧

C.S. Why is that? ❧

I.V.G. Because, according to legend, then the spirits will come. We want them to see we are preserving their work. That's what we believe. ❧

C.S. So, do you hang two of the nicest rugs? ❧

I.V.G. Yes, so they see the rugs we are making now. Because they started the tradition. And we are just continuing it. ❧

❧

❧ CHLOË SAYER

Opposite page
Blanket.
Woven on a pedal
loom.
Teotitlán del Valle,
Oaxaca.
Ruth D. Lechuga
Folk Art Museum.

Arnulfo Mendoza Ruiz was born in Teotitlán del Valle in 1954.
After learning to weave with his father, Emilio Mendoza, he
attended the Fine Arts School in Oaxaca City. Between 1976 and
1979 he studied painting and printmaking as a founding member
of the Rufino Tamayo Visual Arts Studio. In 1980, during a visit to
Paris, he researched tapestry techniques at the Les Gobelins studio.
In 1993 he visited Japan, sponsored by Time Life and the Japan
Foundation. He currently divides his time between weaving and
painting in his studio at La Mano Mágica Gallery in Oaxaca City. ⁓

CHLOË SAYER: Tell me about your childhood. ⁓

ARNULFO MENDOZA: I had a very happy childhood. I am the eldest in
the family so I was very close to my parents. I realized very early on
that weaving was the most important work for the family. I was always
playing with the pedals on my father's loom, and I think that's how my
interest in weaving began. In the beginning, to make a rug here you
had to buy the raw wool on market days in Tlacolula or in Oaxaca City.
And it was our job to wash the wool, card it, spin it and then dye it. I
think everyone in my generation learned these first steps. ⁓

C.S. There were ten children in your family? ⁓

A.M. Yes, four brothers and six sisters in all. I was the first to learn
the trade, and then my brothers and sisters followed. ⁓

C.S. What designs did your father make when you were a child? ⁓

A.M. I can remember seeing popular designs such as the stepped
frets of Mitla and Monte Albán on my father's loom. Also, the
flower of Oaxaca design. When I was a teen, I remember my father
weaving dancers, pre-Hispanic motifs from the Monte Albán steles,
and also Jorge Enciso's Mexican stamps. ⁓

C.S. What colors did your father use? ⁓

A.M. There were a lot anilines in use at that time, but he also
continued to use vegetable dyes, along with other families here,
because he had an appreciation for natural things. ⁓

C.S. Describe your artistic evolution. ⁓

A.M. Since I always stayed close to my father, I saw how he liked to
sketch patterns on cardboard for the rugs. As a child, I always imitated
him. This turned out to be a great influence in my life, because at
school I began to develop a talent for drawing. My father saw my
notebooks full of drawings and one day, he said maybe I should study
drawing to improve my skills. At that time, my father was working
with some contemporary painters such as Rodolfo Nieto, Francisco
Toledo, Edmundo Aquino, etc., who came to Teotitlán to work with
weavers making rugs. This was also an important influence on me,
because I admired those painters a great deal even though I didn't

really know what a painter was. In the end, my father took me to Oaxaca City to enroll me at the Fine Arts School in the early 1970s. ❧

C.S. How many years were you at the school? ❧

A.M. Until they chased us out! We learned a lot of things there. At that time we were finishing university and we had a close relationship with Rufino Tamayo. He told us that if we really wanted to continue professionally as painters, we could forget about school and form our own professional studio. He sent us to some people in Mexico City with his recommendation so they could take a look at our work. There were at least ten or twelve young painters in our group. So we decided to quit university to establish a studio, which we named the Rufino Tamayo Visual Arts Studio because of his support. ❧

C.S. Did you continue to work on the loom, painting and weaving at the same time? ❧

A.M. When I was at the Fine Arts School, I began to feel like I was neglecting my weaving, but I think I was facing a big dilemma, because I didn't want to continue weaving the same way I had before studying fine arts. I felt that way until I finally dared to weave my own designs. The first tapestry I did was based on a print that had received honorable mention at an art competition in the city of Oaxaca. After that, I felt freer to work the way I wanted to. ❧

C.S. What was the design? ❧

A.M. It was a drawing inspired by images of my hometown during my childhood. I grew up here in these mountains, where there are a lot of animals. And there are paths with rabbits hopping across them. That was the starting point. Then, gradually I realized that I could do it. I continued painting and weaving tapestries. After two or three years of weaving, I had enough work for my first show. ❧

C.S. Here in Oaxaca? ❧

A.M. Well, there weren't any exhibition spaces here except for the Sala de Bellas Artes in Oaxaca or the Cultural Center. So, I tried to get invitations from other places like Puebla, Mexico City and Monterrey. Later, I also exhibited my work outside Mexico, in California, for example. ❧

C.S. And throughout this time, were you using both natural and chemical dyes as your father did? ❧

A.M. My father helped me a great deal at that time. I think that without his help, it would have been a bit more complicated. He helped me prepare the dyes until I could do it on my own. Then, I worked with anilines when necessary and I also liked the effect that could be achieved with different tones. Currently, I still use both kinds of dyes. ❧

Opposite page
Arnulfo Mendoza.
Silk and wool
tapestry with
cotton warp.
Predominantly yarn
dyed with cochineal,
with gold and silver
details.
Teotitlán del Valle,
Oaxaca, 1998.
24 ½ x 22 ½ in.
Private collection.

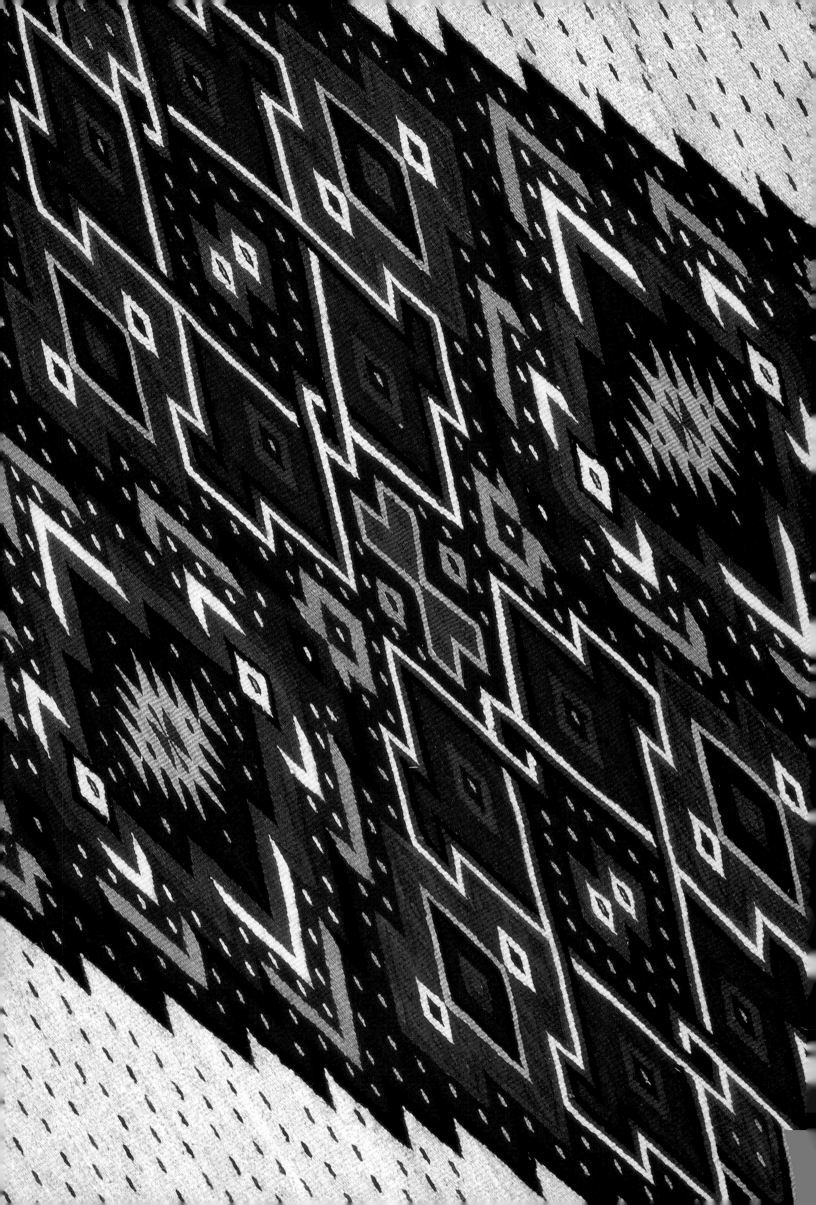

C.S. Would you say that your weavings have a strong influence from Saltillo textiles? ❧

A.M. This is a new trend in the last two or three years. I knew there was a type of Mexican textile called Saltillo tapestries, but I had never seen or touched them. All my friends and other weavers say this work is owned by collectors, with ninety-nine percent of it located outside of Mexico. I vaguely remember seeing an exhibit in Mexico City when I was just getting started. I think it was at the Rufino Tamayo Museum. The pieces were behind glass but I thought they were marvelous! I never thought about trying to revive that tradition. But one day I began to think about it more and thought maybe I should give it a try. I received an invitation to demonstrate this style in a museum in Oakland. It was an exhibition organized by a collector in the United States, and I could show my work there. I've learned so much over the years. Tapestries used to be woven in different regions around Saltillo and Puebla and throughout southern Mexico. ❧

I was very pleased to participate in this effort and I think it's a chance to make a contribution. I don't plan to do this all my life, but maybe it will help revive this tradition, as something that is very Mexican. What we should not allow to happen is for exporters of Mexican textiles to intervene, as they impose certain design motifs on Mexican artists. For example, in the late 1970s, there were many unauthorized reproductions of Picasso or Miró. And that's what Zapotec rugmaking was all about: some "middleman" would arrive with images from other places. This happens with other types of folk art, too. I don't agree with this. I miss all those things that identify us as Mexicans. I think we could reclaim our own folk art with just a little bit of artistic taste and creativity. ❧

C.S. What does the future hold for Teotitlán del Valle? ❧

A.M. Perhaps what we need to do now is to invite young people —since both men and women are entering the world of weaving— so they can get a real sense of this profession, so they don't get caught up in artificial ideas from the market, modern customs and television, but rather defend the ancestral heritage that is the craft of weaving. ❧ Translated by Jana L. Schroeder. ❧

LACQUERWORK

ORIGINS AND FORMS OF LACQUERWORK ◎
◎ *Ruth D. Lechuga*

LACA, MAQUE, ESMALTE AND BARNIZ ARE NAMES USED TO REFER TO a craft technique which involves applying and burnishing layers of oil, calcareous powders and colors, usually onto sanded wood surfaces or the polished surfaces of *jícaras* (round gourd cups) and other varieties of calabashes. ❖

Aje and chia are the oils most commonly used in these techniques; both are pre-Hispanic in origin. The *Coccus axin* insect, which dwells in certain tropical trees, is boiled, ground, filtered and dried in order to extract aje. In the production of chia, a seed (*Salvia chian*) is roasted, ground and mixed with water to form a paste. This paste is then pressed in order to extract the oil, which in turn is heated for its preservation. ❖

Soils and stones with a high lime content are ground and combined to make colorant. Their names differ from region to region. Some artists still use pigments of mineral, vegetable or animal origin, but more often they use aniline paints. ❖

"Painted" gourds must have been widely used in pre-Hispanic times. In the Mendoza Codex alone, it is estimated that tributary taxes in the amount of more than 20,000 varnished jícaras and tecomates were paid annually. In some cases, a gourd's design was precisely planned, while others were made using only one color. There were luxury pieces reserved for members of the elite, as well as pieces for daily use. The *Relación de Michoacán* (Michoacán Chronicle) describes Purépecha priests carrying elongated *tecomate* gourds on their backs. Lacquered and set with turquoise stones, these gourds were evidently ritual objects. From colonial times to the present day, some objects have been produced for daily use, others as luxury items, and still others for ceremonial or religious purposes. ❖

In the state of Guerrero, lacquerwork is made in Olinalá and Temalacatzingo, as well as in

This page and opposite Francisco Chico Coronel. Lacquerwork gourd. Olinalá, Guerrero. Ruth D. Lechuga Folk Art Museum.

Pages 290–291 Lacquerwork heron. Olinalá, Guerrero. Ruth D. Lechuga Folk Art Museum.

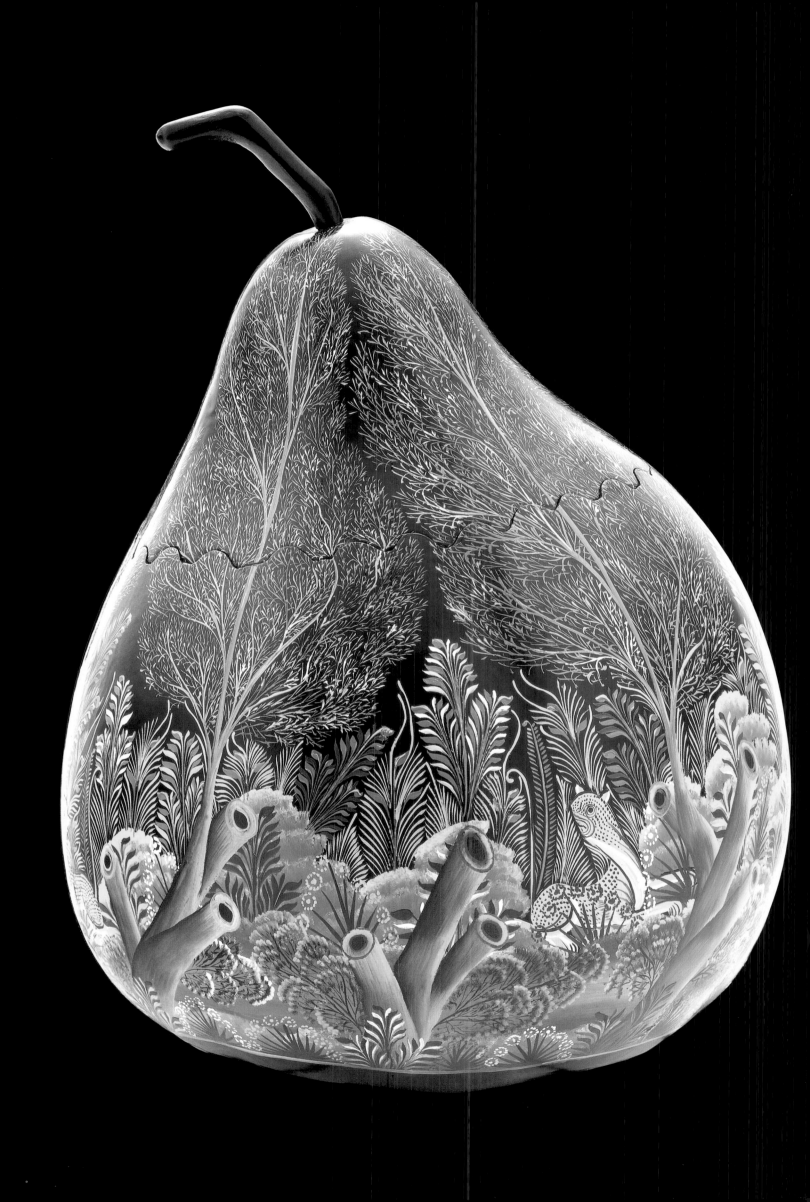

Acapetlahuaya near the state's hottest region. Chia oil is used in these three places. With slight variations, the technique consists of applying a layer of oil and then a mixture of soils and pigment, and later burnishing the piece with a stone. Once the base is thoroughly dry, the artist proceeds with the decoration. ❧

Artists in Olinalá employ two different techniques. The *rayado* (scored) technique is achieved when a second layer of lacquer, generally of a contrasting color, is painted over the base and a design drawn into it with a sharp point while the lacquer is still fresh. Several layers of the soil and pigment mixture are immediately applied, then quickly removed from the outlined design to expose the first layer of lacquer. In this way, the artist obtains a design in relief that contrasts with the background color. ❧

The second technique is the *dorado* (gilded) technique, a name that originated when it was customary to add bands of gold or silver leaf. Once the first layer of lacquer is dry, a design is drawn onto it with a fine brush. A heated mixture of chia oil and soils, called size, is combined with the desired color on a painter's palette. While the scored technique is exclusive to Olinalá, the gilded technique is used in all three lacquerwork centers in Guerrero. In Acapetlahuaya, artists add an additional layer of chia oil to the finished pieces as protection against damage from contact with hot substances. ❧

This page and opposite Francisco Chico Coronel. Detail of lacquerwork trunk. Olinalá, Guerrero. Ruth D. Lechuga Folk Art Museum.

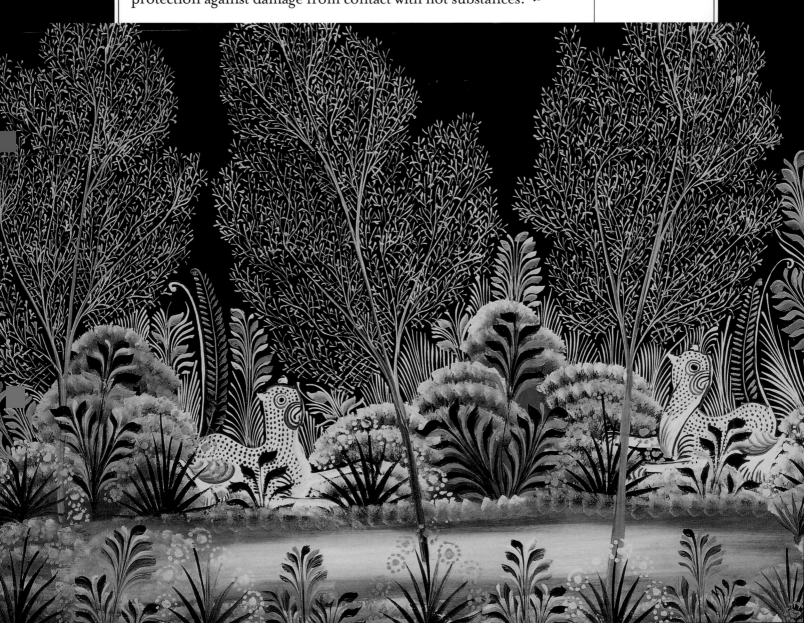

Francisco "Chico" Coronel, an outstanding Olinaltec artist, revived an ancient technique which involves the application of gold or silver leaf. Instead of applying these precious metals in separate bands, he lays them over the entire surface, then paints decorative motifs on top of them with a brush. The result is some striking work with opulent ornamentation. ✦

Jícaras from Olinalá are sold at many Mexican markets and fairs. Indigenous people often carry them on their heads, and when they come upon a river or waterfall, will use the jícara as a drinking vessel. In Olinalá, calabashes are cut in many different ways; frequently the top part serves as a lid. Smaller gourds are used as jewelry boxes; the larger ones serve as sewing baskets. ✦

Other lacquerwork from Olinalá is carved out of wood. Trays and platters of all sizes are covered with lacquer, in either the scored or gilded style. There are also boxes in elongated, square or triangular shapes, depending on their function: cigarette cases, tie boxes, pencil boxes, book boxes, handkerchief cases, and so forth. In addition, there are boxes known as *de a real* (one-*real* boxes), *peseras* (peso boxes) and *tostoneras* (fifty-peso boxes), based on the prices at which the boxes were once sold. Large coffers that serve as wedding gifts are known as *baúles de doñas* (bridal chests). Many of these boxes and trunks are made with fragrant *lináloe* wood, which is common to

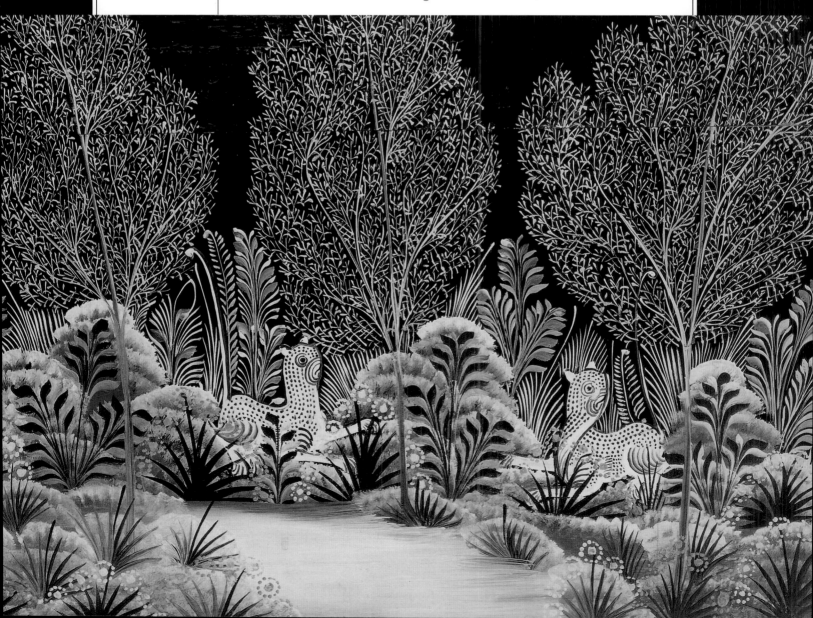

the area; unfortunately, that wood has become quite scarce recently and must be brought in from distant regions. ❧

Cajas de feria (market boxes, or boxes made for commercial exhibition) deserve special mention. They are large, with flat lids, and generally lacquered in black. The ornamentation, made with the dorado technique, includes a landscape on the front panel. They are called "cajas de feria" because during the third week of Lent, a massive and very popular annual fair takes place in Tepalcingo, Morelos, attracting vendors from all over Mexico. There, a special plaza is reserved for artists from Olinalá and Temalcatzingo. ❧

In Acapetlahuaya, only two kinds of jícaras are lacquered. Jícaras employed in daily activities have decorated interiors and are used to serve all kinds of liquids, to keep tortillas hot and also as plates, washbasins, or even lids. Others are painted inside and out and are used at festive events, where the regional specialty, *atole de alegría* (a hot amaranth drink), is served in them. ❧

Many small gourds are grown in Temalacatzingo, both from vines and from trees. Clusters of differently shaped gourds are lacquered to simulate fruit for use as kitchen ornaments. Thanks to a special program which took place during the 1970s, this Náhuatl village has developed a very imaginative range of lacquered toys which consists of a combination of small cut gourds and carved wood. ❧

Michoacán is another state famous for its lacquerwork. Currently, it is produced in both Uruapan and Pátzcuaro, although decorating techniques differ. In both places, aje was traditionally used in combination with chia oil. In a basin filled with oil, a piece of aje is lit on fire and left to drip into a receptacle; a limy soil is added along with a few drops of *ocote* wood resin until the desired consistency is achieved. This mixture, or size, is applied uniformly over the area to be lacquered. This surface is sprinkled with powdered lime, depending upon the thickness desired, and then covered with mineral or aniline-based pigment. The artisan burnishes the piece with the palm of his or her hand. ❧

The ornamental technique used in Uruapan is called the *incrustado* (incrusted) or *embutido* (inlaid) technique. The entire design is etched with an engraver's tool; the maque layer is then stripped from all areas that will be left in a single color, right down to the original surface of the wood. The resulting spaces are immediately filled with size and dye. Once the piece is dry, the operation is

Lacquerwork toy.
Temalacatzingo,
Guerrero.
Ruth D. Lechuga
Folk Art Museum.

Opposite page
Francisco Chico
Coronel.
Gilded lacquerwork
trunk.
Olinalá, Guerrero.
Ruth D. Lechuga
Folk Art Museum.

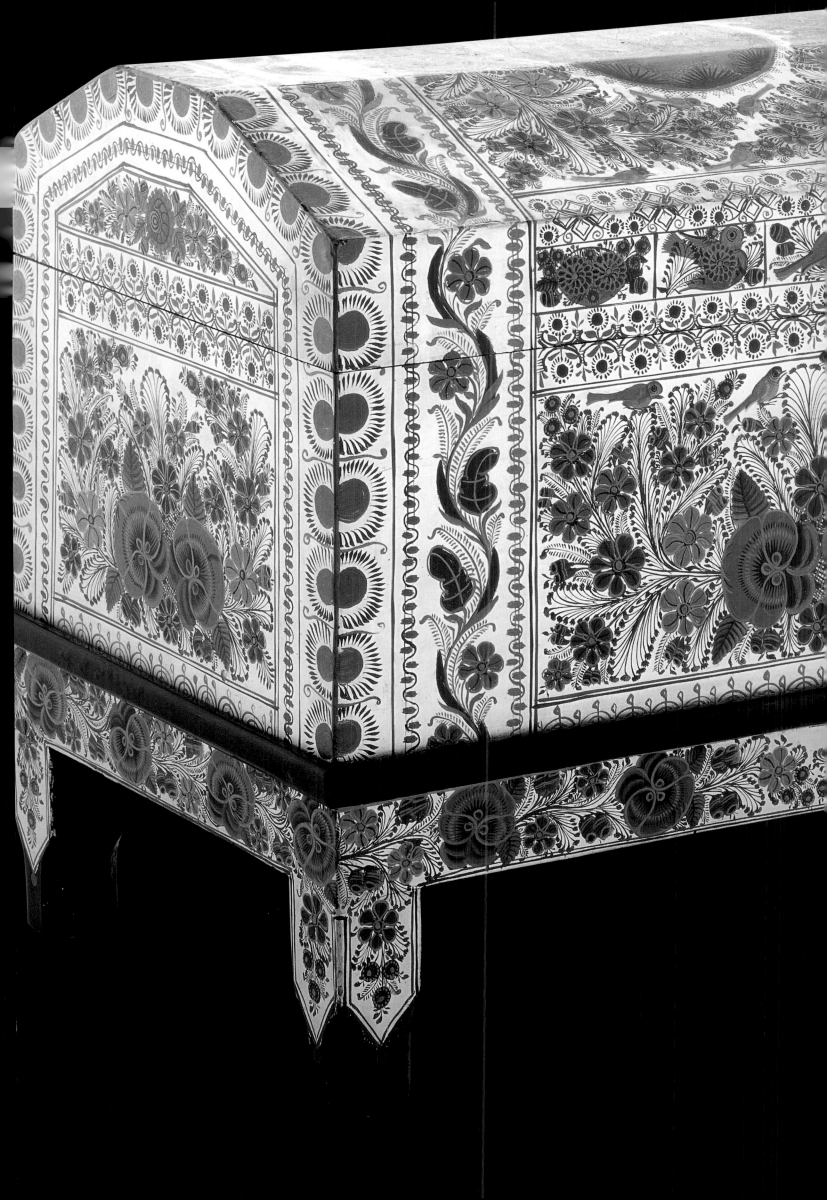

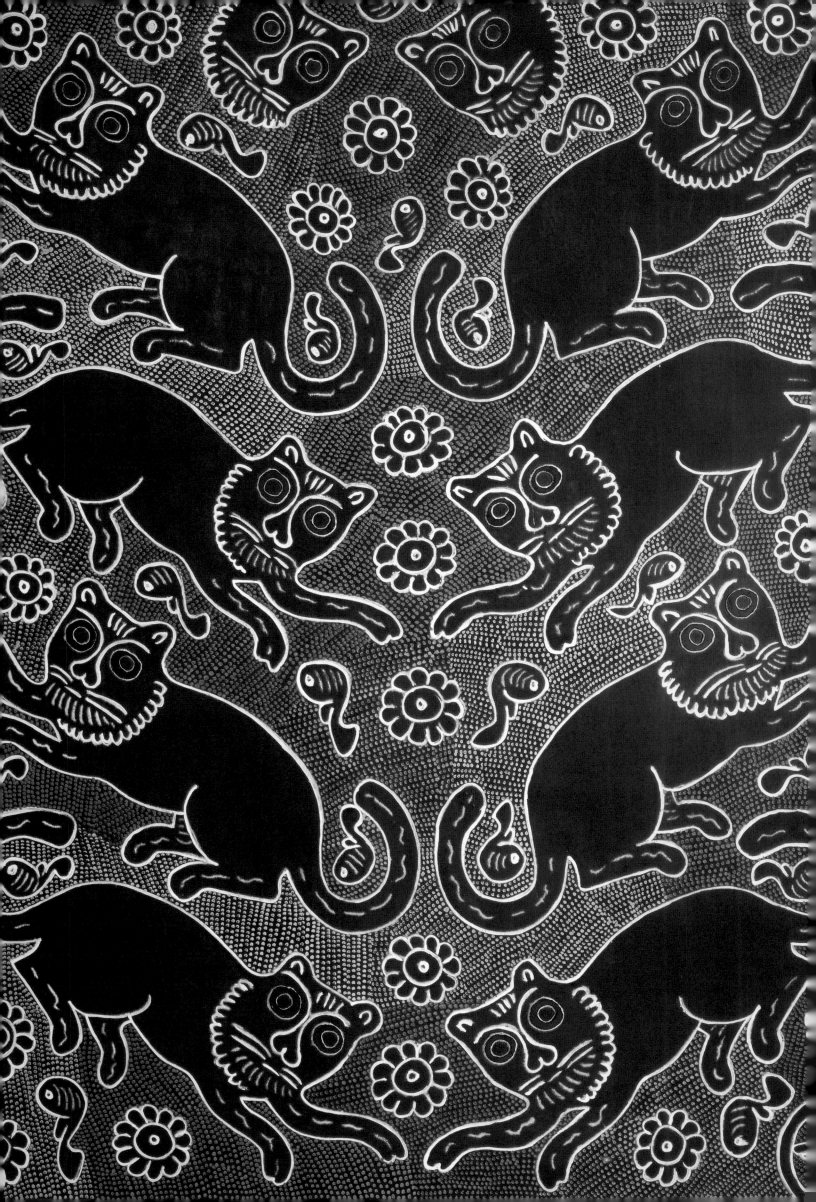

repeated with another color, and the same procedure is followed until the design is complete. The piece is finished with a final layer of size which the artist rubs with a soft linen cloth. ❧

In Pátzcuaro, a technique called *perfilado en oro* (gold outline) is often used. When done properly, the background lacquer must be completely dry, which takes several months. A drawing is then traced on the surface, and the areas to be decorated with gold leaf are covered with oil paint (which serves as a mordant). Gold leaf is applied to this base. Once it has adhered, the excess leaf is removed with a small brush so the design remains sharply outlined. Often, the drawing is complemented with brushwork in other colors. ❧

Michoacán lacquerwork was also produced in Santa Fe de la Laguna, where European style landscapes were painted on lacquered backgrounds. In Quiroga, both decoration and background were applied with a brush onto platters that had been carved with small woodworking tools. A mixture of vegetable oil, natural pigments and melted tar was used. Currently, painted pieces from both towns are quite crudely decorated with commercial oil paints. Museums house luxury pieces, particularly large platters and all kinds of antique and modern furniture from Uruapan and Pátzcuaro. ❧

Chiapa de Corzo is the only place in Chiapas where lacquerwork is still produced. The principal ingredient is aje, though in the past this was diluted with chia or linseed oil, mixed with limy soil and spread over the surface. Pigments are dusted on, and the piece is immediately burnished with the hand or a wad of cotton cloth. Artists apply oil paints with their fingers to make floral decorations. Finer lines are done with a brush. Chiapa de Corzo's production is geared toward more local distribution. Exquisite coffers and other pieces manufactured there can be seen in the local museum. Artists also make objects for religious or festive use, such as large niches for saints' statues and crosses covered with floral motifs. ❧

The villages of the Isthmus of Tehuantepec in Oaxaca would often bloom with the large painted *jicalpextle* gourds that women used to carry fruit in the *tirada de la fruta* ceremony. The bouquets of flowers painted on these receptacles were the perfect match for the women's festive garments, also covered with floral motifs. Today, jicalpextles are decorated with commercial oil paints. ❧

Huichol jicaras painted in red or green, from Jalisco and Nayarit, were first described by Carl Lumholtz in

the late nineteenth century and then in greater detail by Roberto M. Zingg in 1934. Both reported the use of *almagre,* a soil rich in iron oxide, to obtain the color red; a rock of unspecified material to produce green; and chia oil which was employed as a drying substance. Artists applied alternating layers of oil and ground pigment, and polished the piece with a stone. The pieces were, therefore, true lacquerwork. Huichol pieces made in this manner still exist, particularly those created for ceremonial use. ❖ Huichol ceremonial jícaras are kept in churches and sacred caves, and are placed in festival offerings. Symbolic beaded figures are affixed with wax to the surface of wide varnished bowls. According to Zingg, the designs represent prayers to the gods. Other ritual or religious objects include carved wooden Christ figures from Temalcatzingo and others made from cane in Uruapan. Olinalá and Uruapan both produce lacquered masks to be used by dancers during festivals. ❖ Many objects are produced for daily use. Round calabashes are sliced down the middle to make jícara cups that have been common since pre-Hispanic times. In Chiapa de Corzo, these pieces were traditionally made in a variety of sizes; some of the largest of them are used as washbasins. In Durango, the Tepehuan Indians continue to use jícaras crafted with this technique, although without additional decoration. ❖

Today, lacquerwork is a living art form that produces beautiful objects with multiple and varied functions.

❖ Translated by Jen Hofer. ❖

This page and opposite Lacquerwork vase. Uruapan, Michoacán. Ruth D. Lechuga Folk Art Museum.

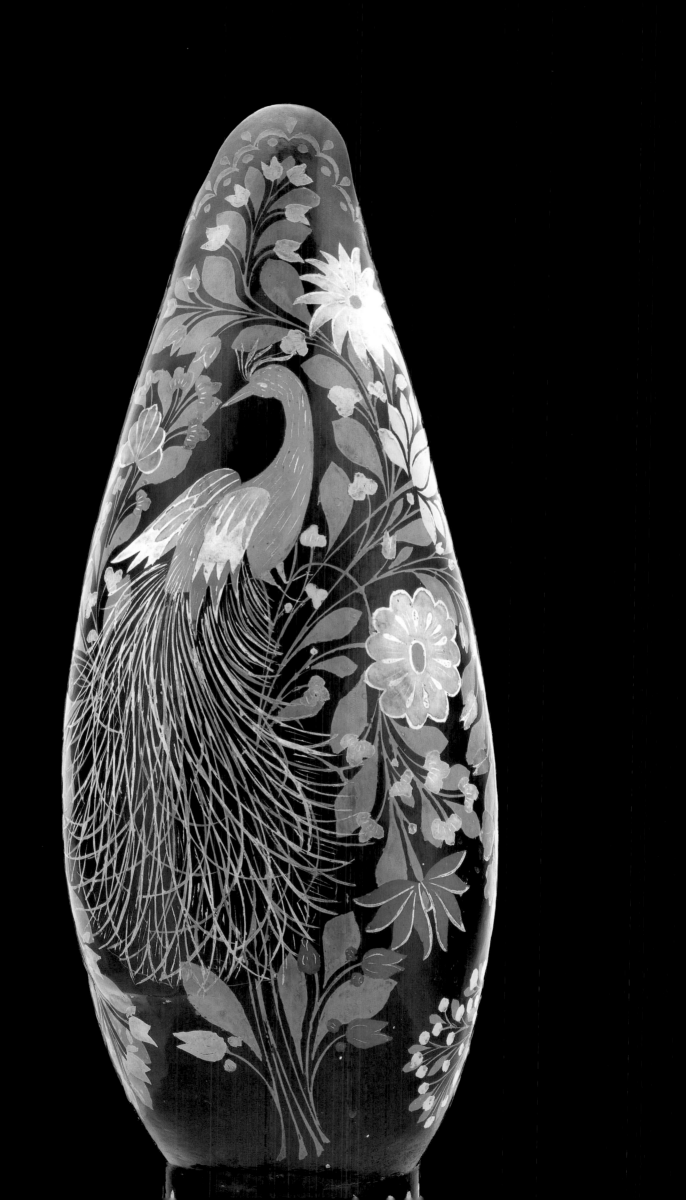

BASKETRY

NATURE AND GEOMETRY ❧

❧*Ana Paulina Gámez*

W<small>HEN YOU HOLD A BASKET IN YOUR HANDS, TWO THINGS BECOME</small> immediately apparent: first, that it is made of plant fibers and second, that these fibers have been woven in a certain way to give the basket its shape. "Basketry is quite simply vegetation turned into culture in a material form," writes Bignia Kuoni. This folk art uses simple processes to transform twigs, grasses or reeds, depending on the botanical diversity of each particular region. The accessibility of raw materials and the simplicity of the work involved made it possible for basket-weaving to become one of humanity's first manual arts. Archaeological evidence from around the world has clearly demonstrated that basketry existed even before the discovery of fire, and therefore, pottery. We can say with confidence that basketmaking has been with us since the beginning of human history. ❧

Many who have written about this folk art believe it to be a woman's invention. It is of course possible that women—inspired by the birds that built their nests from systematically arranged twigs—initiated the practice of intertwining branches or grasses to make the receptacles they needed to gather fruit. "Thus, it was in basketry that structured, congruous surfaces were created through the rhythms of weaving for the first time," writes Kuoni. Basketry must have begun as one of the domestic tasks that brought women together around their work, accompanied by singing. ❧

As we have mentioned, basketry depends upon the botanical resources available and the weaving styles used. It may be defined as a set of techniques through which rigid or semi-rigid rectilinear elements are interwoven, without the assistance of any kind of loom, to form receptacles or flat objects. ❧

Before describing the specific techniques of the trade, it is important to make some distinctions regarding the plants used, and the most common forms and principal components of the final products. We can divide the plants used in basketry into two groups: rigid materials such as wood, cane or wicker; and semi-

*Opposite page
Example of fiber
used in basketry.
Photo: Patricia
Lagarde.*

*Pages 302–303
Tlachiquero (worker
who extracts sap
from maguey plant).
Miniature made
of woven palm.
Oaxaca.*

rigid materials such as leaves, straw and soft stems or stalks. The first group is used in fashioning hard objects such as *pizcadores*, or harvesting baskets. The second group is used to make flexible baskets, such as cylindrical *tompeates* woven from palm. ❖

Each fiber undergoes a unique preparation before weaving. For example, plants which grow in the form of flat stalks, such as *tule* (bulrush) and *chuspata* (cattail), need only be dried. Other plant fibers must be cut into strips, such as palm leaves which are sliced parallel to the vein, or reeds which are cut lengthwise and then flattened in order to obtain fibers suitable for weaving. Some fibers, such as reeds and liana, must also be soaked before weaving to make them more flexible. ❖

Still other fibers require a more involved preparation process to weave them into cordage; henequen is one example. The pulp and fibers are usually separated mechanically and then allowed to dry. According to T. K. Derry and T. Williams, three specific processes are required to turn fiber into rope: "twisting fibers into threads, threads into strands and finally, strands into rope. To prevent the finished rope from unraveling, each individual strand is twisted

This page and opposite Samples of Mexican plant life. Photo: Patricia Lagarde.

in the opposite direction to that in which the strands will later be twisted together." Sometimes strands are braided instead. ❖

In terms of the shape given to the basketwork, three types may be identified: flat objects, bags and receptacles. Flat, two-dimensional objects include mats, or *petates*; bags such as *morrales* (haversacks) can be flat or have volume, depending on what they are designed to hold; and receptacles such as market baskets are three-dimensional. These shapes derive from the three forms of weaving, which establish the guidelines for classifying each piece of basketwork. ❖

J. M. Adovasio writes, "Any piece of basketry consists of three different parts: the walls or sides, the rim, and the nucleus or starting point. The most important element is the main body formed by the sides. In the case of woven containers or baskets, the sides can be easily distinguished from the other two parts—the rim or the nucleus. These distinctions may be arbitrary in other forms of basketry. In the case of mats and other flat or atypical objects, the side makes up the majority of the piece and includes everything but the rim. The side or main body can only be woven using one of the basic techniques which include stitching, weaving and twining." ❖

Spiral coiling is the oldest technique according to archaeological findings. Adovasio defines it as a horizontal, passive element wrapped around itself to form the foundation, which is then subjected to a vertical, active element that is the stitching.

The basket is supported by the successive stitches that keep the foundation fixed in place. ❖

The weaving technique is based on the interlacing of two or more series of active elements, which in textile arts are referred to as the weft and warp. This technique is used for receptacles, bags and mats, and is the most versatile process in basketry. A sub-classification of this process is plaiting or matting. This consists of intertwining two or more fibers or strands that cross over in two different directions. This technique is ideal for making long strips of narrow weaving that can then be joined together by stitching to form a larger weaving. Hats are often made this way. ❖

The final technique is the twining method, known in the textile industry as a connecting weave. Two weft strands—the active, horizontal elements—are used. The first weft strand crosses a warp strand— the passive, vertical element which in this case forms the basket's structure. The second weft strand passes behind and over the first one and in front of the warp. ❖

When two of these techniques—usually weaving and twining—are combined in a single basket wall, the result is known as a mixed technique. ❖

A basket can be decorated with four different techniques: painting, appliqué, varied weaving rhythms and combining dyed strands. Each weaving technique has its own corresponding decorative devices. For example, it is common to see circular, concentric, spiral or cruciform ornamentation on spiral coiled basketry objects. ❖

The painting technique consists of applying color with a paintbrush or some other object to make a design on the surface of a finished object. In the next technique, objects such as shells or feathers are stitched to a woven piece or attached in some other way. A variation in the weaving rhythm can create frets or geometric lines. In the fourth technique, fibers dyed in different colors are combined with undyed fibers. They may be woven in the same rhythm or varying rhythms to create a decorative motif. In many cases, these decorations have symbolic meaning, providing the objects with sacred or ritual significance. ❖

Because the materials used in basketry disintegrate so easily, there are not enough surviving samples to reconstruct the history of this folk art. This has unfortunately left us with a huge gap in our knowledge, making the study of basketry very difficult. ❖

In addition, because basketry objects are produced so abundantly and so inexpensively, they have not attracted much attention. Only recently, with the creation of ethnographic museums, have basketry items become collectable. This explains the great lack of examples of work from before the 1960s, and perhaps why there is so little research on this topic in Mexico, especially that which focuses on archaeological and historical periods, though some ethnographic studies have been published in recent years. ❖

It would seem that while it has been so useful and so much a part of everyday life throughout our history, basketry wishes to disappear without a trace, as if conscious that everything must come to an end. But it is precisely its usefulness, its everyday nature and its biodegradability that make it so noteworthy. What would agricultural work be like without *pizcador* baskets for gathering the harvest and transporting it over long periods of time?

The weave of these objects provides ventilation and protects the contents from bumps and blows; the fibers absorb excess humidity, thus prolonging the life of vegetables stored inside. After much use, when the

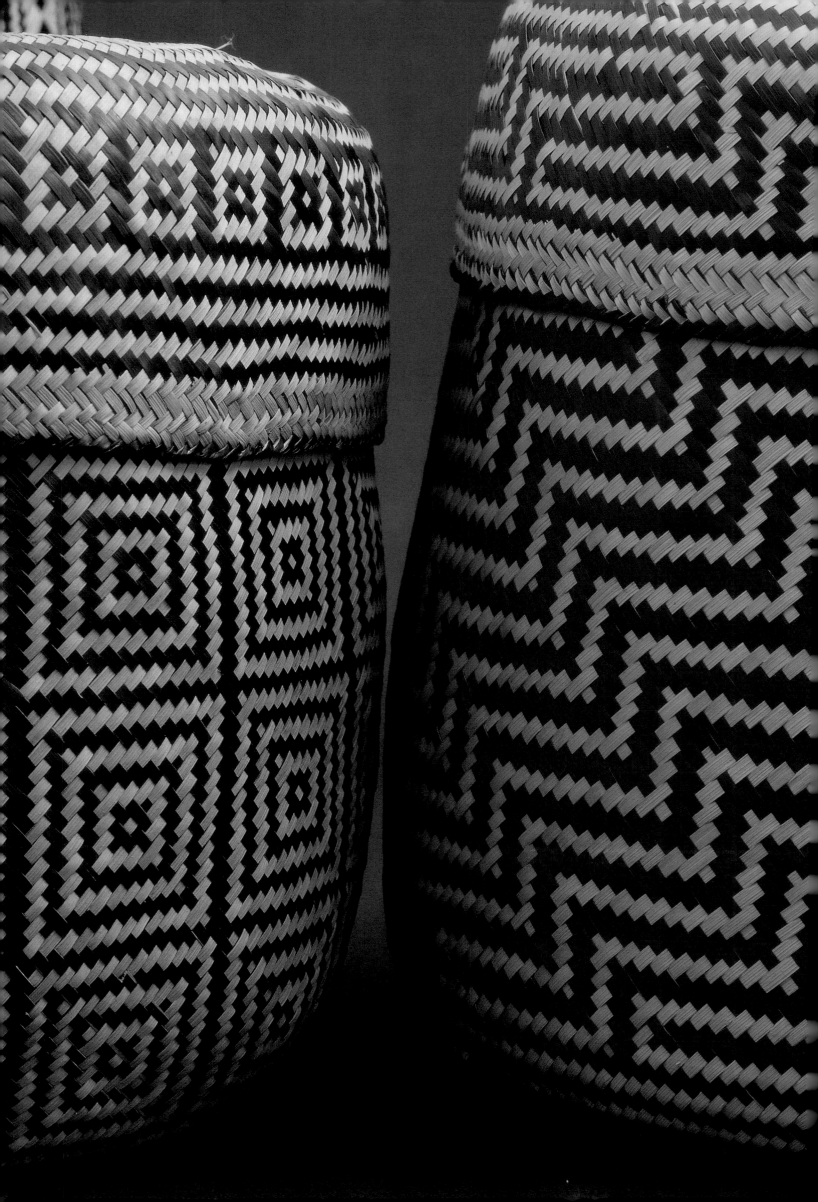

weaving has become loose and the fibers have broken, these objects are discarded because they no longer serve the function for which they were designed. They easily decompose and enrich the soil which gave them life, without leaving behind any harmful residue. ❧

Mexican Markets from Tlatelolco to the Parián

When the Spaniards reached what is today Mexico, they were surprised to find such an abundance of gold and silver, as well as cochineal, cocoa and vanilla. They were amazed by the flavors of exotic fruits such as mamey, prickly pear, soursop, avocado and so many others which were totally unknown in the Old World. ❧ Bernal Díaz del Castillo (1492–1584) wrote a description of the Tlatelolco market in his *History of the Conquest of New Spain*. He took note of the many wares he found there, but seemed to pay no attention to what they were packed in or to the baskets they were displayed in, without which those products would not have made it to the market. Many of those wonderful goods were carried to the ends of the earth, crossing the Atlantic and the Pacific in basketwork containers. The existence of many handmade objects depended on their usefulness and their usefulness for transporting other objects. ❧ Throughout Mexico's history, two distinct basket-weaving traditions have existed side by side. The first, based on the pre-Hispanic tradition, has provided continuity and shaped the techniques and types of basketwork that are characteristic of indigenous cultures, including petate mats, tompeate or tenate cylindrical baskets, *petacas* (trunks), *mecapales* (bearer's head-bands), *soyates* (rope belts) and *cacles* (agave fiber sandals). The second tradition comes from the Spanish, who introduced objects completely unknown to indigenous peoples, such as shopping baskets with handles, one-piece and plaited hats, harvesting baskets and objects used in worship such as woven palm leaves for Palm Sunday and straw hearts. And of course, new fibers such as wheat and barley straw were introduced. ❧

Unfortunately, no examples of basketry from colonial times have survived to this date, so we must rely on post-Hispanic codices, colonial chronicles and period paintings to learn about these objects. ❧ In the Mendoza Codex, we find all the indigenous basketry objects—including petates, tompeates, petacas, soyates and mecapales—that were used throughout the colonial periods as well as before the Spanish Conquest. Petates were used for wrapping bundles of merchandise, as sleeping mats

❧ ANA PAULINA GÁMEZ

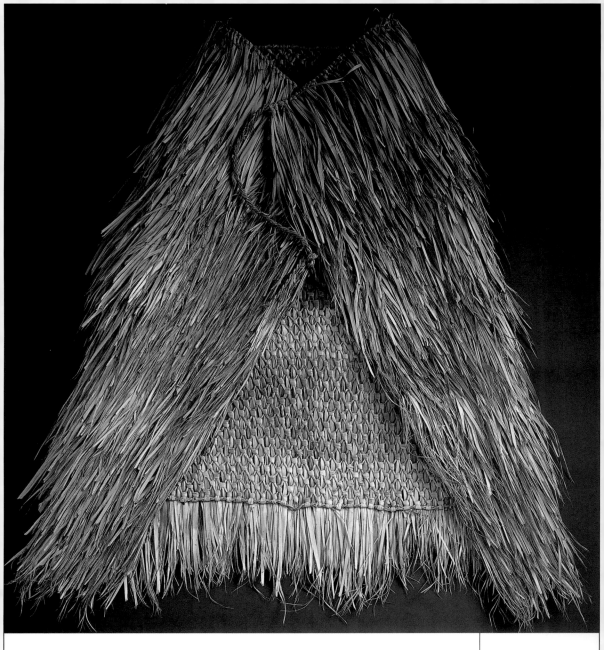

and for burying the dead. Even wedding ceremonies were held on petates, as is still the custom today in indigenous communities. Tompeates, used to store and transport fruit, vegetables and many other products, were carried from place to place on the backs of indigenous porters, with the help of the mecapal, a woven fiber band tied at either end to the tompeate and encircling the porter's forehead. Petaca trunks were used to store clothing and were nearly the only piece of household furniture in the homes of indigenous peasants. Finally, cacle sandals and soyate sashes complemented the indigenous attire. ✧

Indigenous people wore and sold basketry throughout the entire colonial period. Like the domestic manufacture of clothing and

Cape. Zinacantepec, State of Mexico. Woven and knotted palm.

Opposite page Édouard Pingret. Shepherd in the Valley of Mexico. Oil on paper. National Bank of Mexico.

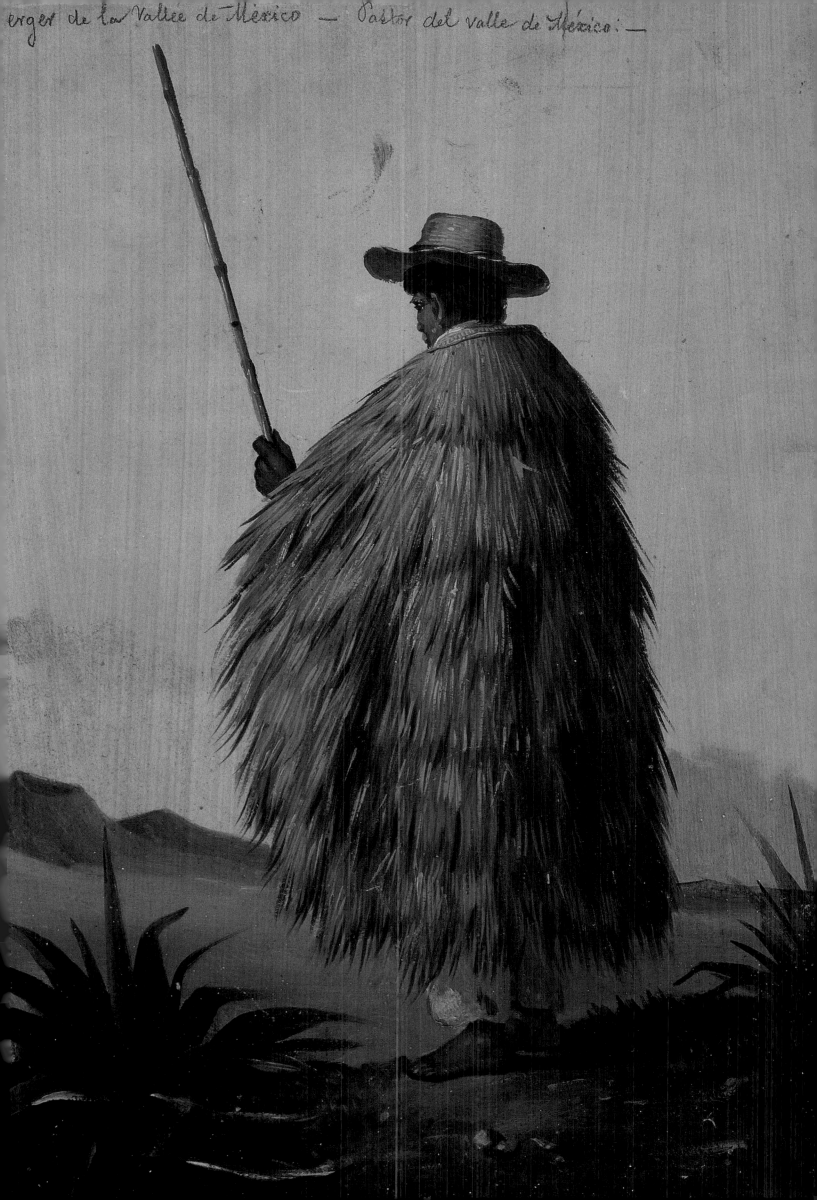

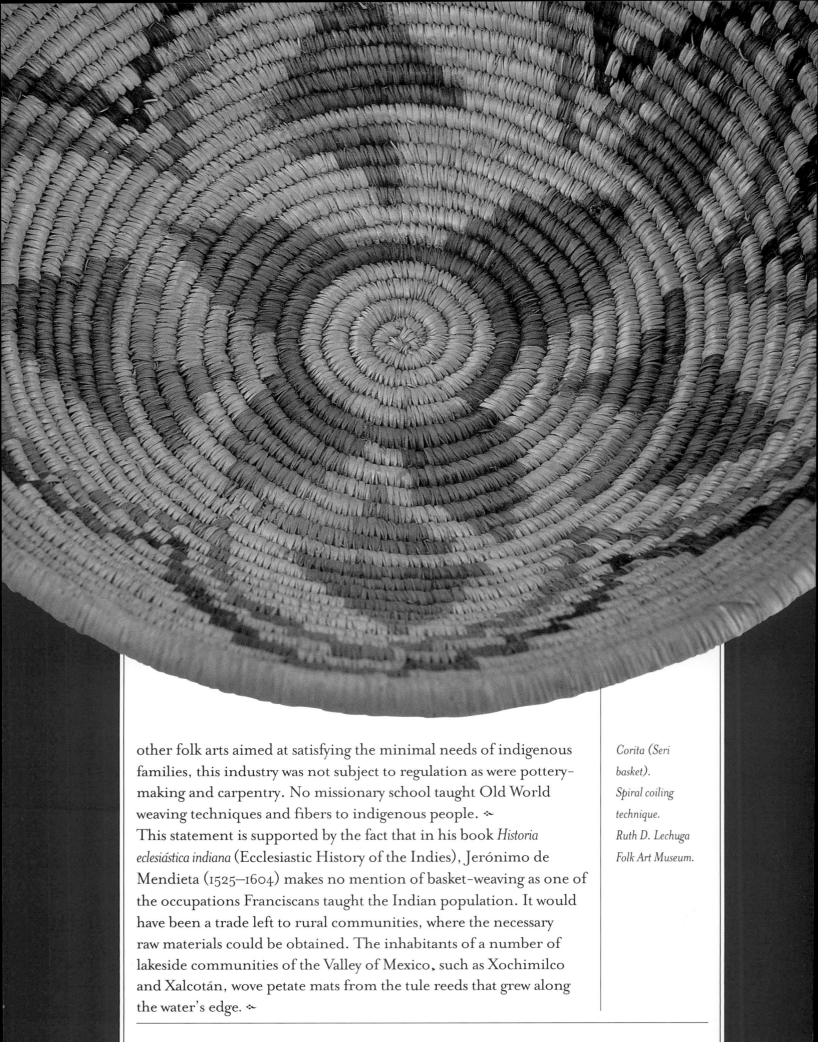

other folk arts aimed at satisfying the minimal needs of indigenous families, this industry was not subject to regulation as were pottery-making and carpentry. No missionary school taught Old World weaving techniques and fibers to indigenous people. ✧

This statement is supported by the fact that in his book *Historia eclesiástica indiana* (Ecclesiastic History of the Indies), Jerónimo de Mendieta (1525–1604) makes no mention of basket-weaving as one of the occupations Franciscans taught the Indian population. It would have been a trade left to rural communities, where the necessary raw materials could be obtained. The inhabitants of a number of lakeside communities of the Valley of Mexico, such as Xochimilco and Xalcotán, wove petate mats from the tule reeds that grew along the water's edge. ✧

Corita (Seri basket). Spiral coiling technique. Ruth D. Lechuga Folk Art Museum.

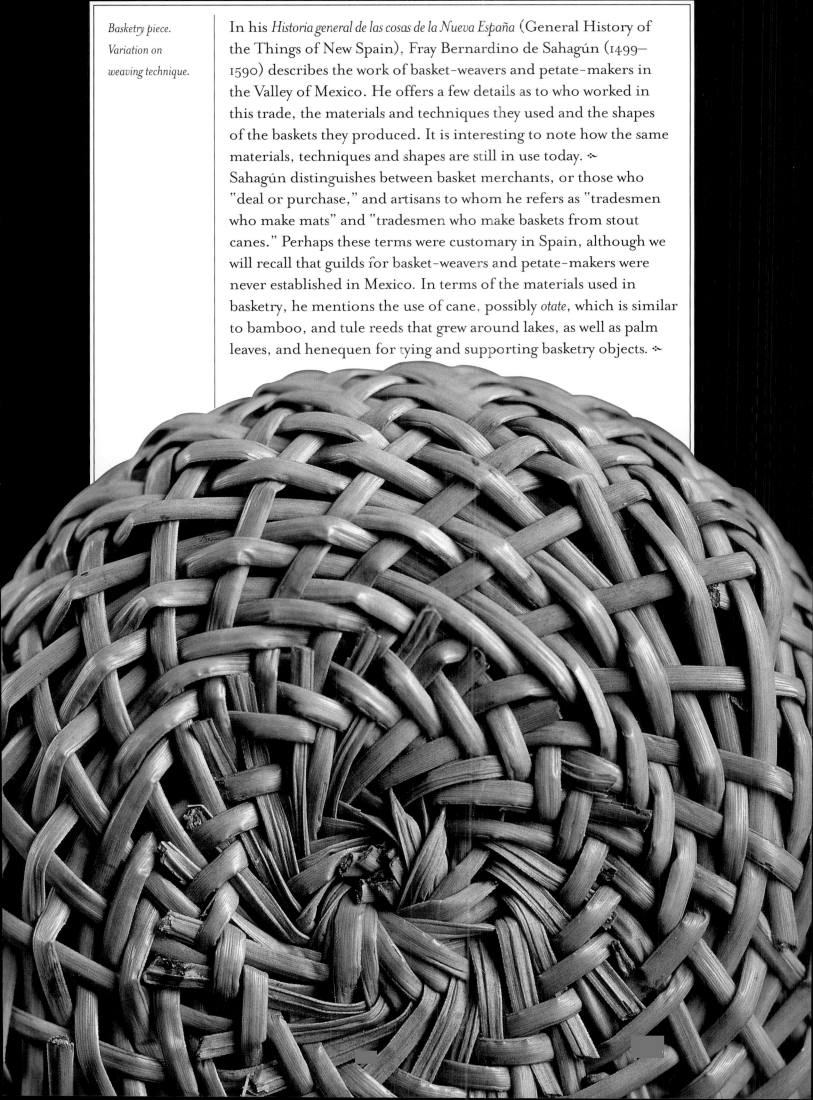

Basketry piece. Variation on weaving technique.

In his *Historia general de las cosas de la Nueva España* (General History of the Things of New Spain), Fray Bernardino de Sahagún (1499–1590) describes the work of basket-weavers and petate-makers in the Valley of Mexico. He offers a few details as to who worked in this trade, the materials and techniques they used and the shapes of the baskets they produced. It is interesting to note how the same materials, techniques and shapes are still in use today. ✢

Sahagún distinguishes between basket merchants, or those who "deal or purchase," and artisans to whom he refers as "tradesmen who make mats" and "tradesmen who make baskets from stout canes." Perhaps these terms were customary in Spain, although we will recall that guilds for basket-weavers and petate-makers were never established in Mexico. In terms of the materials used in basketry, he mentions the use of cane, possibly *otate*, which is similar to bamboo, and tule reeds that grew around lakes, as well as palm leaves, and henequen for tying and supporting basketry objects. ✢

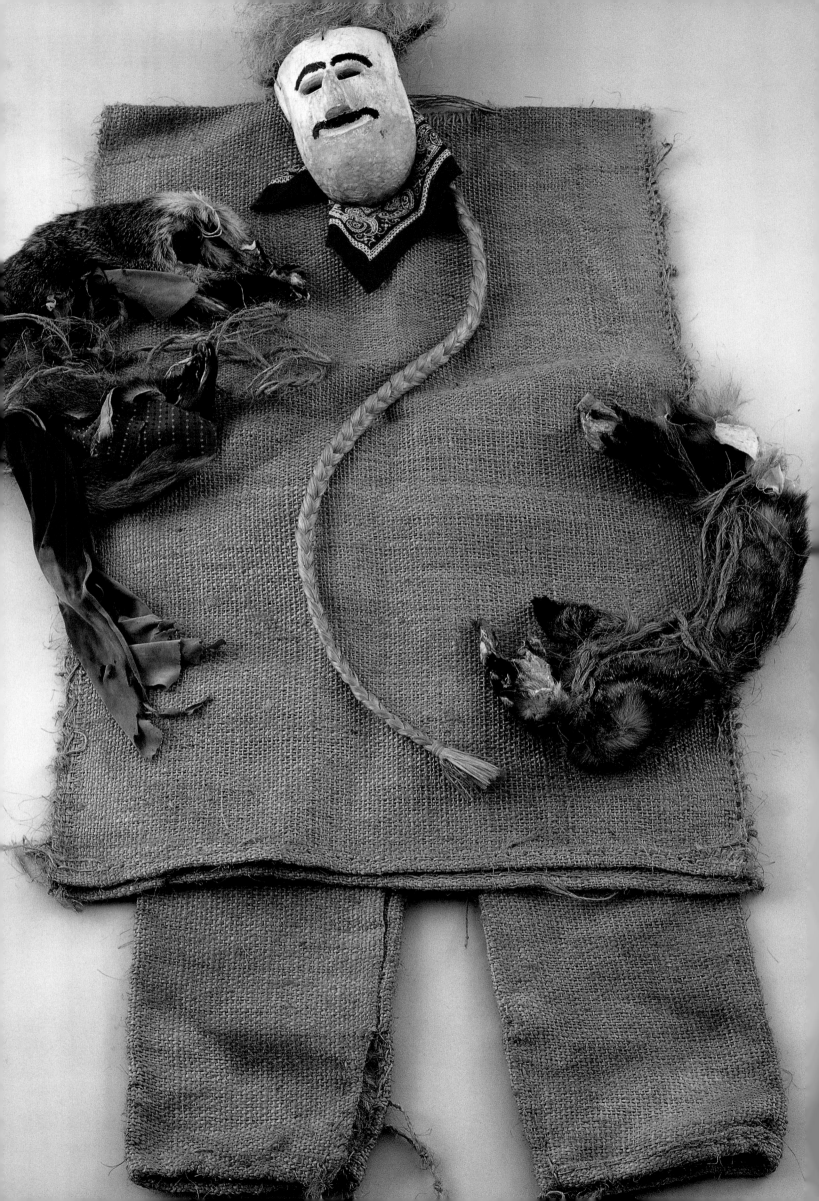

His technical descriptions are brief and focus mainly on details of how materials were prepared, stating for example that tule reeds and palm leaves were dried in the sun before being woven. He also mentions that cane had to be soaked to make it more pliant, and broken to obtain strips that could be woven—practices which continue to this day. ❖

Regarding basketry shapes Sahagun makes note of three types: the *chiquihuites*, baskets woven from canes in different shapes, either like "tiny writing-desks with compartments" or cylindrical; the petacas or *petlacalis*, cubic or prismatic-rectangular baskets with lids, made of cane; the petate mats, of which he notes that some are "long and wide, others square, still others are long and narrow." As in contemporary practice, the forms of these mats may have been varied according to the intended use: for sleeping, for kneeling in front of the grinding stone, or for sitting, all of which are current uses. Finally, he mentions the *otlatompiali* or tompeates and says they were similar to *espuertas* or Spanish two-handled baskets. ❖

The Mixtec region is traditionally a palm-weaving region. The use of certain traditional indigenous basketry objects is registered in the Sierra Codex, which is actually an accounting book listing expenses incurred between 1550 and 1564 in the Santa Catalina Tezupán community, located in what was known as the Teposcolula district. Thirty-one pages of the document have been preserved. They contain lists of expenses which are divided into three columns: in the first, items are written in ideographs; in the second, there are notes in Náhuatl; and the third consists of quantities. ❖

On pages 5, 11, 25, 34 and 44, several basketry purchases are recorded, including petates, *mecates* (ropes) soyates, mecapales and tompeates. In certain cases, it is specified that the objects were to be used for transporting silk to be sold in Mexico City. The cargo was wrapped in petates to form bundles which were then placed on litters with mecapales tied to them so bearers could carry them on their backs.

In other cases, the petates were purchased for the church, perhaps to be placed on the floor as seating for parishioners. It is interesting to compare prices and descriptions of some of the petates, such as those recorded on pages 11 and 34. The petate mentioned on page 11 cost three pesos, but on page 34, the purchase of eighty colored petates came to a total of twenty pesos, at a rate of four petates for a peso. It could be that the petate registered

❖ ANA PAULINA GÁMEZ

on page II was similar to the one Manuel Toussaint mentions in his book *Arte colonial en México* (Colonial Arte in Mexico), which he described as so finely worked with such a delicate design that it could be compared to European tapestries. ❖

Castas paintings, which illustrated the different ethnic groups in New Spain, provide us with one of the most effective forms of studying basketry. In addition to depicting racial aspects, the paintings illustrate professions and trades, and the clothing and homes of different inhabitants of viceregal Mexico. Basketry objects were indispensable in that society, and included a number of forms, such as tompeates, petates, indigenous fans and hats, trays and Spanish baskets with handles. Another interesting aspect of these paintings is the typical representation of non-Christian indigenous Mexicans. The women are often shown carrying their children in woven baby carriers on their backs—the same type of basket used today in the northern mountains of Puebla (page 20). ❖

Another painting confirming the use of these objects is *The Stall at Parián Market*, an excellent, anonymous oil painting from the eighteenth century where we see a bustling market stall well-stocked with food items. Two indigenous merchants display a bundle to two Spanish patrons, while a pair of Criollo children point at the sweets, fruits and delicacies sold there. Among the goods are stacks of tompeates and petates adorning the shelves or containing merchandise, as well as huacales. All of these objects come from the indigenous tradition. There are also Spanish objects such as the trays used to exhibit fruit and other goods. ❖

These late eighteenth-century paintings demonstrate the total merging of the two basketry traditions and their utility in this society that was so much a product of its cultural blend. ❖

Before moving on to the nineteenth century, it is worth noting how indigenous *petlacalis* were transformed into Mestizo velvet-lined petaca trunks covered in leather, embroidered with agave fiber and decorated with ironwork and locks. They were very popular with travelers because they were so lightweight. ❖

BASKETRY IN NINETEENTH-CENTURY ART
Paintings and drawings are one of the few sources we have for studying nineteenth-century basketry, since there are no remaining examples from that era. Fortunately, many artists of the time were interested

This page and opposite Seri basket with Spanish coat of arms, made with the spiral coiling technique. Late eighteenth century. Franz Mayer Museum.

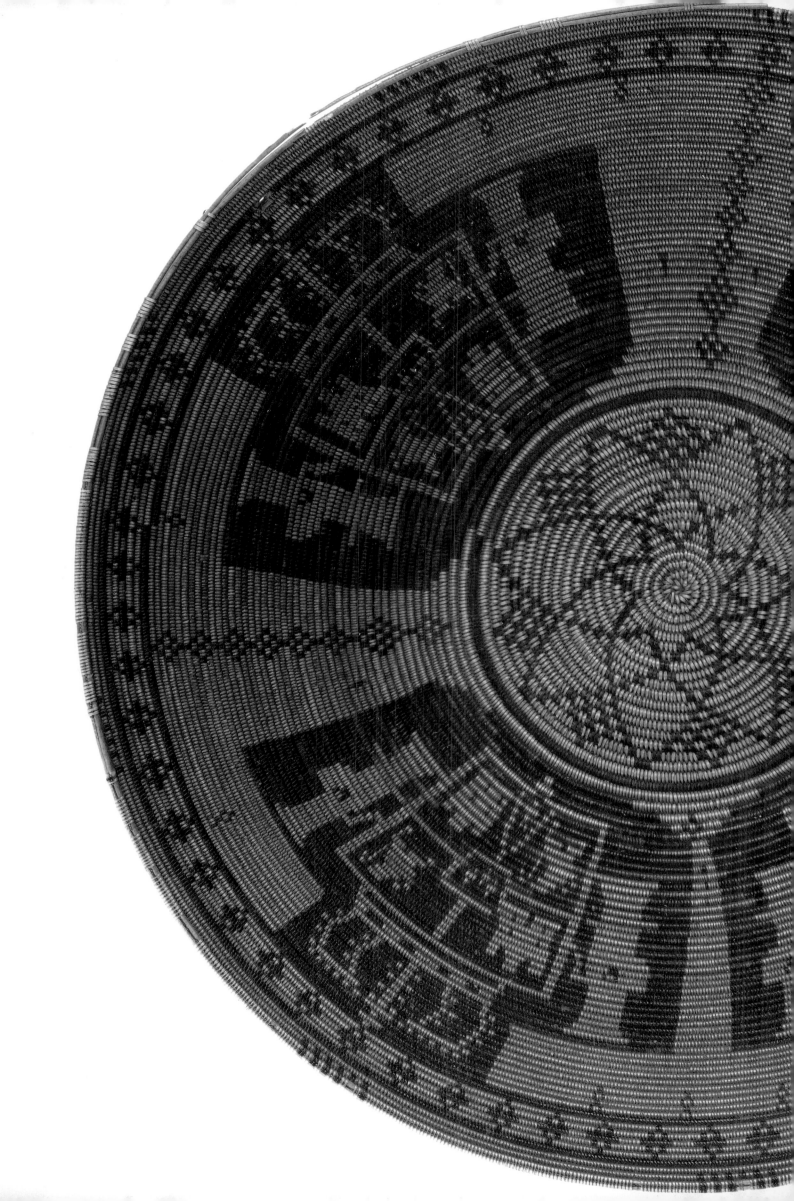

in capturing Mexican customs and everyday life on canvas. The traveler Édouard Pingret (1788–1875) painted humble kitchens and typical household interiors, the first with woven trays, market baskets, fans for the fire, tompeate and chiquihuite baskets; the second showing petates and shopping baskets. In a series entitled *Costumes of Mexico* painted between 1855 and 1856, the artist Casimiro Castro (1826–1886) depicts market scenes with merchants working under petate awnings, selling their goods in chiquihuites and woven trays, while customers place their purchases in baskets with handles and tompeates. In his lithograph portraying Roldán Street and its quay, Castro captures a bustling market with all kinds of goods being hauled in the traditional cone-shaped pizcador baskets of central Mexico, and in rectangular huacales strapped with mecapales to the backs of dock workers. We also see people carrying bread or vegetables in woven trays placed on their heads, and indigenous merchants in their narrow canoes selling fresh produce and flowers brought from Xochimilco in tule or palm tompeates. ❧

Painter José Agustín Arrieta (1803–1874) provides us with some of the most detailed representations of baskets. From his paintings, we have inherited a remarkable registry of different weaves and shapes. He included market baskets in many of his still lifes and *costumbrista* paintings. His powers of observation were so keen that we can distinguish between baskets made of twigs and those made of reeds, the first having a rim finished off with crimping and the second finished off with plaited or simple weaving. He also portrayed tompeates with single or double edges, trays made of reed, and fans and hats made of palm. These detailed canvases permit us to expand our knowledge of the formal characteristics of baskets in central Mexico during the period, and we can infer the weaving techniques used by comparing them to present-day baskets. ❧

The *capote* is a garment for which we have no pre-Hispanic or colonial references, but it is very common to find examples in nineteenth-century art. *Capotes* were capes used to protect the

❧ ANA PAULINA GÁMEZ

wearer from the rain—the drops of water would just slide off the long strips of palm connected to the exposed side. ❖

Dr. Atl and Basketry

The twentieth century was a period of many transformations in Mexico, and folk arts and basketry were no exception. The Mexican Revolution was one of the most important generators of change in our country, affecting both social and cultural life. One important process among all these changes was the developing appreciation for our autochthonous cultures. ❖

Thus, in 1921, on the occasion of the hundredth anniversary of Mexico's independence from Spain, an exhibition was organized to display the country's wealth of folk art to the general public. Roberto Montenegro (1887–1968) and Jorge Enciso (1883–1969) curated the exhibit, while Gerardo Murillo, known as "Dr. Atl" (1875–1964), was in charge of the catalogue. He devoted chapter sixteen to basketry, and although brief, it gives us a clear idea of the shapes and uses of baskets in the late nineteenth and early twentieth centuries. ❖

Murillo states that the most important basketry objects are petates, tompeates and hats. He describes petates made of tule reeds or palm as extremely important articles, as they were still the "quintessential Mexican bed" and also served as the most common and inexpensive way to pack all kinds of goods into bundles. He also mentions that the same technique is used to weave tompeates and *pasillos*—very long mats "spread across the floor in rooms to protect the bricks from scrapes and floor paint from wear." ❖

Miniature orchestra.
Oaxaca.
Dyed woven palm.

Opposite page
Antioco Cruces
and Luis Campa,
basket vendors,
ca. 1865.
From the series
Mexican Types.
Collection of Jorge
Carretero Madrid.

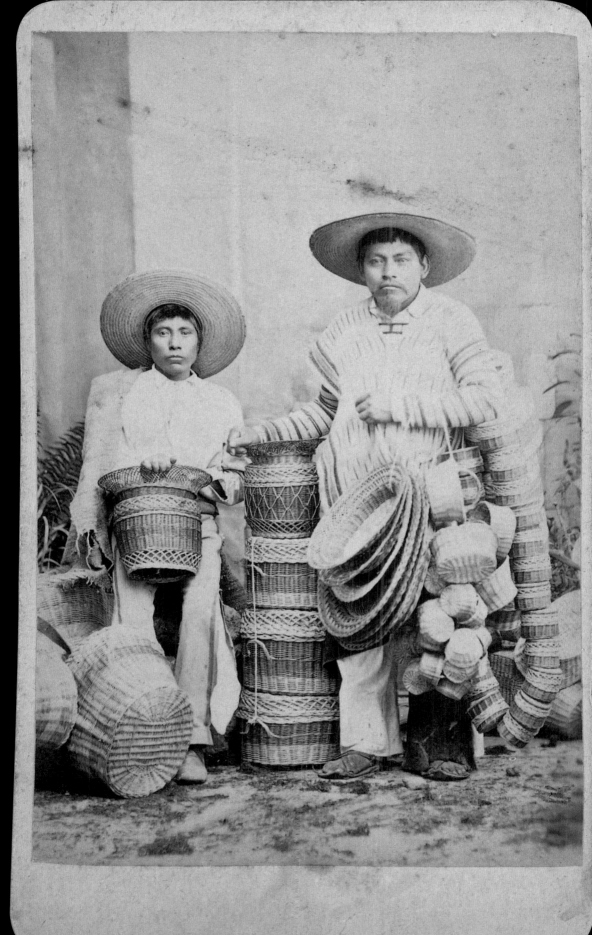

The author also mentions the high-quality petates and tompeates from Puebla and Oaxaca, dyed "red, blue, yellow and violet" and bearing traditional geometrical designs. They are similar to those mentioned in the Sierra Codex which were made in the same region according to traditions that have survived to this day in communities such as Santa Cruz, Puebla, in the Lower Mixtec region, as well as in San Luis Amatlán, Oaxaca. Information on these petates also corroborates what Manuel Toussaint would later write about basketry in the region. ✤

As for basketry using otate, reed and wicker, Murillo only mentions *canastos* which may refer to market baskets with handles, and adds that the states of Puebla, Mexico, Guanajuato, Michoacán and Jalisco were the major producers of this kind of work. He also refers to miniature figures from Silao and Irapuato in Guanajuato, and sewing baskets from Santa María del Río in San Luis Potosí. ✤

As for hats, he only writes of those woven from palm, and identifies two different types: "petate hats" and "cowboy sombreros." This author was the first to refer to basketry manufactured by prisoners in municipal jails, a program of the Ministry of Industry and Commerce that must have begun at the end of the Mexican Revolution, and which continues to this day. The author praised the inmates' abilities and described the work of those in Guadalajara and Iguala as the best. It is clear Murillo was not aware of the excellent basketwork from Northern Mexico, or he certainly would have dedicated a few lines to it. ✤

Beginning in the 1920s, folk art production in general became more dynamic, prompted by the 1921 exhibition as well as by factors such as U.S. tourism and cultural policies that encouraged the manufacture and consumption of handmade articles. Thus, basketry was diversified into two areas: first, articles such as the pizcador baskets that follow traditional forms, for use in rural, agricultural activities; and second, a tendency toward finer work and new types of objects responding to the growing demands of tourism and urban life, such as *pesca novios* ("husband-hunters," a device that traps the finger of the intended victim). These two tendencies have existed side by side throughout the century. ✤

Geographical Distribution of Plants for Basketry

Because basketry requires the use of plant fibers, it has remained primarily a rural occupation, since it is in the countryside where artisans grow and harvest the plants they need. Most basket-weavers are

✤ ANA PAULINA GÁMEZ

peasants who practice this craft when not involved
in their agricultural work, as a supplement to
their inadequate incomes. Like other rural crafts,
basketry is a family-based occupation passed on
from one generation to the next. Each member
of the family has a specific task, such as gathering
the raw material, drying, preparing and weaving it,
or selling the final product. It is important to mention
here that for a number of years now, artisans have learned
to weave not only in their homes, but also in groups organized by
community cooperatives. ❧

In Mexico, there are entire communities dedicated to weaving
baskets to satisfy local demand as well as that of surrounding areas.
But even in rural societies where some other folk art is practiced,
it is common to have at least one basket-weaver who makes simple
objects for local agricultural use. ❧

Due to the different vegetation in each of the country's regions,
distinct local styles have developed which dictate the shapes and
techniques used. We can speak of four basic regions: north, central,
the Mixtec-Oaxaca region, and the Gulf and the southeast. These
divisions are made only to facilitate description of the different
types of centers and do not reflect climatic or cultural divisions. ❧

The North

The northern region includes the states of Baja California Norte,
Baja California Sur, Sonora, Chihuahua, Coahuila, Nuevo León,
Tamaulipas, Sinaloa, Nayarit, Durango and Zacatecas. Since
pre-Hispanic times, the basketry tradition in this region is known
for its consistently high level of aesthetic and functional quality. ❧

The Seri Indians of Sonora have one of the region's finest basketry
traditions. They weave baskets, or *coritas* as they are locally known,
with the branches of a desert shrub known as *torote*. The technique
used is spiral coiling, and the weave is so compact and firm that
containers can even hold liquids. Traditionally, women did this
work, but today, with increasing demand in the tourist market, men
have begun to weave as well. Traditional shapes such as baby carriers
and water containers have given way to more commercial shapes such
as shallow baskets with a wide range of decorative motifs. ❧

In the book *People from the Desert and Sea*, authors Mary Beck Moser and
Richard Stephen Felger write that for the Seris of ancient times and
even for the elderly of today, basketry has always been enveloped
in myths that form part of Seri religion and culture. For example,

*Braided and sewn
palm hat.
Zacán, Michoacán.*

*Opposite page
Palm hats made
sewn in a spiral.
Photo: Jorge Vértiz.*

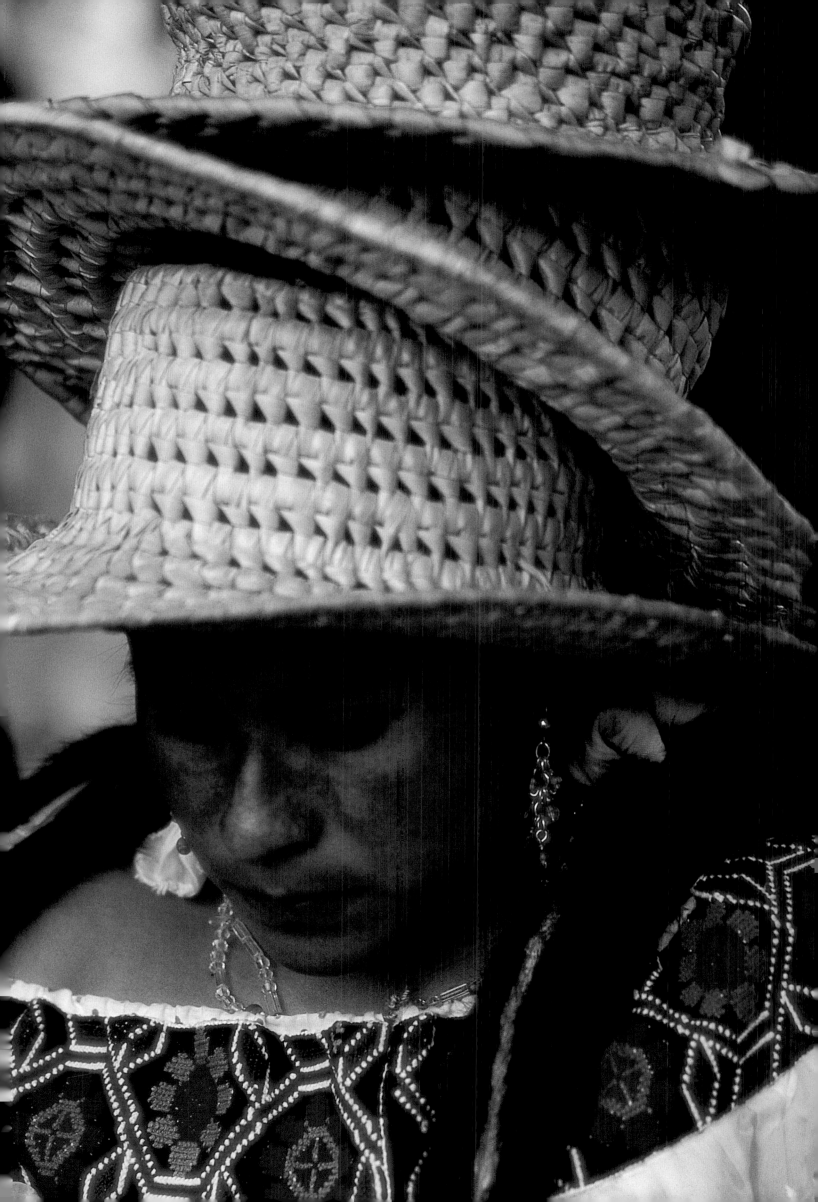

Sample of fibers used for basketry. Photo: Patricia Lagarde.

baskets are believed to have magical powers, and even after they have served their intended purpose, they are left behind, but never destroyed. It is also believed that as a woman weaves, she leaves her soul in the baskets, so when the work is finished, a ceremony is held to enable the weaver to recover what she lost. ❖

Also in the state of Sonora, the Pime Indians weave petates and palm hats, as well as high-quality spiral coiled baskets. In Baja California, the Cochimi and Paipai Indians weave baskets from palms, cedar needles and willow branches using the spiral coiling technique. The basketry of the Tarahumara Indians is one of the most beautiful crafts of the state of Chihuahua. They use palm, reed and pine needles. With the latter, they weave small baskets similar to tompeates and which retain the scent of pine for a long time. Other baskets, known as *guares*, are double-sided so they can hold water. The Huichol Indians of Durango, Nayarit and Jalisco make hats and little palm boxes which are like prismatic rectangular tompeates with a lid, used to hold arrows. ❖ Another craft common throughout the region that should not go without mention is rope-making in all its forms, using an agave species commonly called *lechugilla*. ❖

CENTRAL MEXICO

The central region is made up of the states of Jalisco, Michoacán, Guanajuato, Aguascalientes, San Luis Potosí, Querétaro, Hidalgo, the State of Mexico and Morelos. Basketry in this region corresponds mainly to a Criollo tradition, although there are some objects rooted in indigenous traditions. Wide *charro* sombreros are made in a number of Jalisco and Michoacán communities, as well as in San Francisco del Rincón, Manuel Dobaldo and Tierra Blanca in Guanajuato. ❖

Reed weaving is common throughout the region, especially in the State of Mexico, Morelos and Hidalgo. In Michoacán, chiquihuites, pizcadores, handled baskets, bread trays, *tascales* and miniature figures are made in towns such as Ichupio and Queréndaro, as well as in the state of Guanajuato, where the strawberry-growers of Irapuato are the main customers. In this city and in Silao, the tradition of weaving miniatures and toys continues. ❖

Bulrushes (*tule*) are woven in all the humid zones, one of them being along the shores of Lake Chapala. There, in the community of Santa Ana Acatlán, weavers make petates, *pasillo* mats and figurines, as they do in Lerma and Tultepec in the State of Mexico and in communities around Lake Pátzcuaro such as Ihuatzio, San Pedro Cucuchucho, Jarácuaro and Espíritu Santo. *Chuspata*, or cattail, is another aquatic plant that grows in the shallows of Lake Pátzcuaro. It is similar to tule, but its leaves are flat. It is used in the weaving of baskets of many different shapes and sizes, as well as hats for the tourist market. ❖

Palm is woven in areas extending from Matehuala, San Luis Potosí, to the state of Morelos, where petates, fans and tompeates are made. And in between, the hottest region of Michoacán, where palm is common, is home to some excellent weavers who make braided hats, tompeates, fans, scrub brushes and capotes. In Santa Ana Tepaltitlán, in the State of Mexico, artisans dye the palm in bright colors and weave baskets with the spiral coiling technique. Their work was very fine in the past, producing objects such as oval or cylindrical baskets with handles, trays, platters and spherical baskets, as well as many different animal, plant and human figures. ❖

Today, only a few artisans have preserved these practices. The younger ones use a thick weave and only geometric designs. Palm leaves woven to celebrate Palm Sunday are traditional in this area, as in other parts of the country. ❖

❖ ANA PAULINA GÁMEZ

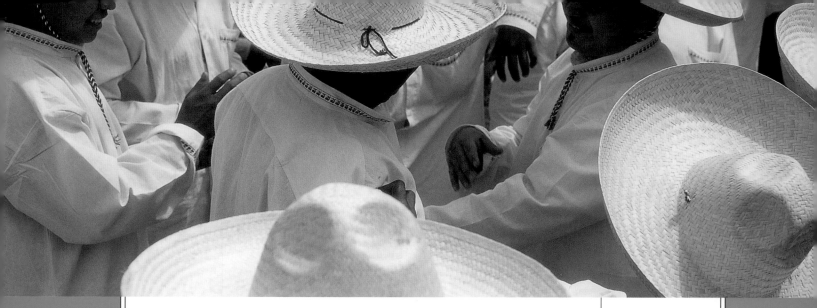

Baskets made from wicker and willow have become a time-honored
tradition in this region. These materials are traditionally woven
into hats, baby carriers and handled market baskets. But artisans
have created a whole range of new shapes and forms, from cat beds
to miniature angels for baptisms and first communions. Weaving
communities include Acámbaro, Guanajuato; Uripitío, Michoacán;
San Juan del Río and Tequisquiapan, Querétaro; and Tenancingo, in
the State of Mexico. ❖

In Michoacán, artisans use wheat straw to weave objects such as
hearts to be hung in kitchens as a type of "offering" to ensure that
there will always be food in the house, as well as flat figures such as
suns and moons, nativity scenes and biblical scenes (sometimes also
made from tule reeds). Finally, in Zacán there are still some elderly
weavers who turn wheat straw into excellent braided hats stitched
with agave thread. These hats are waterproof and were once used for
working in the fields. The *cucharilla* is another plant fiber still used
by some elderly weavers in Uripitío and the surrounding area to
make petates and fans. ❖

The Mixtec Region and Oaxaca

Before turning our attention to the Mixtec regions, it is worth
mentioning some areas outside this zone which nonetheless form part of
the states of Puebla and Guerrero, such as the Sierra Norte in Puebla.
There, the Otomí and Nahua Indians weave baby carriers and bags from
jonote bark. The baby carriers are reminiscent of the huacales carried
by non-Christian indigenous women in *castas* paintings, suggesting
that today's artisans are preserving an age-old tradition. In Guerrero,
weavers make baskets decorated with zoomorphic and geometric motifs
using palm strands dyed in different colors. ❖

The Mixtec region covers parts of the states of Puebla, Guerrero
and Oaxaca where, as we have seen, palm is traditionally woven. This
territory is one of the poorest in the country. The land is highly
eroded and its cultivation nearly impossible. The palm that was

*This page and
opposite
Woven palm hats.
Atlixcáyotl fiesta,
2002.
Atlixco, Puebla.*

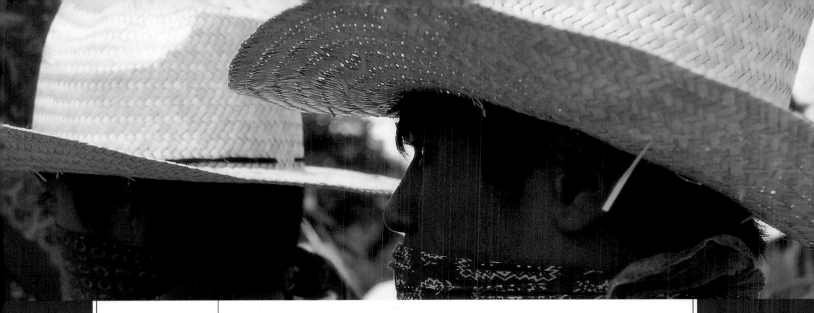

previously so abundant here has almost completely disappeared and must be brought in from farther away every year, which means it is very expensive. Nevertheless, weaving this fiber is the only source of income for many inhabitants. Palm is woven into petates, soyates, fans for the fire, tompeates and, above all, hats. Unfortunately, the old fret designs are disappearing, and most objects woven now are quite coarsely made. The situation is so dire that people can be seen weaving everywhere: in church, community centers and even while walking as they watch over their animal herds. ❖

It is worth highlighting the work of certain communities of Puebla, such as Santa Cruz. There, fine petates are still woven with geometric designs that may be related to those mentioned by Toussaint. Another community is Santa María Chigmecatitlán, where weavers create miniature figures that run the gamut from famous personages, stereotypical characters, musicians and circus performers to entire nativity scenes. ❖

The book *Oaxaca y Taxco* by Manuel Toussaint gives us an idea of the wealth of basketry styles in Oaxaca: "Next to the pottery stands are the basketry stalls. An infinite variety of baskets. The finest have lids, and are made of otate and reed to resist blows and endure the mistreatment of servants and porters as well as the long trips from Puebla or Mexico City when they are full of fragile pottery. Here, too, are petates, extraordinarily fine mats made of palm which can be folded into a bundle, or stretched out to their full three- or four-meter length. Brooms and fans are made of palm. Wide belts plaited with palm and palm hats." ❖

Otate and reed baskets are made in several regions of the state, including the central valleys, the Miahuatlán Valley, the Mixtec zone and of course, Tehuantepec. As Toussaint mentions, the pizcadores are used for transporting all kinds of goods. Until recently, these baskets in varying sizes were used as measuring units in the markets, as was the case with handled baskets, some of them simple and others decorated with miniature woven chains and tiny baskets. ❖

❖ ANA PAULINA GÁMEZ

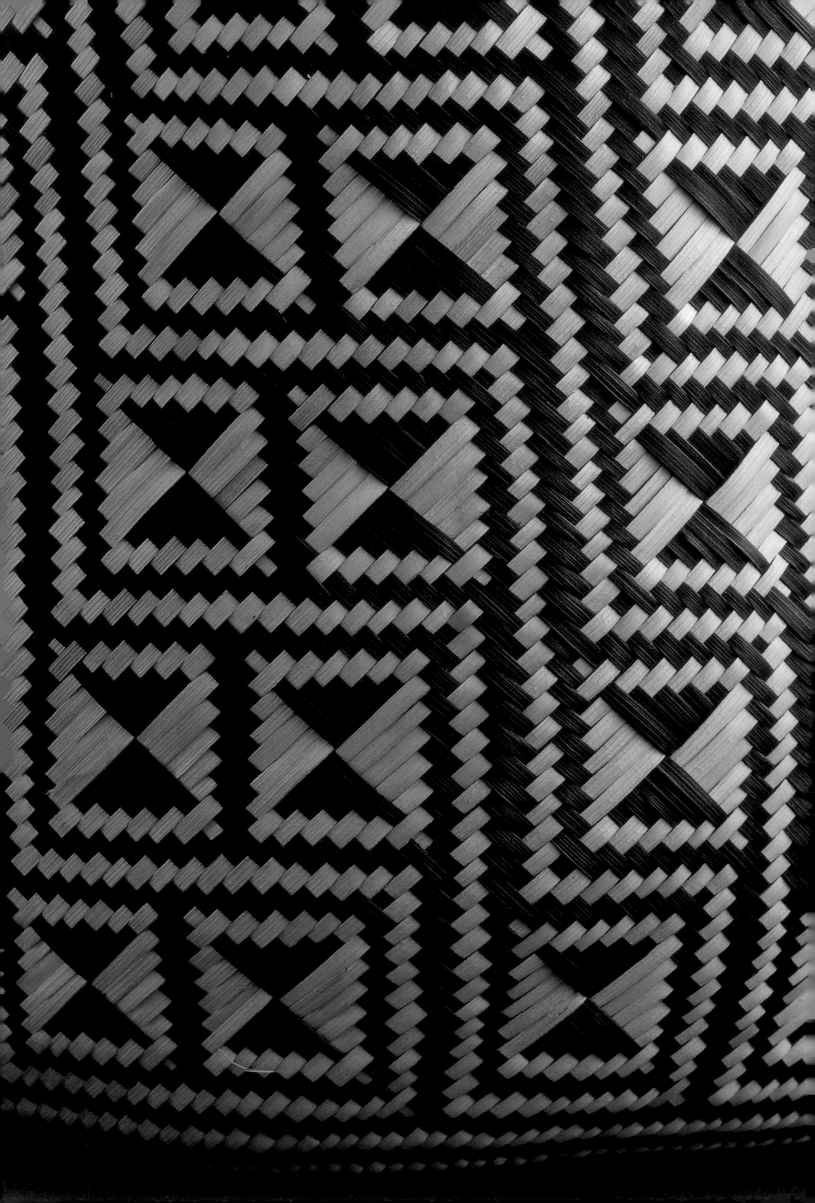

Petates are woven not only in the Mixtec Valley, but also in the Miahuatlán Valley, in some communities in the central valley of Oaxaca and on the Isthmus of Tehuantepec. Some of the finest are from the Mixtec Valley and San Luis Amatlán, where tompeates are also woven. The latter are known as *tenates* in the region and are decorated with geometric motifs which reproduce Mixtec frets. Finally, hats are also woven in the Mixtec region, as we have already mentioned. ❖

Since the mid-1980s, some forms of Oaxacan basketry—especially those of the central valleys—have assimilated Oriental designs. This is primarily due to an enterprising artisan, Amador Martínez, who went to China to study basket-weaving with bamboo. When he returned, he taught other artisans what he had learned. In addition, inmates of the municipal jails of Tlacolula and Ocotlán continue to weave baskets and copy Asian models in an effort to increase their sales. Little by little, new forms have been popularized among the basket-weavers of these valleys, and they are now widely accepted in the markets. ❖

THE GULF REGION AND THE SOUTHEAST

The Gulf region consists of the state of Veracruz, where palm is the fiber most commonly used, woven into petates in Tantoyuca and Santiago Tuxtla, and fans in Papantla. The southeast includes the states of Chiapas, Tabasco, Campeche, Yucatán and Quintana Roo. In Chiapas, palm is widely used for weaving baskets; in addition, *ixtle* or agave fibers are used by the Lacandón Indians to weave bags and nets. In Tabasco, baskets, petates and fans are woven from palm. In Campeche and part of Yucatán, very fine hats are woven from a certain species of palm known locally as *jipi-japa*. In Ticúl, Yucatán, and Becal, Campeche, baskets are made in caves, so fibers will retain moisture and remain pliant during weaving. ❖ All around the peninsula, baskets are made of palm or *huano*, dyed in different colors and woven with the spiral coiling technique. These baskets are usually woven by women, and one of the main communities producing them is Halachó. Henequen is widely used throughout Yucatán to make ropes, nets and bags called *pajo*, traditionally used to carry seeds to the fields. This weaving is done exclusively by men. *Bejuco* or liana is used in the eastern part of Yucatán. ❖

Finally, we cannot overlook an indigenous construction technique called *bajareque* that is intimately related to basketry. It is used traditionally in several areas of the country and the best

❖ ANA PAULINA GÁMEZ

examples can be seen in Oaxaca, Guerrero, the Huastec regions and the Yucatán peninsula. Víctor José Moya Rubio writes, "This procedure consists of a row of posts driven into the ground, half a yard to a yard apart. A lattice framework of interwoven sticks is placed between these poles and then they are covered with clay to form the walls." This technique is also used to make *cuezcomates*, or pot-shaped granaries, commonly used to store corn in Morelos, Guerrero, Puebla and Tlaxcala. ✤

ETERNAL PRESENCE

Throughout this brief survey, we have seen how traditional forms of basketry have been preserved because of their usefulness and connection to rural societies, even while new forms have emerged to satisfy the fickle tourist market. Unfortunately, the raw materials used to make these objects—our natural plant resources—have been endangered due to overuse and environmental deterioration in the regions where they grow. For this reason, it is increasingly difficult to obtain palm in the Mixtec region, wicker or the roots and twigs of the Mexican cypress in Querétaro, and liana in Yucatán. ✤

Basketry has always existed in our country, and always will. It is indispensable in so many ways, but still awaits some acknowledgment of its aesthetic value and of the skilled work of its creators who live such a precarious existence. ✤

If any doubt remains as to the importance of basketry in Mexico's everyday life, we need only mention some of the common expressions and idioms which have emerged from our daily coexistence with this folk art: *petatear*, a verb derived from the word petate (*petatl* in Náhuatl), means to die or never again arise from where one has laid down to sleep. In pre-Hispanic times and even today, many indigenous peoples used petates not only as bedding but also to bury the dead. *Tompetear* is equivalent to going shopping, since the tompeate is what women traditionally use to carry their purchases from the market. *Chiquihuetear* means to pull someone's leg: *chiquihuite* refers to a chicken's ribs, and by analogy, a *chiquihuetero* is someone who likes to handle or touch women. Finally, *hacerse chiquihuite* means to feel inferior. ✤ TRANSLATED BY JANA L. SCHROEDER. ✤

Rolled petate mat. Woven natural and dyed bulrushes.

Opposite page Tompeates woven with variations from natural and dyed palm. San Luis Amatlán, Oaxaca.

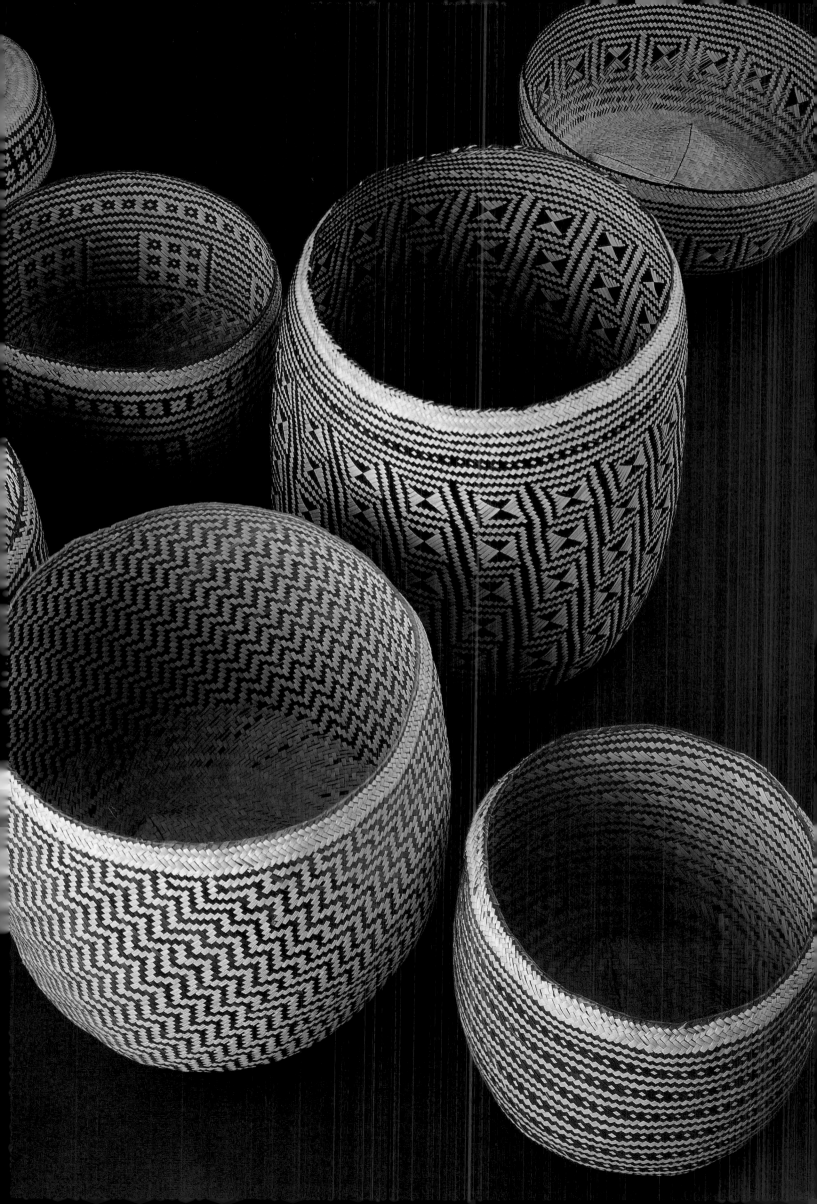

TINWORK

A HUMBLE AND EPHEMERAL NATURE ⚬
⚬ *Gloria Fraser Giffords*

T HE MANY APPLICATIONS OF TINPLATE CAN BE ATTRIBUTED TO ITS
unique advantages: lightness, strength and low cost. This last factor,
together with the ease with which the material is bent, crimped, cut
and soldered to form intricate shapes, accounts for its popularity
among small workshops or itinerant artisans. ❖

The basic equipment required for this manufacturing process can
be reduced to an anvil or other hard surface, mallet, hammer, metal
shears, lead and iron solder, soldering iron, folding tongs and a
few hand tools such as punches and chisels for crimping, marking,
perforating or otherwise decorating the pieces of tinplate. The
process was later refined with vices, and raised stamps or recessed
molds for pounding or pressing thin tinplate to create repoussé
or low relief. By piecing together cut and formed elements and
soldering them in place, the resulting forms and designs achieved
greater strength than those that were simply cut and bent. ❖

The utilitarian aspect of many articles fabricated from tinplate is
partially responsible for widespread ignorance about this art form.
Inexpensive domestic objects are the least likely to attract the attention
of art gallery curators and antique dealers, especially when these items
are as mundane as rusty, dented tin cups or mousetraps. Even rarer—
and often ingeniously crafted—tinplate articles such as candlesticks,
lamps and *nichos* (tin and glass containers for images of saints) are
overshadowed by similar objects of higher value in silver and gold. ❖

The relatively low cost and ease of replacement of tinplate goods
whenever they became damaged or lost their luster gave early tinware
an almost ephemeral quality. The appearance of novel and superior
products also led to tinplate becoming obsolete or simply outdated. In
the early twentieth century, for example, many tin vessels were replaced
by enamelware or graniteware which, besides their attractive modern
appearance, had the added advantage of being easier to clean. ❖

Opposite page
Jorge Wilmot
and Jesús Peña.
Untitled.
Tinplate with
repoussé and
engraving.
Tonalá, Jalisco,
1976.
Regional Museum of
Guadalajara.

Pages 336–337
Painted and combed
tinplate cross.
Mesilla, New
Mexico, 1910.
20 ½ x 15 in.
Collection of Ford
Ruthling, Santa Fe,
New Mexico.
Photo: Tony Vinella.

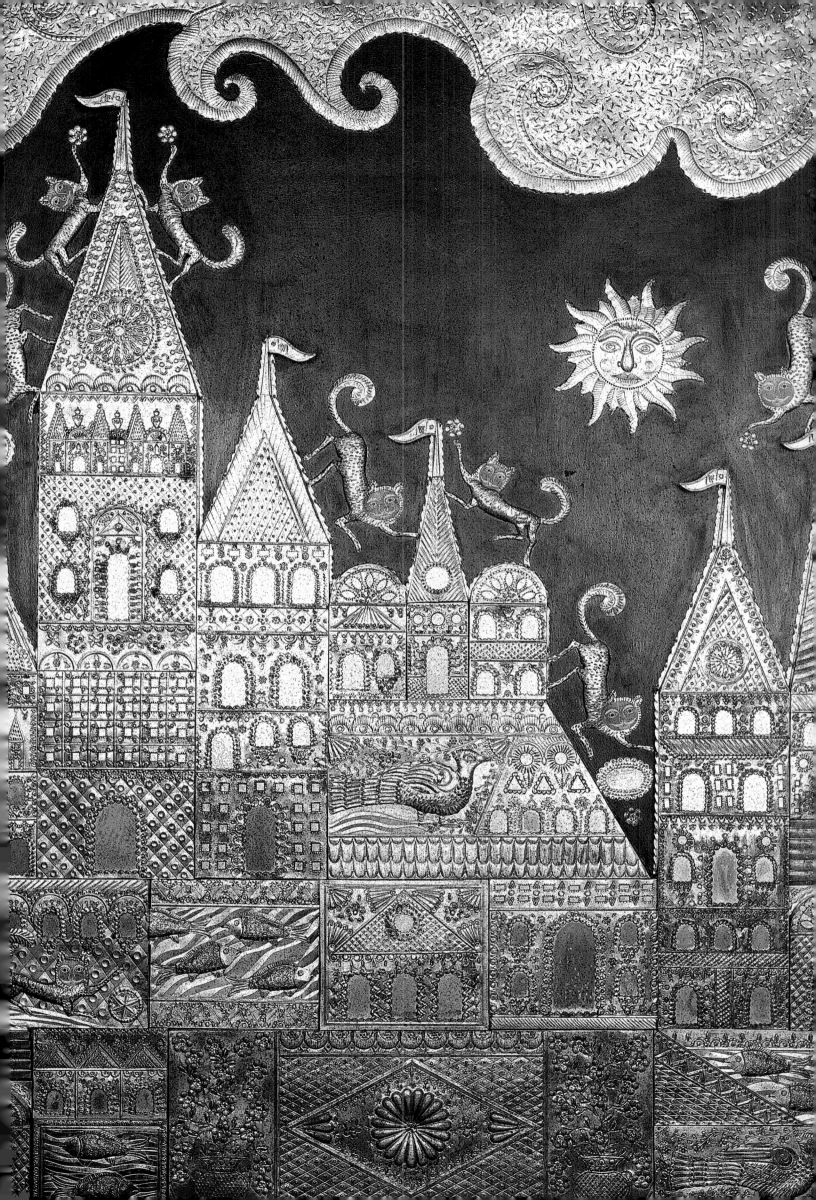

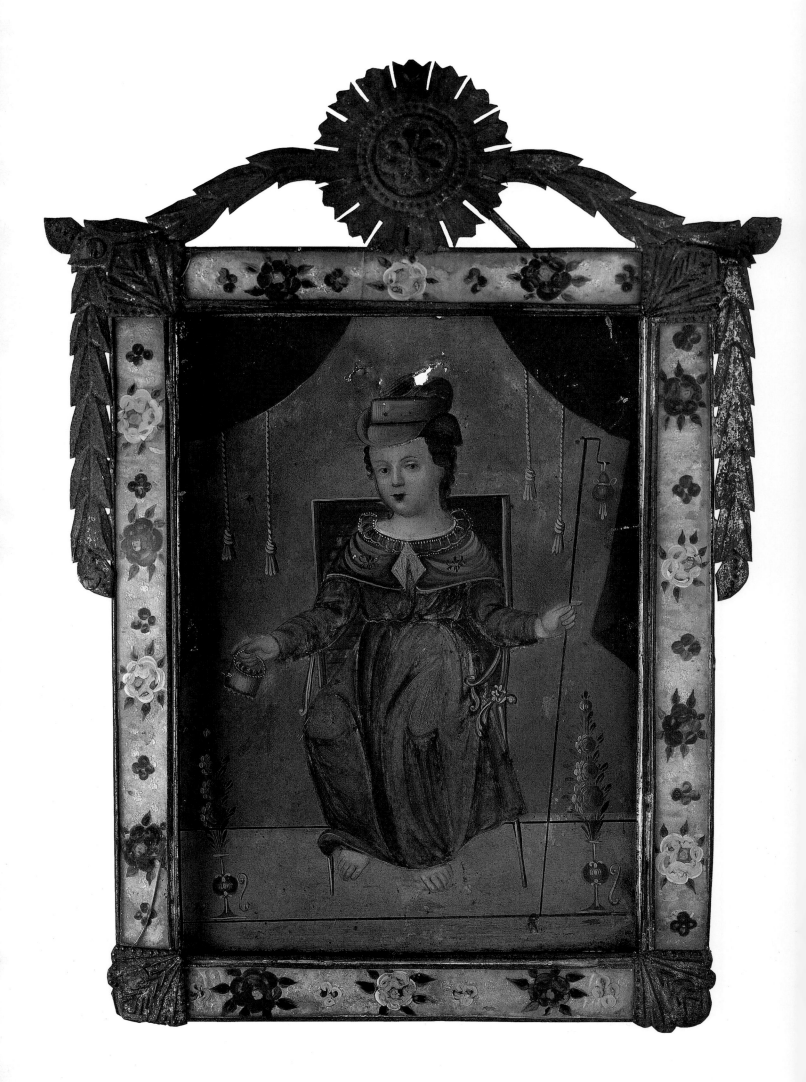

Opposite page
Painted tinplate
frame with repoussé,
with image of the
Holy Child of
Atocha,
ca. 1875.
Private collection.

From Domestic Worship to Spiritual Utility

Nineteenth- and early twentieth-century homes possessed tinplate candlesticks and candle molds, lamps, lanterns, frames, boxes and canisters to store food, tobacco or cosmetics, spoons and ladles, plates, cups, sieves and strainers, matchboxes, trays, tea kettles, pitchers, scoops, coffee pots, egg beaters, graters, cookie cutters, baking and jelly molds, pans, laundry boilers, roasters, lard containers, buckets, chamber pots, washbasins, bathtubs and mousetraps. Tinplate readily loaned itself to decoration with lithography to make attractive boxes and cans for crackers and oil, as well as toys, items for the Day of the Dead, whistles, tambourines and colorful noisemakers for Holy Week. ❖

Workshops, farms and stores would have used funnels, measuring scoops and cups, coal-oil cans, milk cans and other containers. Pipes, gutters and gargoyles were also fabricated from the material. ❖ Tinplate was used for ecclesiastical articles including processional lanterns, missal stands and *ramilletes* (altar ornaments with floral motifs), as well as saints' crowns, angels' wings, daggers for the Madonna's heart and other accessories for religious figures. Inventories done at mission churches and friaries during the eighteenth and nineteenth centuries list tinplate articles such as boxes to store altar bread, holy water and oils; chandeliers, sconces, lamps, candlesticks, plates and frames. Tinplate was one of the materials used to make processional crosses (recorded in 1776 as gifts from the Spanish king to mission churches in New Mexico) because its relatively low price made it a more feasible option for poorer missions. Tin's shiny surface has an appearance similar to silver which to a great extent must have accounted for its appeal, despite its tendency to rust. As these and other decorative objects were intended to be given a significant place in homes or churches, it seems likely that tinplate was regarded as a poor man's silver. ❖ In the mid- to late nineteenth century, some of the most recognized and appreciated uses of tinplate were as a surface for small folk paintings of saints (*laminas* or *retablos santos*) and ex-votos, and to make frames and nichos for these paintings and for religious sculptures. Tin sheets took oil paint well and proved immediately advantageous in the production of retablos, although it is not entirely certain whether the presence of tinplate kindled the incredible boom in retablos during the nineteenth century or if the popular religious imagery reflected in these paintings was a manifestation of other factors: aesthetic ideals and novelty, or political, religious and economic changes. What can be said

with some certainty is that when compared to equivalent paintings done on copper during the eighteenth century, these earlier works consistently display superior technique (chiaroscuro, anatomical correctness, exceptional attention to detail, an understanding of balance and composition, sophisticated glazes). Popular paintings on tin were much less influenced by academic notions of art, and frequently fall into the category of primitive or naïve art. ❖

While the exquisite aesthetic qualities of eighteenth-century paintings of saints on copper may have been transformed into a more spontaneous, less time-consuming and much less expensive work on tinplate, there are some nineteenth-century portraits on tin that are more labored and detailed. Their creation spans the entire nineteenth century and the early twentieth. Without a doubt, the most extraordinary examples were created by the painter Hermenegildo Bustos of Guanajuato, although there were a number of earlier works, most of them anonymous, that are also commendable. Given the availability of tin as well as its inherent qualities, there is a strong possibility that it was also used for *escudos de monjas* (large medallions bearing a saint's image, worn by nuns) and reliquaries. ❖

The wide availability of tinplate does not completely explain the demise of paintings on copper; it is more likely that painting on copper was already going out of fashion at the same time that tinplate began to appear in Mexico. Nineteenth-century high art—dominated by the neoclassical Academy of San Carlos—favored large paintings on canvas and eschewed the small, dark and dense copper panels. Although small paintings of religious themes were done on canvas, the insignificant number that have survived (likely due to their less permanent nature) does not enable us to make an honest comparison with their tin counterparts. Retablo painters produced their own colorful paintings on tin, creating images of popular religious subject matter and dramatic miracles that were accessible to most budgets. ❖

There are frequently solder marks present on the back of *retablos santos*, indicating that a frame or niche-like box was originally intended to hold and protect them. It is likely that a close relationship existed between tinsmiths and artists—in some cases one person may have performed both functions. Some of the most imaginative work created by Mexican tinsmiths can be seen in these frames and nichos, which were often ingenious

Tinplate frame with repoussé with a page from a religious catalogue. Río Arriba Studio, New Mexico. Diameter: 11 in. Private collection.

artifacts in their own right.
Many reflect styles that
could be loosely classified
as "federalist" (using
motifs derived from
French Empire and U.S.
Federal period frames) or
neoclassical, and display
strong architectural
forms such as engaged
columns and square,
round or fan-shaped
corner bosses. ❧
Grooved, pounced
or inscribed roundels,
scallops or plant-inspired
pediments crown the pieces,
with flanges or "ears" attached to
the sides. Embellishments such as
lozenges, crown-like finials or the Mexican
national emblem were occasionally cut from tinplate
and attached to the top of the pediment, frame or nicho. ❧
Typical treatments for tinwork frames and nichos include scoring,
repoussé or embossing, pouncing, and shaping the vertical and
horizontal panels. Around the end of the nineteenth century, the
painted retablo was displaced by lithography, but the tin frame
persisted with little if any change in form and style. The quality
of workmanship ranges from crudely cut and barely soldered, to
extremely accomplished and attractively proportioned objects. ❧

The Double Life of Tinplate

There is little doubt that discarded food and oil cans were used
in the production of retablos and ex-votos, as well as hundreds
of other objects that could conceivably have been crafted from
tinplate. In their book *New Mexican Tinwork, 1840–1940*, Lane Coulter
and Maurice Dixon establish the enormous impact that the
introduction of tinned goods had as a source of material for the
creation of frames, lamps and other household utensils in that
region. As Coulter and Dixon observe, many objects retained the
original painted labeling or embossed stamps. While it would seem
the appearance of an even cheaper source of tinplate (discarded tin
containers) would have inspired tinsmiths in Mexico—and although

*Octagonal tinplate
frame with a
lithograph of the
Holy Child of
Atocha,
ca. 1890.
Mora Studio, New
Mexico.
26 x 25 ¹/₂ in.
Collection of Ford
Ruthling, Santa Fe,
New Mexico.*

❧ GLORIA FRASER GIFFORDS

a few nineteenth-century retablos and ex-votos exhibit marks testifying to a previous life—the soldered seams, stamps and labels are absent in the majority of retablos, ex-votos, frames, nichos and other pieces of tinwork from the same period. ❧

This suggests that the tinned goods industry—which mushroomed in the United States with the provisioning of Civil War troops and later with emigration into the vast western expanses of the country —had a lesser significance in Mexico, especially in rural areas. Tin cans were probably also recycled in nineteenth-century Mexico, but the paucity of such examples from the period suggests that the practice was not widespread. Recognizable pieces of tin produced for other purposes can be seen in the pediment and ears of the frame on a retablo of Saint Anthony of Padua. They appear to be made from a previously embossed piece of tinplate, most likely a ceiling panel. ❧

The moderate cost of materials, the ease of fabrication and the little capital needed for equipment were favorable to the development of a small local tincraft industry. It seems likely that tinplate objects in Mexico—household items as well as retablos santos and their frames—were produced and distributed in much the same manner as in the rest of North America: a cottage industry with distribution by means of itinerant merchants or at fairs and regional markets.

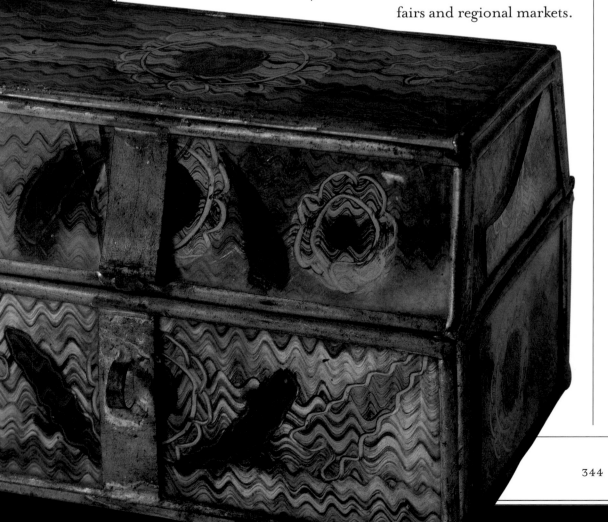

This hypothesis is supported by the fact that rural markets in both Mexico and the United States during the nineteenth century were isolated and unsophisticated, exhibiting a strong demand for novelty items. Moreover, both tin and skilled artisans capable of transforming it into appealing objects were readily available. ❧ Students of material culture find that when viewed in context, tinplate has a richer and deeper significance than its purely functional one: "An inexpensive but attractive rigid material capable of being easily worked into any number of objects." Its presence gives rise to certain reflections upon, among other things, Mexico's economic and trade situation in the eighteenth, nineteenth and twentieth centuries; the development of new skills, forms and objects using the material; and its impact as a replacement for other crafts and materials. In aesthetic terms, the tinsmith's willingness to absorb influences from mainstream fashions or trends—frequently converting simple, inexpensive or recycled material into winsome artistic items—was what permitted him to thrive, as in the case of so many other Mexican artisans. Techniques were generally refined and designs were often quite intricate, belying the common belief that because they were inexpensive or readily available to the masses, the pieces made must have been quickly or shoddily assembled. These objects, which in many cases reflect an agrarian or non-industrial Mexico, display a degree of integrity in their material and manufacture that is totally lacking in their contemporary equivalents produced from pressed or extruded plastic, and exemplify the spark of vitality and imagination that distinguishes Mexico's artisans. ❧

FOUR TINSMITHS SPEAK ◈

◈ Interviews with Arturo Sosa, María Luisa Vázquez de Sosa,
Ramón Fosado and Víctor Hernández Leyva

◈ *Magali Tercero*

O AXACA IS THE STATE THAT PRODUCES THE FINEST QUALITY TINWORK
in Mexico. And the reason for this is that the artisans here leave
a part of themselves in every piece. These four interviews with
tinsmiths from the region attest to the fact that their art originates
in an oneiric world steeped in tradition. The techniques of working
with tin have been improved to such a point that an entire industry
has grown out of this vital tradition that is constantly evolving, with
some surprising results. ❖

*Tools for working
with tinplate.
Photo: Jorge Vértiz*

Arturo Sosa

M.T. What are the main qualifications of a good tinsmith? ❖
A.S. In the first place, a tinsmith should know how to draw, and have
patience, curiosity and a little imagination. I look through a lot of
magazines. When I see something I like, I draw it. Or people bring
me pieces and say, "I want you to make this, but I'll leave it to your
judgment." Part of my life goes into every job, because I give my all to
every piece. Sometimes I see my pieces and can't believe I made them.
I've made many things—I made the battle of France as a freestanding,
three-dimensional piece, for a museum in France. I'm also making a
mirror for a museum in the United States. It depicts a whole town, its
customs, everything. ❖
M.T. Do you have a special way of concentrating, of coming up with
forms? ❖
A.S. I get ideas at night, when I'm in bed. I always have paper and a
pencil by the pillow. I dream things, then wake up and draw them. Some
turn out well and others not so well, but I make a lot of designs. ❖
M.T. Do you have a favorite? ❖
A.S. The one I like best is the Sacred Heart. I had the idea of
making a large heart, because in Mexico City they only make tiny
milagros, but I didn't have any idea of how to go about it. One night I

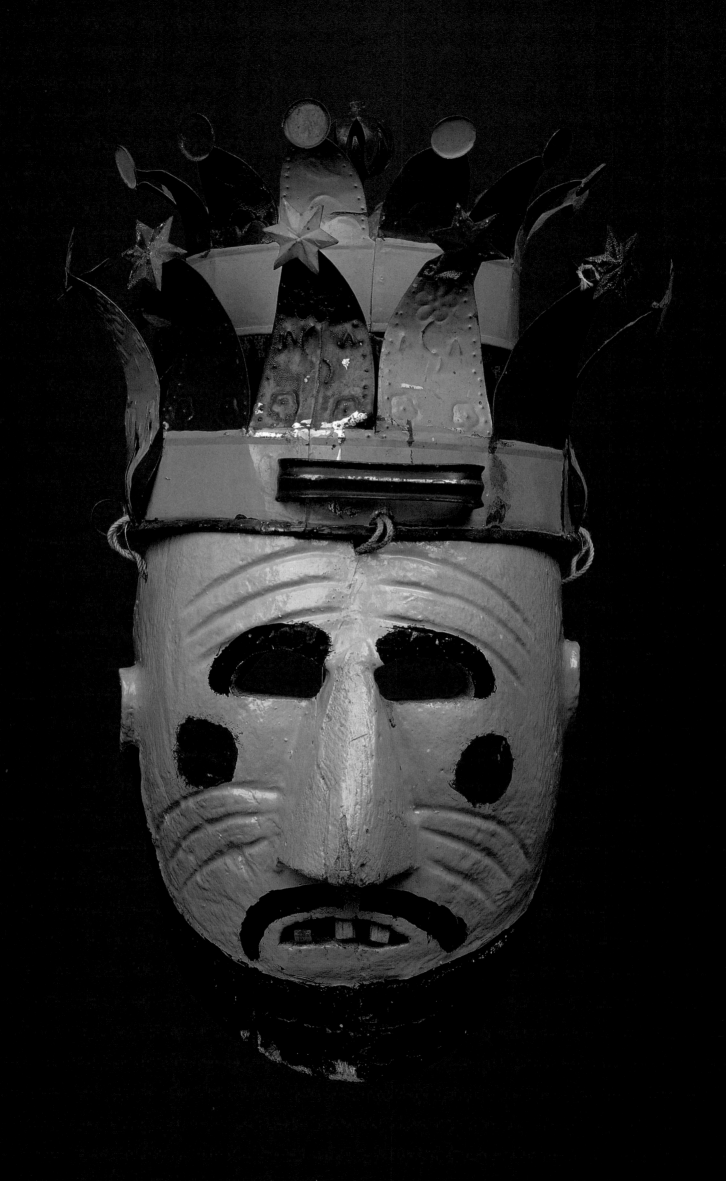

Dancer in the Dance of the Moors, wearing painted tinplate crown with repoussé. Atlixcáyotl fiesta, 2002. Atlixco, Puebla. Photo: Jorge Pablo Aguinaco.

Opposite page Moor's mask, ca. 1975. Carved painted wood. Painted tinplate crown with repoussé.

went to bed thinking about that, and then inspiration struck. I drew the figure, and afterward, placed smaller hearts behind and around it. The same thing happened with the hand; I believe that when you shake hands sincerely, you give from your heart. ❖

M.T. How did you get your start in this craft? ❖

A.S. I started in my father's shop at the age of five, cutting tin. I didn't like the work, but after a while, I began doing it out of necessity. I would make little *nichos*, and my father made statues of the Virgin of Solitude of Juquila. Another man, Guillermo Espinoza, taught me a little more. My father's name was Fidel Sosa Rivas. He made decanters, pitchers, *nichos* for the church. I make utilitarian pieces rather than works of art. My mother, María Luisa Vázquez de Sosa, makes religious statues. ❖

M.T. Do you get a lot out of this craft? ❖

A.S. Yes, although it wasn't easy to have my work recognized—it took about thirty years. I work more for the foreign market; almost exclusively *milagros*. The work is higher quality, in repoussé, with a better finish and finer engraving. I only make the commercial cactus or prickly pear figures for sale in Mexico. ❖

María Luisa Vázquez de Sosa

M.T. Who else besides yourself produces religious images in tin? ❖

M.L.V.S. In the old days, we were the only ones in Oaxaca that made statues of the Virgin of Guadalupe, Christ, the Holy Child of Atocha. My husband and I were young; this was around 1939.

We first started to make small glass cases to hold clay figures of indigenous dancers with real feather headdresses. When my children were young, we made pieces by the thousands. We had a large family, and we all worked. I have two daughters who still make statues of the Virgin. ❧

M.T. What are your daughters' names? ❧

M.L.V.S. Soledad and Consuelo Sosa Vázquez. They are doing very well, because they make virgins of all sizes: fifty-centimeter ones, twenty-five-centimeter ones, and even smaller. The little gown, faces and hands—everything has to be made by hand. The body is made of wood, the hands and face are of sawdust paste, the stars are tin. Putting them together is the hardest part. You have to start with the body: attach the head, then cover the hands, place the ornaments around her neck, and add eyes and a mouth. Years ago the star was made of gilded adamantine, but it was more work. My daughters recently had the idea of using stars that are sold ready-made. ❧

Ramón Fosado

M.T. How long have you been working as a tinsmith? ❧

R.F. I am fifty-four years old and have been in the trade for forty-five of them. The figures that used to be made here in Oaxaca were three-dimensional, freestanding pieces. I had the idea of making the first flat figure. I thought, "Well, if it looks pretty as a freestanding piece, why wouldn't it look good flat?" Many told me I

Moors at fiesta of Atlixcáyotl, 2002. Atlixco, Puebla. Photo: Jorge Pablo Aguinaco.

Moor's crown.

Puebla.

Painted tinplate

crown with repoussé.

was a lazy tinsmith because I did flat tinwork. But it's easier to transport that way; before it was very difficult to carry the statue. All the designs I have made are flat. Now they are made all over Oaxaca, and even in San Miguel de Allende. It was also my idea to make the macaw, the owl, the parrot. Thank God I can draw, because I can create many figures. That eagle is the national symbol; I made seventy of them for the presidential residence at Los Pinos. They put them on a flag and lit them from behind. The gaps have to be cut out with scissors. You draw on the tin and cut out the whole drawing as if perforating it with a little saw. ✣

All the pieces you see take a lot of time, and here in Mexico people don't pay well for them. I feel satisfied that my work has spread to many places. I was so surprised when a German man once came to Oaxaca with one of my own pieces, so I could make more like it for him. ✣

Right now there are thirty-eight people, besides my children, dependent upon me. I give them tools to work at home. My daughter Cecilia teaches painting. My son-in-law is an electronics engineer, and he loves working in tin; whenever he has a little free time, he comes to work, and I pay him for what he does. ✣

M.T. Where do you get the tinplate? ✣

R.F. I buy it in Mexico City, because there you can get different thicknesses. There is tin here, but second-rate. I don't like it because my work is sold around the world. ✣

M.T. Do you need an artist's temperament to do this? ✣

R.F. Yes, I have a lot of imagination. Many people work as tinsmiths but they do nothing but copy. What has kept me going is that I don't copy. I look through magazines and do drawings, but I never make two pieces exactly the same. ✣

M.T. What stage of the work do you like the best? ✣

R.F. I have devoted myself to more artistic work. I feel like a creator of figures, and I love that. People didn't always know how to appreciate the work. I made many designs, but they paid me very little. To make a name for myself, I had to go out to the fairs. The most important fair for tinwork is in Puebla, because people buy a lot. I sell at the Feria de los Fuertes (Festival of Forts), and also in Tijuana, Monterrey and Guadalajara. You can get a list of fairs and the dates they are held from the Ministry of Tourism. ✣

M.T. How would you describe the work currently being done in Oaxaca? ✣

Sacred Heart.

Oaxaca.

Painted tinplate with

repoussé.

Opposite page

Arnulfo Mendoza

and Armando

Villegas.

Moon,

Oaxaca, 1998.

Tinplate with

repoussé and

engraving.

23 ³/₄ in. diameter.

R.F. Those of us who are better known have our own lines of work, and we respect each other. Alfonso Leyva is a very good tinsmith and so are Valdemar Ríos, Alfonso Valdés senior, Aarón Velasco Pacheco, and his mother, Doña Serafina. I tip my hat to that woman. ❖

M.T. What are your favorite techniques? ❖

R.F. Repoussé and making three dimensional objects. This is more satisfying because people appreciate this kind of work more. ❖

M.T. Would you say the art of tinwork is becoming extinct in Oaxaca, or is it being transformed? ❖

R.F. Folk art is moving in two directions at once. One is the conservation of the old, refined techniques with well-made modern designs and individual style. The other, which is more common, is that it is becoming increasingly commercial. For example, women in Oaxaca say, "It's less expensive for me to buy a dress in the store than to weave a huipil." They produce very thin weaves in much less time than they used to, so as to sell them quickly at a lower price. This debilitates the tradition. There is more tinware production in Oaxaca right now. There are more tinsmiths and more creativity. They're constantly making new things, new designs. Some of them are really beautiful and others, very poorly made. ❖

M.T. Who are the most creative tinsmiths in this tendency? ❖

R.F. I think that we each have our own style. For example, there is a young man who is making very pretty earrings, with very interesting designs and very inexpensive. They're lightweight, comfortable, and young people love them. ❖

Víctor Hernández Leyva

M.T. How did you learn this craft? ❖

V.H.L. I learned from a relative, thirty-five years ago. I began for the pure pleasure of seeing the things made. If you want to make a difficult piece, well, you find a way. Some pieces are very eye-catching, large but not very difficult. Sometimes the small pieces are more difficult. Engraving is done directly on the tinsheet by hammering, and for the rest we use a burin or graver. We use very different burins to make a floweret, for example. We first make the central part, shaping it with a small burin and finishing it with a tiny stonecutter's chisel. Another tool is used to make the petals. It could also be die-stamped, but then it wouldn't be a handicraft. We do everything by hand. ❖

M.T. How long would it take a beginner to learn the craft? ❖

V.H.L. The first thing we teach in this trade is to score, which means to trace the mold onto a metal sheet. That's the beginning. Then, we cut it out with scissors and give it the shape we want. After that, we do the engraving. It's all done step by step. Soldering is also tricky. You need patience and care, and to know the exact temperature for the soldering iron. Then comes the painting. We use anilines; we have to prepare the colors, and that is another problem because you have to get it just right. The paint is very delicate. If it's too cold or too hot, it turns out badly, so you have to find a midpoint. The weather is what causes us most difficulties, especially when it rains. Humidity makes the paint cloudy. ❖

M.T. So there are seasons for painting? ❖

V.H.L. We paint all year, but we try to find the right moment. For example, in May we paint all day long, but if it rains, we turn on a lamp to control the temperature so the paint will remain clear. It takes longer this way. But if the weather's good, you can use the paint at room temperature. We make paintbrushes with our own hair, which is very straight. The paintbrushes available where paint is sold are no good—they scratch too much. I don't know how other people work, but that's what we do. ❖

M.T. Which pieces are you fondest of? ❖

V.H.L. All of them. This little mariachi was part of a trio: two with guitars and one with maracas. We sent it to a contest and won the National Handicrafts Award in Toluca. That other piece is like a little band of musicians with trombone, cymbals and drum. I based these figures on some I saw on a lottery ticket. I drew them, scored them on a metal sheet and cut them out to make the mold. ❖

M.T. Are there only men in the workshops? ❖

V.H.L.: Yes, although I've tried to have some women learn in my workshop. I think I'm the only one who hires women. The work is hard—I spend whole days at it. For the last two weeks I've been engraving every day from eight in the morning until nine at night. You get tired. ❖ TRANSLATED BY LISA HELLER. ❖

Angel.
Painted tinplate with
repoussé.

Opposite page
Box decorated in the
typical fashion of
Magdalena de Kino,
Sonora, with red or
orange flowers on a
black background.
Ruth D. Lechuga
Folk Art Museum.

Adovasio, J. M. *Basketry Technology: A Guide to Identification and Analysis* (Chicago: Aldine Publishing Co., 1971).

Amith, Jonathan D. *La tradición del amate* (Chicago-Mexico City: Mexican Fine Arts Museum-Casa de las Imágenes, 1995.)

Basketry, Artes de México (Mexico City), no. 38 (1997).

The Ceramics of Mata Ortiz, Artes de México (Mexico City), no. 45 (1999).

Ceramics from Tonalá, Artes de México (Mexico City), no. 14 (1991).

Ex-Votos, Artes de México (Mexico City), no. 53 (2000).

Folk Art: The Ruth D. Lechuga Museum, Artes de México (Mexico City), no. 42 (1998).

Metepec and Its Art in Clay, Artes de México (Mexico City), no. 30 (1995).

Mexican Lacquerwork. Uso y Estilo (Mexico City: Artes de México-Museo Franz Mayer, 1999).

Mexican Beadwork. Uso y Estilo (Mexico City: Artes de México-Museo Franz Mayer, 1998).

Rebozos from the Collection of Robert Everts. Uso y Estilo (Mexico City: Artes de México-Museo Franz Mayer, 1994).

Retablos and Ex-Votos. Uso y Estilo (Mexico City: Artes de México-Museo Franz Mayer, 2000).

Ruth D. Lechuga: A Mexican Memoir. Uso y Estilo (Mexico City: Artes de México-Museo Franz Mayer, 2002).

Snakes: Folk Representations, Artes de México (Mexico City), no. 56, (2001).

Tiles, Artes de México (Mexico City), no. 24 (1994).

Talavera Pottery from Puebla, Artes de México (Mexico City), no. 3 (1989).

The Tehuana, Artes de México (Mexico City), no. 49 (1999).

Textiles from Chiapas, Artes de México, no. 19 (1993).

Textiles from Oaxaca, Artes de México (Mexico City), no. 35 (1996).

Atl, Dr. (Gerardo Murillo). *Las artes populares en México* (Mexico: Publicaciones de la Secretaría de Industria y Comercio, 1922).

—. "Las lacas." *Arqueología Mexicana* (Mexico City), IV, no. 19 (INAH, 1996).

Barber, Edwin Atlee. *Catalogue of Mexican Maiolica Belonging to Mrs. Robert W. de Forest* (New York: The Hispanic Society of America, 1911).

—. *The Maiolica of Mexico*. (Philadelphia: Philadelphia Museum Memorial Hall, 1908).

Bauz, Susan. *Costume Design and Weaving Techniques in Tenejapa, Chiapas, Mexico* (Washington: The George Washington University Anthropology Department, 1975).

Branstetter, Katherine Brenda. *Tenejapans on Clothing and Viceversa: The Social Significance of Clothing in a Mayan Community in Chiapas* (Berkeley: University of California, 1974).

Cervantes, Enrique A. *Loza blanca y azulejo de Puebla*, 2 vols. (Mexico City: (n.p.), 1939).

Charlton, T. "Tonalá Bruñida Ware, Past and Present." *Archaeology*, 32, no. 1 (1979).

Cordry, Donald and Dorothy M. Cordry. *Mexican Indian Costumes* (Austin: University of Texas Press, 1986).

Deagan, K. *Artifacts of the Spanish Colonies of Florida and the Caribbean, 1500-1800*, vol. I (Washington-London: (n.p.), 1987).

Díaz, May. *Tonalá: Conservatism, Responsibility and Authority in a Mexican Town* (Berkeley: University of California Press, 1966).

Enciso, Jorge. "Pintura sobre madera en Michoacán y Guerrero." *Mexican Folkways* (Mexico City), VIII, no. 1 (1933).

Felger, Stephen Richard and Mary Beck Moser. *People of the Desert and Sea: Ethnobotany of the Seri Indians* (Tucson: The University of Arizona Press, 1991).

Fokko, C. Kool. "La tradición de las lacas en Olinalá." *Coloquio internacional sobre los indígenas de México en la época prehispánica y en la actualidad,* (Leiden, The Netherlands, 1981).

Frothingham, Alice. "Ceramics and Glass." *The Hispanic Society of America Handbook* (New York: The Hispanic Society of America, 1938).

Guiteras-Holmes, Calixta. *Los peligros del alma* (Mexico City: Fondo de Cultura Económica, 1952).

Jenkins, Katherine D. "Aje on Nin-in Painting Medium and Unguent." *Congreso Nacional de Americanistas* (Mexico City, 1964).

Lechuga, Ruth D. *El traje indígena de México: Su evolución desde la época prehispánica hasta la actualidad* (Mexico City: Panorama Editorial, 1982).

León Francisco P. de. *Los esmaltes de Uruapan* (Mexico City: Fomento Cultural Banamex, 1980).

Lynn, Stephen, et al. *Textile Traditions of Mesoamerica and the Andes: An Anthology* (Austin: Texas University Press, 1991).

Morris, Walter F. "Flowers, Saints and Toads: Ancient and Modern Maya Textil Design Symbolism." *National Geographic Research* (Washington: National Geographic Society, 1985).

— *Living Maya* (New York: H. N. Abrams, 1987).

Muller, Florencia and Barbara Hopkins. *A Guide to Mexican Ceramics* (Mexico City: Minutiae Mexicana, 1974).

Pérez Carrillo, Sonia. *La laca mexicana: Desarrollo de un oficio artesanal en el virreinato de la Nueva España* (Madrid: Banamex-Alianza Editorial, 1990).

Reichel-Dolmatoff, Gerardo. *Basketry as a Metaphor.* Occasional Papers of the Museum of Cultural History (Los Angeles: Museum of Cultural History, 1985).

Reiff Katz, Roberta. *The Potters and the Pottery of Tonalá, Jalisco, Mexico: A Study in Aesthetic Anthropology* (New York: Columbia University Press, 1976).

Sayer, Chloë. *Mexican Costume* (London: British Museum Publications, 1985).

Sepúlveda, Teresa. *Maque: Vocabulario de materias primas, instrumentos de trabajo, procesos técnicos y motivos decorativos en el maque.* Cuadernos de Trabajo (Mexico City: SEP-INAH, Museo Nacional de Antropología, 1978).

Tarn, Nathaniel and Martin Prechtel. *Constant Inconstancy: The Feminine Principle in Atiteco Mythology. Symbol and Meaning beyond the Closed Community.* Essays in Mesoamerican Ideas (New York: Institute for Mesoamerican Studies-State University of New York, 1986).

Tibón, Gutierre. *Olinalá.* (Mexico City: Editorial Orión, 1960).

Turok, Marta. *¿Cómo acercarse a la artesanía?* (Mexico City: Plaza y Valdés-SEP, 1988).

Weitlaner Johnson, Irmgard. "Basketry and Textiles." *Handbook of Middle American Indians*, vol. 10 (Austin: Texas University Press, 1971).

— "Survival of Feather Ornamental Huipiles in Chiapas, Mexico." *Journal de la Société des Americanistes, Nouvelle Série,* XLVI (Paris: Musée de l'Homme, 1957).

— *Design Motifs on Mexican Indian Textiles* (Graz: Academische Druck and Verlagsanstalt, 1976).

Zuno, José Guadalupe. "Las llamadas lacas michoacanas de Uruapan no proceden de las orientales." *Cuadernos Americanos* (1952).

GUTIERRE ACEVES PIÑA, an art historian, is former director of the Cabañas Institute in Guadalajara and research coordinator at the Western School of Conservation and Restoration in the same city. He has written "Costumbre y tipos en la escultura popular," in *La escultura mexicana: De la academia a la instalación*, as well as *Jorge Wilmot: La unidad y la dispersion. Una cerámica entre el oriente y el occidente* and *Tránsito de angelitos*. ✤ ALFONSO ALFARO, doctor in anthropology from the University of Paris, he has written, among others, *Voces de tinta dormida: Itinerarios espirituales de Luis Barragán* and *Moros y cristianos: Una batalla cósmica*. ✤ ALEJANDRO DE ÁVILA, doctoral candidate in anthropology in Berkeley, he is also an activist for environmental conservation and the protection of Mexican cultural heritage. He is the founding director of the Ethnobotanical Garden in Oaxaca. ✤ MARGARITA DE ORELLANA, doctor in history from the University of Paris, she is the editor of the magazine *Artes de México*, and author of numerous articles. She has also published several books on movies, history and folk art. ✤ GLORIA FRASER GIFFORDS, an art historian specializing in nineteenth-century art and architecture in colonial Mexico, is the author of *Mexican Folk Retablos* and articles on religious folk art in Mexico. She coordinated the *Artes de México* issues on tinwork and postcards. ✤ ANA PAULINA GÁMEZ, art historian, is the author of the book, *Sombreros, tazcales, sopladores y petates: la cestería michoacana* (1991) and has contributed articles to *Artes de México*. She has curated shows at museums in Mexico and the United States related to ceramics, textiles and daily life. ✤ WILLIAM T. GILBERT, specialist in the ceramics of Mata Ortiz, Chihuahua, has published different books on the topic, including *Crossing Boundaries/Transcending Categories: Contemporary Art from Mata Ortiz* and *Juan Quezada: The Casas Grandes Revival*. He has been curator of several shows of Mata Ortiz ceramics. ✤ RUTH D. LECHUGA, photographer and specialist in Mexican traditional art, with more than fifty years' experience, is the author of *Traje indígena de México, Las técnicas textiles, Cestería michoacana* and *Mask Arts of Mexico*. She is the founder of the Ruth D. Lechuga Folk Art Museum, with more than 10,000 folk art pieces and 21,000 photographic negatives. ✤ OCTAVIO PAZ, poet and essayist, was awarded the Nobel prize for literature in 1990, the Cervantes Prize and the National Prize for Literature. He was cultural liason at several Mexican embassies, until 1968. He is the author of numerous books, including *The Labyrinth of Solitude*. The text published here is an extract from his essay *El uso y la contemplación*, from the collection, *México en la obra de Octavio Paz* . ✤ ALBERTO RUY-SÁNCHEZ, editor-in-chief of the magazine *Artes de México*, he is the author of *Los nombres del aire* (winner of the Xavier Villaurrutia Prize), *Los jardines secretos de Mogador* and *En los labios del agua*, among others. ✤ CHLÖE SAYER, specialist in Mexican folk art, has published *The Arts and Crafts of Mexico, Mexican Patterns: A Design Source Book* and *Textiles from Mexico*, among others. She has curated a number of shows and organized ethnographic collections in Mexico and Belize, as well as the British Museum's collections on the subject. ✤ LUIS MARIO SCHNEIDER, researcher, critic, translator and writer, has written several collections of poems as well as *La literature mexicana, Diego Rivera y los escritores. Antología tributaria* and *México y el surrealismo*. He won the Xavier Villaurrutia Prize for *La resurrección de Clotilde Goñi*. ✤ MAGALI TERCERO, editor and journalist, co-wrote *La nueva crisis de México* (Editorial Aguilar, 2003) and contributes to *Milenio, Arquine* and *Saber Ver*. She was an editor at *Artes de México* from 1989 to 1998. She was awarded the Rockefeller Scholarship for *Crónica de la frontera* (1997). ✤ MARTA TUROK WALLACE, anthropologist, has published several books, including, *¿Cómo acercarse a la artesanía?, El caracol púrpura: Una tradición milenaria, Fiestas mexicanas* and *Living Traditions: Mexican Popular Arts*. She is president of the Mexican Association of Art and Folk Culture (AMACUP). ✤ LUZ DE LOURDES VELÁZQUEZ THIERRY, art historian and specialist in tiles, has written *El azulejo y su aplicación en la arquitectura poblana* and collaborated on the book *Arquitecturas andaluzas y americanos: Influencias mutuas*. ✤ IRMGARD WEITLANER JOHNSON, specialist in Mexican indigenous textiles, is the author of *Design Motifs on Mexican Indian Textiles, Los textiles de la cueva de la Candelaria, Coahuila*, and the articles "Supervivencia de un antiguo diseño textil basado en la urdimbre" and "Análisis de un tejedo de Tlatelolco." She worked for many years at the Folk Art Museum and the National Indigenous Institute, visiting indigenous communities to study their textile techniques. ✤

❧ EDITORS:

Margarita de Orellana

Alberto Ruy-Sánchez

❧ GUEST EDITOR:

Eliot Weinberger

❧ EDITORIAL COORDINATORS:

Michelle Suderman

Gabriela Olmos

❧ DESIGN:

Luis Rodríguez

❧ PRODUCTION:

Carolina Martínez

❧ COPY EDITORS:

Richard Moszka

Joanne Reames

❧ TRANSLATORS:

Susan Briante

Charlotte Broad

Carole Castelli

Mónica de la Torre

Lisa Heller

Jen Hofer

Jessica Johnson

Helen Lane

Richard Moszka

John Page

Jana L. Schroeder

Michelle Suderman

❧ DESIGN ASSISTANTS:

Daniel Moreno

Aidee Santiago

Mariana Zúñiga

❧ PREPRESS:

Alejandro Pérez Mainou

❧ PHOTOGRAPHY:

Cover ❧ Tachi

Inside pages ❧

Rafael Bonilla: p. 71.

Laura Cohen: p. 4.

Dolores Dahlhaus: p. 7.

Raúl Dolero: p. 52.

Ricardo Garibay: pp. 84, 155, 158, 160, 224–225, 229 to 233, 236, 252 to 255, 260.

Gerardo Hellión: pp. 30–31.

Patricia Lagarde: pp. 15, 17, 64–65, 68, 100–101, 105.

La Mano Mágica: pp. 276 to 280, 287, 288.

Salvador Lutteroth/ Jesús Sánchez Uribe: p. 137.

Pablo Morales: pp. 140–141, 159.

Museo de América, Madrid: p. 114.

Diego Samper: p. 173.

Gerardo Suter/Lourdes Almeida pp. 10, 117 to 128.

Tachi: pp. 1, 66, 69–70, 82, 96, 98–99, 104, 106, 113, 144 to 147, 290 to 301.

Jorge Vértiz: pp. 5, 6, 8–9, 14, 16, 20, 22 to 39, 44, 51, 54, 57 to 62, 86 to 91, 110, 130 to 135, 138, 139, 143, 148 to 152, 156, 161 to 172, 174 to 223, 226, 234, 237 to 251, 256 to 259, 261 to 275, 282 to 284, 302 to 335, 342 to 355.

❧ ACKNOWLEDGEMENTS:

Banco de México. Trusteeship for the Museums
of Diego Rivera and Frida Kahlo

Ford Ruthling Collection. Santa Fe, New Mexico

Ethnological Museum of Leiden, The Netherlands, Collection of
Irmgard W. Johnson

Instituto Nacional de Antropología e Historia

Instituto Nacional de Bellas Artes

La Mano Mágica Gallery

Museo de América, Madrid

Museo Bello, Puebla

Museo Dolores Olmedo

Museo Franz Mayer

Museo Regional de Guadalajara

Museo Universitario de Arte Popular, María Teresa Pomar

Pellizi Collection, Mercedes Servio

Sna Jolobil, Pedro Meza

Jorge Carretero Madrid

Ruth D. Lechuga

Horacio Gavito

Roberto Mayer

Samantha Ogazón

Marie-José Paz

Nina Rist